Digital Photography from the Ground Up

Digital Photography from the Ground Up

A Comprehensive Course

Juergen Gulbins

rockynook

Juergen Gulbins, jg@gulbins.de

Editor: Gerhard Rossbach
Copy editor: Judy Flynn and Lisa Danhi
Layout and Type: Juergen Gulbins
Cover Design: Helmut Kraus, www.exclam.de
Cover Photo: www.asgphotowerks.com
Printer: Friesens Corporation, Altona, Canada

Printed in Canada
ISBN 13: 978-1-933952-17-8

1st Edition
© 2008 by Rocky Nook Inc.
26 West Mission Street Ste 3
Santa Barbara, CA 93101
www.rockynook.com

Library of Congress Cataloging-in-Publication Data

Gulbins, Jürgen.
 [Grundkusr Digital Fotografieren. English]
 Digital photography from the ground up : a comprehensive course / Juergen Gulbins. – 1st ed.
 p. cm
 Includes index.
 ISBN 978-1-933952-17-8 (alk. paper)
 1. Photography—Digital techniques. I. Title.
 TR267.G9513 2008
 775—dc22
 2008000347

Distributed by O'Reilly Media
1005 Gravenstein Highway North
Sebastopol, CA 95472

This book is printed on acid-free paper.

Table of Contents

Preface

Today, digital photography has largely replaced analog photography. There are several reasons for this shift. Digital cameras have become less expensive and more compact. At the same time, their technology has become as sophisticated as that of their analog counterparts, and even exceeds it in many aspects:

▶ The photographer can evaluate his pictures on the digital display immediately after capturing them.

▶ The digital workflow is easier to manage and cheaper than the analog process. Photographers may edit images on the computer and adapt them to their intended use. They may also shoot freely, because an electronic image does not cost anything to capture, view, and (eventually) discard.

▶ Digital photography allows for immediate electronic use of the images, as opposed to analog photography, which requires additional time and work-intensive steps to modify it for electronic use.

▶ Digital images can be printed easily and quickly through a computer-printer setup or directly with a photo printer.

▶ Digital pictures simply can be presented on a broader range of media – on the computer screen, on a TV, with a projector, on the Internet, and, of course, also on paper.

▶ Images are increasingly required in digital form for use on the Internet or for desktop publishing purposes (i.e., brochures, advertising, or documentation). The prepress workflow takes place almost completely digitally and, therefore, digital photography saves several steps, including developing and scanning.

To create effective images you will need, as in every craft, practice and a basic knowledge of tools and techniques. This book shows you how to use a digital camera and introduces additional tools. It is written for the ambitious beginner as well as the amateur. It covers techniques for using a simple consumer camera, as well as how to work with semi-professional tools. However, this book does not describe specific product features but instead addresses the foundation of the craft of photography, which is not related to the latest technological advances.

After an introduction to the basic technology of digital cameras in chapter 2, this book starts with a section (chapter 3) on image composition, which is independent from analog or digital technology. This section attempts to show you how to compose pictures with interest and excitement, and thus create better images.

Chapter 4 shows what to keep in mind when shooting different subjects and doing different types of photography like landscape, portrait, children, animals and many more variations.

The central part of the book (chapter 5) introduces you to image editing.

I dedicated chapter 6 to the editing of RAW file formats. The RAW format is becoming more important with the increased popularity of single lens reflex (SLR) cameras.

Chapter 7 gives an introduction to printing – mostly printing using a inkjet printer. But I will also cover other methods to present your photos like slide shows and web galleries.

Finally, chapter 8 demonstrates how to capture, administrate and archive your images.

Most of the images in this book were taken with a digital camera, transferred to computer, edited in Photoshop Elements or Photoshop, and then placed into the digital document. A few pictures were scanned from slides or prints.

Special Thank You

I would like to thank Adobe Systems Inc., Apple, Extensis, iView Media Pro (now part of Microsoft), Hamrick Software, LaserSoft, Canon, Epson, Nikon and Hama. They have supported this book by supplying trial versions of their software, as well as photos of their products.

I would also like to thank friends who have contributed their pictures and experiences, and, through their encouragement, helped to shape this book. A special thank you goes to Angela Amon who supplied the composition diagrams, and many pointers and ideas in chapter 3.

Some of the best images in this book were taken by my brother, Rainer Gulbins, who, as a fellow amateur photographer, supported me with invaluable advice.

Thank you also to my daughter Sarah, who served many times as modeling "victim" as well as assistant.

Keltern, March 2008 Juergen Gulbins

Introduction

1

Most of us have taken photos before finding this book. There are many excellent automatic cameras available today, making it easy for anyone to go out and snap some pictures. All the knowledge and practice that was essential in the past – i.e., the choice of film, the correct aperture and shutter speeds, as well as focusing – has become mostly automated; even the novice can get usable pictures without knowing these basics.

Nevertheless, you can see the difference between snapshots, and the images of photographers who deliberately study the craft, who have mastered and continue to stretch the technology, and who are familiar with the rules of image composition. Their photographs are not happy accidents, but are appealing and rich in expression.

Granted, it takes some time to prepare and learn the applicable techniques, both for actual imaging and possibly for reproduction. However, the better result usually justifies the additional effort, and can create a much more usable product.

* Many of the pictures in this book were taken with an Olympus C-1400L (one of the very early digital cameras), a digital camera with only 1.3 Megapixels, but good optics, which shows that you do not need the most expensive equipment to create good images.

As is the case with desktop publishing, the amateur often takes on responsibilities that previously were completed by trained professionals. In the past, only a few amateur photographers enlarged their own pictures, but with the rise of digital photography, many more images are being reproduced, be it on printers, screens, or for display on the Internet. Enlargements generally require specific cropping and image corrections. Thus, digital photographers often assume a much more active role in image manipulation than we would have in the past.

Even though digital and analog photography have much in common, there are a few significant differences that you should consider; in addition, there are new tasks and options, such as image editing, to enhance your work and your craft. Thus, even if you have mastered analog photography, there is still much to learn.

Photographing is like hunting alligators. You always have to keep a watchful eye.

➡ Usually you can find the complete camera instructions in electronic form on the CD provided with your camera.

Practice, Practice, Practice

A book can explain many concepts and ideas, give background information, expand your understanding, set a framework, and illustrate a workflow. All this information can make your work easier and more efficient, and therefore more fun, which in turn can inspire you to look even deeper into the camera and its techniques.

But you must practice to get the benefits. You have to know your camera and the many options it offers, practice setting the controls, and read the manual. Take some time for this important aspect of your growth as a photographer.

The manuals supplied with many digital cameras are often brief and only describe the most important steps. Normally, you have to take a look at the electronic manual on CD to find all the camera settings.

If you do not already have experience with analog photography, you also need to train your eye. You need to learn about the new possibilities digital technology offers, and, if you want to take full advantage of them, you need to study the computer programs available for image editing and archiving.

Conventions Used in the Book

Besides information in the text and margins about resources on the Internet, you can find additional references in Appendix C, starting on page 343.

The organization is simple. The notation "Image ▸ Scale ▸ Image Size" describes a menu sequence. Red or green arrows and circles are used for emphasis in pictures and diagrams. Some screen shots have been simplified to keep them small and concise.

This book is not meant to be a software manual. Therefore, the instructions should be understood as general working procedures, and not as specific program directions. The principles could be applied to other cameras and programs, even though the terminology may differ slightly, the

buttons may be labeled differently, or another keystroke sequence may be used.

The book limits itself to a small number of editing programs, specifically focusing on Adobe *Photoshop Elements* (version 6.0) for image manipulation and the *Organizer* module of Elements version 6 for image organization and archiving. (*Organizer* is part of the Photoshop Elements installation on Windows.) Photoshop Elements is a effective program, relatively cheap, and is sometimes part of camera or scanner bundles. Photoshop Elements is available for Windows as well as Mac OS X. Most of the descriptions in this book, though using Photoshop Elements 6 as their base, also apply to previous versions; the graphical user interface may, however, be slightly different.

However, Photoshop Elements is not the only, or necessarily the best, program. There are numerous other programs which are often cheaper, or even available as freeware.

Even if this book describes some of the functions of Photoshop Elements or Photoshop, it should be understood not as a software manual, but as an aid in explaining principles.

The descriptions and workflow sequences in this book are meant to be aids and suggestions, not dogma and must-dos. To achieve engaging results, it is most important to employ creativity and to enjoy experimentation.

→ *"Picture ▸ Rotate ▸ Own ..." describes a menu sequence.*
The notation Ctrl-A *means that both keys* Ctrl *and* A *need to be pressed at the same time.*
⇧ *represents the Shift key.*
◯ *or* ⬭ *emphasize specific points in pictures and diagrams.*

Testing and Deciding

The variety of programs relating to photography is vast and often confusing. Features of programs often overlap. For example, most image management software include a few simple, semi-automated image corrections. Similarly most amateur image editing programs contain simple tools for image management. Fortunately, almost all programs have demo versions that can be tested for a specific time period, or used with some restrictions. Test all the programs that seem interesting to you, but decide on only a few, i.e., one for image editing, one for image organizing and archiving, and one for special effects or conversions. This is the only way to really learn your software programs, and to use them efficiently.

→ *Create quick reference guides of the most important functions of your programs. It helps while working, especially when you do not use them on a daily basis.*

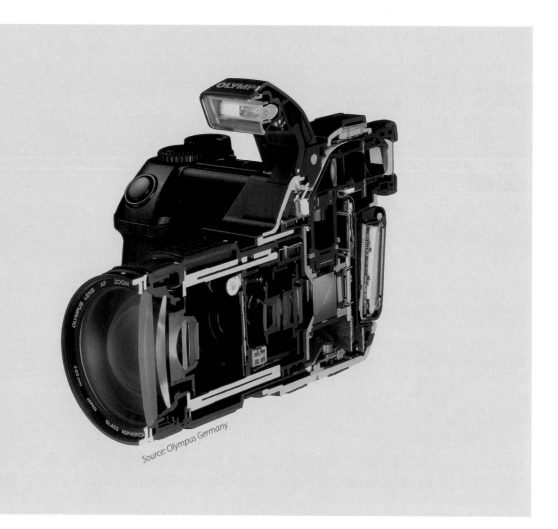

Source: Olympus Germany

Cameras and Accessories

2

The digital camera has much in common with its analog cousin; however, it has additional components and some variations to learn about. This chapter covers the construction of digital cameras in principal, their differences to film cameras, and the differences between various types of digital cameras. It gives an overview of the most important technical data and helps you to choose your own camera and accessories.

Some price information is supplied for your reference, and is representative of the average US prices at the end of 2007. These prices are constantly changing; generally speaking, they have mostly decreased.

Web-Cam (Logitech, ClickSmart 519)

* *"Megapixels" is also called "millions of pixels"*

*An example of a digital compact camera
(Canon IXUS 400)*

*SLR = single-lens reflex cameras
DSLR = Digital SLR*

*Digital single-lens reflex camera, with built-in
lens (Sony R1, 10 megapixel)*

2.1 Digital Cameras

The variety of digital cameras on the market today is as large as it once was for film cameras, especially in small format cameras. In addition, there are digital backs for medium- and large-format view cameras, which will not be covered here.

Cell phone cameras populate the low end of the spectrum. Their resolution ranges approximately from 320 x 240 to 1280 x 1024 pixels, and their image quality is fair. They cannot be used for serious photography. They are followed by web-cams, which usually have a resolution ranging from 640 x 480 to 1280 x 1024 pixels (0.3 to 1.3 megapixels) and often lack zoom optics. These camera types only allow for relatively simple pictures, and therefore, are not included in this book.

Next in line is a large range of consumer camera models, which today extends from an approximate resolution of 6.0 megapixels (i.e., $2\,816 \times 2\,112$) up to 12 megapixels (i.e., 4000×3000), with a strong tendency towards the higher resolutions. At a resolution of 6–12 megapixels the optical system of lower-end models will not be able to produce the level of quality required to take full advantage of the image sensor. Prices can range from about \$150 to \$500. The price is determined by the resolution, the quality of the lens, and the technical features, as well as its overall size: the more compact the camera, the more expensive it is. In addition, the optical zoom factor influences the price, especially once it surpasses a factor of 3 to 4. With higher zoom factors (up to a factor of 16) and greater focal lengths, image-stabilizing technology becomes useful.

The semi-professional and professional camera models are yet another step above; they begin at roughly 8 megapixels and go beyond 22 megapixels (as of 2007). This category also tends towards higher resolutions. It includes digital single-lens reflex (DSLR) camera models, with built-in lenses (also called *bridge cameras*) such as the Sony R1, as well as removable lenses, which we know from film cameras, such as the Canon EOS 400D (in the US named "Rebel XTi", shown on next page).

The price begins at approximately \$400 for the 8–10 megapixel models, and has no upper limit. For models with removable lenses there is the additional cost of the lenses. Many of these models still utilize lenses developed for film technology; however a focal length multiplication factor (also called *crop factor*) of 1.4 to 2.0 must be taken into account, which is due to the size difference of the image sensor to small format film (24×36 mm). This multiplier means that an analog 85 mm lens becomes an approximately 120–135 mm lens on a digital camera. This is good news for nature and sports photographers, who often like to use telephoto lenses. But it is not useful for wide-angle imaging. Also, good quality lenses must be used to take full advantage of the capacity these cameras have.

The range of new digital cameras available is enormous. Therefore, it is important for you to decide before you buy which features your new

camera should have, how you will use it, and how much you are willing to spend on it. Compact cameras, for example, rarely offer the best optical lenses and are limited in their settings options. However, because of their size – typically 110 × 60 × 5 mm and weighing less than 200 grams (7 oz.) – they are especially well-suited for spontaneous photographic situations. Compact cameras mostly have displaced larger models, even in the consumer segment of analog cameras.

Amateur-DSLR: Canon EOS Digital Rebel XTi (400D), SLR, 10,1 Megapixel

To produce high-resolution images, and to be able to utilize a large repertoire of equipment and program options in the amateur and semi-professional area of photography, you need a larger camera model. If you want to use the existing lenses of your film camera, you must resort to an expensive DSLR model. To use these cameras to their full capacity, your lenses should support autofocus and be of good quality.

With sustained popularity and sales success, the development of digital cameras continues. In the past, slightly modified film cameras served as the base for digital cameras; however, today there are new developments that are finely attuned to digital technology. One of these developments resulted from the cooperation between Olympus and Kodak, and is called *Four Thirds*. The system creates a standard that allows for the interchangeability of cameras and lenses from different manufacturers. *Four Thirds* refers to an image sensor in the size of ⁴/₃-inch and was planned to be entirely digital. The concept allows for compact lens construction adapted to the special requirements of the digital sensors of single-lens reflex systems. The first models were introduced to the market at the end of 2003. Compared to 24 × 36 mm film cameras the crop factor of *Four Thirds* DSLRs is two. Up until now, only very few camera manufacturers (e.g. Leica and Panasonic) picked up the concept. Sigma builds some lenses for this type of camera.

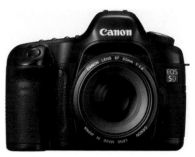

Professional DSLR using a full-frame sensor: Canon EOS 5D, 12,8 Megapixels

Just as in other computer-related sectors, technology is developing to increase storage capacity and resolution, even at continually decreasing prices. The functionality of cameras in the middle price range will continue to grow and include more sophisticated software programs, faster storage capacity, shorter switch-on and shutter delays, and more photographic adjustment options.

In the price range above $500, DSLR models will almost exclusively be offered in the very near future. Of course, some anticipated improvements are desirable, but the existing technology already allows for excellent images, so there are few reasons to wait for future improvements.

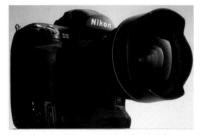

Professional Camera: Nikon D3 (full-frame sensor) 12.1 Megapixel

2.2 Camera Technology

Whether you are buying or working with a digital camera, it is quite useful to have some basic knowledge of the components and their functions. Therefore, let's have a look at the technical side of digital cameras.

2.2.1 Image Sensor

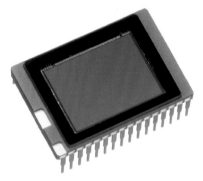

CCD-image sensor of the Olympus E-1

In digital cameras, the image sensor replaces the film used in analog cameras. The sensor is responsible for capturing the picture, or reading the image electronically, and writing it to a storage medium. The characteristics of a digital camera are generally determined by the resolution, the size, and the sensitivity of the sensor.

Sensors used in digital photography are often charge-coupled devices (CCD) or complementary metal oxide semiconductors (CMOS), which are electronic devices used to capture an image.

The sensor consists of individual light-sensitive sites, which read and store the incoming light. Each individual site builds up a positive charge that allows it to attract the negatively charged photons of the incoming light energy, which it then stores. A site is only sensitive to light intensity and not light color, and, therefore, a filter matrix (also called a *Bayer array*) is placed above the sites. This matrix is made up of alternating red, green, and blue colors, and it filters the incoming light for the sensor sites. A glass covering is placed above the filters, which protects the sensor, and act as a UV filter. Many new digital cameras also have a layer of micro lenses that concentrate the light through the filters and prevent light that falls on non-sensitive sensor areas from being lost.

The human eye is especially sensitive to green: we have more green-sensitive cones on our retinas than red- or blue-sensitive cones. For this reason, and because the green sites record more detail, twice as many green sites are located on the filter matrix than red or blue ones. Generally, the sensor does not measure the exact green, red, and blue values of the incoming light per sensor site. Rather, it measures the values of four neighboring sensor sites and uses a mathematical algorithm (the Bayer algorithm) to calculate a "mixed" (interpolated) color of those four sites.

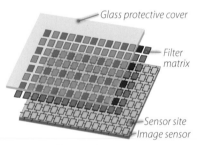

Glass protective cover

Filter matrix

Sensor site

Image sensor

Structure of a typical camera image sensor

Some sensor models use two different types of green in the filter matrix, a darker green and a lighter bluish-green. Using a slightly different algorithm, these new sensors result in even better color differentiation.

Another characteristic of the sensor is the resolution, or bytes per image pixel. One byte corresponds to 8 bits ($2^8 = 256$ possible values) per pixel and color channel (red, green, and blue), resulting in 16,777,216 possible colors. High-quality cameras can record 10, 12, 14, or even 16 bits per image pixel, and, therefore, can register even finer illumination and color gradations. Even though the finished picture, especially in print, can hardly reproduce the full range of 8-bit (with color prints it is $3 \times 8\text{-bit} = 24\text{-bit}$), and the human eye can only recognize approximately 10 million colors, it

creates reserve information for image processing and correction on the computer. In order to do this though, the image must be stored in RAW format. (For more information, please see page 41.)

To achieve a higher sensor sensitivity and a better dynamic range,* Fujifilm's sensor sites consist of two parts: a smaller element to capture the brighter light values, and a larger one to absorb weaker light signals. Both components are then mathematically combined. This improvement parallels the developments of scanners in recent years, in which even low-cost scanners can capture 3 × 12 or even 3 × 6 bit per sensor site. Naturally, the demands on the internal, temporary camera storage, and the requirements on the capacity of the processor also increase.

Another way to capture color is with a Foveon image sensor, which registers all three RGB (Red, Green, and Blue) color components separately at each image sensor site. The sensor stacks three layers of sensor sites, one each for red, green, and blue, and uses silicon's natural ability to separate, or differentiate between, colors depending on their wavelength. This image sensor does not supply a higher resolution, but higher color accuracy, and, therefore, crisper images than is possible with conventional image sensors using color filters.

We can expect to see more variations in the future. The focus in development, however, lies with increasing the resolution, the light sensitivity, the dynamic range, and the processing speed of the image sensor. The latter will also require faster camera processors and faster storage media.

For quite some time we have observed fierce debates whether CCD or CMOS image sensors are better. However, both technologies have their advantages and disadvantages. The CMOS sensor uses less electricity, which means it stays cooler and, therefore, should, at least as a tendency, produce less noise in pictures. However, this discussion is almost pointless. You can find very good sensors from both technologies on the market and some manufacturers will even offer both in their products.* What is far more important is how much noise a particular sensor or camera produces. *Noise* is an effect of digital imaging, which looks similar to the grain of high-speed film (even if both exist for very different technical reasons).

Noise in a digital image is seen as luminance, or color jumps, in neighboring image pixels, hence we distinguish between *luminance noise* and *color noise*. It is more apparent in darker image areas, and especially in those areas that have been lightened during image editing. Technologically, noise is caused by inaccuracies while the information captured by the sensor is read. Generally, larger sensors produce less noise than smaller ones – they simply have more surface area to capture light particles, and the information does not need to be amplified as much. It is just this process of amplification that creates the noise.

Large sensors have distinct advantages concerning the level of noise. However, the disadvantages are: much higher manufacturing costs; and larger, and, therefore, heavier and more expensive lenses are needed to achieve longer focal lengths.

* *Dynamic Range describes the range and the gradations from the lightest to the darkest point in an image.*

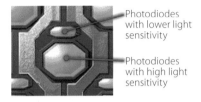

Photodiodes with lower light sensitivity

Photodiodes with high light sensitivity

Diagram of the Fujifilm-Super-CCD-Sensor Site

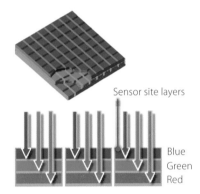

Sensor site layers

Blue
Green
Red

Construction of the Foveon-Image Sensor in 3 Layers

* *Although in different camera models.*

→ *We are looking here at small format cameras, whose reference size is the 35 mm small format film with an image size of 36 x 24 mm. Medium and large format cameras have different sensor sizes.*

The sensor sizes in small format cameras are divided into full frame sensors (with a size of about 36 × 24 mm), the so-called APS-C (*Advanced Photo System type-C*) sensors (about 25.1 × 6.7 mm) and the compact sensors, which are even smaller. At times, the sensor sizes are given in inches, which refers to the diagonal size of the sensor. For example, the ⁴/₃-inch format, which is used in the newer Olympus and Panasonic DSLR camera models measures approximately 18.0 × 13.7 mm.

The size of the sensor in point-and-shoot cameras is typically noted as $1/x$ (i.e., ¹/₁.₈"). This measurement also describes the diagonal size of the image sensor, therefore the larger x is, the smaller the sensor.

One can assume that the larger the sensor is, the higher the resolution (the number of sensor sites or image pixels). In principle, this formula is correct; however technology has made it possible to squeeze many sensor sites onto very small sensors. Point-and-shoot cameras with a resolution of 10 megapixels, which means 10 million image pixels are now available. The resolution is approximately 3 800 x 2 590 image pixels. Advertising campaigns promise that the higher the resolution is, the more detail will be captured in the image, which suggests to the customer that he has a purchased a particularly good camera. However, this is true only to a certain degree. Once the individual sensor site becomes too small, it can technically only capture a low number of light particles. This lowers the light sensitivity of the camera. Another problem that occurs with too-small sensors is that the sensor signal must be amplified so strongly that the light values become incidental – with a high level of noise as a by-product.

Consequently, a compact camera with a resolution of 10 megapixels by no means delivers a better image quality than one with 5 or 6 megapixels, especially with point-and-shoot cameras. Naturally, developments in sensor technology will continue, but there will always be physical limits to the sensor size and its light sensitivity.

Hence the question becomes: how large do you want to print your finished pictures? Five to eight megapixels are plenty for an enlargement to letter (8.5" × 11") or ledger size (11" × 17") – preferably with the least amount of noise. If you buy a compact camera with an image sensor between ¹/₁.₈" and ½.₅" (the sensor's diagonal measurement), you can expect better image quality and less noise with a 6-megapixel camera than with a 10-megapixel model. With bridge cameras and DSLRs, 8, 10, or even 12 megapixels in the newer models are quite acceptable, and deliver good image quality with lower noise levels. The trend for full frame cameras lies with 16 megapixels and more. When you buy your camera, be aware that a higher resolution also means you'll need more storage capacity and a faster processor for image editing afterwards.

Film Sensitivity • Another defining characteristic of image sensors and cameras is the light sensitivity of the sensor. It is noted in ISO values – as is the light sensitivity of film.

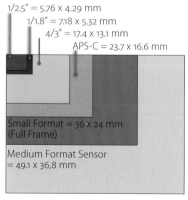

1/2.5" = 5.76 x 4.29 mm
1/1.8" = 7.18 x 5.32 mm
4/3" = 17.4 x 13.1 mm
APS-C = 23.7 x 16.6 mm

Small Format = 36 x 24 mm
(Full Frame)

Medium Format Sensor
= 49.1 x 36,8 mm

Various sensor sizes compared (actual size) with approximate measurements

ISO = International Standards Organization. Here ISO is a value for the light sensitivity.

Just as you can choose different types of film (light sensitivity) for different lighting conditions in film cameras, you can change the sensitivity of the image sensor (within limits) in more complex digital cameras. This adjustment is achieved by amplifying the analog signal of the sensor, which in turn causes higher levels of noise – the visual equivalent of radio static. In an image, an overamplified analog signal causes luminance and color jumps of individual pixels, and can be compared to the visible *grain* of highly sensitive photographic films.

Therefore, there are upper limits to the experimentation with the sensor's sensitivity. The light sensitivity of digital cameras falls between ISO 80–6400, and the higher values can only be found in some professional models. For example, the old Olympus E-20P has a range of ISO 80–320, while the Canon 10D offers ISO settings between 100–3200, and the newer Nikon 3D goes up to ISO 6400 and can even be extended to 25600. To compare: normal transparency film ranges between ISO 50 to 400, and color film ranges between ISO 100–400. Film as fast as ISO 800 is already called *high-speed film*. Whenever the lighting conditions allow, it is better to choose a lower ISO setting to keep the noise level to a minimum. The program mode in most cameras will lower this setting automatically.

Just as in other technologies, light sensitivity also continually improves with the enhancement of image sensors.

The ISO value of conventional films can be *pushed* during development to achieve a higher light sensitivity, and, in the same way (with some limits), the sensitivity of a digital image can be adjusted later during image editing (see *tonal corrections*, page 168). However, increasing the ISO value of the sensor yields better results than software manipulation of the image. In some cases, you may have to smooth out especially apparent noise during editing.

Table 2-1: Film Sensitivity (Film Speed)	
ISO/ASA	**DIN**
25	15
32	16
40	17
50	18
64	19
80	20
100	21
125	22
160	23
200	24
250	25
320	26
400	27
500	28
640	29
800	30
1000	31
1250	32
1600	33
2000	34
2500	35
3200	36

2.2.2 Camera Optics – Lenses

One of the vital characteristics of a camera's quality is the quality of its optics, or more specifically, of the lenses used. Most low- and medium-cost digital cameras include built-in lenses, whereas the more expensive DSLR models have the option to interchange lenses. Four parameters determine the value and use of lenses:

▸ Focal length and zoom
▸ Speed (maximum aperture)
▸ Quality of the optics and of the autofocus systems
▸ Image stabilizer (if existent in the lens)

Keep these parameters in mind while buying a lens, and also note if the lens has a filter thread or bayonet latch to attach lens hoods, filters, or auxiliary lenses. Because of their low weight and small size, most compact camera models do not offer these features.

Built-in 10x Zoom,
Fuji FinePix S5000

Zoom 14–54 mm (Olympus)

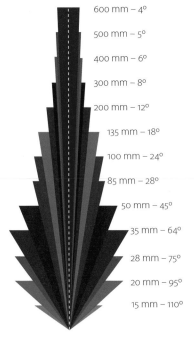

Telephoto Lens, 300 mm (Olympus)

600 mm – 4°

500 mm – 5°

400 mm – 6°

300 mm – 8°

200 mm – 12°

135 mm – 18°

100 mm – 24°

85 mm – 28°

50 mm – 45°

35 mm – 64°

28 mm – 75°

20 mm – 95°

15 mm – 110°

Angle of View of the Camera with Different
Focal Lengths, Small Format (24 x 36 mm)

Focal Length • To make digital cameras with different sized sensors easier to compare, both the optical focal length of the lens is noted, as well as the focal length that was calculated be the equivalent of that of small format cameras (a 24 × 26 mm sensor).

Many digital cameras do not have full-frame sensors, which are the same size as the original 35 mm small format film; therefore, semi-professional and professional digital cameras are said to have a *focal length multiplication factor* (also called *crop factor*). This factor describes by how much the focal length, compared to small format film, is extended due to camera construction and sensor size. Full frame cameras have a multiplication factor of 1 (no extension). Many DSLRs have a factor of 1.5–1.6. If the factor is 1.5, a traditional 50 mm lens will function as a 75 mm lens (compared to small format film). Although this extension might be welcome for telephoto purposes, it interferes with wide-angle photography.

In small format cameras, focal lengths below approximately 35 mm are called *wide angle*, between 35–70 mm *normal*, and above 70 mm *telephoto*. Zoom lenses, which cover a range of focal lengths, were common with small format film cameras, and they now prevail among digital camera models. The standard zoom for cameras with built-in lenses – calculated to be equivalent to small format film – is 35–120 mm: it basically covers the area from slightly wide angle to slightly telephoto, with a zoom factor of approximately 3–4.

Some models offer zoom factors of up to 15, which may include focal lengths of up to approximately 420 mm, all of which is reflected in the price tag. Long focal lengths allow you to photograph a frame-filling object even from large distances, but the amount of light needed increases as well as the likelihood of camera shake, because small hand movements get magnified by the zoom factor. Therefore, expensive cameras or telephoto lenses incorporate image stabilization technology, which mechanically or electronically balances certain camera movements. These lenses are relatively expensive, and the image stabilizing technology is really only advantageous with focal lengths above 100 mm.

The physical focal length of these lenses is noted at the front end of the lens. It typically lies below the values calculated to be equivalent to small format film: approximately 8 mm (instead of 35 mm) in the wide-angle range and 32 mm (instead of 115 mm) in the telephoto range.

Many digital cameras also offer a *digital zoom* besides the *optical zoom*. The digital zoom magnifies the image electronically. It does so at the expense of image quality and produces an image with little resolution in the details, which limits its use. It is better – meaning more controlled – to magnify the image later on with help of an image editing program on the computer.

Digital single-lens reflex cameras (DSLRs) with interchangeable lenses offer the highest flexibility regarding focal lengths. They were very expensive in the past, but since the end of 2003, the prices have dropped to below

$1000 including lenses. We can expect that prices will come down further and approach those of conventional film cameras in the $500 range. Presently, most manufacturers are offering lenses specifically developed for digital cameras – some of them only usable with cameras using an APS-C sensor. They are compact and deliver high image quality, but some of them cannot be used on analog cameras or on digital cameras with full format sensors, because their imaging circle is much smaller.

Wide-angle attachment for lens

Another important aspect of lenses is the *minimum focusing distance*, which is the shortest distance between object and lens for which the lens can still be focused. This distance does not limit the quality of the lens; however it determines how the camera and lens (without auxiliary lenses) can be used. Some compact cameras provide a minimum focusing distance of 0.8–4 inches, while the typical range is 8–20 inches, and above 40 inches for telephoto lenses. You can look up this distance in the camera manual and consider it while composing your images. If you position yourself too closely to the object, your pictures will be blurry, which is not easy to see in the normal optical viewfinder. Some cameras will not allow the release of the shutter if the image cannot be focused.

➔ *You should know the minimum focusing distance of your camera/lens, and make use of it. For a rough estimate you can use the following:*
8 inches = spread-out hand (adult)
20 inches = forearm and hand

A number of cameras have specialty functions that allow closeup and macro photography, giving you the option to position the camera close to the object. However, remember to deactivate the macro program mode again after taking the closeup picture because it prevents the camera from focusing on subjects located further away.

Speed • The speed of a lens is determined by its largest *aperture*, which is the size of the opening in the lens that allows the light to pass. Another term often used in this context is *f-stop*. F-stop is the diameter of the opening (aperture) divided by the focal length of the lens. A small *f-stop* (i.e., f/2.8) implies a large shutter opening (large aperture), and a large f-stop (i.e., f/11) describes a small shutter opening (small aperture). Small f-stops are desirable for many subjects that are located fairly close to the camera. A small f-stop – meaning a large aperture – allows more light to pass to the sensor and, therefore, shortens the time needed to properly expose the image, which reduces camera shake and motion blur in your pictures. Thus, it allows you to photograph even under low light conditions. Apertures of f/2.0–f/2.8 (in the range of a normal lens, approximately 50 mm with small format cameras) can be considered as very good, but even f/3.4–f/4.5 usually suffice. In the telephoto range, the speed of the lens decreases, because only part of the captured light actually passes to the image sensor due to the enlargement of the projection. High speed telephoto lenses are available, but they are extremely expensive.

➔ *Large apertures cause some loss of image quality, because the optical quality of a lens decreases towards the edges – therefore, you may have to weigh between speed / aperture and sharpness on the edges of your picture.*

There is no difference in the aperture between film and digital cameras – except that it is better not to *stop down* the aperture too much on digital cameras. f/11 should be considered the maximum aperture value.

➔ *Apertures noted as f/2.8 and f2.8 are equivalent. See Chapter 2.9, page 53 for more details.*

Quality of the Lens • Focal length and speed of a lens can easily be determined from the technical data of the camera, but to determine the quality of the lens is more difficult. More elaborate comparisons using test images are needed to this end. A high quality lens has the least amount of aberration (inaccuracy) possible, which could develop in certain areas of the image (mostly along the edges) and with certain lens adjustments. These inaccuracies appear greatest when the lens is set to one of its extreme settings: either the widest wide angle, or the highest telephoto setting.

In lens design, the manufacturer has to make a compromise, especially with zoom lenses, between the largest possible image area and acceptable aberration. Additionally, the lens should be compact and not too expensive. Most of the time small inaccuracies can be accepted, since they do not detract much from the image, but it will depend on the purpose of your photography. For example, small distortions hardly interfere with a wide-angle landscape picture, but they can be very distracting in an architectural photograph with many horizontal and vertical lines. The same is true for telephoto images, in which it is usually more important to capture the subject as large as possible, than to capture it without slight inaccuracies.

A second important characteristic of the quality of a lens is the consistent brightness of the whole image area. Inaccuracies can be seen as slightly darker areas on the edges of the image. This is called *vignetting*. It is most pronounced when the lens is set to its widest angle of view in combination with a large aperture.

The vignetting of a lens can be tested by photographing a uniformly white or gray wall at maximum aperture and angle of view. This allows you to evaluate the differences in brightness in your image.

If you know the aberrations of your lens, the mistakes can be reduced by means of a computerized correction later on. However, for this to work correctly you have to know the exact focal length and aperture used. Requiring these values makes the correction complicated and rarely used. Most amateurs do not need to concern themselves with this process.

When working with digital cameras as opposed to film cameras, it is even more important to have high-quality lenses, because the light rays need to be redirected to fall onto the sensor as perpendicularly as possible, to prevent the light from spreading to neighboring sensor sites. The effect of light spreading to neighboring sensor sites is called *blooming*. Traditional film coatings are much more tolerant of the angle the light strikes them.

Autofocus • Except for very cheap models with fixed lenses, all digital cameras feature lenses with variable focusing distance and autofocus. The latter is responsible for automatically adjusting the lens to create a sharp image. The most common autofocus mechanism is the measurement of the highest edge contrast in the image, which is generally concentrated in the center of the viewfinder. There are other processes used; for example, an infrared or laser beam can be used to measure the distance to the subject. Some cameras use a focusing light located in front of the camera during low light conditions. While photographing take care not to cover these lights and sensors with your fingers!

Autofocus does not happen instantaneously; it takes a little time and the shutter can usually only be pressed once the process is finished. Sometimes autofocus can take longer than desirable, depending on camera model and lens. Lag times between 0.1 and 1.0 second are typical. For this reason, high quality interchangeable lenses have a small and fast built-in engine for focusing, often called *High Speed Motor* (HSM). In addition, the camera electronics, the light conditions, and the structure of the subject influence the focusing speed.

Certain imaging situations can create problems for the autofocus mechanism. Problematic conditions include low light, low contrasts, uniform areas, and moving subjects, which can noticeably prolong the autofocus process and increase shutter lag.

A potential problem also occurs when you want to focus on an area that is not located in the center of the viewfinder. Most cameras will allow you to recompose your picture in the viewfinder to center the subject you want to focus on (or a subject with the same distance), and press the shutter button half-way to autofocus. Once focusing is finished – often indicated by a beep – keep holding the shutter button half-way, recompose your image in the viewfinder to the desired composition, and press the shutter button fully to take the picture. This technique can save time in critical situations, i.e., during sport- or action-photography.

Newer cameras more frequently feature various autofocus fields that can be adjusted quickly. For closeup photography with macro lenses it is advantageous if the autofocus can be deactivated and the focus can be achieved by manually adjusting the lens or by moving the camera slightly.

Image Stabilization • Technological developments have made it possible to counteract camera shake to a certain degree. Special features measure the movement of the camera and then compensate the image for the movement. This can either be accomplished through a quick shift of a lens element – this type is called *optical stabilization* – or a counter movement of the sensor chip. Both versions have advantages and disadvantages. But with both methods you gain approximately 1.5–3,5 shutter speeds or f-stops – which is a huge improvement under low light conditions. A third method of image stabilization enlarges the sensor chip slightly (by adding additional image pixels outside of the regular image area), so that it can capture an image slightly displaced by camera shake. To accomplish this, the camera measures the amount of movement, recalculates the image, and eliminates the movement from the blurry image. However, the results do not compare to the quality of the other two methods described above

So far most DSLRs rely on compensation from the lenses, but the technology is only contained in expensive telephoto lenses. While Canon calls these lenses IS (*Image Stabilized*), Nikon uses the term VR (*Vibration Reduction*). You may also come across the label OIS (*Optical Image Stabilization*). Konica Minolta (and now also Sony) compensate for camera shake with a movement of the image sensor in the camera itself.

▲ *Here the camera autofocus mechanism was confused by the window and focused on the window beams.*

▼ *Below the landscape is in focus.*

Some compact cameras and even some DSLRs compensate for camera shake with a moveable sensor. The engines for moving the sensor chip can be much smaller than the ones that move lens elements. A moveable sensor has the advantage that it can be used with all lenses, not only those that come with this feature built-in, allowing you to use less expensive lenses while keeping the advantages of image stabilization.

Shutter Speeds • The shutter speeds selected by the camera's auto mode vary greatly, from approximately $\frac{1}{500}$ second to about 2 seconds. With professional DSLRs this may range from $\frac{1}{8000}$ second up to minutes in bulb-mode. If manual adjustments are possible, more settings will be available, especially for longer shutter speeds. Shutter speeds faster than $\frac{1}{1000}$ s need extremely bright light, and shutter speeds slower than $\frac{1}{60}$ second (with normal focal length lenses) require a support or tripod to avoid camera shake. These considerations are even more critical with longer focal length lenses.

The camera should provide a manual exposure mode, or at least a partial mode, in which you can set the shutter speed and the camera will select the corresponding aperture, increasing your creative options.

Shutter speeds beyond 2 seconds significantly increase image noise (depending on how the particular image sensor produces noise). Long exposures such as these are almost exclusively used for night photography, in which, due to the many dark image areas, the incidence of noise is additionally increased. Some cameras incorporate *noise filters*, which work through a computer program inside the camera and visibly improve image quality at the higher ISO settings. This noise filter prolongs the processing time for image storage – with some systems significantly. When adequate levels of light are available, and normal shutter speeds and moderate ISO settings are used, the noise filter should be turned off and the necessary corrections should be handled in an image editing program. Shareware and commercial software for this purpose can be found on the Internet.*

** For example, see [101] and [119] in the bibliography.*

Some cameras offer program modes with certain preset shutter speeds. For example, a program called *sports photography* would automatically set short shutter speeds and corresponding large apertures, and *night photography* would set long exposure times with high ISO settings.

Bracketing is another useful feature. The camera will automatically take several (usually 3) pictures, one that is slightly underexposed, one that is normally exposed, and one that is slightly overexposed. In the end you pick the image with the best result. Some cameras also provide bracketing for different color temperatures.

2.2.3 Viewfinders

Digital cameras can come with one or more of four different types of view-finders: optical viewfinders, single lens-reflex viewfinders, electronic view-finders, or displays.

Optical viewfinder, Nikon Coolpix 3700, from
behind (left) and from the front (right)

Optical Viewfinders • Although optical viewfinders have been the standard viewfinders for digital cameras, they are being omitted more commonly now, especially in the more compact models. They possess their own optic – separate from the imaging optic – and show the subject in focus at all times. Because of the parallax error, the image captured does not completely match the image seen through the viewfinder. This is especially pronounced in closeup photography. The optical viewfinders of some digital cameras are so small that they are no longer useful for qualified evaluations of the picture.

DSLR Viewfinders • This type of viewfinder can only be found in DSLRs and digital bridge cameras. Light entering the lens is reflected through a semi-transparent mirror into the optical elements of the viewfinder. This type has the advantage that the image you see is almost identical to the image the sensor captures. To take the actual photograph, the mirror is flipped up, which causes the viewfinder to darken. Most DSLR viewfinders will display the most important camera settings on the edge of the focusing screen. In most cases this type of viewfinder provides the fastest and best presentation of the image. However, usually they do not show the full picture – typically only about 95–98%.

SLR Viewfinder, Olympus E-1

If instead you are using the electronic display to compose your images (which until now was only possible in few DSLRs) you should manually lock up the mirror to prevent light from the viewfinder from falling on the sensor. The same is true when you work with a cable release or self timer.

EMV/EVF (*Electronic Magnifying Viewer or Electronic View Finder*) • EMV/EVF viewfinders are small, high-resolution LCD monitors built into the viewfinder, which magnify the image by means of an optical loupe. For example Minolta's DiMAGE-7 series uses such viewfinders. The advantage is that these viewfinders can be slightly swiveled, similar to the LCDs of some video cameras, and the image can be brightened electronically. A size adjustment dial allows zooming in to evaluate image sharpness. At low light levels the viewfinder intensifies the strength of the light, so that the subject is still visible.

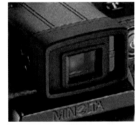

EVF Viewfinder with 235,000 pixels,
Minolta DiMAGE A1

The disadvantage of these viewfinders – also called video viewfinders – is the somewhat higher level of power usage compared to the optical or DSLR viewfinders. In addition, they tend to be a little sluggish, giving a slight delay between image reproduction in the optical elements and the viewfinder image. An additional disadvantage compared to a DSLR viewfinder is the lower image quality in the viewfinder. Minolta's EMV viewfinder is so sophisticated that, to save battery power, it will only activate

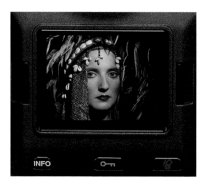

Display used as viewfinder, Olympus E-1

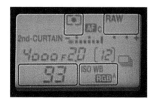

Second display showing camera settings (Olypmus 20EP)

Typical display sizes range from 1.5″ to 3.0″ with resolutions of approximately 80,000 to 250,000 pixels.

A pop-up shade for the camera display is practical in bright sun light.

when the eye approaches the viewfinder, which also deactivates the LCD monitor on the backside.

Display • Virtually all digital cameras feature a display in addition to the viewfinder. It can reproduce the image as the sensor sees it, as well as play back the captured image including its camera settings, and in professional models, it can even display the histogram of the last picture taken (see section 4.1.4 on page 82 about histograms). If your camera has this feature, you should definitely use it to check the exposure of your images.

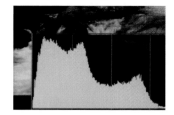

Histogram shown by a Nikon D70

In the past, most DSLRs did not give a live preview before the image was taken. Some commendable exceptions are the Olympus E-330 and E-500. However, in the near future, you will find this feature included with most modern DSLRs.

The size and brightness of the display screen is specific to manufacturers and camera models, and will influence how well an image can be evaluated. Some bridge cameras feature a display that can be flipped up, so that it can be used like a right angle viewfinder, which is especially useful for closeup photography, or when photographing overhead. The display can also help you assess the subject as a 2-dimensional image, which is much harder to do with an optical viewfinder. The image on the display follows the image the sensor sees with a slight delay, which can be distracting when trying to capture fast movements.

Ideally the display will adapt its brightness to the surrounding light levels. If you are photographing in rough terrain, you should cover your display with a protective film (or leave the manufacturer's on), because replacing the display can be costly. Some cameras (such as the Nikon D200 and D300) offer a plastic protective covering for their displays.

A snap-on, pop-up display shade can be helpful for faint displays, or while photographing in bright sunshine. They must be purchased separately but are available for most cameras and display sizes.

The display consumes additional power – especially with an active preview. If you need to conserve battery power, turn off the display.

Most cameras feature another, usually one-color, display, which shows the current camera settings.

2.2.4 Camera Program Modes

Digital cameras come with an integrated computer, which handles many of the processing functions and allows the user to choose from several program modes via a switch or dial, for different photographic situations.

The full auto mode is programmed to make all decisions regarding the image including the correct aperture, shutter speed, ISO setting, and the

sharpness of the subject (via autofocus), as well as if flash is needed. Even the white balance is set automatically.* The photographer only needs to set the desired image quality (resolution and compression), and the zoom factor, which is adjusted with a toggle switch on most compact camera models.

* See "Color Temperatures" for more information on white balance, page 50.

Photos thus attained are often quite usable, though they may not always be perfect, because the program mode may not have the needed information for special circumstances. Therefore, the more sophisticated camera models allow the photographer to intervene and make specific settings through simple "situational" programs. For example, a *sports photography* program assumes that the photographer wants to freeze fast movements, and, therefore, automatically sets fast shutter speeds and corresponding larger apertures. For *night photography,* the camera will choose slow shutter speeds, without exposing the image for normal conditions. The *portrait photography* mode uses a large aperture to throw the background out of focus, and the *landscape photography* program works with a larger depth of field, and perhaps locates the plane of focus further into the distance.

Many cameras have more preset programs from which to choose, sometimes 15 or more. Besides the full auto mode, usually indicated by a P, there should be the following three variations.

Tv *Shutter Speed Priority* – the photographer chooses the shutter speed, and the camera automatically sets the appropriate aperture.

Av *Aperture Priority* – the photographer chooses the aperture, and the camera automatically sets the appropriate shutter speed.

M *Manual* – the photographer chooses the shutter speed and the aperture, and the camera shows how far these settings deviate from the measured values of the light meter.

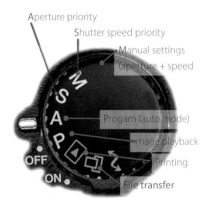

Aperture priority
Shutter speed priority
Manual settings (aperture + speed)
Progam (auto mode)
Image playback
Printing
File transfer

→ *Some consumer cameras do not have a manual mode, which would allow you to freely set apertures and shutter speeds. This is a disadvantage for your creativity.*

Moreover, there are functions for image playback, and image transfer to the computer, as well as a program to send the images directly to a printer. The newer models allow the camera – through use of the PictBridge standards – to communicate with printers made by different manufacturers as well. In order to use this feature, the camera as well as the printer have to support PictBridge.

Many compact cameras also offer a macro mode – often labeled as ❀ – that allows the camera to focus on subjects located very close to the lens. Additionally, cameras are frequently equipped with several flash programs, for example a pre-flash for red-eye reduction, or a fill-in flash (a flash with lower intensity), or a synchronization for external flash units.

Simple symbols, or mnemonics, usually identify such programs (*portrait, landscape, sport,* or *night* photography) on the LCD screen.

Particularly newer cameras offer a respectable range of different program modes, however their functions are not always clearly identified by their associated symbols – thus it becomes necessary to consult the user

manual. Most of the provided printed manuals are very compact; therefore, you may have to download the digital version from the provided CD and read it on-screen or print it on your own printer. It is easy to miss useful functions without this information. However, how a camera program actually works is rarely explained, even in the online documentation.

2.2.5 Storage Media for Digital Cameras

An essential component of a digital camera is the memory card. It determines the number of images that can be stored, as well as determining how fast the data or images can be saved. A third, important factor to consider is the amount of power it uses.

The range of different storage media has grown considerably, and is constantly being developed. It is, therefore, reasonable to assume that one's financial investment in memory cards will be outstripped quickly. Furthermore, when you choose a specific camera, the memory card for the individual camera is usually fixed. Only a few cameras, generally in the middle and upper price range, support different options for this media.*

Some new high-end DSLRs allow for Compact Flash as well as SD-HC cards.

Some types of storage media have already reached the end of their development cycle. An example is the SmartMedia card, with a maximum capacity of 128 MB.

Table 2-2 (page 25) gives an overview of common storage media available in 2007, and their approximate prices.

The memory card provided with each camera is almost always too small, because the manufacturer is trying to keep the camera price as low as possible. Therefore, you will have to invest in additional memory cards. Memory cards with larger capacities tend to have a lower price per megabyte, while the latest media (with the largest storage capacity) tend to be more expensive when they are introduced to the market. Therefore, it is often advantageous to wait a few months before buying these new cards. The price decline of storage media cards has been considerable in the last few years, and is not nearly finished.

➔ *Storage media cards should be handled carefully. They should be protected from water and dust, as well as strong magnetic fields and voltage. Any compression of the cards should be avoided as well. However, the x-ray machines used at airports to control the baggage do not pose a problem.*

All card types listed here are subject to wear, which means they cannot be written to endlessly. Card wear can become a problem in the future if one's own cards are defective and cannot be replaced because they are no longer manufactured.

Our recommendation: Buy cards with a total capacity of 1,000 to 2,000 images – and more for longer travels. However, use at least two to three cards.

SmartMedia • SmartMedia was one of the first commonly used flash memory cards, and it occupied a large market share. It is relatively thin and light, but does not have a built-in controller (an intelligent interface between computer and card), so it is programmed by the camera. Therefore, only those card sizes are supported that were common when the camera was introduced to the market. Newer generation cards (cards with greater storage capacity) can only be supported by firmware

SmartMedia Card:

Size:	*20.0 x 25.0 x 1.7 mm*
Data Read Rate:	*3.0 MB/s*
Data Write Rate:	*5.0 MB/s*
Weight:	*2 g*
Capacities:	*16–128 MB*

updates, which can be expensive or hard to find. Therefore, the SmartMedia card reached the end of its development cycle with a maximum capacity of 128 MB. When handling these cards, be careful not to break them as they are quite thin.

CompactFlash Cards • CompactFlash cards (CF), are used for numerous other devices besides cameras, for example for MP3 players or PDAs. They are not the smallest cards, but they are being developed continually. They have relatively high transfer rates of up to approximately 16 MB/s (at the end of 2007) and capacities of up to 16 GB. With the use of low-cost card readers, CF-cards can transfer data directly to and from a computer and through the PCMCIA-bus (a card bus slot that you find in most notebooks) can reach their maximum transfer rate.

CompactFlash cards come in CF Type I and Type II, with the only difference being their thickness. While Type I is 3.3 mm thick, Type II is 5.0 mm thick and is used in the IBM/Hitachi-Microdrives for example.

CF high-speed cards (including standards 3.0 and 4.0) embrace new technology that enables faster data transfer rates. Transfer rates noted as multiples (such as 120x) refer to the base rate of 150 KB/s.

In the fall of 2003, Version 2 (not to be confused with Type II) of the CompactFlash card specifications was introduced. It offers significant improvements in transfer rates while staying compatible with older camera models. However, in this case, the transfer rates will only be approximately 6 MB/s, but should improve with further development in the coming years. The fastest transfer rates available range between 80–150x of the base rate, which theoretically reaches up to 19 MB/s. However, these transfer speeds are only approximated by the high-end DSLR camera models. It is still worthwhile, though, to buy the faster Compact Flash cards, especially since they are not much more expensive than the slower models.

MultiMedia Cards • MultiMedia cards are the predecessors of the Secure Digital card. These cards have an integrated controller, and adapters allow their insertion into CompactFlash readers. Because of their low weight and small size, these cards are also used in cell phones and PDAs. Hardly any digital camera is using this type any more.

Memory Sticks • Memory Sticks were developed by Sony and, so far, are used almost exclusively in Sony cameras. Their prices began higher because of the initial lack of competition, but in the meantime additional manufacturers have begun producing Memory Sticks. The second generation was introduced in 2003, with the Memory Stick Pro, which has a storage capacity of up to 4 GB, though they are not compatible with older camera models. These

CompactFlash Type I:

Size:	*36.4 x 42.8 x 3.3 mm*
Data Read Rate:	*3.5-32.0 MB/s*
Data Write Rate:	*4.5-16 MB/s*
Weight:	*11.5 g*
Capacities:	*32 MB–48 GB*

CompactFlash Type II:

Size:	*36.4 x 42.8 x 5.0 mm*

CompactFlash Version 2:

Data Read Rate:	*6.0–16.0 MB/s*
Data Write Rate:	*5.0–14.0 MB/s*
Weight:	*11.5 g*
Capacities:	*1–16 GB*

MultiMedia Card:

Size:	*32 x 24 x 1.4 mm*
Data Read Rate:	*5–12.0 MB/s*
Data Write Rate:	*2.0–8 MB/s*
Weight:	*1.5 g*
Capacities:	*16 MB–2 GB*

Memory Stick:

Size:	*49 x 21 x 3 mm*
Data Read Rate:	*2.5–10 MB/s*
Data Write Rate:	*1.8–10 MB/s*
Weight:	*4 g*
Capacities:	*32 MB–4 GB*

Memory Stick Duo:

Size:	*32 x 20 x 1.6 mm*
Data Read Rate:	*4–10 MB/s*
Data Write Rate:	*4–10 MB/s*
Weight:	*4 g*
Capacities:	*64 MB–16 GB*

xD-Picture Card:

Size:	*20.0 x 25.0 x 1.7 mm*
Data Read Rate:	*3.0–6.0 MB/s*
Data Write Rate:	*2.0–3.0 MB/s*
Weight:	*2 g*
Capacities:	*32 MB–2 GB*

Secure Digital:

Size:	*32.0 x 24.0 x 2.1 mm*
Data Read Rate:	*3.5–20.0 MB/s*
Data Write Rate:	*2.5–18.0 MB/s*
Weight:	*1.5 g*
Capacities:	*32 MB–4 GB*

SD-HC:

Size:	*32.0 x 24.0 x 2.1 mm*
Data Read Rate:	*3.5–20.0 MB/s*
Data Write Rate:	*2.5–18.0 MB/s*
Weight:	*1.5 g*
Capacities:	*2–32 GB*

Hitachi Microdrive:

Size:	*42.8 x 36.4 x 5.0 mm*
Data Read Rate:	*3.5–5.0 MB/s*
Data Write Rate:	*3.5–10.0 MB/s*
Weight:	*16 g*
Capacities:	*512 MB–8 GB*

media contain a built-in controller. Memory Sticks are also used in Sony video cameras and MP3 players. Plans for further development include media that can store up to 8 GB of data. The high transfer speeds of up to 20 MB/s are reached only by the newer models.

A compact version of the Memory Stick, the Memory Stick Duo was introduced in 2001. It is only about ½ the size of the original Memory Stick, but with the use of an adapter can be inserted into those readers that accept original Memory Sticks.

xD-Picture Cards • xD-Picture Cards are a newer development by Olympus and Fuji, and are also manufactured by other companies, including Toshiba. Their current capacity reaches to 2 GB, but they will potentially deliver 8 GB of storage in the future. These cards are very small and do not have a built-in controller, which makes them potentially cheaper than cards with built-in controllers. So far this difference in configuration has not been reflected in the price. However, it limits these cards' potential to the maximum card capacity at the time the cameras were introduced.

Secure Digital cards • Secure Digital cards were specifically developed for multimedia data. Therefore, they offer a special write-protect switch feature, for example, for copy-protected music files. In addition, they have an integrated controller. Secure Digital cards have become the most common form of digital media storage in compact cameras, in large part because they offer a good price-to-performance ratio.

There is a second generation SD card available now, called SD-HC (*High Capacity*). While most modern digital cameras using SD will run with SD-HC as well, older cameras cannot use SD-HC.

A Secure Digital mini card is also available, which is be even more compact and offers most of the same technical features. The main use of these cards will most likely be in cell phones and compact music players.

Yet another type of SD card is the Micro SD card, which is not yet used in digital cameras. It is even smaller than the Mini-SD card and mainly targets usage in cell phones and PDAs.

Hitachi Microdrives • Hitachi Microdrives are small, compact hard disks. For some time they offered the highest capacity for digital cameras at a reasonable price. However, the disadvantage is their high usage of power to spin the disk, even while the drives are not being used. They are also more sensitive to physical shocks and temperature changes. Their size and interface matches that of CompactFlash cards and they can, therefore, be used in cameras that support CompactFlash Type II cards (which is basically applicable to all DSLR models). Spinning the disk uses approximately 20 mA while idle, and 250 mA of power (at 3.3 Volts) while transferring data.

Table 2-2: Overview of storage media for digital cameras (as of summer 2007):

Medium	Typical Capacity	Transfer Rate Read/Write	Built-In Controller	Approximately Price per MB	Remarks
SmartMedia	16–128 MB	3.0/5.0 MB/s	–	Rarely available	Practically outdated
CompactFlash	32 MB–32 GB	10.0/8.0 MB/s	+	$0.02	Low cost, versatile
MultiMedia Card	16 MB–2 GB	8.0/6.0 MB/s	+	$0.05	Includes write-protect
Memory Stick	32 MB–4 GB	6.0/6.0 MB/s	+	$0.03	Primarily for Sony cameras
xD-Picture Card	32 MB–4 GB	5.0/3.0 MB/s	–	$0.03	Very compact, relatively new
Secure Digital Card	64 MB–16 GB	16.0/15.0 MB/s	+	$0.02	Write-protect switch, common
Hitachi Microdrive (second generation)	2 GB–8 GB	5.0/10.0 MB/s	+	$0.03	Cheaper for higher capacities, high power usage

The technical data of memory cards can differ significantly between the various models, especially concerning the read and write transfer speeds. To efficiently use the high speed transfer rates though, your camera processor needs to be fast as well.

It is pretty clear that the range of storage media is too vast – at least from the customer's point of view. We can assume that the field will be weeded out, and new products will be offered. The SmartMedia card is outdated, while the CompactFlash card, the standard of the DSLR models, will continue to have strong support and new developments. The microdrive will lose its advantages with the availability of other large capacity media. All remaining media will increase their storage capacity and reduce their cost per megabyte.

Both CompactFlash and SD cards are efficient and inexpensive solutions with medium and large storage volumes, if you have the choice while buying a camera. For compact cameras, SD and SD-HC cards offer high capacity for a low price. The write-protect functions of the Secure Digital and MultiMedia cards are hardly important for camera use. We can also expect new products in the near future.

The capacity of individual memory cards should be coordinated with the size of the image data of the camera. A capacity of approximately 100 images per memory card seems practical. Coordinating image size with card storage size lowers the chances of losing many images if there is a malfunction of the memory, either the card or the data system.

Most cameras allow you to choose a lower resolution than the physical sensor resolution. This setting creates smaller image files and thus more images can be stored on the same memory card, at a faster transfer speed. However, this setting significantly lowers image quality.

Storage media, just like computers, can have errors in the data structure. The most common reason for this is that the card is ejected from the camera or the battery dies before the data transfer is complete (while the

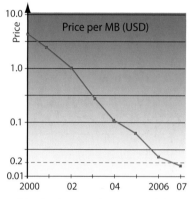

Price development of memory cards by example of CF cards.

Table A-4 on page 333 shows the image capacity of various memory cards in connection with image resolution and compression.

images are still being written to the card). In rare cases, there can be a mechanical defect or a serious electrical failure.

Images that were accidentally deleted can be restored with special programs (in a similar fashion as done on the computer) as long as their storage space has not been reused. For CompactFlash cards (and basically all other storage media) that use a Fat16 or Fat32 data system, programs such as *PhotoRescue* (by DataRescue), *ImageRescue* (by Lexar) can be used. They can be found on the Internet, and are often supplied with the memory cards or card readers.[*]

If the whole data structure (not just a single data file) on the storage medium is deleted or becomes unreadable, the memory card can be reformatted. However, all previously stored data on it will be lost. Most cameras offer functions for this purpose. But the storage media can also be formatted with special programs through the computer or the card reader.

Outside of the camera, memory cards should always be stored in the appropriate plastic covering, because most are very thin and sensitive to mechanical impact. Low-cost appropriate casings can be found in a camera store.

Portable Storage Drives • Some time ago small, compact portable storage drives were introduced to the digital imaging market, including card readers, which can transfer image data from memory cards to a local hard drive. Basically these devices are small, mobile computers with a built-in card reader, and a 2.5" hard disk that is powered through a rechargeable battery. There is no keyboard or large display, and the whole unit is very compact, at about 5.0 × 3.3 × 1.0 inch, and 9 ounces. Portable storage devices can be hooked up to a computer via a USB (*Universal Serial Bus*) cable for data transfer. The price of these drives ranges from $100–$400, which is roughly equal to two to four large memory cards. The capacity of portable storage drives currently lies between 30 and 160 GB.

Some models have a small LCD screen and a few keys, and can be used for basic image evaluation and presentation. These additions add weight to the device and increase the price by about $100. Some of these units have the function to write the data directly to a CD-R or CD-RW, however, these models are quite a bit larger and more bulky than the previously mentioned drives.

* More information on this topic can be found at: www.datarescue.com, www.lexar.com, or www.hama.com

Media-Safe PD70x by CompactDrive

2.3 Accessories

The following section may appear to be a product catalog for photography, but is really meant to introduce necessary and practical accessories, and give advice on how to keep costs for these components low. Some traditional photography equipment can also be used in digital photography, like tripods, filters, and auxiliary lenses, which can be bought much cheaper secondhand or on Internet auctions.

2.3.1 Camera Bag

Even inexpensive, small digital cameras deserve camera bags. They protect the camera during transport, and accommodate any additional necessary equipment, such as memory cards and extra batteries. You should budget at least $20-$30 for a useful and practical camera bag. Higher priced bags are often big and bulky, but can hold extra equipment. Lower priced bags are often compact, but do not have extra room to spare.

Professional and semi-professional photographers might own several bags for different occasions. Depending slightly on material and size, prices for bags hardly have a limit. Often it is better though – at the beginning of your photography career – to start simply and learn from experience which equipment suits your needs. The bags camera manufacturers offer are fitted well to the camera models, but are generally expensive and too small for additional accessories. After market companies such as Tamrac or Hama offer greater variety for less money. For upscale needs you should visit a camera store, but be sure to bring an adequate amount of money. You can also build your own, starting with an existing bag and adding foam and partitions for your particular needs. If you have special pieces of additional equipment, you might consider a backpack. Make sure that it sits comfortably on your back and that it has wide and soft straps.

For rough transporting and working conditions, you can buy specially made hard cases, some of which are even waterproof. They are useful for transporting equipment on airplanes or in open boats – i.e., on a canoe trip.

Small, soft camera bag

Water and shock resistant suitcase (by Pelican)

2.3.2 Rechargeable Batteries

Batteries, or better rechargeable batteries, are indispensable equipment for digital cameras. Nothing happens without them, and experience shows that they always die when you find an especially good subject to photograph. Digital cameras use a lot of electricity – even more than conventional cameras. Internal flash units drain the batteries especially quickly.

As is the case with memory cards, you should have at least one or two extra batteries (or rechargeable battery sets).

Battery compatibility varies significantly between various camera models. If you are traveling with your camera for an extended period of time, you will have to employ the battery packs offered by the manufacturer. In the middle and upper price range, most manufacturers offer additional battery grips, which are either mounted on the side or below the camera. The extra expense is usually considerable. Generally, it will be easier for the amateur to buy extra high-capacity, rechargeable batteries. For some models – especially the extremely compact ones – you have to buy the relatively expensive batteries from the manufacturer, which need special chargers. (These components often can be bought for less at online stores.) However, these rechargeable batteries have the advantage of holding high capacity for their size.

Camera and manufacturer-specific rechargeable batteries.

Type AA rechargeable batteries

Some cameras today are built to use AA batteries or rechargeable batteries – for DSLR cameras you will have to buy the additional battery grip for this option. Currently 2700 mAh (milliamp hour) should be regarded as the useful lower limit for battery power for rechargeable AA cells. You should have at least two sets in addition to the ones that shipped with the camera. A set of four rechargeable batteries costs about $15–$30. Preferably, you should use Nickel Metal Hydride (NiMH) rechargeable batteries. The increase in capacity of rechargeable batteries has progressed slowly – in the last 5 years the AA battery cell developed from about 1300 mAh to 2500 mAh. The cheaper Nickel-Cadmium (NiCad) rechargeable batteries are not useful because of their lower capacity.

Check low-cost consumer cameras for compatibility with standard rechargeable batteries before you buy them. They are much cheaper than specific or built-in rechargeable manufacturer's batteries and can be replaced with cheap, disposable batteries if needed, which last a little longer than rechargeable batteries. While rechargeable batteries hold 1.2 V per element, disposable batteries hold 1.5 V per element. This difference in output poses no danger to your camera.

With both disposable and rechargeable batteries you should simultaneously only use batteries of the same capacity, type, and age, and avoid mixing them.

→ Today, most specialized rechargeable camera batteries are Li-Ion type batteries.

Litium-Ion (LI-Ion) and NiMH rechargeable batteries do not show a memory effect. However, NiMH rechargeable batteries should be discharged (with the appropriate charger) from time to time before charging to avoid the lazy battery effect. Rechargeable batteries only achieve their maximum capacity after several charge and discharge cycles.

Small battery bags, which may already come with the batteries, are quite practical. They keep the set together and prevent accidental short circuits in your equipment bag or the pocket of your pants. A small note marked "Full" on one side and "Empty" on the other will identify the current state of the pack, or you can just place empty rechargeable batteries upside down into the bag.

Practical bag for rechargeable batteries

Rechargeable batteries should only be stored fully charged. Likewise, the camera should only be stored with full or recharged batteries, because otherwise it might reset the date as well as other basic settings. Professional models are, therefore, equipped with an additional small lithium battery, which lasts 2–3 years. You should also have a spare for this one!

2.3.3 Chargers

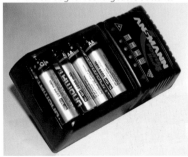

Charger with individual controls and discharge function

If you use rechargeable batteries, you will also need a charger. To achieve an acceptable life span from your rechargeable batteries you will need a high quality charger with a charge control function. For AA batteries (4–6 parallel) you will have to pay around $35–$45. The charger should offer a charge control, the option of conservation charging, at least a basic performance check, and a discharge function. These controls help preserve the life span

of rechargeable batteries. Generally, these devices will also allow a controlled speed charge, so that a AA-battery (or several placed parallel in the charger) can be charged in 90 to 120 minutes. The same charge in normal mode would take about 15 hours. For traveling, the charger should be able to work with voltages ranging from 100–240 Volts and with 50–60 Hz.

The chargers supplied with the cameras (for AA rechargeable batteries) are usually not of the best quality, because the manufacturer is trying to keep the package price down. Therefore, at least for AA rechargeable batteries, it is recommended to spend the extra money for a good charger.

Third party manufacturers now offer chargers for the specialty rechargeable batteries of many cameras, and practically all DSLRs. Often, they can work with the rechargeable batteries of various models with the use of adapters, and some can even be operated through the power adapter, or cigarette lighter in a car (but this option costs quite a bit extra).

2.3.4 Tripods

Almost no one likes tripods because they are difficult to carry around, but nevertheless they are indispensable to motivated amateur photographers. They are necessary for portraits, architectural, and landscape – especially panoramas –, as well as images taken in bad lighting conditions or with long focal lengths (telephoto images).

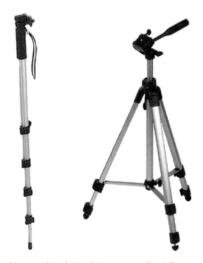

The range starts with simple tabletop models for about $20, continues with compact tripods and monopods, and ends with solid tripods or 4-legged-pods for about $60–$300. A flexible, ball-and-socket tripod head can cost extra. For the amateur photographer, the models in the range of $60-$100 including ball-and-socket heads should be sufficient in most cases.

Carbon tripods are even more expensive. They have the advantage, though, that they are very light, and still very stable.

Monopod and tripod; two options for different photographic situations

The amateur might find compact tripods and monopods to be a practical solution. The tripod needs to be able to handle the weight of the camera including lens. It is always worth it to spend a few more dollars for a higher quality, more stable tripod.

Quick releases allow for a fast switch between having the camera tripod-mounted or hand-held. The quick release consists of a small metal plate (the camera plate), which is screwed into the bottom of the camera, and then snaps in to and out of the tripod head by means of a lever, without having to screw and unscrew the camera. The disadvantage is that it is easy to lose or misplace the camera plate.

A walking pole or ski pole with a removable head, outfitted with a tripod thread, is a practical variation on a monopod.

Soft (left) and hard (right) lens hoods

2.3.5 Lens Hoods, Filters, and Adapters

Lens Hoods • An important lens attachment is the lens hood. It prevents light from hitting the lens from the side, which can easily cause lens flare; the larger the diameter of the lens, the stronger the effect. Generally made for high-quality cameras, a lens hood is often a part of the basic camera equipment or comes with a detachable lens. (With most compact cameras, however, there is no easy way to attach a lens hood to your lens.)

While shooting, you can shade the lens with your hand, but then this hand is unavailable to stabilize the camera.

The lens hood has to fit to the lens. First of all it must fit the dimensions of the lens to either screw on or snap on, but it also must fit the camera's angle of view. It must not shade the edge of the lens, which is of primary concern in wide-angle lenses or wide-angle settings of zoom lenses.

Picture without a Filter (a little dull)

UV Filter • Besides the lens hood, the Ultra Violet (UV) filter is arguably the most widely used piece of lens equipment. It filters the UV light rays out of the spectrum of light. The UV light rays are especially pronounced on sunny and

slightly overcast days, near the ocean, and in the mountains. The UV light rays are not visible to the human eye. However, the UV filter produces more clear and pure colors in ample lighting, and will lessen the existing haze that appears in pictures when the sun is particularly bright. Because of this haze-reducing effect it is sometimes called a *haze filter*. Most digital cameras already come with an internal, light-weight version of the UV filter. However, a stronger effect can be achieved with a polarizing filter (see below).

The UV filter also serves as convenient protection for the sensitive front element of expensive lenses in dusty, wet, and otherwise rough environments. Some photographers leave the UV filter on their lens at all times.

Skylight Filter • A variation of the UV filter is the skylight filter. It is supposed to increase the image contrast when the sky is clear or slightly overcast, and give the image a slightly warmer cast. However, it often gives cloud images an undesirable, slight magenta cast, and is mostly unnecessary.

Picture with Pol Filter (colors are a little more saturated)

UV and skylight filters eliminate little or no light. In addition they protect the camera lens from dust and water spray. They are, for sure, significantly less expensive than a new high-quality lens. Replacing built-in lenses of cameras in the low or middle price range will cost almost as much as buying a new camera altogether. Therefore, it is recommended to use a UV or skylight filter to protect your lens from dust or other adverse weather conditions. The rumor that such a filter should be used constantly is simply wrong, though, because even a good filter eliminates some light and lessens image quality slightly. Only use them when necessary due to dust or moisture.

Polarizing Filter • A polarizing filter is used to reduce or completely remove light reflections from water, windows, lacquer, and other reflective surfaces, with the exception of metal. The polarizing filter allows only light from one polarizing (oscillating) plane to pass to the lens. Because the light from the reflection is strongly polarized, by rotating the filter to find the optimal angle you can block out this distracting plane. Another, secondary effect is that colors will appear to have greater contrast and saturation – especially the blue of the sky, if the filter is turned at the correct angle to the sunlight. In addition, the polarizing filter also acts as a UV or skylight filter. The light-loss factor is about 1–2 aperture or shutter speed stops. Be cautious with wide-angle lenses or wide-angle settings on zoom lenses, though, because in these cases the filter cannot consistently cover the entire angle of view.

Polarizing filters come in linear and circular versions. Generally, for digital photography, circular polarizing filters are used. The price of a good polarizing filter ranges between $40-$100, depending on filter size and quality.

Correction and Creative Filter • There is a multitude of specialty filters available (also called creative filters) for special effects from soft focus to kaleidoscopic. The digital photographer needs to ask the question: can one achieve these effects more efficiently and cheaper on the computer with an image editing program? Even color filters, which are still in use in analog photography, have become superfluous within digital technology.

A decent white balance adjustment or a color correction on the computer will take care of color adjustments for less money and is much more flexible. Likewise, on most higher quality cameras you can manually lower the ISO value to reduce the light intensity without shifting colors, instead of using gray filters to achieve this effect. Adjusting the ISO value manually has the added benefit of reducing noise in the final image.

Filters require either a filter thread, bayonet connector, or an adapter on the lens for mounting. These configurations are usually not present in compact camera models. Another method is to use a filter bracket, which is attached to the bottom of the camera, but reduces ease in handling.

If the camera came with a filter thread or bayonet connector, and you already own filters of a larger diameter, you can buy relatively cheap adapter rings to fit these filters to the diameter of the lens.

Image without polarizing filter ▲ (see engine hood and window). And with correctly adjusted polarizing filter ▼

Cokin filter bracket to attach filters without threads

Adapter rings for filters and auxiliary lenses

Wide-angle auxiliary lens (left), and Tele-photo auxiliary lens (right) (both Olympus)

Typical vendors for auxiliary lenses are the companies Hama, Soligor, and Novoflex (among others)

2.3.6 Auxiliary Lenses

All digital cameras in the lower and middle price range, and all compact cameras, come with a built-in lens, usually with zoom function. While you can change the focal length range of cameras with removable lenses by using a different lens, on cameras with built-in lenses you will have to work with auxiliary lenses to expand the span of the zoom lens. This technique is a compromise compared to a specialty lens, but is often cheaper and achieves acceptable results. However, in order to use auxiliary lenses, your camera needs to have the appropriate filter thread on the lens.

Auxiliary lenses by the camera manufacturer usually exhibit the best quality, but are also usually the most expensive solution. Closeup (macro), wide-angle, and telephoto auxiliary lenses are available. Many third-party manufacturers offer universal auxiliary lenses with different filter thread diameters. Except for certain exceptions, these auxiliary lenses should be used only within a moderate range. For example, telephoto lenses should be used with an extension factor of only approximately 1.5–3.0. In addition, you should be aware that these lenses do not have image stabilization technology and it is, therefore, more likely to see camera shake in those images taken with a long focal length.

With wide-angle auxiliary lenses, the extension factor lies at approximately 0.8–0.5. More extreme corrections generally will be prone to showing distortions and fall-off (dark areas), especially on the edges of the image.

Most current camera models offer a macro function, which allows for a very short focusing distance. However, if the typical 10–25 cm focusing distance is still not enough, you can add closeup lenses. Their prices range from $25–$50, depending on diameter and quality. Again, for the amateur, it is better not to use very large magnifications, because extremely magnified images usually require special lighting, such as a ring flash unit.

2.3.7 Flash Units

Almost all digital cameras in the low and middle price range are equipped with an internal flash unit. The smaller and cheaper the camera is, the weaker the flash. It can thus only illuminate shallow distances.

Flash is not only used for low lighting conditions, but also to fill in portraits with back lighting, as well as for brighter illumination in diffuse or dull lighting. In these cases, you need to specifically turn on the flash, even if the camera does not measure the low light automatically.

Unfortunately, manufacturers in the lower end of the market do not give much information about the strength of their camera's flash units. Such units generally reach about 6–9 feet. Integrated flash units of semi-professional models cover about 15 feet. While using the internal flash, it is important to remember that it significantly drains the battery of the camera.

A disadvantage of built-in flash units is that they are positioned very close to the optical axis of the camera, and therefore, often cause the

Flash unit with tilting head (Photo: Hama)

red-eye effect seen in portrait photographs. Some cameras offer a red-eye reduction option, which consists of sending a series of low-powered preflashes to contract the iris of the person photographed. The blood-rich retina located behind the iris becomes less visible, thereby reducing the red-eye effect. However, in many cases, the pre-flashes can cause the subject to close his or her eyes completely, and, therefore, lead to unusable images.

The red-eye effect is also significantly reduced by placing the flash further away from the optical axis of the camera. Thus larger cameras with pop-up flashes do slightly better in this area.

Cameras in the middle and upper price range come with an extra hot-shoe adapter to attach an additional flash unit, as well as a flash sync cord plug to connect a completely separate flash unit. A hot-shoe flash reduces the red-eye effect significantly. But a flash unit placed even further away on a flash bracket or completely separate from the camera yields even better results.

Flash bracket (Hama)

Another alternative to prevent the red-eye effect is to bounce the flash. The flash is directed towards a light-colored surface such as the ceiling or a wall, and indirectly illuminates the subject. Redirecting the flash reduces the overall lighting intensity, but creates a softer and more natural looking light in the image. While built-in flashes do not allow the flash head to be rotated up, you should make sure that this option is available when buying a separate flash – even if it costs a few extra dollars.

To illuminate larger areas you will need especially strong flashes or several flash units. At the upper end of the spectrum are the professional studio flash systems. Multiple flash units can be triggered without cable connections by use of a master flash and slave system. When the master flash fires, the slave flash units also automatically discharge. If one of the flash units does not have an integrated slave receiver, it can be added inexpensively to the hot-shoe. The internal camera flash is often used as master flash.

Slave flash receiver (Hama)

For closeup or macro photography, most flashes will be too strong or have the wrong angle for the direction of light. Therefore, specialized ring-flashes are used. They are attached to the front of the camera and completely surround the lens. They light the subject very evenly from the front. You will have to decide if the price of $200-$300 (or more) is worth the expense. Ring lights are a little cheaper. They do not flash, but illuminate the subject with white light–emitting diodes, which is usually sufficient for distances between 2–8 inches.

Flash units have a specific color temperature, approximately 5700 K, which is relatively cool (more in section 2.8, page 50). Whenever you photograph using light from your flash unit as your predominant light source, make a note of the specific color temperature of your flash, which can be found on the manufacturer's data sheet, and set your white balance to match, if your camera offers this function.

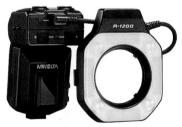

*Ring-flash for macro photography
(Nikon SB-29s)*

More information about using flash can be found in section 4.9 on page 100.

Small air-brush with bellows

Can of compressed air for the removal of dust

Air blower with bellows for sensor cleaning and brush for removing dust from the lens element

Some digital cameras can record voice memos. To transfer and replay these memos on the computer you will have to install the appropriate software, which is often supplied with the camera.

2.3.8 Additional Useful Tools

Besides the equipment already mentioned, there are many additional useful tools. However, you will have to decide which tools are really necessary, which ones you can do without, and those tools you can replace with other simple solutions. If you photograph often, you may find that an air-brush with a small bellows is a useful utensil to remove dust and dirt from the camera and lens without causing any damage. A soft, lint-free cloth (i.e., microfiber) is a good choice for wiping down the body of the camera and the display, or to remove rain drops before storing the camera in the photo bag.

You can also use a can of compressed air for cleaning. It is also useful for removing dust from slides before scanning, or cleaning the glass plate of the scanner. But do not use it to clean the sensor!

Chemicals should not be used for cleaning your camera equipment. In most cases, distilled water is sufficient. Under special circumstances you can take the camera to a specialist for cleaning.

Dust on the sensor is a nuisance and is hardly avoidable in DSLR cameras with removable lenses. Only a few cameras – for example, DSLRs made by Olympus – solve the problem elegantly by using an ultrasonic vibration on start-up. This (hopefully) will shake off dust from the sensor.

To clean the sensors of other cameras, you have to use more antiquated methods such as carefully removing the dust with an air blower (not compressed air!) and cotton swabs. Clean the sensor very cautiously, with a steady hand, and above all, follow the instructions given in the manufacturer's manual. Be sure to close and lock the mirror and keep it locked until the operation is finished. It is very important to have enough power left in the rechargeable batteries to complete this task! Beginners should have their camera's sensors cleaned in a professional shop, which costs about $40–$50.

A cable or remote release is practical for closeup and night photography, though they are rarely available for compact cameras. These remote controls prevent the slight camera shake or vibration that occurs when the shutter button is depressed. Infrared remote releases are relatively cheap and available for many DSLRs.

A trivial, but nonetheless very useful, tool is a small notepad with pencil, to make notes concerning imaging conditions, addresses of models (to thank them, and to send prints), and to record other important information. Of course, you can employ modern technology and use a PDA or record the information directly into the camera for a specific image. If you are planning a photo trip, you may want to take along a small voice recorder. Although in practice, the simplest methods are often the most convenient.

Other useful tools, such as photography lamps (substituting, for example, cheap construction spotlights) will be discussed in the following chapters. This category also includes light-colored cardboard, which is used to lighten up portraits or still life settings. Black cardboard can supply a good

background for portraits or product photography, as well as reduce the show-through effect of items on the back-side of scanned pages. The white backside of advertisement posters – which are given out for free at trade-shows – also make good backdrops for still life, small object, and portrait photography.

Card readers are very important for transferring photo data from memory cards to the computer. Some newer consumer cameras come with so-called *docking stations* for the camera. The docking station is connected to the PC via a USB cable and allows the transfer of data – similar to card readers. Compared to separate card readers (or PCMCIA adapters), they do have the disadvantage that the camera needs to be turned on to transfer the data. Some docking stations have an external power supply and can re-charge batteries.

PCMCIA is a port on many laptop computers.

2.4 Choosing Your Camera

Having introduced the essential aspects of camera technology, we offer a few considerations for choosing which camera to buy. To this end, it is important to set a few parameters, and ask yourself the following questions:

1. **How will the camera be used? Are you looking for:**
 – A compact camera for quick snapshots and personal souvenirs?
 – A camera with higher resolution, larger focal lengths, and some options for manual settings?
 – A creative-use camera with high requirements on functionality?
 – A replacement camera, or an addition to an analog, single-lens reflex camera?

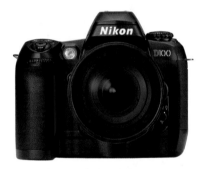

Large (Nikon D100) or compact (Canon IXUS)?

2. **How will the images be used later on?**
 – Your intentions for your final images largely determines the necessary resolution and image quality of potential cameras.

3. **How much money do you want to spend on the equipment?**
 In addition to the camera, the following equipment should be considered basic necessities (These accessories amount to roughly $100–$300. For DSLR models with removable lenses, you'll need to add the price of the lens as well.):
 – At least 2 sets of rechargeable batteries and a high-quality charger
 – One or two extra memory cards with a minimum of 1 GB each
 – A camera bag, if one does not come with the camera package

4. **Camera Technology**
 – Do you want a compact camera or a larger model?
 – If choosing a larger model, consider models with built-in lenses or single-lens reflex technology (the latter preferably, with removable lenses)

Also consider:
- The resolution of the image sensor (preferably ≥ 6 Megapixel)[*]
- The size of the image sensor (as important as the resolution)
- The speed of the lens (smaller aperture values are better)
- The range of focal length (preferably a zoom factor of 3 or more) (this topic does not apply to DSLR cameras with removable lenses)
- Adjustment options in addition to the full auto mode:
 • Shutter priority, aperture priority, and manual mode
 • Manual focus (in addition to autofocus mode)
 • Various flash programs, and a connection for external flash units
 • Viewfinder type and the size of the display
 • Memory card technology and interface with the computer (CompactFlash and SD cards are universal and inexpensive)
 • Threading for filters or auxiliary lenses

5. **Camera Ergonomics (Handling)**
 - How does the camera fit into your hand? Is it easy to operate?
 - Is there a delay on start-up?
 - How fast is the autofocus mechanism?
 - Does it have a too-long shutter lag?
 - Does it offer various program modes?
 - Is the camera a comfortable weight, size, and form for easy handling?

In addition, there are some criteria for excluding a camera from your consideration. This category includes cameras with a built-in memory card without the option to exchange it. A monitor or display, a tripod thread, and a connection for an external flash unit should be among the basic features.[*]

To have more creative freedom in your photography, you should be able to turn off the autofocus mode and have the option to choose between full auto, aperture, and shutter priority, in addition to being able to choose aperture, shutter speed, and ISO settings manually. An additional characteristic of semi-professional and professional camera models is that they support the RAW format. (See page 41 for a description of the RAW format.)

Diagram 2-1 shows the price ranges of different camera models at the beginning of 2007. You can tell from the graph that prices for cameras with the same pixel count can still vary considerably. This variance is caused by the technology included such as the quality of the optical system, and the range of focal length (zoom factor). In general, developments tend to focus on higher resolutions, but for the low-end market, the resolution will most likely reach a limit in the 8–12 Megapixel range. Resolutions above this range require more complex optics to reproduce the nuances that are possible with higher quality images. They also contain more sophisticated internal memory and computing components as well.

At the end of 2007 the typical range of resolution for small format cameras in the middle price range is about 6–8 Megapixel, and 8–22 Megapixel for the high-end models. Some medium format cameras have resolutions of up to 40 Megapixel, but these are hardly affordable for the amateur.

You may have to forgo these features with very compact camera models.

Today a camera should have a resolution of at least 4–6 Megapixel. Above that figure, the quality of the lens becomes more important.

In the lower price range you should avoid cameras with a CMOS sensor; they show too much noise and too many color inaccuracies. The CMOS sensors in the middle and upper price range are of a different caliber.

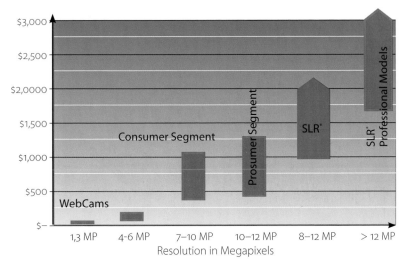

Diagram 2-1:
Price ranges of digital cameras depending on resolution (mid-2007 for small format cameras)
** For SLRs add price of lenses .*

When a new camera model is introduced to the market, you may be able to buy the preceding model at substantial savings, given that you are not completely fixated on owning the latest technology. Camera technology today is so sophisticated that you no longer need the latest developments. In the high-end price range, you may consider buying a used camera; however, buying used is not advisable for low-end models, because the potential repair costs may outweigh the value of the camera.

2.5 Computer Equipment

It is entirely possible to use a digital consumer camera like a conventional film camera, and download the images directly from the memory card to a picture station in a photography store or send them via the Internet to a digital print shop. The prints will be sent back within a few days. At the picture station you also have the option to make basic image adjustments, such as cropping, correcting red eyes, and increasing the contrast. However, if you choose this path you pass by a great many possibilities of digital photography, which can be garnered with almost any available computer. Therefore, we want to introduce the necessary equipment and software tools, and provide an insight into the many ways they can be used. These methods will be described in more detail in the following chapters.

Photo: Apple

2.5.1 Road from the Camera to the Computer

The first step in digital image editing is transferring the image data from the camera to the computer. There are a few different transfer options:

▸ Direct transfer from the camera to the computer via cable
▸ Copying image data from the memory card via a card reader to the computer

‣ Transfer of image data from the memory card via an adapter

‣ Wireless transfer (i.e., cell phone, Bluetooth, or Wireless-LAN)

Direct Transfer from the Camera to the Computer

	Transfer Rates:	
Interface	Maximum:	Actual:
Serial Port	0.1 MB/s	10.0 KB/s
USB 1.1	1.2 MB/s	0.9 MB/s
USB 2.0	40 MB/s	8–20 MB/s
FireWire 400	40 MB/s	> 35 MB/s
FireWire 800	80 MB/s	> 60 MB/s
SCSI II	10 MB/s	6.0 MB/s

Refer to table 2-2 on page 25.

→ *Sony refers to the FireWire port (IEEE 1394) as i-Link.*

FireWire, 6-pins (left) and Fire Wire, 4-pins (right)

Left: USB-B; middle: USB-A; right: Proprietary USB

The transfer of 1 GB of data usually takes about 10 minutes with a USB 1.0 connection or 4–5 minutes with a USB 2.0 connection. Faster connections (such as USB 2.0 and FireWire) are limited by the transfer speed of the memory card.

Most photographers transfer image data via a cable from the camera to the computer. In the beginning stages of digital photography, image data transfer occurred via the relatively slow serial port connections in lower cost computers, and via the SCSI interface in high-end machines. In the meantime, USB (*Universal Serial Bus*) ports have become standard, and some computers feature FireWire ports as well. Until the end of 2002, USB 1.1 was the standard with a transfer rate of approximately 0.9 MB/s. In 2003, USB 2.0 replaced the older standard and theoretically allows transfer rates of up to 50 MB/s – in reality, the actual transfer rates are a lot slower, although they are usually fast enough to use the full transfer speed of the memory cards.* Even FireWire connections have an older (IEEE 1394a) and a newer standard (IEEE 1394b), which approximately doubles the maximum transfer rate. However, even the older FireWire standard has enough capacity, at about 30–40 MB/s, for a fast transfer of any memory card used in your digital camera.

Besides the port on your computer (USB or FireWire) you also need the appropriate cable, which is most often supplied with the camera. The first generation of FireWire has two different types of plugs: the smaller 4-pin plug, which is used in almost all cameras that utilize FireWire (digital video cameras also use this plug), and the 6-pin plug, which is mostly used in computers. USB wires have many different manufacturer-specific variations; only the computer ports are standardized. Therefore, it is important not to lose this cable, because replacing it can be expensive. The standard USB plug has two variations: the flatter and wider USB-A plug and the more square shaped USB-B plug. The latter is mostly used at the connecting site of the device, for example, to connect an external card reader or scanner). Thus, even with USB cables you have to know which cable to buy. The USB-B plug is too large for many compact cameras, and, therefore, smaller, manufacturer-specific plugs are used.

If your computer does not include a USB or FireWire port, it is relatively inexpensive to upgrade your system with the appropriate card (if you run Windows 98, Mac OS 9, or Linux 2.4 or newer operating software). Cards cost about $15–$20.

The software for the image data transfer is almost always included in the camera package, but can also be found for free on the Internet. Also, most image editing software programs are capable of downloading image data from cameras.

Most camera models allow image data to be transferred directly via the cable port (USB or FireWire), without a card reader or adapter. The camera must be switched on for the data transfer, and, therefore, uses some battery power. The drain on the batteries is not overwhelming, though

(exceptions are serial and SCSI ports). However, for extensive transfers it is better to employ a card reader, adapter, or an external power supply.

Some cameras allow you to take pictures and make other camera and data adjustments directly from the computer, which can be useful while working in the studio.

Transfer of Memory Card Data via Card Reader with an Adapter

There are relatively inexpensive adapters and card readers available for all of the memory cards listed in section 2.2.5, which are often more practical than connecting the camera directly to the computer. While earlier card readers could only accept one type of memory card, several current models can read up to six different types of memory cards. These devices usually come with a USB 1.1 port and, since 2003, with a USB 2.0 port. If you buy a new card reader, you should definitely choose the faster one, even if it is still a little more expensive.

USB memory card reader for 6 different types of cards

While Windows 98 still needs special drivers for adapters and card readers, the newer Windows versions, as well as Mac OS and current versions of Linux, recognize the memory cards in adapters without any additional drivers. Memory card adapters, which allow to connect the card directly to the internal bus, usually a PCMCIA/card slot, cost approximately $10–$20. They also allow relatively high transfer rates. FireWire-based card readers are still rare. Most new notebook computer now usually come with build-in card readers for SD memory cards.

Compact and inexpensive CF-adapters are available for use with CompactFlash cards and a notebook computer, and almost always fit into the computer's card slot. In this case, there is no need for a separate, external adapter, which is advantageous while traveling. Floppy adapters allow you to insert some memory cards (for example the SmartMedia card) into a cassette similar to a floppy disk, and to transfer the data by reading them in the floppy drive of the computer. They have not proven to be practical, and they need specialized batteries.

PCMCIA adapter for CompactFlash cards

Increasingly, new computers are built with integrated card readers, so a separate adapter is no longer necessary.

Newer ink jet printers – so-called photo-quality printers – priced over $250, are also manufactured with integrated card slots, generally for a variety of memory card types. While you may print images directly from the memory card, you cannot transfer them to the computer with this method.

Desirable computer hardware requirements for new systems:	
CPU	≥ 1,7 GHz
Memory	≥ 2.0 GB
Hard drive	≥ 120 GB
Monitor	≥ 17″
Color Depth	≥ 2 4-bit

2.5.2 Computer Requirements

Most computers can be used for image editing, organization, and storage, including systems running Windows (W2K, XP, Vista ...), Mac OS X, and Linux, provided they have sufficient speed and storage capabilities.

The computer should have a large enough hard drive (≥ 120 GB), enough memory (≥ 2.0 GB), a high quality monitor, and a fast CPU (e.g., a 2 GHz Pentium or a 1.7 GHz Intel Core 2 Duo). Multiprocessor systems offer advantages. While 2 GB of main memory is good for a hobbyist, least 4 GB of memory is recommended for a professional setup; even more is useful.

Speed and storage requirements continue to increase, and more is always better, which basically translates into increased work speed and greater storage capacities. Monitor resolution should be at a minimum XVGA (1024 × 768 pixels) and be capable of displaying 24-bit color depth. CRT as well as LCD/TFT monitors are adequate.

➔ *That which was film or slide in conventional photography is now image data in digital photography. It must be stored securely and durably. Memory cards are too expensive to use as storage devices, and hard drives fill up too quickly and are not secure enough. Therefore, it is imperative to invest in secure, external storage.*

Having a DVD reader/writer is advantageous, because the hard drive fills up quickly with image data and is not cost-effective for storage. In addition, it is important to make backups on external data storage media, which can be kept separate from the main computer.

Programs, necessary for efficient data handling, which will be discussed in more detail in later chapters, include an image editing program, as well as an image archiving program (photo album program) that offers the function of backing up your image data to DVD or other large data storage media (such as an external disk). Alternatively, you can use a stand-alone DVD-creation program, for this purpose.

2.6 Image Formats

After the image is captured, the camera reads the data from the CCD or CMOS chip, processes the information, and writes it to the memory card. In general, the memory card already possesses a simple file structure, thus the camera saves the image data in a specified image format. Normally, the camera offers several image format options, which differ mostly in their compression method, and the intensity of compression. Three image formats are typical: JPEG, TIFF, and RAW. The JPEG format also often gives the option to set different degrees of compression.

File Structure on Memory Cards

Memory cards have been formatted with the FAT16 file structure, which you may recognize from DOS and Windows. FAT16 has disadvantages for large memory cards and, therefore, newer cards above 1 GB usually use FAT32. This format is not always recognized by older camera models though, so be sure to check your camera's capabilities before you buy. The images on the card are usually organized according to the DCF standard (see the description on page 42).

Image Formats used in the Camera

JPEG • The JPEG format was defined by the *Joint Photographic Experts Group* and is a method of compression rather than a file format. The file format that goes with it is called JFIF (*JPEG File Interchange Format*), however the name JPEG has established itself for this file format instead. JPEG compresses the image content to create a small file that can be stored easily. It is a "lossy" compression method, which means that part of the original image information is lost during the process. It is important to remember that the JPEG format will compress a file every time it saves it, which means that the more often a file is saved in JPEG format, the more image information will be lost. The compression algorithm tries to keep the visual image loss to a minimum by varying the amount of color or tonal information that can be removed. While image editing programs generally allow the user to choose from several degrees of compression, most cameras only offer a few options, such as for example SHQ (*Super High Quality*), HQ (*High Quality*), or SQ (*Standard Quality*). You may also see such descriptions as *Fine, Standard,* and *Economy*.

JPEG formats, in addition to pure image data, can also contain comments on the image, such as copyright information, for example, the metadata of EXIF and IPTC formats.* However, so far only a few programs are able to display or process these comments. In the future the new JPEG-2000 format will also be supported in digital cameras.

JPEG allows several variations, such as 24, 36, or 48 bit per pixel (which means 3 x 8, 3 x 12, or 3 x 16 bit); and it offers different degrees of compression; interlacing, which means that the image becomes progressively clearer as it loads; different optimization methods; as well as additional data in EXIF, IPTC, or comment formats.

* *See the description on page 42.*

TIFF • The widespread image format TIFF (*Tagged Image File Format*) is, in reality, a format envelope that allows numerous internal variations. Digital cameras in general only use one of these variations though, one that saves the image without any loss of data.

While camera-generated TIFF files do not use any compression, the TIFF format supports various types of compression, such as the lossless methods of RLE (*Run Length Encoding*), LZW (*Lempel-Ziff-Welch*), ZIP, or even the lossy compression of JPEG. As opposed to JPEG, TIFF can also contain grayscale images and line drawings (bitonal images). In addition, TIFF files also support metadata, layers, and paths.

TIFF is a format envelope for different raster images with numerous sub-formats. Cameras, however, usually use a relatively simple TIFF method without compression.

RAW • Data formats are often the proprietary formats of camera manufacturers, which can still differ from model to model. The image information is stored complete and in its original form, and typically with or without lossless compression. The RAW format uses a large amount of storage space, but, therefore, offers potentially the highest quality and largest number of options for image editing. If the camera can capture 12 bit (or more) per color channel, this information can only be transferred to the computer via the RAW format. You will need to work with special RAW-converting programs, which are often supplied with the camera, or acquire a plug-in for image editing programs such as Photoshop. (As of version CS2 and CS3 this plug-in is included with Photoshop). The RAW format allows and requires a subsequent white balance adjustment as well as contrast adjustment.

The RAW format generally consists of 1 color value per pixel. The RGB value has to be calculated within the computer. Therefore, the image file is only about half as large as an uncompressed TIFF file.

➜ *IrfanView [79] is a free viewer, which can show numerous RAW formats, open them, and save them in a different format.*

You can find more information about "RAW conversions" in chapter 6, beginning on page 235.

Generally, the camera software does not sharpen images saved in the RAW format. Sharpening is applied later on, during image editing.

Until recently, the RAW format has been used widely in camera models in the middle and upper price range; however, lately it is also spreading to models in the lower price range.

Metadata Formats

Besides the actual image data, cameras and image editing programs store additional, descriptive information about the images called *metadata*. Metadata is data that describes objects, including date, resolution, aperture, focal length, shutter speed, program or flash mode, and similar information.

** JEIDA = Japan Electronic Industry Development Association. Recently, JEIDA has changed to JEITA (Japan Electronics and Information Technology Industry Association).*

EXIF (or **Exif**) • (*Exchange Image Format for Digital Still Cameras*) is a format developed by JEIDA* to store metadata about images, including image capture information noted above, and data about the camera. The date and time, which are set in the camera, are also included in metadata. The EXIF data is embedded into the image format (in JPEG, TIFF, or RAW formats) in addition to the actual image data. By now, EXIF has become the standard with several manufacturers. However, this data is still not recognized by all image editing programs, and some even delete this information once you save the image file within the program. Until this situation changes, you can use a free reader program that can display the information, extract it, and save it in a separate file (i.e., the free Windows program *Exif-Viewer* or *Exifer*). Windows XP, Windows Vista and Mac OS X can display the data without the help of additional programs. You simply highlight the file, right-click and choose *Properties*, and then click on the *Summary* tab.

You can find more information on Exif-Viewer and Exifer in the reference section under [75].

IPTC • IPTC (*International Press Telecommunication Council*) data is similar to EXIF data about an image, but in this case, it is targeted to the needs of the press, media agencies, and authors. It includes specific fields of entry for creator (photographer), copyright notice, rights usage terms, intellectual genre, a URL (to reach the copyright owners), a subject name or image title, subject description (or comments), as well as descriptive keywords. There is a certain overlap of metadata between EXIF and IPTC data.

DCF • DCF (*Design Rule for Camera File System*) is the most common format used today for file and folder names on the memory cards of digital cameras. The specifications were created by JEIDA. The format specifies the naming convention for image files and the folder structure of the data system of the camera. The image files are typically saved in RAW, TIFF, or JPEG/JFIF file formats. Image metadata is generally embedded as EXIF format. At first glance, the file name *P7122675.JPG*, as shown in figure ①, is meaningless. Broken down into its components, it reveals that it is image number 12677, from July 12, 2007, in the JPEG format. The year is not evident from the file naming convention, but it can be found in the EXIF data for the image. For an example of EXIF data, see figure ① on page 318.

① File name structure of a DCF image file

DPOF • DPOF (*Digital Print Order Format*) is a format for files that includes parameters for print orders for the image file. The DPOF data can include how many prints should be produced; which size and rotation they should be; and if specific information such as dates, image title, or image number should be printed as well.

Some cameras can print directly to a photo printer via a cable connection. Also, some picture stations in photo print shops accept DPOF print orders. Newer DPOF standards can also specify automatic transfers and automatic playback (with a possible reference to image, audio, or video data).

Figure 2-2:

Directory and file structure on memory cards according to DCF/DPOF

A DPOF description can be found on:

www.panasonic.co.jp/avc/video/dpof/.

PictBridge • PictBridge is a further development of DPOF. It was created to provide a compatible interchange of image data between digital cameras and printers (and their print functions) that support PictBridge.

The above named metadata formats are still relatively new and continue to be developed further. Therefore, it is important to note the program version while working with metadata. In addition, you can find other metadata components, for example, the comment or image title, in JPEG file formats. The support for these formats (reading, entering, or changing information) varies from program to program.

A PictBridge-compatible printer (pictured is the Canon i560) can print images directly from the camera, even if the camera is made by another manufacturer

2.6.4 Other Image Formats

Once the image has been transferred to the computer, it can be saved in several other image formats, through image editing programs. In addition to the already mentioned RAW, JPEG, and TIFF files, the following formats can be used:

GIF • GIF (*Graphic Image Format*) is used particularly for graphic files on Internet sites. In the past it was used to save photographic images, but, because it only supports a color depth of 8 bit per image pixel, its color reproduction is very limited compared to the digital camera's 24 bit (3×8 bit) image capture.[*] GIF also supports transparent areas in the image (like PNG).

PNG • PNG (*Portable Network Graphics Format*) is a relatively new format for storing rasterized files, which offers both lossy as well as lossless compression methods. The lossless compression has a slightly better compres-

* *Some high-end cameras allow 36 bit (3×12 bit) or even 48 bit (3×16 bit).*

sion factor than TIFF-LZW. In addition, PNG supports different color depths and compression methods, as well as supporting transparent image areas. PNG can (like GIF) save images as *indexed colors,*** when it is specified as PNG-8, and as 24 bit (3×8 bit), or 48 bit (3×16 bit) when using 8 or 16 bit per color channel.

** More about this on page 157.

JPEG 2000 • JPEG 2000 is a new variation of JPEG, although it uses a different compression method – the wavelet-method. We can assume that it will eventually replace the JPEG format, because it offers more options and features and a 15–20% improvement of compression with the same degree of quality. In addition it can compress an image file to approximately 40–50% of its original size without any image data loss and, therefore, is better than TIFF-LZW or TIFF-ZIP.

JPEG 2000 also features a method of compression that compresses simple image areas more, while preserving fine structures and color gradations with weaker compression. Popular support for JPEG 2000 is growing for this reason. So far not all programs and only a few desktop publishing programs support JPEG 2000. Therefore, if you want to use JPEG 2000, you should make sure that your image editing program can read this format.

Like JPEG, JPEG 2000 is a type of compression method, and a compression format, which can be embedded into another file format.

PSD • PSD (*Photoshop Data*) is the proprietary internal image format of Adobe Photoshop. It does not use any compression and, therefore, uses a lot of storage space. However, all image data is preserved and additional information regarding image editing can be stored as well, for example, selection paths, transparencies, layer information, and more. It is the storage format of choice if you want to continue editing an image later on, with all the necessary editing information preserved. Because Photoshop has become a standard in the image editing world, many other image editing programs support PSD as a storage format, or can at least read the files. PSB is a variation of PSD and designed for very large image files.

Paint Shop Pro's format is called PSP. Other image editing programs use their own formats.

* A raster image is build up by individual pixels, while a vector image consists of lines, rectangles, circles, and similar elements that can be easily scaled.

Besides the formats mentioned here, there is a nearly unmanageable range of data formats for raster and vector images.* Examples include: Windows BMP, and Macintosh PICT. In the pre-press world, Scitex still has its significance. Other formats you may see are: TARGA, EPS, DCS, Pixar, WMF, WBM, RAS, and PPM.

EPS	= Encapsulated PostScript
DCS	= Digital Color Separated
WMF	= Windows Meta Format
WBM	= Wireless BitMap
RAS	= Sun Raster Format
PPM	= Portable PixMap

Most of the formats mentioned in the previous paragraph are of little relevance to the amateur photographer – at least in regard to digital image files. The Adobe Acrobat format has proven to be useful for sending images (and other data), because it can package most image formats without adding much file space, and the receiver only needs the Acrobat Reader software to view and print the file. Acrobat Reader is free for Windows, Mac OS, and Linux.

Table 2-3: Image Formats and Options [a]

Format	Compression	Color Depth (per channel)	Metadata	Transparency	CC-Profile	Comment
RAW	Little to none	10–14 bit effectively per channel	EXIF	–	+	Proprietary to manufacturer
TIFF	Differs: None, LZW. ZIP, RLE, JPEG	1–32 bit	+	+	+	Multifunctional
JPEG	Lossy	8, 16 bit	+	–	+	Optimizes storage
JPEG 2000	Lossless & lossy	8. 16, 32 bit	+	–	+	Still relatively new
PNG	Lossless	8, 24, 48 bit in total	+	+	(+)	Compact, but little used (no ICC in Photoshop)
GIF	LZW, loss through 8 bit	2–8 bit in total	–	+	–	For Internet graphics
PSD	LZW for layers	1–16 bit	+	+	+	Exchange of data between image editing programs

[a] Also see the comprehensive Table A-2 on page 332.

Other Metadata

Besides the metadata already mentioned, there are additional metadata that can be embedded into image files. Some metadata is proprietary and only supported by a few programs. This category includes, for example, JPEG comments, as well as watermarks. The function of the watermark is to incorporate rights usage terms into the image data, so that they will be preserved even through image editing. Digimarc created the most widespread system for this purpose, and is supported by Photoshop and Paint Shop Pro.

Adobe Photoshop (and Photoshop Elements) checks each image for watermarks while opening, and displays them. With an appropriate add-on module you can integrate these watermarks into your own images. If someone wishes to use the image commercially, you (the photographer) can be identified through a link to the Digimarc homepage that provides photographer contact information.

XMP (*Extensible Metadata Platform*), originally designed by Adobe, is a type of container for metadata. It allows you to pack several different kinds of metadata, like EXIF and IPTC and comments, into this container. This XMP container can either be embedded into the image file or can be stored in a separate file, which Adobe calls a *side-car file*. If you add metadata to a RAW file, Adobe programs like Photoshop or Photoshop Elements use a side-car file for this. It has the same basic name as the image file and uses the file name extension ".xmp". You might find this kind of file sometimes in your image directories when working with Adobe programs.

Image at 300 ppi: the enlargement shows
the individual pixels

Enlarged section of the window from the
image above

Line drawing with 1 bit per pixel (bitonal, here
black and white)

Continuous tone photographic image, 4 bit
per pixel

2.7 Pixels, Points, and Lines

In digital image editing you will come across the terms dpi (*dots per inch*), ppi (*pixels per inch*), lpi (*lines per inch*), and spi (*samples per inch*). The descriptions dpi and ppi are often used interchangeably, which is, in essence, incorrect. Lpi is used almost exclusively for print, while spi is used very rarely to describe the resolution of scanners. The term *dot* and the corresponding *dpi* is used to describe a print dot, while the term *pixel* or *ppi* is used to reference pixels (picture elements) in digital data.

Digital images in the computer consist of individual picture elements, called *pixels*. Depending on the type of image, between 1 and 48 bit are used per pixel. A 1-bit image is a line drawing, in which a pixel can be either black or white. Such an image is called *bitonal*. If you want to see finer tonal gradations in your image – as is most often the case with photographs – you need more information (more bits) per pixel. For black-and-white photographs, information is typically 8 bit (but smaller or larger numbers are possible). Eight-bit images translate into 256 distinct tonal values. These are called *continuous tone images* with a color depth of 8 bit. Color images are composed of several color components, depending on the color delineation. The RGB process used in digital cameras uses the base colors of red, green, and blue. Therefore, most digital cameras produce three 8-bit color values per pixel; 8 bit for each of the red, green, and blue channels. Thus, a pixel consists of 24 bit (3 × 8) color information. Professional camera models can capture 10, 12, 14, or even 16 bit per base color (color channel) in the RAW format.

The higher the camera's resolution, the more picture elements can be captured for both the X and Y axis, and the more details will be visible in the image. If the resolution, or number of pixels used, is too low, you can clearly distinguish the individual pixel. If the number of pixels is high enough, the image looks smooth, and continuous in tone, like a photograph. If that image is enlarged and viewed from a short distance, the individual pixel may once again be visible. The resolution, therefore, depends on the number of picture elements per unit of measurement; hence it is specified as pixels per inch, or short *ppi*.

Because the image transferred from the camera does not yet have an assigned image size – the image can be displayed smaller or larger on different media – the resolution is initially not given in dpi or ppi, but in the number of pixels in its horizontal and vertical axis. For a typical DSLR camera, such as the Nikon D100 or the Canon Digital Rebel, this figure might be 2,816 × 2,112 pixels. Some cameras specify this figure in millions of pixels. If the camera can capture 2,816 × 2,112 picture elements, its resolution is described as 5,947,392 pixels or approximately 6 megapixels.

If you display this image on a monitor with a typical monitor resolution of 75 (or 72) dpi, the image will be about 37.5 × 28.2 inches large – much larger than the typical monitor. Therefore, to display the full image on-

screen, you will need to sample it down, which is usually done automatically by the viewer or image editor.

If the image is printed on a digital photo printer with a resolution of 300 dpi, the same image will measure only 9.4 × 7.0 inches, which is smaller than letter size. A digital photo printer computes the digital image data and prints photos on photographic paper at a photo print shop.

To create a good print on an up-to-date inkjet printer, the image needs a resolution of approximately 150–300 ppi. For example the image could be printed at 200 ppi and would measure about 14.0 × 10.5 inches, or a little smaller than tabloid size. However, only high-end inkjet photo printers (above $600) handle these paper sizes.

This printing resolution seems to contradict the specifications of printers. The resolution of inkjet printers usually ranges from 1400 dpi, up to even 5760 dpi. How come color photographs are printed at only 150–300 dpi? The difference comes from how the picture element is created or, more precisely, how the printer defines a dot. While a pixel on the monitor can assume any one of 256 possible brightness values between black and white, a laser or inkjet printer has to simulate gray or other color values. In reality, it can only do one of two things: place a dot, or not place a dot. Printers are not able to print graduated tonal values; they can only simulate a tonal value by placing several small dots. The same goes for a color printer when it has to reproduce a color other than one of the saturated, native printer colors. If it lays down many small dots in an area, the area will appear dark, if it lays down only a few, the area will appear light. A printer requires several micro (printer) dots to simulate one image pixel (here also called the *raster dot*).

Continuous tone photographic image, 8 bit per pixel

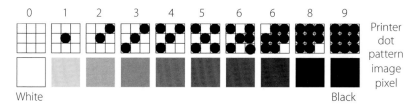

Figure 2-3:

The implementation of a dot raster with 3 x 3 dots and 10 possible tonal values. Different tonal values simulated by a pattern of singe printed dots. The dot formation and shape can differ individually.

To simulate a range of 144 brightness (tonal) values, the laser printer needs a matrix of 12 × 12 image dots. Its effective resolution for the reproduction of continuous tone images would, therefore, be ¹⁄₁₂ of the originally noted printer resolution. Some laser and inkjet printers can vary the size of the print dot (variable dot-size printers), and, therefore, improve the look of halftone images significantly. However, because a range of 64–128 halftones (tonal values) also renders acceptable results, most printers use a matrix of 8 × 8 or 9 × 9 printer dots. Even high-quality laser printers with a resolution of 1200 dpi are

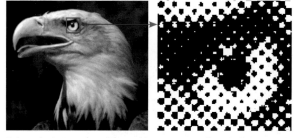

Enlarged printing raster of the eagle's eye in a printed image (laser printer)

limited in their reproduction potential of continuous tone photographic images.

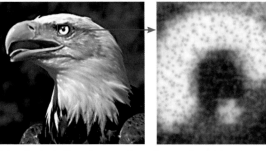

Printed color halftone image enlarged image of an inkjet print

The situation for inkjet printers is similar, but slightly better. For one, printer resolutions of 1480 to 5760 dpi are typical, which is much higher than for laser printers. In addition, the fluidity of the inks causes them to mix with each other, and allow additional color tones to be achieved by layering different colors. Some printers can even vary the size of their print dots, and some photo quality inkjet printers utilize at least six ink colors, so they need fewer raster dots to mix colors effectively. The translation of the image pixels into the printer dot matrix is called *dithering* and happens in the print driver, or RIP, and can be controlled to a certain extent in the print dialog box.

Enlarged version of an offset print on paper

The color and ink absorbency of the paper needs to be considered for printing, which is why inkjet printers require you to set the paper type before printing. Some printers try to recognize the type of paper automatically, but this method is not always trustworthy. It is recommended to always set the correct paper type manually.

Those printers marked as *photo-quality inkjet printers* often work with more than the standard four ink colors. They use six or more colors, which can reproduce finer gradations of tonal values. In addition to cyan, magenta, yellow and black, they usually make use of light cyan, light magenta, and light gray. Some colors, such as skin tones, can be reproduced more accurately with a mixture of fewer dots of magenta and more dots of light magenta. A printer that uses 7 colors or more usually adds a light gray ink as well. Good print drivers can create smooth transitions in this way. Also pixels with similar color values benefit from these extra ink colors, for example skin tones, and light-but-solid color tones (through the use of light gray).

Lines per Inch

As explained above, the printer simulates the image pixels of a digital photograph with a pattern of micro print dots. The accumulation of these dot patterns is called a *raster*, and the individual image pixel reproduced is called a *raster dot*. These raster dots are arranged with specific angles, so that the pattern formed is a line. The number of lines per measurement unit define the resolution, just as with image pixels, and with resolution, the quality or fineness of the printed image. As opposed to dots per inch, it is noted as lines per inch, or lpi, and is also called line screen. In countries using the metric system, you would see resolution or line screen referenced as L/cm.

Very coarse line screen with 10 lines per inch

If an image is printed in color, the raster dots of the base colors are printed at a different angle to avoid creating a moiré pattern.

Table 2-4: Recommended line screens for various printing conditions

Raster width		Usage	Image resolution
53 lpi	21 l/cm	Laser printer (600 dpi, 65 gray levels)	70–110 ppi
70 lpi	27 l/cm	Newspaper print, typical rough paper	90–140 ppi
90 lpi	35 l/cm	Good quality newspaper print	140–180 ppi
120 lpi	47 l/cm	Acceptable quality for books and magazines. Raster cells points can still be seen.	160–240 ppi
133 lpi	52 l/cm	Good quality for books and magazines. Raster cells points can still be seen.	170–265 ppi
150 lpi	59 l/cm	Good offset or silk printing. Individual raster point may hardly be recognized	195–300 ppi
180 lpi	70 l/cm	Good offset and silk printing, very fine raster, individual raster point hardly recognizable; good inkjet printing, individual raster point no longer recognizable at a reading distance of 20–30 cm (9–12 inches)	250–360 ppi
200 lpi	79 l/cm	Very good book prints; very smooth (coated) paper needed for printing. Raster cells points hardly recognizable.	300–400 ppi

For the same reason the line screen is varied slightly between different base colors. A moiré pattern develops by layering fine, evenly spaced structures (line screens) slightly offset. (See the image at page 48).

To print rasterized images, the line screen has to be adapted to the printing technology (such as laser or inkjet printers, etc.) and the medium (type of paper). The formula *"a high line screen equals high print quality"* is not completely accurate. A roughly textured paper surface – for example newsprint, or the standard paper used for inkjet printers – requires a coarser line screen to avoid colors spreading into each other, which would significantly lower the quality of the printed image. The same is true for printing books and magazines. The enlargement of the print dots on paper is called *dot gain*. Table 2-4 shows the appropriate line screen for various commercial printing technologies. However, digital photo printers and inkjet printers work with slightly different line screen methods. Useful print and resolution recommendations for printing with inkjet printers are listed in table 2-5.

L/cm = lines per centimeter (used in Europe)

The Interrelationship of Input Ppi and Output Lpi

There is a mathematical correlation between the input resolution of an image and the line screen in the final print. One factor is determined by how many gray tones or color levels per image pixel should be reproduced in the print. In essence, how many print dots are needed for each raster point? In addition, a small offset between raster dots needs to be maintained to avoid undesired mixing of the print dots. It is easiest to convert the desired line screen of the print into the input resolution by means of a quality factor. Quality factors typically range from 1.3 to 2.0. You would need an image with an (unscaled) input resolution of roughly 300 dpi to result in a good quality book print, which is printed with a line screen of 150–165 lpi. If the image needs to be scaled up or down with desktop publishing software, the appropriate resolution needs to be multiplied with the scaling factor.

If in doubt, ask at your print shop or digital photo service provider about the correct line screen for printing.

Table 2-5: Possible Print Sizes of Various Camera Resolutions

| Mega-pixel | Resolution in Pixel (approximately) | Camera Example | Maximal Print Size in Inches | | |
			150 ppi Inkjet printer (acceptable)	200 ppi Inkjet printer (good); Digital photo printer (acceptable)	300 ppi Inkjet + digital photo printer; book print (good)
4.0	2408 × 1758	Kodak C433	16.1 × 11.7	12.0 × 8.8	8.0 × 5.9
6.0	2816 × 2112	Sony DSC S600	18.7 × 14.0	14.1 × 10.6	9.4 × 7.0
8.0	3356 × 2304	Canon Rebel XT	22.4 × 15.4	16.8 × 11.5	11.2 × 7.7
10.2	3872 × 2592	Nikon D200	25.8 × 17.3	19.4 × 13.0	12.9 × 8.6
12.8	4368 × 2912	Canon 5D	29.1 × 19.4	21.8 × 14.6	14.6 × 9.7
16.7	4992 × 3328	Canon Ds Mark II	33.3 × 22.2	25.0 × 16.6	16.6 × 11.1
21.0	5616 × 3744	Canon Ds Mark III	37.4 × 24.9	28.1 × 18.7	18.7 × 11.5

Because typical digital photo printers can produce real halftone dots without a dot matrix, this conversion is not necessary for the digital printing process. The same is true for dye-sublimation printers, which mixes colors more effectively, and thus produces good print quality with image resolutions of about 200–300 dpi. The typical resolution for digital photo printers ranges between 250–400 dpi. These values do not need to be multiplied; they yield the correct resolution in pixels per inch (ppi).

For the conversion of 150 ppi, the inkjet or laser printer needs a multiple of 8–10 print dots (dpi) in order to simulate the graduated tones using a raster with micro print dots!

What are the options if you need a significantly larger print? For larger print formats, the image might have to be sampled up. However, the larger viewing distance compensates for the loss of sharpness in the details. With a DSLR camera with 6, 8, or 16 megapixel you can produce almost any size print. The larger the viewing distance, the lower the print resolution needs to be; hence for a 24 × 30 inch poster you only need 80–100 ppi.

2.8 Color Temperature

→ *While most digital cameras handle daylight situations well, the white balance in artificial light can be tricky, which can trigger the camera to choose the wrong temperature. At times you may have to intervene (see images below).*

The human eye (or rather the human brain) reacts adaptively to visual stimulation much more effectively and automatically than technology does. The eye adjusts itself to the existing light conditions and matches the current information with the values stored through past experience. Therefore, we connect red and pink hues in the face and on the body with the experience of skin color, even with large brightness and hue differences.

In this way the retina corrects *color casts* automatically. The associated regions in the brain compare the current light effects with those it registered previously. Technology can only correct color casts to a certain degree, and is much more objective or neutral in the process – which is not always desirable in photography. We perceive a piece of paper in the light

of sunset as white, even though objectively it shows a red color cast. In bright sunshine it appears as white as well (perhaps a little brighter), even though it reflects a more bluish hue.

Digital cameras try to simulate this behavior with an automatic function called *white balance*, which is an improvement over film technology. However, this adjustment is only suitable to a limited extent under the many possible lighting conditions. Therefore, at times you may have to adjust the white balance manually by setting the current lighting conditions in the camera menu, or by photographing a continuous-toned area that the camera can use as white reference. This practice is also called *white balance*.

The term *color temperature* – measured in Kelvin (K; 0° Celsius = 273.15 Kelvin) – comes from the fact that a black-body radiator emits different colors at different temperatures: from glowing red to white to glowing blue. White light consists of many colors. The light spectrum of lower temperatures is redder in nature, such as candlelight. Higher temperatures appear bluer.

Table 2-6 on page 51 shows typical color temperatures of different lighting conditions. The example of the moonlight shows that there is no 1:1 correlation between color temperature and brightness.

Do not simply trust the camera auto white balance; you should specifically set the appropriate lighting conditions. Most cameras can handle normal daylight situations well without displaying color casts, but they struggle with artificial light, as can be seen in camera tests in magazines or online.

Sometimes the camera automatic chooses the wrong color temperature in artificial light

Corrected white balance

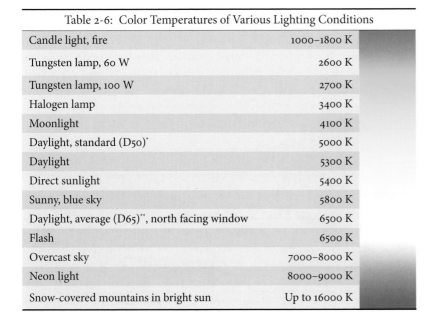

Table 2-6: Color Temperatures of Various Lighting Conditions	
Candle light, fire	1000–1800 K
Tungsten lamp, 60 W	2600 K
Tungsten lamp, 100 W	2700 K
Halogen lamp	3400 K
Moonlight	4100 K
Daylight, standard (D50)*	5000 K
Daylight	5300 K
Direct sunlight	5400 K
Sunny, blue sky	5800 K
Daylight, average (D65)**, north facing window	6500 K
Flash	6500 K
Overcast sky	7000–8000 K
Neon light	8000–9000 K
Snow-covered mountains in bright sun	Up to 16000 K

* *D50 = US standard*

** *D65 = European Standard*

You can set the white balance in high-end cameras in three different ways:

▸ Set the color temperature in the camera menu
▸ Complete a manual white balance (as described below)
▸ Perform a white balance adjustment in the RAW conversion program. This is only possible for cameras that support the RAW format, and if you saved your images as RAW files.

Consult the owner's manual concerning white balance (or WB), because the settings differ from camera to camera. Instead of displaying color temperatures, some cameras offer menu settings such as *daylight* (which corresponds to roughly 5300 K), *tungsten*, *flash*, *overcast day*, *shade*, or similar descriptions. Some low-end consumer cameras do not offer any manual white balance settings.

▲ *Image without manual white balance*

Image with manual white balance ▼

Manual White Balance • To complete a manual white balance, position the camera in such a way that the whole picture area is covered with a white or light-gray, even surface. Then activate the camera's white balance setting. The camera records the color cast of this surface and removes it from the subsequent images. Thus, images taken under those light conditions will be neutral in color (i.e., will not have a color cast). A manual white balance adjustment is not available in all digital compact cameras, but in all bridge cameras and DSLRs.

At times, you may want to capture a specific mood in your photographs. Therefore, images shot in candle light, near a camp fire, or on the street at night should not necessarily be neutral in color, but have a visible yellow-red cast. An image taken in snow or at dusk may show a slight blue cast. Under these circumstances, you may avoid setting a white balance, and the camera will usually capture the mood correctly. You can always remove the color cast later during image editing, or even intensify it slightly.

Sometimes – as with this image –, it is better not to do too much white balancing, or the mood of the picture will be lost.

2.9 Depth of Field

Depending on the size of the aperture, a photographed object will only appear sharp in an area a specific distance away from the camera. The human eye, or brain, still accepts some areas of the image as acceptably sharp if they lie near the plane of focus, and already show a small degree of blur. This depth, which is still in acceptably sharp focus, is called *depth of field*. Conventional single lens reflex cameras used to have a scale (depth of field scale) engraved on the lens, which showed how large an area of the image was in acceptably sharp focus. Digital cameras do not usually display such a scale. How large this depth of field is depends on the lens, and more specifically on the focal length, the aperture, and the distance to the subject:

▸ Small apertures (large aperture numbers, i.e., F11) result in a larger depth of field.

▸ Short focal length (wide angle) have a larger depth of field than long focal length lenses (telephoto).

Only a limited distance is in sharp focus (depending on aperture and focal length)

▸ If the plane of focus lies further away from the camera, the depth of field is larger than if the camera focuses on an object close by. Above about 30 feet, the depth of field of a normal lens (50 mm) set at a medium aperture (roughly) will reach from approximately 21 feet to the horizon. In macro photography, the depth of field can be as low as a fraction of an inch.

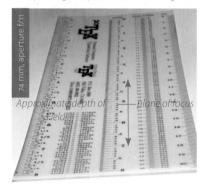

▸ Because of a small sensor size and short focal length lenses, digital compact cameras exhibit a larger depth of field than DSLRs.

▸ The depth of field is roughly twice as large behind the *plane of focus* (the exact distance the camera is sharply focused on) as in front of it.

The depth of field of digital cameras is larger than that of conventional cameras due to their shorter focal length lenses. (This is no longer true for digital full-frame cameras or if you translate the focal length into a small format camera focal length.)

To use the depth of field optimally in an image, it is best not to focus directly at an object, but approximately 20% behind it; due to the depth of field proportions, the image is sharp about ⅓ in front of the plane of focus and 2/3 behind it). This technique is called *hyperfocus*. (*Hyperfocal distance* is the distance at which everything from one-half that distance out to infinity is in focus.) This method helps to maximize the depth of field around the object in focus. You will have to set the distance manually – measure it, or make an educated guess – or focus on another object the same distance from the camera. This method is relatively involved and is usually only worth utilizing for important images.

The same angle of view with different planes of focus.

The above-mentioned depth of field of ⅓ in front of and ⅔ behind the plane of focus is only valid for normal images (images taken using no mag-

nification). For macro photography, above magnifications of 1:1 (i.e., the image on the sensor or film plane is larger than the actual object) these depth of field proportions are reversed. The depth of field is larger in front of the plane of focus, and smaller behind it.

Depth of Field as Limitation and as Design Element

For the photographer, depth of field is both a limitation and a design element.

Only the leaf in the foreground is in focus (f/4.5, 1/1000 s, 90 mm, ISO 100)

The building and the leaf in the foreground are (almost) in focus (f/18, 1/125 s, 90 mm, ISO 100)

For some images, such as product photography, technical details, or landscapes, a large depth of field is important. It is undesirable in other pictures. For example, a shallow depth of field is advantageous in portraits, because it keeps the viewer focused on the face. The same is true for many animal pictures.

By your choice of lens, focal length, and aperture setting, you can use depth of field as a creative element in your images. Typical consumer cameras do not allow you to check the depth of field through the optical viewfinder – you can only view the image at the largest aperture opening. Even most traditional SLR cameras have limited options for a depth of field preview, which requires a stop-down mechanism to close down the aperture. Depth of field preview images are generally much darker, because less light enters through the lens when it is set a small aperture (that is, at a large aperture number), which makes checking these images difficult.

Compact cameras, with their relatively small image sensors, have different focal length and extension factors than SLR models. For instance, you can generally focus on objects very near the camera (sometimes as close as ¾ inch) and maintain a much larger depth of field, compared to the larger bridge and SLR models. This flexibility is often desirable for photographing smaller animals and objects.

2.10 Aperture and Shutter Speed

A certain amount of light is needed to make an exposure on film or to capture an image in the image sensor. Light striking the film causes chemical reactions in the emulsion of the film. Light striking the image sensor charges the corresponding CCD or CMOS image elements, which are then read by the camera's imaging unit. If the capturing substrate (film or sensor) is exposed too long (overexposed), the result is a white image pixel (or a clear spot on the negative film). If it is not exposed long enough (underexposed), the image pixel will be dark, or even black. The incorrect areas in both under and overexposures are missing all details.

The amount of light in an image can be controlled through aperture and shutter speed – it is a product of these two variables. Within limits they are interchangeable. A third factor is the sensitivity of the film or sensor. A correctly exposed image results from either a long shutter speed with a small aperture, or from a short shutter speed with a large aperture. From analog photography we are familiar with standard aperture and shutter speed values, or aperture and shutter speed stops. For example the standard aperture stops are:

1.0, 1.4, 2.0, 2.8, 4.0, 5.6, 8.0, 11, 16, 22, 32, …

They originate from the multiplication with the factor 1.4 (rounded), or more precisely with $\sqrt{2}$, and each stop indicates that half as much light passes through the lens, or that double the amount of time is necessary to produce a correct exposure. The range of aperture values available is typically much smaller in most cameras, depending on the lens, than the range enumerated above.

| F/1.4 | F/3.5 | F/16 |

Small aperture values indicate a large aperture diameter. A larger aperture value equals a small aperture diameter.

Because the aperture value is the result of the equation of the effective aperture diameter over the focal length, it is noted as f/x (for example, f/2.8). Sometimes you may see it written as "F2.8" or "aperture 2.8". The complete accurate notation would be "1:2.8".

Corresponding to the aperture values, there are also standard shutter speed values, which are in seconds:

1/2000, 1/1000, 1/500, 1/250, 1/125, 1/60, 1/30, 1/15, 1/8, ¼, ½, 1, 2, 4, 8, …

Digital cameras often note shutter speeds faster than one second without $1/x$ – for example 1/125 is shown as 125. Shutter speeds above one second are specified with the second mark ("), or the minute mark (').

Of course, you can also always use intermediary aperture or shutter speed values, but the calculations get a little more complicated. While most cameras offer very long shutter speeds, only the expensive models provide shutter speeds below $\frac{1}{1000}$ second. Some professional models can expose for $\frac{1}{8000}$ second, but shutter speeds this fast are only used for specialty purposes under extreme lighting conditions.

Image sensors tend to capture significant noise with exposures over 2 seconds, noise that will be visible in the image. You should compensate, either by using noise suppression, which some camera models offer, or later, during image editing using the noise reduction function of your RAW converter or image editor.

The difference of one of the above aperture and shutter speed stops is also called one *exposure value* (EV). Two exposure values already indicate four times the amount of light, three exposure values eight times.

In a given lighting situation, the following settings would result in the same amount of light in an image:

Possible aperture and shutter speed combinations in a given light situation.

Aperture	1	1.4	2.0	2.8	4.0	5.6	8	11	16	22	smaller diameter →
Shutter speed	$\frac{1}{500}$	$\frac{1}{250}$	$\frac{1}{125}$	$\frac{1}{60}$	$\frac{1}{30}$	$\frac{1}{15}$	$\frac{1}{8}$	$\frac{1}{4}$	$\frac{1}{2}$	1	← shorter time

The images would look very differently though, because the depth of field increases as the aperture values increase. In addition, gradations, or fine tonal transitions change slightly with different shutter speeds.

If you are unsure of the correct exposure for a given image, you can bracket the exposure using most digital cameras (and all DSLR models). The camera will take several exposures with different exposure values. Often you can program how many images the camera will bracket, and how big the exposure difference will be between bracketed images.

The third exposure factor is the sensitivity of the film or the sensor. Again there are standard ISO values, which we are already familiar with from film photography:

ISO 25, 50, 100, 200, 400, 800, 1600, 3200, 6400, ...

* Also see section 5.13.6 on page 186.

Many cameras also let you set intermediate sensitivity values. In a given light situation, doubling the ISO value also doubles the sensor sensitivity, thus allowing for half the shutter speed, or an additional aperture stop.

More advanced camera models allow you to set the ISO value within a certain limit, which generally starts at 80–100 and can extend to ISO 3200. As image sensors become more sensitive and create less noise, well-lighted images can be created using less and less existing light.

Rule of Thumb for Exposure

To avoid a fuzzy image due to camera shake, the following rule of thumb applies to the maximum shutter speed for handheld photography (without tripod or support):

Time (in seconds) = 1/focal length *(focal length in small format cameras)*

For a zoom of 120 mm – which is the typical maximum zoom of compact cameras – this corresponds to $\frac{1}{125}$ second (or shorter), if you do not want to risk camera shake. You may use longer exposure times (by a factor of about 2–3) if your camera or your lens has an image stabilizer.

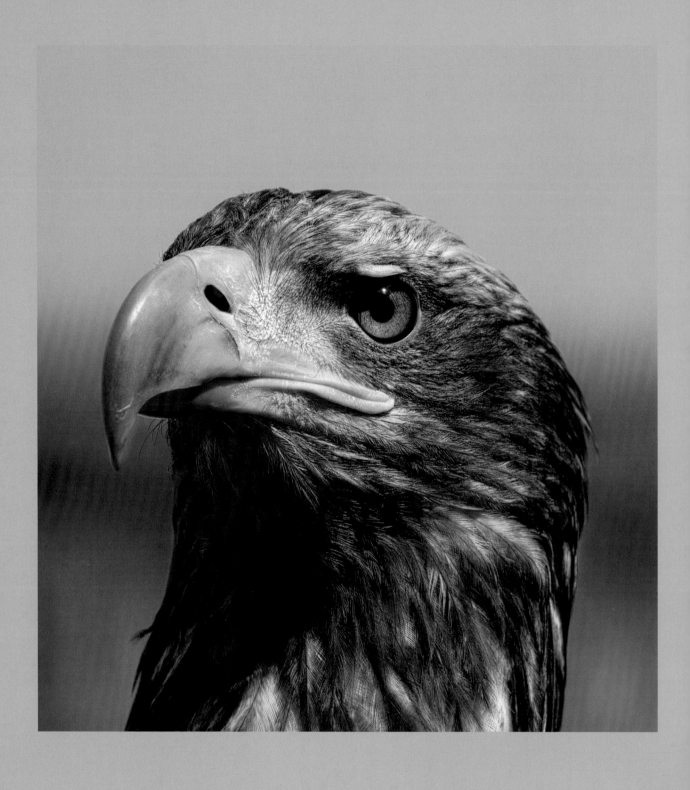

Composition in Photography

3

Good pictures are generally composed, or deliberately arranged. You bring the camera into a certain angle of view to the subject, choose suitable cropping, the appropriate depth of field, and the correct exposure. Except for a few lucky snapshots, only by following such considerations will you capture good photographs. Therefore, this chapter briefly illustrates the most important rules of composition, and explains how to process existing images to achieve optimal impact.

Upon examination of these rules of composition, we discover that they are not born of photography, but have been adopted form classic art. Photography is – just like drawing and painting – an abstraction. The photographer has to decide what he wants to show in his image, and what he wants to omit.

There are different rules for creating a passport picture (above) than for a portrait on a birthday card (below).

In most instances the important subject should fill most of the image frame.

3.1 Image Considerations

Most photographs today are snapshots – perhaps taken with good intention, but not well thought out. The result is usually nothing more than a memory for the photographer that ends up in a shoebox, or at best, in an album, collecting dust in a closet. The poor results are not due to the camera used, because you can create decent pictures with most of them. The reason is that the photographer did not think enough, and did not take enough time to compose the image.

The result can be significantly improved if you take a moment to contemplate the desired image before pressing the shutter button. Ask yourself the following questions:

▶ **Why am I taking this picture?**
For memories, documentation, capturing a mood, or a special situation? What is the best perspective, the best cropping, and the most suitable lighting?
The purpose of a portrait could be a passport picture, or a memory of a loved one; the composition would look very different in each case.

▶ **For whom is this image intended?**
For your own memory, or to tell a story, to prove something, or perhaps to sell to a client? What are the viewer's expectations?

▶ **What do I want to capture or to express?**
The architecture, the situation, the mood, the color, a specific detail? What is the most important object in the image? What is relevant, typical, and what needs to be shown? What can and should be omitted?

▶ **What do I see without the camera and how can I show it in the image?**
In cooperation with the brain, our eye sees our experience and associations with more meaning than the camera does. Additionally, we see in stereo, with two eyes, and move our eyes or even heads, which, though almost unnoticed, causes our focus to change continuously. On the other hand, the camera captures more than we consciously perceive, and thus gives importance to locating a suitable vantage point, beneficial lighting situation, and the best cropping and depth of field.

▶ **Is the image worth the effort?**
A digital image hardly creates direct costs. However, it takes time to create it and later it takes time to transfer it to the computer, look at it, evaluate it, and possibly delete or save it. Of course, there are additional costs to print and store it.

All these questions seem lengthy to list, but are the basis for creating good photographs. Actually there is no such thing as a *good image*, only a *good image for a specific purpose*. Thus, a picture should be created with some thought, preparation, and composition.

Most beginners look through the viewfinder, solely focus on the subject that interests them, and forget that it occupies only a small portion of the overall image. The subject is large and interesting only within their perception. They overlook image elements and areas that will later distract, bore, or confuse the viewer.

Therefore, go back to the questions: What is the most important object in the image? Which environment is suitable to emphasize this main object? What is distracting on first sight? A few steps forward, backward, or to the side, is often enough to exclude distracting fences or telephone poles. Sometimes you just have to wait a little bit until the light becomes better, the street becomes emptier, the cloud formations become more interesting, an animal turns around to face you, the subject person becomes more relaxed, or the grouping opens up more. Photographing requires patience and thought. These are the qualities that make a good photographer, even more so than the available equipment. Photography has many parallels to painting – it is, in fact, *painting with the camera*. The result is a picture.

Light and color that are not present at the time the image is taken will still be missing during image editing and presentation, and are very difficult, if not impossible, to add to the image after the fact. Every distracting and superfluous object in the image that I can omit during the composition process saves me much time during image editing. Every distortion that I can avoid – for example in architectural images – saves cumbersome perspective corrections. Every distracting shadow needs to be elaborately retouched. Blur cannot be removed, or even partially removed, without time-consuming effort.

As a rule of thumb, we can assume that one minute of preliminary thought can save 10 or more minutes during image editing, and make the image more useful to begin with.

Once the preparations are made, you should take several pictures, each one with slightly modified exposure (which bracketing mode on high-end cameras can do), as well as trying different angle of view and various crops.

The sharpness of objects that are not the main focus can be distracting (above). Therefore, I used an image editor to blur the head of the man in the image editor (below).

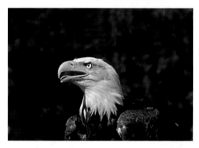

As in drawing, the art in photography consists of deciding what should be included in the image and what should be omitted. Photography is an abstraction. That which you want to show should be easily recognizable, and fill the image frame as much as possible.

Just as a painter knows his paints, a photographer should know and master his camera, its various settings and modes, and its pleasing and problematic characteristics, to understand its potential and limits. Only study and practice produce effective images, which are less a product of chance, and are created more efficiently. Try to school your eyes to see the right crop, suitable perspectives, and generally photographically interesting scenes, as well as fully utilize the tool of your art, your camera.

Even a slightly blurry picture can be useful as an exception.

A diagonal line directs the eye of the viewer,
increasing dynamic tension in the image.

3.2 Composition Diagrams

There are a number of composition principles used in photography that also apply to graphic arts, drawing, and painting. For a photograph, or series of images, you choose which of these principles you want to use – depending on the subject and the intention of the photograph. You make important decisions about your image by choosing the angle of view, the crop, as well as light, shadows, and depth of field.

For the sake of demonstration, we first use sketches to explain these concepts and then add concrete photographic examples.

The following rules are not recipes written in stone, but need to be individually adapted to the purpose of the image. Nor are they dogmatic principles to be followed blindly. These points can, however, help to compose better images. It requires experience and practice to capture the right moment at a given time, i.e., before the child runs away or the sun has set. You can observe existing images and ask yourself what you like (is it the composition, the layout, the arrangement of colors?) or what you find distracting to improve your discrimination. Is it that the feet are partially cut off, or that there is blur in important image areas? Are the colors pale, or the contrasts harsh?

Format • The first consideration of the format is how large the object is compared to the imaging frame. The larger the image is in relation to the picture frame, the stronger is its presence and its significance. A small object in a large, busy environment becomes part of the *image pattern* without much individual significance. The same object placed in a serene environment has much more individual power of expression.

In the extreme case, you do not see the entire object filling the frame, but only a part of it, which causes the image to become abstract, and the viewer may even have to guess what the object is. Often the variations Ⓑ, Ⓓ, and Ⓔ (below) are the most interesting compositions. In variation Ⓐ, the object needs to be clearly distinguished from the environment, for example with a strong color contrast.

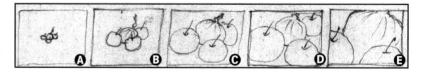

While it is highly unlikely that you would paint the same object again and again in different sizes, digital photography makes it easy to create series of images of the same object. In this way, a series can even become *one image*.

For the final image you should not only confine your picture to the standard vertical or horizontal camera formats in the 4/3 ratio (or the 3/2 ratio of small format film). Some images require different formats – landscapes and panoramas, for example, need long horizontal formats;

individual people often need thin, vertical formats; and faces and single flowers can benefit from almost square formats. Simply crop the unnecessary and distracting portions from your image using your image editing program. If the presentation format differs, you can add a black border. White borders are especially distracting for screen, TV, or projector presentations; black or dark borders are much more pleasing! For prints you will have to decide on black or white borders (i.e., for a calendar with a black background) or if cropping off the border is the best solution. You could also consider colored borders. The same photograph can make very different impressions depending on whether a vertical or horizontal format is used.

The effect of different formats (horizontal ▲ versus vertical ▼)

Another important aspect of format is completeness. Shapes and objects need a certain completeness, which can vary from object to object. For example, the photo will appear ugly if a face is cut at the chin, or an eye is missing, while it is perfectly acceptable to crop hair slightly. If you photograph a whole figure, you should either completely include the feet (preferably with some room in front of them as well) or completely omit them. Half a car is usually displeasing to the eye as well, if it is an essential part of the image.

Lines • An image can be divided into horizontal and vertical lines, and the positioning of the main object in relationship to these lines creates very different expressions. The horizontal line represents calmness and space; the vertical line causes static; and the diagonal line creates dynamic, movement, life, and perspective.

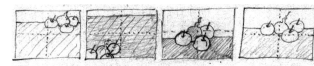

The center of the image is the most prominent position for an object, especially when there are no clearly distinguishable lines in the picture. Therefore, single and essential objects are placed in the center of the image.

After scanning the center, the eye then looks for the central object in the upper right corner. Therefore, an object placed there is more prominent than one placed in the lower left corner.

Larger objects within their surroundings can also be arranged well, according to the golden rule (for example 3:5 or 5:8). 1:3 is also a useful division. This rule can be applied to horizontal as well as vertical compositions.

The horizon and the shadows create lines in this image.

The horizon emphasizes the middle line. The perspective lines of the street create a diagonal. The colors were more saturated with a polarizing filter.

A reflection that extends into the foreground creates the illusion of depth.

Within a book or magazine the upper right corner of the page is the most prominent place for a graphic, and thus mostly upstages the rest of the spread.

A placement of the horizon at the vertical image center is not often ideal for a landscape photograph with a clear and mostly level horizon line. Dividing the picture frame into thirds is much better. If the sky is very light, place the horizon line in the upper third; if it is dark and dramatic, the sky may occupy 2/3 of the image area.

The diagonal line is another compositional element. It directs the main focus of the eye from the upper left to the lower right or from the lower left to the upper right. The ascending direction, bottom left to top right, is often viewed as a positive technique in advertising layout.

Planes and Space • Even though a photograph is 2-dimensional and flat, a suitable angle of view and the use of perspective elements can create the illusion of space. Geometric perspective lines foster the impression of space as they lead the eye into the distance. For example, the lines of a street converging at the horizon in a landscape picture lead the eye through the picture and increase the impression of 3-dimensionality.

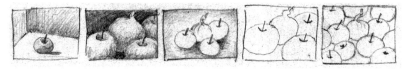

In addition to planes and space, blur and focus play an important part in photography, much more so than in painting. Their skillful use by the photographer can clearly emphasize the effect of space. For example, well-placed objects in the foreground, which may be a little blurry, increase the impression of depth in the image. The use of depth of field, which changes the focus from sharp to blurry within one object, also creates the illusion of space.

In a portrait, the focus on the person is stronger when the eyes are sharp and the background is blurry, as opposed to having a large depth of field, which usually renders the background too distracting.

Provide enough space in the image for the important elements. Often the image only becomes effective because of the added space, as the adjacent image of the ship in the fog shows. The slightly off-center placement of the ship – horizontally as well as vertically – creates tension and gives the ship space that it can seem to move through. The fog separates the areas of sky and water without a sharp division of the gray tones. This image is an excellent example of sparse image elements creating a strong impression.

The beauty of this image lies in its barrenness.

Contrasts • There are many different pairs of *contrast*: small/large, light/dark, solo/group, close/distant, calm/action, sharp/blurry.

There are several variations of contrast between colors; for example the contrast of complementary colors, of saturated (loud) and subtle colors, or between cool and warm colors.

Contrasts between different shapes can also be used, such as angled versus round, or the contrast between sharp and blurry.

Focal Point • An image usually has an *optical focal point*, which can be determined by shapes, colors, and arrangements. Darker and more saturated colors seem more dominant than lighter and more subtle colors. When three equal elements are arranged in a triangle, the focal point lies in the center of the triangle, even when the triangular arrangement is not centered in the image.

The optical focal point is not necessarily identical with the mathematical focal point; it does not usually lie in the center of the image, but is slightly offset. This type of composition is perceived as harmonious and creates a slight tension. Elements near the edges of the image can change the optical focal point of an image. This is also true for strong lines and movements in a clear direction, or strong colors like the red shirt in the image of the ball game.

Tension • Related to the subject of *contrast* is the aspect of *tension*. Tension can be created through the use of contrasts, opposing shapes or color differences, and spacial composition elements.

Tension is created by avoiding complete symmetry or uniformity. Symmetry, which was used during the Renaissance as a symbol for sanctity and peace, is considered rather monotonous today. However, shadows and small deviations can break homogenous symmetry and build a certain amount of tension.

Tension can also be created with colors or environments that are out of the ordinary for the object. Alternately, the object can be shown only partially,

The small red ball in the lower right corner provides contrast to the rest of the image by its size and color.

The focal point of the image has shifted to the left because of the red shirt. The orange ball compensates slightly for this shift. The action happens in the center of the image.

Even though it is not in focus, this image shows a certain tension because of color contrasts (red/blue, cool/warm), motion, and arrangement.

which causes the viewer to wonder about the part that is missing. Tension may also be created with heavily disproportional items.

Rhythm and Pattern • Interesting compositions can be created with several of the same or similar objects used in repetition and arrangement. Make sure to avoid monotony and keep a certain tension in the composition. Also naturally repeating patterns can make for interesting images (see adjacent image).

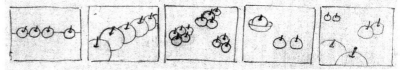

Even more so than in painting, you can find interesting images in the structures and patterns of nature. The pattern should fill the frame as much as possible. You can find examples in the microcosm or in the patterns of landscapes. Beautiful images can also be designed with colors or shapes that repeat in variations.

Calmness and Static • Horizontal lines generate calmness, and vertical lines give the impression of static, especially when the image does not have many details or colors. Solidity can also be expressed through the vertical line, a concept that is used quite frequently in advertising.

Large and dark elements seem static and calm. In landscape images, the typical horizontal image format produces calmness, while a vertical format with clear perspective lines communicates more dynamic energy and tension.

The calmness of the picture originates from the muted, cool colors and the horizontal image format.

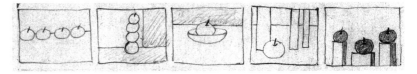

The colors present in an image are also to be considered. For example, the colors blue and dark green, as well as other dark colors, exhibit more calmness than warm and bright colors like a fire. Symmetry is similarly comforting.

Dynamic • Geometric perspective lines, on the other hand, create the impression of dynamic, or action, in the image. So do obvious movements, or movement sequences, for example, the inclined position of a biker, the evasive posture of a boxer, a person caught in midair, or a sailboat tilted at an angle.

◂ ▴ *Dynamic caused by movement and motion blur.*

Motion blur in an image creates a high degree of dynamic. The background can be blurry (as in the picture of the small, fleeing caribou), or the main object can show motion blur; one of the two planes should be in focus. Colors also support dynamic tension, such as a saturated red.

Positive and Negative Space • If essential objects in the image have strong shapes, you can experiment with the contrast between these shapes and their environment.

The same is true for strong colors. In addition, the rhythmical arrangement of the same or similar objects is a strong compositional force.

Reflections are special compositional elements. They repeat shapes and patterns in more or less modified copies of the original. Reflections in still water impart a sense of calmness and harmony.

Even though this image contains many colors, the picture is not too colorful. The base colors are green and red, while blue and yellow are harmoniously distributed.

RGB base colors, and CMY complementary colors

Color • Color is an exceptionally strong compositional element. Therefore, it should be used selectively and purposefully. Just like a colorfully painted picture often comes across as childlike or cheap, a photograph should also not be too colorful. By *colorful* we mean a collection of colors that are equal in intensity, saturation, and size.

Color can be perceived as calming, if the image uses few contrasting and saturated colors. Color can agitate, as well, if the image uses colors that are *loud,* highly saturated, glaringly bright, or strongly contrasting. Colors that contain yellow and red are *warm*, while colors with a high blue content are *cool*. Color can create a field of tension with contrasts between light and dark, warm and cool, strong and subtle, pure and muddy.

Strong contrasts occur when complementary colors meet. On the color wheel, complementary color pairs are located opposite each other (at 180°) such as green and magenta, blue and yellow, and cyan and red. Even more tension is created with colors that are not directly complementary, but slightly offset on the color wheel, for example blue and red, as well as dark blue and saturated green. The more saturated the colors are, the higher the contrast.

If a "loud" color is the center of attention in the image, i.e., a saturated red, it generally requires a balance. If this same color is repeated with less intensity in another area of the image; for example, in a smaller area or a more muted shade, such balance can be achieved.

In the left image with the red coat, there is no balance between the bright red and the cold blue. In the right image we added small red colored spots, which were provisionally added with a brush. Ideally, in this example, they would be small red flowers, which could have been copied from another image, and which can be quite blurry in contrast to the red coat.

Colors influence each other. For example, a saturated bright red surrounded by pink or yellow has one effect, while in a black or blue environment, it has another. There are color combinations that clash, those that make the colors seem more or less intense, and those that we perceive as natural or nature-oriented.

Monochrome images, with mostly one color in many gradations, appear as calm, without being

boring. They are well-suited to capturing specific moods, as the following examples show. These moods are often present shortly before or after sunrise, at sunset, in diffused or indirect lighting conditions, and at night.

Images with only few colors that appear to be black and white photographs at first sight, can be arresting if they include only soft, light colors or dark, almost black colors. The impression of the image can be improved during image editing by carefully decreasing the color saturation in the picture.

Even though it is almost black and white, color has a function in this image.

In some situations, colors and their contrasts can be intensified by using a polarization filter while taking the photograph; for example, the blue sky can provide contrast to a dark or bright subject, under certain lighting conditions. The effect of the polarizing filter can be even stronger under certain circumstances (for examples, refer to the top two images on page 64).

Color can be adjusted during image editing: its intensity can be reduced or amplified, or the color can be partially replaced. Color adjustment is one of the strengths of digital image editing technology, and it allows for effects that were not possible with conventional technology, or only possible with much effort.

An essential aspect of working with colors is achieving the correct exposure. In a situation that combines several different, or opposing, lighting conditions it might be useful to shoot several images exposed to each lighting condition, and then collage together the best parts of each image.

The low perspective lets the person appear larger-than-life.

The tree trunks form a frame for the gazelle.

Three different, yet similar, types of framing. With the two images to the right, the frame is accented by the border that picks up a color from the image.

Symbolism • We react subconsciously to symbolism, including the symbolic representation of colors, shapes, perspectives, or lighting situations. We are reminded by purple of cardinals, by crimson of kings, by red of the Communist party, by black of death and mourning, and by white of weddings and joy. However, color symbolism is dependent on culture. In India, for example, white is the color of death.

Symbolically, a round arch is perceived as *protective*, and a portal shape as an *entrance*. The depiction of a person from a low vantage point elevates and makes the person appear more authoritative. Examples of such symbolism can be found in sacral art as well as in car advertising. Additionally, if the object is placed in the center of the image, the symbolism becomes even stronger. You can witness this strategy in advertising when a race car driver and his car are portrayed as stars.

The same concept is used during medal ceremonies, where the winner stands on a higher podium than those of the other athletes. Of course, this symbolic element can also be used in other ways, without immediately calling to mind holy people or stars.

Frames • Frame elements can enclose an image, group different objects together, or guide the viewer to the main element in the picture. The frame itself can be symbolic. Often, a photographed object only becomes attractive with the use of a frame. There are many opportunities and options to find frames.

An obvious frame is a window frame, which can be used to frame the scene beyond it. If the frame is dark, the effect of the frame is strengthened. Buildings, trees or other confining elements can also serve as frames. In the picture of the gazelle, tree trunks create the frame. Ideally, the animal would have been positioned in the exact center of the framing triangle. In

an image that cannot be repeated, you may have to carry out an elaborate retouch, or live with the compositional compromise.

The picture frame and mat are also elements to enhance the image. If you frame your image with a mat, you can pick a color from the image as the color of the mat.

Object and Environment • An object has an important relationship to its environment. A background can either emphasize an object, or swallow it, depending on the color and chaos in the surrounding area. Colored areas, color tones, or background structures and patterns can create a mood for the main focus of the image, or stand in stark contrast to it. A background's color or light-to-dark transitions can cut into an object. However, the photographer can easily avoid these unpleasing relationships by moving the camera to a different vantage point. You should contemplate which parts belong to an object (for example, the feet in a full body shot), which elements add to the object (for example, the tools of a craftsman), and which element is distracting (for example a passing car in an architectural photograph). The partial cropping of people's heads was not well liked in the past, but is now accepted as emphasizing their presence.

A Buddha above partially cut by the sky appears unhappy. The image below has been edited to correct this problem.

Especially if your image has a light sky background, you should make sure that the most important parts of the object are not positioned in the brightest area, as the images of the ostrich head demonstrate. Often you can simply move your position a little – kneel down, climb up, or move to the side – to achieve a more harmonious composition.

Sometimes it is helpful to render the background soft or blurry during image editing; or, as in the case of the Buddha, I added some more wall to the background using a clone tool. You can also cut out the object, or place it in front of another background. However, these procedures are far more time-intensive than fixing these problems while taking the picture.

Combination of Effects and Breaking the Rules • In most cases you will use a combination of the compositional elements introduced here. However, try to avoid a mere accumulation of principles in a single image, because it can easily turn into *visual chaos*.

It is definitely permissible to break these compositional rules, but you should know what you are accomplishing by doing so. Skillful deviation from these principles can be interesting and exciting.

3.3 Designing with Camera Techniques

Some impressions can be intensified or reduced while photographing. For example, a low and close vantage point gives the impression that you are looking at a tall object, while a telephoto image, taken from a larger distance, tends to minimize height or size. Hard light coming from the side amplifies wrinkles and surface structures, while diffuse light softens them. This is the reason why soft, diffuse lighting or even soft focus auxiliary lenses often are used for portraits. You can make your subjects look younger by bouncing a soft light onto their chin from below. If you use flash for the portrait, reflectors made from white-colored cardboard can be placed to the side of and below the chin (of course, not close enough to be visible in the image). Stronger light from one side can create interesting shadows.

Wide-angle lenses increase the distance between objects of different planes (distances), which is more pronounced the closer the objects are to the camera. Long focal lengths (telephoto settings) have the opposite effect. With the correct depth of field you can separate the object from the background, for example, in a portrait.

Color saturation can easily be changed in an image editing program, including making one or all colors more saturated and strong, or reducing the color saturation to create greater harmony. It is also possible to selectively work with individual colors to increase, decrease, or replace them altogether. This process is fairly easy for one color, but becomes tedious if many colors are involved.

Increasing the contrast of the image is a correction that is done frequently – but don't overdo it. This adjustment can also be limited to individual, interesting areas of the picture. Another correction technique allows you to sharpen the image moderately. Some cameras offer settings for sharpening during image capture, but the process is much more flexible and controlled when it is done on the computer afterwards.

Some images show their full impact only when viewed at a specific size.[*] This image, as well as others shown here, would look better if they were reproduced larger.

This image was designed using sharpness and blur.

This image was designed using color contrasts and motion blur.

** See the image of the caribou on page 67, for example.*

3.4 A Stockpile of Image Elements

Because individual images cost so little to produce in digital photography, and since the cost of storage space has come down significantly, collecting interesting image elements and storing them for later use is now recommended. These stock images can be added to other images to increase their interest. Examples of such image elements are: skies, background areas, patterns from nature, water surfaces, and special background lighting. You will need interesting backgrounds, patterns, and compositional elements, especially when creating collages. Other elements can be used as frames in

other pictures. Even faces, or other components that include skin colors, are useful objects, if they are captured and stored true to the original color. These images can be opened in a second window and are useful for comparison while color-correcting problematic images.

Of course, you can buy image elements, but be aware: licensing costs for commercial usage rights can be high, and there can be tricky legal implications to use them in publications. The most important consideration of all is the pride you can have in taking all of your own images.

In addition, your own image elements, if well-captured, can easily stand on their own and become the basis for collections, such as front doors, street signs, patterns of nature, or others.

These elements can be used not only as background elements, but also to create whole new images using collage techniques (see page 208). Generally, the individual elements can become more abstract and even bizarre. While such collages could be created through double exposures in conventional photography, digital photography plus image editing is an easier and more flexible method for creating collages.

Types of Photography

4

There are many different imaging situations photographers encounter everyday that require special techniques and equipment to achieve their desired results efficiently. In the following section, we describe several typical scenarios and give tips and advice.

This chapter also covers some image editing aspects, because digital photography only shows its true potential by combining the products of image capture and editing. For more in depth information on image editing, see chapter 5.

We attempt to cover the fundamental challenges that photographers face, however, we cannot cover every challenge you will meet. We hope to provide enough information to allow you to find your own answers and develop your stills from the guidance given here.

4.1 Basic Photographic Techniques

4.1.1 Preparation

The following information may sound elementary, but it will be helpful for you to have while taking pictures, as well as for becoming acquainted with your camera model and its useful settings for standard situations.

Reading the Manual

It needs to be emphasized again: Use your camera manual! Cameras and their adjustments are so sophisticated and the buttons and wheels so versatile that it is difficult to guess all their functions intuitively. Take your time and read the manual while keeping your camera handy so that you can find the corresponding functions and settings, and remember them easily. For most cameras there is also very compact a short reference guide that can easily be taken along.

Standard Settings

The first step after buying a new camera is to learn about its functions, even if at first you only use the auto mode. Find the most important elements and settings, and the best way to hold the camera in your hand. Where are those elements that should not be covered with a hand or finger – i.e., the infrared autofocus beam? Determine a hand and finger position that makes it easy to access the most important buttons and wheels without having to put down the camera. For compact cameras, be sure to locate the toggle switch for zooming, the buttons for the flash, and various camera program modes, as well as the switch for the macro mode. Are you familiar with the meaning of the various symbols? Do you know how to increase the ISO setting for especially low lighting conditions, beyond using auto mode?

➜ When in doubt, it is better to slightly underexpose an image than to overexpose it. Underexposed images can still be corrected during image editing, while completely overexposed (washed out) areas cannot be corrected, or only with much effort!

Even if at first you only use the auto mode, you still have to choose a multitude of settings, including the standard resolution with which to capture the images. If in doubt, it is best to choose the highest resolution with no compression (i.e., TIFF or RAW)* or only a slight compression (JPEG). For the highest quality image demands, you need to choose the RAW format, if it is available on your camera.

** These formats require the largest storage space and take the longest to process. Therefore the quick capture of various image series may be hampered.*

More creative models also allow you to choose the method by which the exposure is automatically determined. Most of the time there are three variations: spot metering, center-weighted averaged metering, and evaluative metering. The evaluative metering mode is the best choice with which to begin.

Whenever the lighting conditions allow, deactivate the internal flash, or use it only as a fill-in. Your camera may have a separate setting for this kind of use.

In addition, the display can be set to act as a viewfinder, or, for cameras with an optical viewfinder, to show only the captured image, or you

can deactivate it completely. The second showing the captured image eats a little bit more battery power than a deactivated screen, but it helps when you are just starting to use your camera to quickly spot bad adjustments.

The Correct Posture

However trivial it may sound, the correct posture and holding of the camera is important – this is especially true for larger cameras with heavy lenses. Generally, the camera belongs leaned onto the face and not held at half an arm's length in front of your body to see the display better (as long as you have an optical viewfinder). Steadying the camera on your forehead gives more stability and reduces the chance of camera shake. In most cases, using the optical viewfinder is preferred over using the display, because the image can be evaluated in more detail. Many compact cameras no longer come with an optical viewfinder. In these cases position ① is necessary.

Larger cameras with heavier lenses are held as follows:

▸ The camera is placed on the heel of the left hand. The left hand carries the camera and supports the lens and the camera body. It also handles mechanical zooms and, in manual cameras, it sets the focus.

▸ The right hand operates the shutter (gently) and possibly other buttons and wheels.

In bad lighting conditions or when using a long focal length, you will need to have a calm hand. Support your elbows on your knee, or on your chest – or lean against a stable surface or a railing, or use a tripod.

A tripod needs to be able to carry a camera comfortably and securely, especially when attaching large telephoto lenses. The further you extend the center post upward, the less stable the tripod becomes. Thus, it is better to work with a smaller center post, or a taller tripod. Make sure that the extensions of the legs are securely tightened, and that the tripod head is secure while working. When taking long-exposure photographs, a self-timer, cable release, or remote release reduces the chance of camera shake. If possible and available, use a sturdy tripod. If a tripod is too inconvenient (e.g., too heavy), use a monopod instead.

➡ *Stable, used tripods can often be purchased inexpensively, and are much preferred over new, cheap tripods.*

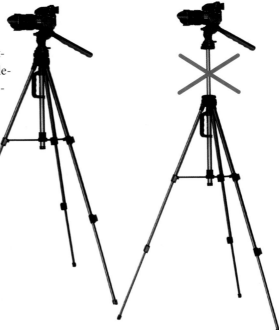

4.1.2 Correct Exposure

The auto exposure modes of digital cameras are constantly becoming more sophisticated. They can take into account many factors, such as specific settings, which are either done manually or through a program mode (i.e., portrait or night modes). For example in portrait mode, the camera chooses the largest aperture possible to separate the person optically from the background. In night mode the camera underexposes the image (compared to the standard program) and takes into consideration that there is supposed to be a significant amount of black in the image.

Normally, the camera auto exposure mode assumes that the complete picture displays a tonal value equivalent to 18% gray, and exposes accordingly. However, auto mode does not fit all image needs.

A snowy landscape, for example, would be underexposed and the snow would end up looking 18% gray (and not white). The same is true for photographing a bride dressed in white. In both cases you need to compensate for the automatic exposure mode by overexposing the image slightly:

▶ Set the aperture and shutter speed manually (as most professionals do), or

▶ Set an exposure compensation (which is possible in all bridge and DSLR cameras), or

▶ Set a camera auto mode for special situations (which is part of all compact cameras).

Low-key images – those with predominantly dark image areas – also do not fit the 18% gray rule. In these cases, you need to compensate by underexposing the image slightly, so that the dark image areas will actually be dark or black, instead of middle gray. You can use the same techniques as mentioned above for the correction.

As a photographer, it is important to develop experience assessing which situations deviate from auto mode or circumstances that do not benefit from the 18% gray rule, and learn to correct the exposure accordingly. Compensation can also happen depending on the type of light metering mode you use. High-end cameras, generally, offer: *spot metering, center-weighted averaged metering*, and *evaluative metering*. Evaluative metering measures several areas of the complete image and evaluates them according to the middle gray rule; in center-weighted averaged metering mode, the areas in the center of the image or viewfinder carry more weight in the metering evaluation; and in spot metering, only the center of the viewfinder is taken into account.* If an object not positioned in the center of the viewfinder should be the reference point for metering, you place it in the center of the viewfinder and press the shutter button half-way. This fixes (freezes) the measurement (some cameras have a separate button for this function) and you can reposition the camera to the original composition before pressing the shutter button all the way.

Evaluative metering

Center-weighted averaged metering

Spot metering

* Newer DSLRs (for example the Canon Digital Rebel XT and XTi) allow you to choose the individual metering point in the viewfinder you want to act as reference point.

Of course, the gray or brightness value of the main object also needs to be considered for the center-weighted averaged metering and spot metering modes (even if the object is colored). In certain cases, the exposure value will have to be corrected in these modes as well.

The exposure of an image can be evaluated by checking the camera display or the histogram (if provided by the camera). If your camera offers the histogram and highlight warning, be sure to activate these options and evaluate the information they provide after each shot.*

* See explanation in section 4.14 on page 82.

As was mentioned in section 2.10, correct exposure depends on three parameters: aperture, shutter speed, and ISO setting (high values cause too much noise).

The correct combination of these three factors produces a *correctly exposed image*. For the sake of creative photography, it is useful if the camera allows you to control these settings directly. The appropriate combination depends strongly on the subject. Moving objects – typical in sports and wildlife photography – require extremely short shutter speeds to yield sharp results. Landscape and macro photography, for which a tripod can usually support the camera, require a small aperture (i.e., aperture 11 or more) to achieve a larger depth of field. If you want to separate an object from its surroundings, use a large aperture (small aperture value), to limit the depth of field.

As far as ISO settings are concerned, if you can set them manually, the lower the number the better! The higher the ISO number, the more noise will be present in the image. This rule of thumb is especially true for compact cameras. However, it is better to have a grainy image than a blurry one.

In order to avoid camera shake we already mentioned another rule of thumb for small format cameras: the shutter speed should be about 1/focal length. Often it is safer to use only half of the time, for example $\frac{1}{100}$ second with a 50 mm lens, and $\frac{1}{200}$ at a focal length of 100 mm. This almost guarantees a sharp image. When using long exposures (perhaps over ¼ second) you should lock up the mirror in your DSLR camera.** This prevents vibrations when the mirror flips up after pressing the shutter button. Of course, at this point you should be working with a tripod. Camera shake can also be avoided by using a self-timer, cable release, or infrared remote control.

** *In this rule, the focus length of a full-frame camera has to be used. If your camera has a smaller sensor, you have to multiply your actual focal length with the crop factor.*

This whole discussion shows that if the photographer wants to be creative, the camera needs to offer manual settings for shutter speed, aperture, ISO, or exposure compensations in automatic modes. Prefabricated program modes for different lighting conditions may be helpful – especially when just starting out in digital photography – however, they limit your creative expression to situations for which these pre-made programs are designed.

4.1.3 From Analog to Digital Photography

Many photographers who switch to digital cameras already have extensive experience with conventional photography. What differences need to be considered in digital photography?

We have already mentioned many of these aspects; however, below is a useful summary. Keep in mind, though, that there are considerable differences between the various camera models.

▸ **Shutter Lag**

Digital cameras can have a longer shutter lag than analog models, and from the time the shutter button is pressed until the image is captured, a significant amount of time can pass.* This lag time is caused by autofocusing and other internal program preparations. While in the beginning of their development, the lag time for digital cameras could be as long as 1–4 seconds, many improvements have been made and the lag times nowadays are usually no longer than 0.1–1 second. In dynamic situations, even half a second can be critical to getting a good image. Learn how to compensate for shutter lag and how you can minimize its effect.

▸ **Pre-Focus**

If you point your camera at an object and depress the shutter button half-way, most cameras automatically acquire settings (focus, shutter speed, and aperture). Wait a moment and press the button all the way, and the shutter lag will be minimal.

You can use this technique to pre-focus on an object that has clear contours or is located at the same distance as the object you want to photograph. Once pre-focusing is finished you point your camera towards the actual object and take the picture.

▸ **Problems While Focusing**

Some expensive camera models allow you to choose different focusing modes. Become familiar with these options and switch between them if you need to, or focus manually. There are cameras that offer a continuous autofocus mode for moving objects. The autofocus mechanism might have problems focusing when the light levels are low or the object to be photographed does not show clear structures or contours. The mechanism may search for the focus for a while and not find it, in which case you cannot release the shutter button. Because most autofocus systems are programmed to look for vertical lines, it may help to rotate the camera into the vertical position to focus, press the shutter button half-way and return the camera to the horizontal position to take the picture. As mentioned before, you can also pick another object to focus on, fix the settings by pressing the shutter button half-way, and return the camera to the desired composition to take the picture.

Cameras need a certain amount of light for focusing. For example, many Canon and Nikon DSLRs will require a minimum of $f/5.6$ to

Shutter lag seems to happen in all older digital cameras, and in less expensive models. Newer models have seen huge improvements in the last few years. In addition, inadequate lighting conditions (or a high zoom factor) can cause longer focusing times.

➜ *To save storage space while preserving quality, it is better to choose high resolution with high compression, than to switch to low resolution image capture.*

Some camera models have separate buttons to choose focus and aperture/shutter speed settings.

➜ *Be sure you do not cover the focusing light with your fingers.*

autofocus. Avoid zoom lenses which have a lower aperture at the extreme setting (e.g., at the end of the zoom range) greater than 5.6, as many cameras will not be able to autofocus at these settings.

▶ **Larger Depth of Field than Analog Small Format Film Cameras**
Digital cameras have a greater depth of field than analog camera models due to their structure and smaller-sized image capturing devices; the sensor is smaller than small format film.[*] This represents a change for photographers who enjoy working with shallow depth of field. The advantage is that you can get acceptable depth of field at relatively low aperture values and low light conditions. To get the same depth of field in digital cameras that you would in analog models in manual mode, you can open up the aperture by 1–2 stops.

Actually, some high-end digital camera models have an image sensor the size of small format film (24 x 36 mm). They are called "full-frame sensors", and the same rule applies as does for small format cameras.

▶ **No More Film, But You Choose the ISO**
While you choose different types of film for an analog camera for different lighting conditions, so you choose the sensor sensitivity in many digital camera models. Generally, if set accordingly, the camera will choose the ISO value through an auto mode up to certain limits. If enough light is available, this will be the lowest possible value (usually ISO 100–200). However, you can set a higher value. Extreme values will have to be set manually because they produce considerable noise in the image.

The limits for settings such as ISO, shutter speeds, and apertures depend on the camera. The larger the image sensor, the better the camera can handle low light.

The camera auto mode usually does not make use of other extreme values as well, and they must be set manually, for example shutter speeds below $\frac{1}{1000}$ or above 2 seconds.

While you need special films to shoot in artificial light, the digital camera can process an automatic white balance. Another method is to conduct a manual white balance, or manually set the color temperature.

▶ **Discrepancy Between Viewfinder Image and Sensor Image**
Compact and simple digital cameras show an image in the viewfinder slightly offset from what the image sensor actually captures. (This discrepancy also occurs in analog cameras.)

Imaging at night, and with artificial light, does not require special film with digital photography.

The discrepancy increases the closer the object is to the camera and can be significant in closeup photography. Therefore, you should evaluate your image crop on the digital display, which shows exactly what the image sensor captures. Even SLR cameras have slight discrepancies between viewfinder and sensor images; the actual image captured is usually 3–8 % larger than the image shown in the SLR viewfinder.

▶ **Including Color References**
Images that require a high degree of color fidelity (i.e., jewelry or fashion), should be photographed with a color or gray scale placed on the edge of the image (plain gray cardboard will do). Doing so allows for a

Color and gray scales can be bought in specialty photo or graphic design stores.

Image editing is described in chapter 5, beginning on page 127.

more exact color correction during image editing. During editing, transfer the correct values to other images taken under the same lighting conditions, and crop the color or gray scale out of the picture when you are finished.

4.1.4 The Histogram – An Important Aid

One of the essential advantages of digital cameras as opposed to their analog predecessors is that you can visually evaluate the captured image on the digital display immediately after taking the image. Most digital cameras, and all bridge and DSLRs, offer two methods for checking your images:

① *Preview image on the camera display after capturing the picture*

▸ **A JPEG Preview of the Image**
The digital display will provide a JPEG preview of each shot. This also applies if you shoot in RAW. However, the preview is so small that it can only be used for a crude evaluation (figure ①). Sometimes you can zoom in on the image, but it might be distracting for viewing other images.

▸ **Histogram of the Image**
A histogram shows the distribution of brightness in graph form (figure ②). Generally, dark tonal values are shown on the left and light ones on the right. In addition, some cameras mark over- or underexposed image areas by blinking pixels in the JPEG preview mentioned above. How you activate the histogram on your particular camera – if it has one at all – you will have to glean from your camera manual.

② *Histogram with brightness distribution of the image pixels*

The histogram, even if it is shown very small, usually offers a more reliable exposure check than the JPEG preview. An image with normal contrast would show a histogram similar to figure ②; the brightness values neither touch the left nor the right side of the diagram.

If the brightness values touch the left side, as shown in figure ③, it signals that some tonal values are completely black, or colors are completely saturated. There is a high likelihood that some tonal values have been cut and the dark image areas (such as shadows) will lack detail. In some cases this is desirable, such as in night scenes; however, it, generally, indicates a strongly underexposed image.

③ *Histogram of a clearly under exposed image*

If the brightness values touch the right side, as shown in figure ④, some image areas will be completely white and it is likely that you lost image details. A loss of detail in the light area of the image is usually more serious than in the dark areas, because our eyes tend to focus more on the bright areas of a picture. Ideally, no part of an image should be absolutely white. The exception would be a few catchlights (spectacular highlights), small bright spots such as reflections on water, glass, or metal, which should be completely white. In these cases, the histogram might look like figure ⑤. If you see such a histogram, you will have to crosscheck the JPEG preview image to determine if it is indeed highlights, or the overexposure of

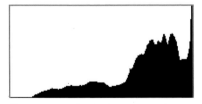

④ *Histogram of a clearly overexposed image*

important details. Of course, toggling between the JPEG preview and the histogram takes a little flair, and some experience.

While interpreting the brightness histogram, you should be aware that different colors are valued differently in this summary histogram. Green – the color our eyes are most sensitive to – is weighted at about 60%, red at approximately 30%, and blue only at 10%. Thus, it could happen that an image with much saturated blue is still shown to be a good exposure in the histogram, while some saturated blue areas might have been lost. Accurately interpreting a histogram also takes a little experience.

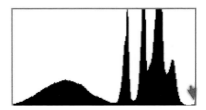

⑤ *Histogram with small bright areas – perhaps acceptable highlights*

To make up for this ambiguity, some newer cameras (such as the Nikon D80, D200, D300, or Canon 40D) offer a color histogram in addition to the brightness histogram. With the help of a color histogram, you can easily recognize these problems.

Besides the histograms displayed after the image capture, some newer cameras now show live histograms – a histogram before the image is captured. Of course, a live histogram is even better, but still rare (for instance, available in the Olympus E-300, Nikon D300, 3D, or the Canon 40D).

In addition, there are imaging situations in which the image contrast is so high that the camera cannot capture the full range of contrast adequately. Figure ⑥ shows the histogram of such a situation. In this case, you have the following choices:

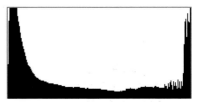

⑥ *Histogram of a scene in which the contrast exceeds the tonal range the camera can capture.*

1. You decide on one side – the light or dark area – and expose this area so that it shows details. The opposing tonal values will be lost, but you accept this loss. Choose those areas that are important to the scene and to you. For example, you may decide to crop out the sky, which is often quite bright. Sometimes it helps to zoom in (or get a bit closer) to your object of interest.

2. You can use a gray filter, which reduces the overall contrast. Or you could use a graduated gray filter to seamlessly darken the sky. Working with filters effectively takes some experimentation.

3. You can use a fill-in flash to lighten up the shadows. This technique also reduces the overall contrast range, hopefully to a level the camera can manage.

4. You can use HDRI, which stands for *High Dynamic Range Images*, images that display a high range of tonal values. To this end you take several images with varying exposures – an exposure series – and collage these images together with the appropriate HDRI software tools.[*] Afterwards, the now very large tonal range of the image will be reduced to a range that can be reproduced on screen or in print.

** For example Photomatix by MultiMedia Photo; see reference [60]).*

The details of this method would far exceed the framework of this book. A good introduction to HDRI can be found at www.hdrsoft.com/resources/dri.html. Additionally, a very thorough book on HDRI is *The HDRI Handbook* by Christian Bloch.

Home-made passport picture; photographed in front of white cardboard. US and European countries, however, require the ears to show in passport pictures, which is not fulfilled here.

A semi-profile; flash on camera from approximately 10 feet, with a 120 mm lens.

This semi-profile accentuates the face, supported by the background.

4.2 Portraits and Group Photographs

Pictures of family and friends belong to the standard imaging situations to be mastered at the beginning of an amateur photographer's career. If you invest some time and effort, you can create exceptionally beautiful portraits that are highly memorable.

4.2.1 Portraits

There are many types of portraits with many different requirements. A passport picture needs to be designed differently than an image that is supposed to reflect the person's character. The passport picture always consists of a frontal view, with a homogenous, uniform background in which not only the face, but also the ears and the shape of the head, are clearly recognizable. A white or off-white presentation board is a good choice for the background. You can also use a white bed sheet, tablecloth, or wall. The distance between background and subject should be at least 10–15 inches, which should render the background blurry.

The face should be lighted evenly and diffusely, diagonally from the front, or from two sides. It is better to direct the light from the side, than to use harsh frontal lighting, which can flatten the features of the subject.

A slightly telephoto setting (approximately 80–120 mm from about 6 feet) gives enough distance between model and photographer. If you use a small aperture value (i.e., f/2.8–f/4.0) you can blur the background. The camera position should be at eye level or slightly below. Make sure the eyes are in focus.

On the other hand, in a character portrait, the head can fluently transition into the background, or you can show the face from an angle (or profile), which usually has more impact if you use a differentiating light that emphasizes the subject's features. You can achieve this effect by capturing your subject in a semi-profile with stronger lighting from the side (sun; or better, half shade, or flash) and a diffuse, indirect light from the other side. If you arrange the portrait, you can use a reflector as the second light. In the simplest case, it could be a large, white presentation board or a Styrofoam sheet from a home improvement store. An alternative could be an emergency blanket, or silver or gold foil from the crafts store. Gold foil supplies a beautiful, soft light with a warm glow. This kind of portrait allows you to experiment, for example, with backlighting, special hair styling, or poses.

In portrait photography, you can take full advantage of digital photography's low image costs. If you do not have a studio lighting system, it might be helpful to go outside and shoot under an overcast sky. If the sun is shining, find a shady place to work and use a reflector to bounce the sunlight onto your subject, or use a fill-in flash. You want well-illuminated images without harsh shadows from the sun or the flattened features caused by direct flash. Daylight also prevents the red-eye effect of on-camera flash

units. If some shadows are still visible, you can retouch or blur them during image editing.

If you position your subject into a profile view, you should leave some space next to the person in the direction of his sight. In the image with the smoker (below), this space is also needed for the smoke.

Image of a "Topping Out" ceremony – his job title is clear.

In addition to the often-used head shot, there are numerous other types of portraits: a half-length portrait from the front or the side, seated at a desk, or with an instrument while making music; a ¾ or full length portrait; or a picture taken in the typical work or leisure environment. Generally, these images need a little preparation and time to wait for the right conditions. However, the lively and interesting images you can create are well worth the effort.

Memorable portraits can also be made with a telephoto lens from a distance, whenever the person is completely unaware of the camera: at parties; on excursions; at work; while exercising or talking, resting, or thinking. Including a little bit of the environment provides the setting or mood for the image. Distracting elements can be blurred or removed during image editing with a Gaussian blur filter.

Portraits shown in context are often more interesting, for example, if you include the hard hat of a construction worker. But interest could be invited by be a simple smile, or particular gesture, or the slight smoke of a cigarillo – as shown in the picture to the right.

When shooting people in profile, leave enough space in the direction of their gaze.

Skin colors are critical in portraits. They are also called *memory colors*, because these colors are engraved in our mind. While performing image corrections it is, therefore, essential to subordinate how other colors look to the correct skin color. When you have your images printed at a professional lab, the skin colors should be reproduced fairly accurately; however, this is not always the case when you print your images on a normal 4-color inkjet printer. Photo quality inkjet printers with 6 or 7 colors, which include light-cyan and light-magenta and possibly light-gray, instead of the standard 4 inks, can reproduce skin colors much more accurately. If harsh lighting rendered the subject's face too red, you can correct the color temperature and also reduce the color saturation* slightly (approximately 5%) during image editing. Generally, it can be helpful to add some blue and reduce the red tones; this can be done through the dialog box called *color balance*.** Keep also in mind, that skin colors may vary strongly according to culture and race. In addition, the colors preferred by those being photographed

This image was created with a spot light and a 400 mm telephoto lens.

* Also see section 5.8.2, page 172.

** Also see section 5.8.1, page 170.

change along with the culture and the race. While most Caucasians now-adays prefer a healthy looking sun tan, most Asians prefer whiter skin.

4.2.2 Images of Children

Children are ideal subjects for photography, and even less-than-perfect images are always welcomed by parents, grandparents and aunts. Children are not always easy to photograph, though, because at certain ages, they may become rather camera shy, and may try to avoid the attention by grimacing or hiding. Younger children often are less shy and may pose with joy.

Most of what we described for portraits above is also true for children's images, i.e., the face or at least the eyes should be in sharp focus. Eye level with the child is the best vantage point for the camera. Using a telephoto lens allows you to keep some distance, which helps the child stay natural. Again, it is important to show the child as frame-filling as possible in the image.

① Children at play always make engaging subjects.

Give yourself and the child enough time. Wait until the child forgets about you (as photographer) and becomes immersed in play, or take the picture from an unob-served location. These are usually the best images.

It also could be beneficial to talk to the child while taking the pictures. Of course, this requires a high degree of concentration on the photographer's part, who must be able to carry a conversation while photographing. This discussion can also be led by a second person, so the photographer can concentrate on shooting. Show the pictures you take to the child, as it will build trust for further photographs. If the child starts to pose during the ses-sion, it could be beneficial. However, the poses often will look very un-natural. You may just shoot a few frames (which you may discard later on) and wait until the child is be-having naturally again.

It is easier to shoot images un-observed from within a group. This is possible at parties, for example, where the image of the little girl

② Often you can get color-intensive images of small children.

③ Soft, pastel colors complement young children with delicate skin tones.

④ In an undisturbed moment.

(figure ④ on page 86) was captured. Outdoors, it can help to use a fill-in flash to create suitable lighting conditions or to avoid harsh shadows caused by the sun. The flash should be used from a little bit of distance (about 6 to 10 feet).

Generally, it is best to avoid flash while taking pictures of children – their soft contours could become too hard-looking, and a flash often spoils carefree moments. If, however, you have to use flash, try to soften the light by using a soft-bounce cap or tilting your flash towards the ceiling or a white wall. This bounces indirect light on your subject's face and also helps to avoid red eyes.

4.2.3 Group Photos

The challenge of group photographs is that they should not appear as staged and unnatural. Typical situations for group photos are at school, birthday parties, weddings, or company picnics. There is not much to say about posed groups like these examples, except that it is very difficult to get every person to look at the camera at the same time with a suitable expression.

One option is to take several frames and then, with some effort in your image editing program, combine the heads with the best expressions into one image – if you approve of image manipulation of this magnitude. This process allows you to exchange the head of Mrs. Peterson with closed eyes in one image, with the same head with open eyes from another image, in which Mr. Smith is grimacing.

On-camera flash is not suitable for larger groups – you have to shoot the group outside, with daylight, on stairs, so that everyone's head is visible in the image. You cannot shoot a group of this size up-close, because only some heads would be sharply focused and the people on the top stairs would be shown too much from below. In this case, using a telephoto lens is ideal, especially with zoom, so you can change the cropping on the fly without having to change your vantage point. Focus on the middle row, or slightly beyond, to maximize depth of field in larger groups.

⑤ *Group photograph of "my three girls" (my wife and my two daughters).*

⑥ *It is rare to find such discipline in large groups.*

The fall-off of light on the people in the last rows in the group photo (see photo ⑥ on page 87) can hardly be avoided in such a scenario, not even with flash. In this example, the faces of the people in the last rows were lightened slightly during image editing.

Using flash is problematic, even in smaller groups, where people are located at different distances to the camera. The people in the front receive too much light, and the ones in the back, due to light fall-off, receive too little. If you bounce the flash off a ceiling, you can get better results, but you need a flash that can be tilted up, and that is stronger than the built-in flash units in most digital cameras.

With some patience, more interesting images can be made, for example, when you take your time at a party and use a light telephoto lens to photograph small groups from a distance, preferably without being noticed. It is perfectly acceptable if additional people are located in the blurry foreground, which bestows authenticity and a certain atmosphere to the image.

Images of people in action are always more lively than images of posed subjects.

Even more interesting are images of small groups in action, at a competition, while swimming, dancing, or playing music together. You can observe tension and expressiveness in their faces, which results in images that are much more natural than posed group shots.

A variation of a group photograph is the family portrait. In addition to their expressiveness, they also have sentimental value, which increases over the years. Unfortunately, family portraits appear mostly posed. Therefore, it is important that the photographer directs his subjects, and controls the lighting and the composition to produce an expressive image. Two persons standing stiffly side-by-side appear dull, while hugging (or fighting) siblings create a lively image. A zoom lens is advantageous here for last minute compositional changes.

Shooting outside under overcast sky, in the shade, or inside near a bright window creates the best lighting conditions. If you have to use flash, move backwards slightly (about 6 to 10 feet) and use a higher zoom factor (longer focal length) to show the subject filling the frame, with as little background as possible. Make sure the person has adequate distance to the background to minimize harsh flash shadows in the image.

Group, shot from behind (under an overcast sky)

Captured in the shade, on a bright day.

4.3 **Animal Photography**

Animals are more elaborate models for the aspiring photographer, but equipped with adequate patience, you can get some very interesting pictures. Many aspects of animal photography correspond to portrait photography principles. The head is the most important part and must be in focus. As is the case with portraits, the eyes need to be in sharp focus. Photographing animals at their eye level is a good starting position for the camera.

Ideally the animal will cover more than 20 % of the image area – if suitable. Here, less is better.

Similar to portraits, it is also advantageous to separate the animal from the background by using a shallow depth of field, which is also useful for capturing zoo animals without letting the cage dominate the image. You can also blur the background in your image editing program at home. If you have to shoot through glass, it is best to place the camera as close to the glass as possible to minimize reflections.

Wait to take the picture until the animal turns its head to you or shows its profile. And of course, keep a safe distance!

Getting good animal pictures takes substantial patience, and some luck.

Learn a little bit about the character and the habits of the animals you want to photograph.* Try to capture the animal in its native environment in typical positions or movements. The image of the hummingbird is a excellent example.

* *Many animals, especially wild animals, do not want to make eye contact, and feel disturbed, or even attacked by it. Eye contact may be considered as a provocation and should be avoided.*

The distance needed for photographing animals is usually larger than that for photographing people. For wild animals, you will need a telephoto lens with very long focal length; 250–600 mm (in small film format) are the lowest practical focal lengths. For birds you usually need 600 mm or even more. The photographer was wise to keep his distance to the grizzly bear with cubs in the wilderness by using a 600 mm lens.

If the focal length in itself is not large enough, it also helps to shoot at the highest resolution, because it can give you some leeway for enlarging and cropping the subject later during editing.

Hunting is a typical behavior for wild animals, but also one of the most difficult to capture on film. These challenging shots take extensive preparation, a well-hidden camera, and very long focal length, and it belongs primarily in the domain of professional photographers.

It is recommended to keep a healthy distance when photographing wild animals.

The eyes of the animals should be in focus – even if they are closed as in this photo.

You can practice photographing animals in the zoo, without extensive preparations, and without extra long focal length lenses. Using an open aperture (small aperture value) helps to blur fences and enclosures in the background. Using flash is rarely possible and is often prohibited in zoos. Therefore, you are dependent on the current lighting conditions, your own planning, patience, and luck.

It is even more advantageous to photograph pets, because you can move up close, and you might find that appreciative owners make good customers for your photographs. Cats are ideal pets to start practicing with, because they are cute, have expressive facial features, and need long recovery periods in photogenic positions, when you can even take closeups of their faces. Just as with children's images, you can capture more lively and interesting pictures if you photograph animals while they are playing.

The look: Where is my food?

For cats – and many other animals – the details in the fur are well worth the effort of making a careful exposure or perhaps even an exposure series with several different shutter speeds or aperture values.

Full body shots of animals with black fur are exceptionally difficult. They require strong light and good light reflections on the fur to produce usable (not flat) results.

Sleeping cats provide the chance to capture images characteristic of their kind even without telephoto lenses, although the eye contact will be missing.

At times you have to break the rules for certain images – for example, of photographing at eye level with the subject – cat lovers have experienced many times the reproachful gaze upward if food is not given instantly.

With a little patience – a mainstay of nature photography – you can also create interesting images of small animals, for example, of the birds in an aviary, or in your neighborhood.

Using a high zoom factor or a high resolution, which allows you to make enlargements of small image areas, you can even compose interesting images of small insects, such as the dragon fly, to the right, the caterpillar, on page 89, or the bumble bee, on page 103, which was captured with a macro auxiliary lens. The dragonfly here was shot using a bridge-camera with tele-lens-setting of about 140 mm.

Animals can be photographed in front of the front door.

4.4 **Landscape Photography**

Landscape images belong in the standard repertoire of vacation pictures. There are three essential aspects to a striking landscape photograph:

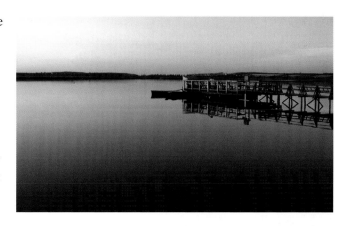

▸ The right vantage point
▸ The right cropping
▸ The right light

All these aspects require patience and perseverance – for the right lighting conditions you may need even more patience, or you may have to get up extra early. Walking around a little bit or climbing to higher locations can often open an unobstructed view over the landscape.

While a slightly wide-angle lens is a suitable choice for landscape pictures, some situations can benefit from a telephoto lens, for example, capturing a village from a distant hill or visually shortening the distance from rocks to the ocean.

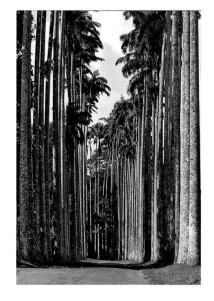

Make sure that the horizon is perfectly horizontal in your image, so it does not have to be repositioned during image editing. Tilted ocean horizons are especially distracting. Carefully position the sky in your image. If it is covered with clouds or colors, it can occupy more than half of the image frame; if it is monotonous, a quarter of the image area is sufficient. If the sky is quite bright, which often is the case with bright sun light, it is often best to have as little sky in your photo as possible.

Landscape images do not have to be shot horizontally. Square or vertical formats may be as appropriate and strong lines such as deep blue rivers or streets can provide depth to the image, because they draw the eye of the viewer into the space of the picture.

One special technique uses panorama images, which is described in section 4.11 on page 105. Panoramas show a wide portion of the landscape and do not require special camera techniques or dealing with the distortions of extremely wide-angle lenses.

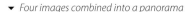

◂ *Four images combined into a panorama*

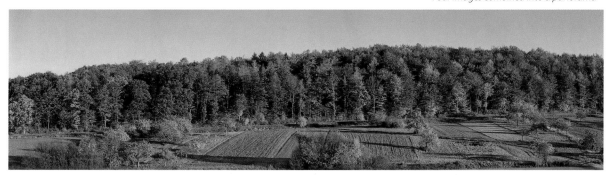

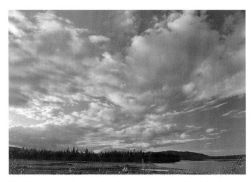

① *The expense of the landscape is emphasized by the large sky.*

② *The polarizing filter could not cover the wide angle of the lens, leading to strong blue striations in the sky.*

③ *Captured early in the morning.*

→ *Landscape images are only impressive at a certain size. Therefore, make sure not to choose a presentation method that shows the images in miniature.*

A tripod is a prerequisite, which is of benefit to landscape photography at any rate, because it allows you to work with longer shutter speeds and, therefore, smaller apertures and a larger depth of field.

If the sun is very bright, it is recommended that you use a UV filter. Colors will glow more and be more saturated, while the gray cast of the UV light will be reduced slightly. At the same time, it protects the lens from dust and dirt. If the sun is not directly behind you, or if the sky is not overcast, lens hoods can prevent lens flare (sun reflections on the lens).

If it is a very bright day, you can use a polarizing filter – it reduces the light intensity by one to two exposure stops. It can not only remove reflections on water, but also increase the contrast of clouds at the right angle to the direction of light. To get good results, you may need to experiment with different angles of polarization. In very bright snow landscapes, the polarizing filter's light-reducing action is quite welcome.

In wide-angle images – beginning at about 28 mm (small film format) – the polarizer does not cover the entire image evenly anymore. The blue of the sky shows different color tones, as shown in image ②.

You can create depth in the image by including objects in the foreground – for example people, parts of buildings, plants, or trees, which can be slightly blurry.

The best light for landscape photography is in the summer, until about 9:00 a.m., and in the late afternoon, after 4:00 p.m., and before sunset. Around noon, the shadows are usually harsh, and the landscape and the light seem flat, and the colors appear lifeless (not saturated).

Clear winter days, especially in the morning, offer excellent opportunities as long as pastel colors still dominate the scene. You may find frosty meadows or fog banks to photograph. Landscapes are especially well suited to capturing different moods. You rarely have to perform a color temperature correction (see page 49) while photographing outdoors. Even when the lighting conditions are unusual, you can keep the color cast in the image. If needed, you can always make changes during image editing.

While capturing the sunrise or sunset, you want to emphasize the light of the horizon; therefore, you will have to measure your exposure of the horizon and not on the dark foreground elements. Often, we specifically want to create a high contrast silhouette effect. Evaluative metering is not the best choice for this type of photograph; a center-weighted averaged metering yields better results if you take a meter reading of the light areas of the horizon.

4.5 **Sports Photography**

The digital camera has been capturing the sports photography market – especially for newspapers and magazines. The brief processing time needed, and the fact that images can be sent quickly to the editorial department via either laptop or cell phone, are strong arguments for using this option. In addition, the focal length multiplication factor, which is common in the current DSLRs, helps with the need for long focal length in sports photography.

This dynamic image is created by movement and motion blur while panning the camera at 1/60 second.

A disadvantage in this situation is the shutter lag of digital cameras and the shorter image sequence possible due to the added time the camera needs to process and store the digital images. However, every new digital camera generation shows improvements in both of these areas. Also, memory cards with very high capacities allow you to shoot many images without changing film or media – as long as the batteries last.

Elite sports photography is, just like animal photography in nature, part of the domain of professional photographers with elaborate equipment. With more humble requirements, you can create exciting images, even with normal equipment, as the images on this page illustrates. You just have to prepare for them carefully.

A lucky shot with a digital camera (with flash).

In sports photography, it is essential to freeze the motion and still show dynamic movement. You need to use short shutter speeds (\leq ¹/₁₂₅ second). If you pan the camera with the direction of movement, you can compensate a little for the motion and use a longer shutter speed. Usually, you have to set a medium to long telephoto setting. You can set the focus manually or focus on the intended arrival point and press the shutter button halfway to freeze the focus, because the auto-focus mechanism has trouble focusing on fast-moving objects. Only newer and more expensive cameras offer a special focusing mode that can follow the movements of the subject.

A flash can be used to improve the light situation, up to a distance of approximately 30 feet – as long as it does not bother the athlete. However, the internal flash of the camera is not sufficient for this purpose,* and you will need to use a strong external flash unit.

** The internal flash of the camera normally only covers 6–10 feet.*

Image on the left: A carriage race on the "Manitoba Stampede"

4.6 Architectural Photography

Architectural images are demanding and difficult to produce for the amateur photographer; even few professionals embrace the subject. Those who do use special camera techniques – generally, medium or large format cameras with lenses that have the capability to tilt the plane of the lens to compensate for perspective distortion. The distortions occur when photographing large objects from a close and low vantage point.

① *Taking the image from a larger distance avoids perspective distortion in architectural images.*

Finding a high camera position, for example on one of the top floors of a neighboring building, can compensate for perspective distortion in images of buildings. If there is enough room in front of the building, the image can be improved by moving further away, while using a telephoto setting, as in figure ①. These methods result in fewer distortions.

② *Perspective distortion caused by a wide-angle lens and a close vantage point.*

③ *The perspective distortion was corrected during image editing with the "Transform ▸ Perspective" command.*

The perspective distortion (see figure ②) can be evened out with some effort during image editing by using *Perspective* under the *Transform* menu, as in figure ③ (see section 5.13.8, page 196). If you plan on reducing the perspective distortion on the computer, you should leave enough space around the object in your image so that you can crop it appropriately afterwards (in figure ③, the space of the streetlamp was lost).

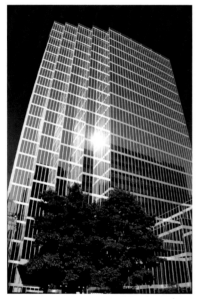

④ *A slight barrel effect caused by a wide-angle lens.*

Another disadvantage that can occur with wide-angle lenses (below approximately 35 mm) are bottle ☐ or barrel ☐ effects, as figure ④ shows, in which the middle of the building seems to be protruding. They can be corrected as well, during image editing, however, you will need special filters. Some image editing programs already contain the filters – such as Paint Shop Pro, starting in version 8.0 and Photoshop CS2/CS3. Figure ④ was corrected with the free Photoshop plug-in filter, "*Lens Distortion Corrector*" by Richard Rosenman [114], and the result is shown in figure ⑥ on page 95. Alternatively, you could use the standard Photoshop filter Lens Correction (which can be found under Filter ▸ Distort).

Pure perspective distortion can also be used to convey your own point of view. The converging lines in figure ⑥ enhance the impression of height, supported by the reflection of the neighboring building.

As an amateur photographer, you can choose unusual perspectives and record your subjective impressions and points of view, in which you can specifically use the concept of perspective distortion.

Instead of composing your images with complete buildings, you can also take pictures of interesting architectural details, such as the "demon's face" on the cathedral in Strasbourg (see figure ⑤).

⑤ *Figure on the cathedral of Strasbourg.*

Modern glass and aluminum facades offer great opportunities for capturing light impressions and reflections at the right time of day – a phenomenon also planned by architects. The effects grant buildings their own esthetic value, which should be captured.

Thus, many beautiful and colorful detail images can be created, such as the detail of the glass roof of the train station at the Frankfurt airport (figure ⑦), photographed from the platform.

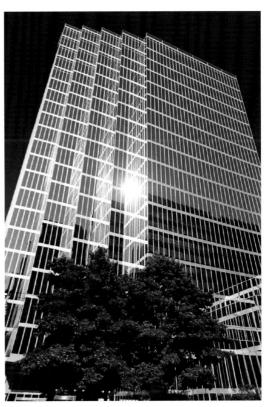

⑥ *Image after correcting it with the filter, "Lens Distortion Corrector" (see [73]).*

⑦ *When shooting inside a building, here it is the railway station at Frankfurt airport (Germany), you may have to obtain permission of the owner to do so.*

⑧ *If the people are distracting to your eye, you can remove them using an image editing program.*

As is the case in landscape photography, morning and evening hours are the best for architectural images. Especially during the early morning hours, the image will be less disturbed by passing traffic or pedestrians. Even images captured at night can be interesting, especially if the inner lighting competes with the last light of the day.

Passing pedestrians or cars can be distracting in many architectural pictures. One solution is to shoot several images and collage them together in a way that covers the distracting elements. The people in figure ⑧ could also be removed with the clone stamp tool (see section 5.13, page 186).

You can see, after a perhaps skeptical view of architectural photography, that there are many interesting images that can be produced. In addition, architectural details lend themselves to collections, such as doors, windows, archways, entrances, or reflections.

⑨ *Modern architecture can make impressive images. (Hypo Vereinsbank at Munich). In this image I had to correct a slight barrel distortion caused by the wide-angle lens I used and its imperfections.*

4.7 Light, Shadows, and Reflections

Photography is the interaction between perspective and light. Therefore, photographing special lighting conditions, shadows, and reflections, offers creative opportunities for pictures. To this end, you need to train your eyes to see these situations, but once you do, you have numerous options, even within your habitual environment. Such images will, generally, come across as more artistic, rather than documentary.

① *Play with shadows.*

Included in the play of light are reflections. Landscape images with diagonal falling light (morning or evening light) and still water communicate a strong sense of tranquility. Stillness is further emphasized by the symmetry of the landscape, and its reflection on the water. The reflection can be the main subject of the image and only show the original subject suggestively, as shown in figure ③.

If you photograph an object reflected in a mirror or another reflecting surface, it is important to focus on the surface of the mirror and not on the reflected object. Additionally, you will want to avoid being seen in the picture yourself, so you will have to find the right angle from which to shoot. An angle of about 45 degrees is, generally, favorable to avoid casting shadows on your subject. Remember to take into account the light from your flash in the mirror, as well.

② *Taken at a 45 degree angle to the mirror.*

A flash was used in figure ②, but at an angle of approximately 45 degrees, so that neither the flash nor the camera is visible in the mirror. The flash lights the child from the side, as well as the front, by bouncing off the mirror.

Backlighting situations are quite intriguing to explore while playing with light. The light can be used to create interesting light streaks (light rays that differ from the color of the sky), to produce high contrast silhouettes, colors, or reflections: i.e., the rays of the sun through leaves, or light reflections of dewdrops on plants (see the image of the fern on page 119).

You may have to search a little and develop an eye for capturing situations like this one. At times you may also have to crouch down or stretch yourself a bit.

In almost all the scenarios described here, the optimal exposure is not clear-cut. The camera's auto mode also does not always do justice to these special circumstances. Therefore, you should experiment and try to think in terms of finished images. Take several images at different exposures (bracketing). The image with the best exposure can be determined much easier on the computer screen than on the small camera display. However, a quick look at the histogram will tell you if your exposures are in an acceptable range. Only semi-professional and professional DSLR model cameras offer histograms (the marking of overexposed details), but this feature will step down to bridge cameras and prosumer cameras as well.

On the other hand, reflections are not always desirable. The photographer rarely wants to see himself in his images. Therefore, the direction of the light

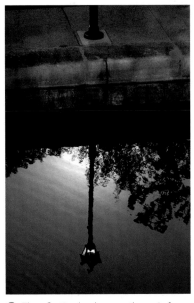

③ *The reflection has become the main focus.*

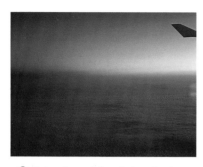

④ *Dawn, through the window of a plane. The camera was placed right on the glass of the window, and the lighting from inside the plane was blocked by the photographer's body. However, slight striations remain (i.e., on the right).*

needs to be taken into account as well as the angle of the light to the reflecting surface. If the reflection of the photographer is unavoidable, it is best to be dressed in black, which does not show up as well in the image.

A change in position, and therefore, a different angle of light, can reduce or strengthen reflections.

If you photograph through glass – for example at the zoo – it is also possible to see your own reflection, as well as light from behind, reflected in your images. You can reduce these effects by positioning the camera as close as possible to the glass, and using your own body to shield the camera from the light behind you. You may have to focus manually, because the autofocus mode may focus on the glass instead of the object, especially if the glass is scratched or stained.

A polarizing filter can reduce reflections significantly (see the example on page 30). Unfortunately polarizing filters do not work with metallic surfaces. The effect is strongest if the light comes predominantly from one direction. The optimal setting is determined by twisting the polarizing filter.

Reflections from side lighting are also not desirable. They either cause lens flare or a flat image. This effect is more pronounced if the glass area of the lens is larger, as in wide-angle, or fisheye lenses. The easiest solution is to use a lens hood. However, with wide-angle lenses or zoom lenses in the wide-angle setting, it is important to make sure that the lens hood does not cast dark shadows into the image. If you do not have a lens hood available, you can use your own body to shade your lens.

At times, you may want to have some reflections in your picture (see the example on page 63 (bottom). They can also be added during image editing, with the appropriate lighting filter, which is a much more controlled method.

Strong Lighting Contrasts

Evaluative metering does not give sufficient results in situations with strong lighting contrasts. Spot metering or center-weighted averaged metering are better methods for determining exposure. Point the middle of your camera's viewfinder to either the dark or light image areas to determine the area you would like as a basis for metering. Metering off the lighter sky created the mood and the dark tree silhouettes in figure ⑤.

⑤ *The exposure was taken off the sky to create the silhouettes of the trees, and maintain the contrast.*

→ *The image sensor may be damaged while photographing into the sun, or even into strong light sources. You may need to use a strong gray filter to reduce the light intensity.*

In the image with the shadows (figure ①, page 97), it was important that the figures show some detail. Therefore, the exposure was taken off the figures, which caused the details of the column to be lost. However, this loss is acceptable, because the shadows show enough detail.

In strong lighting conditions, it may be necessary to use a neutral gray filter, which reduces the light intensity by 2–6 exposure stops. The neutral gray filter will prevent the image from being overexposed if your camera's lacks a fast enough shutter speed. Because the exposure of images with strong contrasts is always a little bit problematic, bracket your shots with

different exposures, for example using -1, 0, and +1 exposure stops. You may even want to sandwich parts of all three different exposures together into one new, perfectly exposed image. In general, it is better to slightly underexpose, rather than overexpose, because a slight underexposure can be corrected fairly easily during the image editing process.

4.8 Night Photography

Images taken at twilight or during the night can turn out beautifully with a little preparation. Due to the long shutter speeds, you will need to use a tripod, or at least have a sturdy support. If a tripod is not available, you can use a wall or bench as a support. If exposing for more than two seconds you should activate the camera's noise reduction feature, if available. The flash can only cover a relatively small foreground area. If you also want to include the background, you need to activate the flash, and at the same time, set a longer exposure, if possible, which is noted as a slow flash synchronization (⚡ Slow). Some cameras label this feature with the moon symbol ⌴.

① Shot with a tripod at aperture f/2.8, 1/30 sec, ISO 320.

For image effects like those in figure ①, you explicitly deactivate the flash (or don't flip it up). In addition, the ISO setting is increased to the maximum and the noise reduction feature is turned on. However, keep in mind, that a high ISO setting will increase the noise in your image. The proper ISO setting depends very much on your camera and its sensor (and how much noise you are willing to accept). Newer APS-C and full-frame cameras allow for higher ISO settings as their sensors get better from year to year. With compact cameras, however, the increase in pixel resolution counteracts these improvements.

Some cameras have problems focusing at night, therefore you may have to focus manually, or switch the mode to landscape ⌂, which automatically sets the focus (almost) to infinity.

For the fireworks in figure ② we used an exposure of ¹⁄₁₀ second to capture the light of several rockets.

Camera metering modes do not work optimally at night. Lighter objects often end up overexposed. Therefore, you may have to correct the exposure down by 1–2 stops, and preferably bracket. The choice of the best image can then take place on the computer screen.

Figure ③ was taken during evening twilight, which can be seen in the color of the sky. A tripod was used and the image was exposed at ¹⁄₁₅ second at ᶠ/2.8. The camera's light meter setting was corrected down by 1 exposure stop.

② 120 mm, ISO 200, f/4, 1/10 sec, tripod

③ 35 mm, ISO 200, f/2.8, 1/15 sec, tripod

④ *We used direct flash and corrected red-eye during image editing. We held wax paper over the flash head to get the effect of a softer, more diffuse light at the very short distance of about 5 feet.*

➜ *Moreover, the internal camera flash uses a lot of battery power. You should consider this while planning your battery backups.*

➜ *Even though the camera regulates the internal flash, using it below 4 feet can be problematic, and can overexpose objects located very close to the camera.*

▲ ⑤ *Direct flash causes red-eye in people, and a yellow reflection in animals.*

▼ ⑥ *The image below was corrected with an image editing program.*

4.9 Flash Photography

In normal circumstances, the best flash is the one you do not use. Many compact cameras with integrated flash are programmed to use flash in low light conditions, which often results in washed-out image areas or reflected objects, especially in the foreground. To prevent overexposure, you have to manually turn off the flash unit – or at least decrease the flash intensity when shooting at close distance. Using flash correctly requires significant experience. However, a digital camera's low cost per image allows you inexpensive lessons.

An essential advantage of flash is that it delivers light with a color temperature of 6500 K, or neutral daylight.

Almost all compact cameras come with an integrated flash, but they have disadvantages. The smaller and more compact the camera is, the smaller and weaker the flash will be. Its reach is very limited, up to about 8–10 feet for an even illumination of the subject. It can be used much more often, and with much better results, as a fill-in flash in moderate lighting conditions, or under overcast sky for subjects in the range of 6–20 feet.

Another disadvantage of a built-in flash is that it can only fire to the front, and therefore produces a flat, expressionless light on the subject. Because the light of the flash diminishes with distance, you can get images that may be slightly overexposed in the foreground and underexposed in areas located further from the camera. Additional lights – for example the ambient lighting of the room, or an additional light – can reduce this effect significantly.

Red-Eye Effect • A flash located near the axis of the lens can easily cause red eyes in your subjects, especially if they look directly into the camera. The effect occurs because the blood-rich retina at the back of the eye becomes visible when the pupil is open and direct flash is used. Animals may have light-yellow or even white eyes instead of red, because they strongly reflect the light (figure ⑤).

While the red-eye effect in people can be fixed fairly easily (see section 5.13.9 on page 200), the effect on the large eyes of a horse are more difficult to correct. One option is to copy the eyes from a picture of a horse without red-eye and place them in your image. Another way is to use selective color corrections on the animal's eyes only. Figure ⑥ shows the result.

In red-eye situations, it might help to activate the red-eye flash (◎) of the camera. The camera sends several low intensity pre-flashes that, ideally, cause the pupils to contract, and avoid or reduce the red-eye effect. Another alternative is to increase the ambient lighting in the room, so that the pupil is smaller to begin with. It is best to use an off-camera or indirect flash.

The pre-flash has the disadvantage that you cannot take surprise shots, because the series of low intensity flashes warns the subject of your intention.

Reflections • Using flash lighting can cause undesirable reflections, especially when the light strikes a reflecting surface, such as glass, at a steep angle (in this case, from the front). A shallow angle is better. This technique was used in figure ② on page 97.

Flash Programs • Cameras almost always offer several flash programs, depending on the configuration of the camera. Although the symbols can look slightly different in various camera models, internal flash usually offers four options:

▸ Flash turned off (⚡; perhaps fold in the flash.)*
▸ Active flash (⚡ flashes if the light level is low; you may have to flip up the flash unit)
▸ Flash turned on (even if the camera's auto-mode would not consider it necessary)
▸ Flash with pre-flash (◎ to prevent red-eye effect)

In addition, some camera models offer the following program modes:

▸ Flash synchronization with long shutter speeds (⚡ Slow)
▸ Flash synchronization with long shutter speeds and pre-flash (⚡◎ Slow)
▸ Rear-curtain flash synchronization (⚡ Slow, rear curtain)

The shutter speed synchronization for flash is normally ¹⁄₁₂₅ or ¹⁄₂₅₀ second, or even shorter for some DSLR cameras. For flash with long shutter speeds the shutter stays open longer, and the flash acts as additional light to the ambient lighting. This method allows you to not only capture the foreground area with the flash lighting, but also include elements in the background. It is useful for night photography if you want to include more of the environment in your picture. The flash acts more as a fill-in flash than as the sole light source in the image.

Rear-curtain flash synchronization causes the flash to fire just before the shutter closes. It is used if you want to work with long shutter speeds and capture movements from behind (i.e., a car). In figure ⑧, you can see slightly streaking rear lights, while the car is almost sharp.

Most of the time, it makes sense to use normal flash synchronization, which automatically synchronizes the flash to fire when the shutter first opens (*front-curtain flash synchronization*). It is more appropriate for moving objects because you, generally, focus on the starting position of their movement.

Flash Guide Number • The guide number of a flash gives information about its strength, or how far it reaches. The higher the guide number is, the stronger the flash. Here is an easy formula: $aperture = \frac{guide\ number}{distance}$. This formula is valid at a film or sensor sensitivity of ISO 100, with a standard lens (50 mm small film format), and a distance measured in either yards or meters. If the guide number is 80 feet, for example, at a distance of 20 feet, the aperture value would be ᶠ⁄₄ at an ISO of 100 (or aperture ᶠ⁄₈ at ISO 200).

*

⑦ *Front curtain flash (slow, front curtain)*

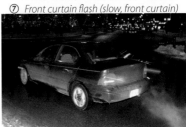
⑧ *Rear curtain flash (slow, rear curtain)*

$$aperture = \frac{guide\ number}{distance} \times \frac{ISO\ value}{100}$$

$$distance = \frac{guide\ number}{aperture} \times \frac{ISO\ value}{100}$$

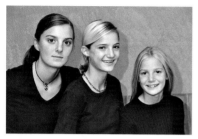

⑨ *Image taken with direct and indirect flash bounced off a white ceiling. The shadows in the background can be reduced during image editing.*

→ *When buying a flash, make sure that the flash head can be tilted horizontally as well as vertically.*

If the flash can be focused, which is only possible with a separate flash unit, it can reach further at the same strength. If camera and flash are synchronized, you do not have to carry out these calculations, because the camera will take care of it. A rough estimate is still useful though to assess if the flash is sufficient for the desired distance. Many flash units display a table or dial on their backside for guide number calculations.

Separate flash units that come with a flash head can be tilted to the ceiling or to a white wall, creating softer and more diffuse lighting with moderate or no shadows. Be aware, though, that colored walls and ceilings reflect less light and create a color cast in your image.

In individual cases it may also be helpful to hold a white piece of paper at an angle in front of the flash to deflect the light to a light colored ceiling or wall, and obtain indirect light.

Many digital cameras in the middle and upper price range feature external flash connectors such as flash cables and hot shoes. A flash bracket, on which camera and flash are mounted, can help, but can be bulky. The larger distance between the axis of the lens and the flash reduces the red-eye effect.

Cameras that feature an external flash connection can also be used with two flashes: the internal one, and an additional external flash (for example used indirectly).

If the camera does not feature an external flash connection, you can use an external *slave flash* unit. These are external flash units that are not triggered by a cable connection, but by a light signal from the camera's internal flash. A good flash unit lacking this function can easily be upgraded with a small slave unit. The external flash unit is attached to the slave unit, which accepts the light signal, and triggers the flash.

Through the Lens (TTL) flash units offer the best camera-to-flash integration and synchronize the amount of light with the camera. With TTL flash units the amount of light output is controlled through the camera meter. However, these units are usually offered only with the higher priced, larger camera models, and they can be quite costly. A number of third-party manufacturers offer more affordable flash units, which can be fitted to many different camera models using an adapter.

All other solutions require the calculation of flash guide numbers, distances, and aperture settings; and the flash must be set manually. In many cases, the amateur can get away with a little experimentation, especially since the result can be checked on the camera display immediately, and bad images can be deleted on the spot.

You can manually focus the light beam of higher quality external flash units to change the length of their reach, which is advantageous for telephoto images. For wide-angle images, use a scattering filter (which is often part of a flash set) to scatter the light. A scattering filter also creates a more diffuse light for images shot at normal focal length, renders shadows softer, but reduces the reach of the flash.

Elaborate studio flash heads, and complete lighting systems with flash, spotlights, and reflectors (such as umbrellas) are used in professional photography. The costs of these systems quickly break the budget of amateur photographers.

A studio flash is rarely needed by the amateur. If you do need a special lighting setup occasionally, it is cheaper to rent one or to take the image to a professional studio.

Alternatives • In closed rooms you have a number of alternatives to using flash, especially when you are photographing an arranged setup. Sections 4.12–4.13 introduce some of these options.

When you mix light from different sources, setting the white balance can be tricky because the internal white balance of the camera can be overwhelmed by too many light sources. If the camera allows you to set the white balance manually, you can adjust it to the most dominant light source. Experimentation often yields successful results.

Another alternative to flash is to use the higher sensitivities of the image sensor, which are getting better with newer camera models. Some cameras now offer settings up to ISO 6400, but you will see dramatic differences between low-cost and expensive models. However, you will have to live with more noise in your images.

This studio flash system (by Hensel) costs about $500 new.

4.10 **Closeup or Macro Photography**

Compact digital cameras are limited in their telephoto capabilities. Telephoto lenses, or telephoto auxiliary lenses, are only available for expensive models. However, most of them feature a surprisingly short minimum focusing distance – some will go as low as 0.8"–4". Generally you will have to activate a special macro mode (❀) to access this feature.

Closeup and macro photography open up completely new fields in photography; be it documentation of collections, such as coins, stamps, insects, other small animals, or details of buildings, bodies, flowers, or structures.

If the minimal focusing distance of the camera is not sufficient for your purposes, and your camera has a filter thread on its lens, you can add relatively inexpensive macro filters. A few companies offer a set of three to four macro auxiliary lenses with different diopters that can be combined. They come in a compact box for about $50. They do not deliver the same distortion-free quality as do true macro lenses, or extension tubes, but are sufficient for many images. They are available in different diameters.

When photographing animals, it is better use telephoto settings, perhaps in combination with macro filters. In keeping your distance from an animal, you do not disturb or confuse him, and you take care of your own safety at the same time.

① *Classic closeup image using an auxiliary lens with +2 diopters.*

② *In macro photography you must choose the plane of focus carefully.*

→ *A magnification ratio of 1:2 means that the photographed object is half as large as in nature.*

** *Also note that you can use a lens from another camera as the 2nd lens; because it is connected with an adapter, neither the diameter nor the camera mount need to match.*

③ *Closeup image during the day with fill-in flash.*

The autofocus mechanism is not often suitable for macro photography in most cases. It is better to focus manually – as long as your camera offers this feature. Alternatively, you can lock in the focus on the lens, and then fine-tune the focus by moving the camera slightly forward or backward. You can check the focus via the viewfinder with DSLRs, and on the display with compact cameras. The depth of field of macro images is very small. Therefore, you need to choose the plane of focus carefully. In figure ②, it was set at the dewdrop and leaf.

The high-quality DSLR cameras offer several options for closeup photography: you can use special macro, or even magnifying, lenses. These lenses will give the best results. You can also use the closeup filters already mentioned, although with a little more distortion. Another variation is extension tubes (between camera and lens) or bellows (in principle, bellows are adjustable extension tubes). When using bellows, you usually lose the auto aperture setting on your camera controls. An often less-expensive variation is adapter rings for reversing lenses. (Reversing rings are approximately $20 each.) They are attached to the lens mount on the camera, and the lens (which should be between 30–150 mm focal length) is attached to it in reverse. This setup delivers a respectable macro lens, but the camera's automatic aperture control cannot be used.

Another variation is to connect two lenses together – front-to-front – with a special adapter ring. The lens attached to the camera will be in normal position; the one attached to the front of this lens will be reversed. Again you cannot use automatic aperture control with this setup. The second lens (the reversed lens) should have a fixed focal length. The resulting magnification ratio is determined by $\frac{focal\ length\ of\ lens\ on\ camera}{focal\ length\ of\ 2nd\ lens}$, for example 35 mm/70 mm = 1:2. Again the second lens should have a fixed focal length (for better image quality) and should not be too heavy.[*]

The amount of light necessary for extremely closeup images can cause a problem. Because the depth of field is very small in macro photography, it is necessary to work with the smallest apertures (or largest aperture values) possible to increase the sharpness in the image. This requires an adequate amount of light. Additionally, if possible, you should work with a tripod or a support for your camera.

Below a distance of approximately 20, inches the built-in flash cannot be used effectively, because it either only partially lights the object in front of the lens due to its light direction, or it lights it too much. In the latter case you can help yourself by manually correcting the exposure down by 1–2 stops.

You can also tone down the flash with a filter, or a white handkerchief, held in front of the flash head, which can significantly improve the illumination. This technique creates the effect of a *softbox:* It diffuses the light and creates a soft lighting effect. You can also improve the lighting conditions by working with reflectors, which bounce the sunlight or the flash indirectly onto the subject. They also create desirably soft lighting. White cardboard, or a sheet of Styrofoam, can serve as a simple reflector, while

professional, store-bought reflectors go for about $40–60. An alternative to a flash is a bright lamp, i.e., a 50 W halogen lamp, placed a short distance from the object to be photographed.

An optimized ring flash, as is used in dental images, may be worthwhile if you do a considerable amount of macro photography.

Sometimes, for closeup photography, a simple flashlight (e.g., LED-based) or two can be used instead of a flash unit.

Macro images are more impressive the larger they are printed – letter size (8.5 × 11") is a good start for such a photo. This size emphasizes the magnified view into the small, and often unnoticed, world of the microcosm.

A well-illustrated explanation of macro photography can be found in the book Closeup Shooting *by Harnischmacher [5].*

4.11 Panoramas

There are special cameras for creating panoramas; however, they are rarely worth their cost, even for professional photographers, because panoramas can be made without specialty cameras, using a digital camera, a tripod, appropriate panorama software, and some patience. The panorama image is created from a sequence of single images that are stitched together. Accordingly, the software is called stitching software.

➡ *The subject of creating panoramas is multifaceted. Therefore we can only give a brief introduction here. You can find good information at www.panoguide.com*

Panoramas can be created with only a few images, or a 360 degree view can be stitched together with many images. For a 360-degree panorama you will need, depending on the focal length used, about 12 to 20 images. You need fewer images for the panorama if you use a fish-eye lens, but you will have to deal with perspective distortions at the seams between the images. You can even create spherical panoramas. They are much more difficult to produce and are, therefore, not covered in this book.

The field of panorama software is relatively large and covers a wide range of different purposes. One quite efficient free software for stitching panoramas called *Panorama-Tools* (provided by Helmut Dersch). The Software is available for Windows, Mac OS, and Linux, and there are Photoshop plug-ins as well. Panorama-Tools is operated using text commands, but *PTgui* [87] offers a java-based graphical user interface.

Many digital cameras come with simple panorama software. *Panorama Factory* [88] is another program available. Many image editing programs such as Photoshop, Photoshop Elements (under Photomerge) and some image cataloging software like Paint Shop Photo Album feature integrated (although simple) panorama modules.

A good introduction to creating panoramas can be found at Panorama Factory's website.*

Generally, panoramas are stitched together from a sequence of horizontally arranged images; but you can also create a vertical panorama to produce a high resolution image of a cathedral, or skyscraper. A composite image can also be created from several rows of images arranged above one another, but not all programs support this feature.

** see www.panoramafactory.com/ camera_setup/setup.html*

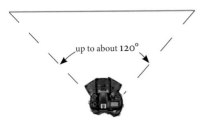

Planar Projection – ideal for landscapes up to 120 degrees.

** How you can find the nodal point of your camera and lens is explained at: http://en.wikipedia.org/wiki/Entrance_pupil*

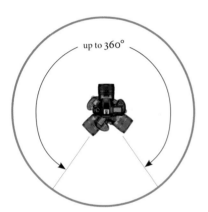

Cylindrical Projection – ideal for rooms and areas up to 360 degrees.

➜ You should avoid using flash for panorama images, because it leads to an uneven illumination throughout the panorama.

Panoramas can be distinguished into planar projections and cylindrical projections; the latter is used for all-around views and is best looked at with a special program in electronic format. Spherical panoramas are also called spherical projections. Another variation is an object that can be viewed from all sides, or that you can virtually walk around.

While taking the individual images for a panorama you should consider the following principles and techniques:

1. Ideally, the camera is rotated around its axis point, or the *entrance pupil* of the optical system, to avoid parallax error in panoramas (in photography this point is often mistakenly called the *nodal point.** This point lies between the lens and the sensor, and differs with the lens and the zoom factor. The camera needs to be attached to a bracket that allows this point to be placed directly above the pivot-point of the tripod head. When photographing panoramas and buildings that are located further away from the camera (beyond roughly 25 feet), mistakes due to the parallax error are so slight, however, that this expense is not necessary.

2. Use a tripod for the photographs. Make sure that the camera is horizontal (the tripod head should be exactly level). It is ideal if the tripod head has a built-in level, or you can set a specialty small level on the hot-shoe of the camera.

3. The neighboring images should overlap at about 20–30%. A degree ruler on the tripod head helps you with this task. If the overlap is too large (perhaps more than 50%), the stitching software may have problems recognizing the correct seam between the images.

4. Important objects – i.e., a portal, or people – should be placed in the center of the image. They stay more in focus when stitching the images together and do not create ghostly shadows. (A "ghostly shadow" shows an image twice in the image, slightly offset, and half transparent.) Try to avoid moving objects, or place them in the zone that is unaffected by the overlap.

5. Make sure to shoot your series of images with the same exposure. Take meter readings of several angles of view, and determine the middle values; then set your camera on manual mode, with the determined aperture and shutter speed. If possible, shoot all your images with these settings. It is especially important not to change the aperture to keep the depth of field identical in all images. Most panorama software modules can correct some brightness differences at the seams between images. However, you should not rely heavily on this option.

 A bright day with a light cloud cover is ideal for a panorama shoot, because the illumination is very even.

6. Use a consistent focal length for the images. It is best to deactivate the autofocus mechanism if objects are located close to the camera, and to work with a consistent manual focus. This technique will produce a

consistent depth of field in the image series. When photographing landscapes with enough distance from the camera, using autofocus does not pose a problem. A large aperture value (small aperture opening) will give you the desired depth of field.

7. Do not use an extremely wide-angle lens (at least for your first few attempts). They cause significant distortions that are hard to remove using the panorama software. Be sure not to change the zoom factor while taking the images!

8. Copy all images of the series into one folder, and number the images in sequence from left to right to simplify the image processing task.

Start with relatively easy landscape panoramas. The following example was created with the *Photomerge* function in Adobe Photoshop Elements (Using *Photomerge* with Photoshop CS2 or CS3 will provide some additional options). The process is typical for simple panorama programs:

1. Before beginning the stitching process, you should evaluate the individual images, and retouch distracting elements and mistakes. If strong brightness differences are present, you can correct these also. Arrange the images side-by-side on the screen for a good comparison of the brightness and tonal values. If you have RAW files, convert them now to TIFF or JPEG. Below are the six images for our example:

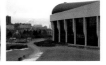

2. Now start Photoshop Elements and select File ▸ New ▸ Photomerge Panorama to open the panorama stitching program dialog box.

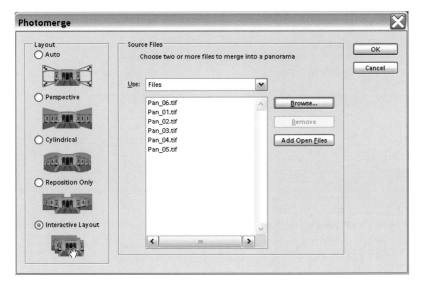

➜ *If you are not looking for an extreme-panorama image, it may be better to shoot the individual images in vertical format. You will need to take more images in the series, but the result is a more balanced format that is neither too skinny, nor too wide.*

➜ *Panorama calculations take a lot of computing power. It takes some patience to let the program do the work. At times, the program may not react to other commands while processing the panorama.*

① *First you have to choose which function to use, and then you select the images for your panorama.*

First we select which type of panorama we intend to create. Under Layout, choose which panorama you want to make:

– **Auto** – assumes a planar projection of the images on a flat surface and will create your panorama without any interaction on your part.

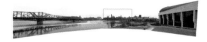

Perspective Projection

– **Perspective** – produces a perspective projection (usable in Photoshop Elements to 120 degrees). (At bit later, in the main dialog you should use the *Set Vanishing Point Tool* (🅰) to set the vanishing point in the logical center of the image (see figure ②); the perspective projection will be built around it).

In this case we selected *Interactive Layout*. Now you select the images for the panorama and click on OK.

3. Photomerge usually does a good job of placing the images together and shows a preliminary result in the preview window. If you would have chosen the function *Auto* (see figure ① on page 107), we would already be finished. However, we decided to have the option to make some adjustments if necessary. Photomerge will show the result of the first automatic placement. The calculation for this may take a minute.

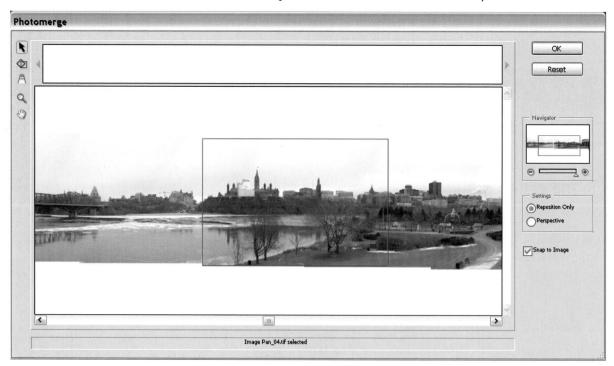

② *Photomerge dialog box with image and settings.*

4. With the navigator, hand, and zoom tools you can view the complete image, as well as details (although not strongly magnified). By selecting an image by the 🅺 tool, you can adjust the image using your arrow keys.

5. In the Photomerge dialog box you can also make some corrections:

 – If the image sequence is not correct, you can change individual images in the composition. The *Rotate Image Tool* () allows you to rotate one of the images at a time.

 – Individual images can also be dragged out of the composition into the upper area (called the *light table*). They are removed from the panorama. Images on the light table can be re-inserted into the panorama, perhaps at a different place.

 – The checkmark in the Snap to Image box prompts Photomerge to look for the same objects in neighboring images, and to place the images with these parts overlapping. Therefore, it should be activated.

9. At the end, click OK to process the final panorama.
 Depending on the number of images to be stitched together and the overall image size, this calculation can take awhile. In the resulting image, Photoshop Elements indicates transparent areas with the checkerboard pattern (). Transparent areas are due to the individual images being slightly offset by height and perspective corrections.

→ *Creating large panoramas not only requires a lot of computing power; it also requires a lot of space on the hard disk and the scratch disk (configured in Preferences).*

③ *Panorama image after processing in Photomerge*

The image produced by Photomerge often needs further editing. In our example, there were color shifts in the sky, marked in red above. They were corrected with the clone stamp tool. We enhanced the contrast, sharpened the image, and cropped it. The result can be seen on page 110.

Instead of cropping the sky (in figure ③), the missing parts could also be added with the Clone Stamp tool of the Photoshop Elements Editor, or a sky from another image could be inserted.

Other detailed editing is now possible, for example, objects that are not stitched together well can be copied from the original photographs and placed over the seams in the panorama to correct (cover up) the mismatches or ragged places.

For our example, no more image editing was necessary. The final image can bee seen in figure ④ on page 110.

Because the original images already had a high resolution, at 2240×1480 pixels, the finished panorama came to 8720×1386 pixels, or approximately 30" × 4.7" at 300 dpi. The size in TIFF format (with LZW compression) was about 67 MB. At this size, you can see why you need a lot of hard

④ *Panorama of Ottawa (Canada)*

* *A 300 dpi TIFF in CMYK color mode is used,*
 for example, for printing this book.

disk space and temporary storage to work on panorama images. A medium JPEG compression reduces the image to approximately 6 MB,* with sufficient resolution to print a poster at about 47" × 7.5". For larger prints, a line screen of 150 ppi is used; the larger viewing distance allows a coarser resolution to be used for printing, which is usually done on large inkjet printers.

4.12 Tabletop Photography

The term *tabletop* describes images made of objects located on a table or stand – equivalent to still life in painting. There are three essential components to these situations:

▸ The environment, or backdrop, for the image
▸ The right viewing angle, and cropping
▸ The right lighting

The correct lighting poses the greatest challenge for amateurs. Applications of tabletop photography are pictures of jewelry, or other small objects that you may want to sell over the Internet, or supplying detail for technical manuals.

A typical method, which is also employed in professional studios, is the use of a backdrop with a seamless transition between the horizontal and the vertical backgrounds. You can achieve this seamless look with a continuous foil, a sheet of cardboard, or a piece of cloth that is draped to form a soft, round transition that hides the edge between the horizontal and vertical planes. For tabletop photography, you can use a simple frame and attach paper or foil to it. When you use a low depth of field in your image, the edge of the background will disappear completely.

For this purpose, I found an old sheet of Plexiglas and shaped it with a hot-air gun. This shape can be either mounted on a wooden frame, or placed on a table or chair. As a background, you can use white or black matte drawing paper. For jewelry, you can also use a soft, matte fabric. You may choose tracing paper (or a wide roll of wax paper) as a background for some objects. Both of these papers allow illumination from behind and below, which can be an attractive lighting setup. The background is simply taped onto the Plexiglas shape. The camera is positioned on a tripod in front, or above.

Two low-cost lamps from the home improvement store serve as lights. They are positioned to the left, and to the right, with an approximate angle of 45 degrees. This lighting setup is also ideal for the reproduction of books or magazines, described on page 114. Of course, you can buy pre-fabricated tabletops in specialty stores, but their purchase is rarely worthwhile for the amateur.

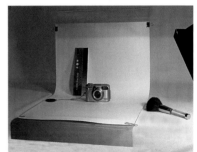

Home-made tabletop with props

Depending on the object to be photographed, you can also attach a single-pointed light or several spotlights. You will have to experiment with the positioning and sources of light and the position of the camera. A quick look at the camera display gives you instant feedback, and control images can be checked thoroughly on the computer screen. Again, we recommend that you bracket your exposures, and perhaps even create a series of exposures with different color temperatures. However, it is important to stay as close as possible to the original colors. The final impression can be quite different, as the following images show.

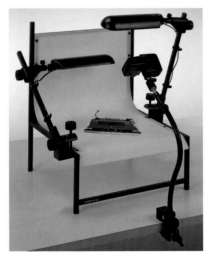

Digital tabletop studio (by Kaiser)

① *The same necklace on a black velvet (left), a transparent background, illuminated from below (center), and on a light-colored cardboard (right).*

You can create interesting images by placing an object in front of a window, and using the diffuse light found there. The picture in figure ① of an old can of tobacco and other glass objects was created using this technique. The branches and foliage from the garden form the background.

If you want to photograph furniture individually, you can place the piece in a large entryway, or even outside. You will have to make sure that the background is either very calm, or very blurry. For simple objects that can be cut out easily, the background can be fixed during image editing, for example by cutting out the piece of furniture completely, and then placing it in front of another fitting background, or by inverting the selection and blurring the rest of the image (the background).

If the furniture cannot be moved because of practical reasons, you should at least cover the surrounding areas with soft flowing fabric, or keep them in the shadows, so they will not distract from the main focus of the image.

Alternatively, you can retouch the background during image editing. Retouching is much easier if there is sufficient contrast between the object and its background. The image of the cupboard was simply cut out in image editing, instead of emptying it and taking it off the wall. In addition, we corrected the perspective slightly (see section 5.13.8, page 196).

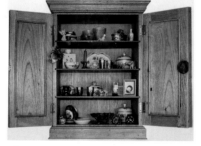

③ *Original image with original background.*

④ *Cupboard cut out, and slightly corrected (contrast and perspective).*

4.13 **Studio Backgrounds**

What is being done on a small scale with tabletop photography is being done with background materials and lights on a larger scale in the studio. Studio photography allows for photographing furniture, other larger objects, as well as people under controlled lighting situations. The expensive studio setup is usually not feasible for the amateur. However, with a little skill, a few cheap materials, and some improvisation you can create what you need on your own. I bought a few cheap lamps at the home improvement store, and a few rolls of paper tablecloth in different colors. The ones with a matte and fleece-type surface may be a little more expensive, but they are more durable, and more suitable, due to their matte surface.

Attach the roll to the wall with pins, tape, or picture hooks, and pull it down loosely so it does not wrinkle. Let it drape with a smooth, seamless transition over the table or floor (see figure ①). The paper backdrop can also be attached to the hook of a projection screen. Of course, you can find colored backdrops and picture backdrops used in professional settings in many variations; however, amateurs can usually do without such expensive props. For small objects, a scarf or another peace of clothing may be used as an additional backdrop.

If it is not raining, you can set up on an outside wall, as figure ② shows. This location has the advantage that images shot in daylight, perhaps with a fill-in flash, do not need to be corrected for color temperature.

Make sure that there is enough contrast between subject and background, and remove all unnecessary distractions so that selection and cut-out during image editing can happen with the least amount of effort. For the example using the chair, we used a simple white, paper tablecloth for the background, and shot the image outside under overcast sky, with a fill-in flash.

In addition, we used a polarizing filter to prevent any reflections on the polished surface of the chair. The white background had so much contrast to the color of the chair that the selection in the image editing program could basically be done with the magic wand.[*]

Remaining items were removed with the Eraser tool. Of course, after that, we could have added another colored background fitting to the color tone of the chair.

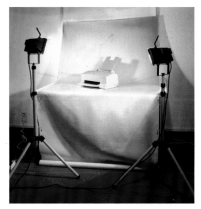

① *A useful background, if you need more space.*

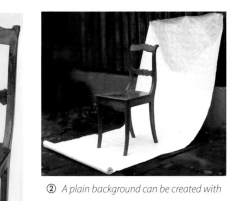

② *A plain background can be created with simple materials – here we used a paper tablecloth.*

* *For selections with the Magic Wand tool see section 5.3.6, page 147.*

4.14 Reproductions

① *Simple setup for reproduction work with two neon lights.*

In certain situations, the digital camera can replace a scanner, as well as a copy machine. For example, with a digital camera with a resolution of 3–4 megapixels, you can photograph a stack of book or magazine pages fairly quickly. After some image editing, the quality is so good that you can run OCR software (text recognition) on the page.

You will need a tripod and two lights for illumination (roughly 80 W for incandescent lights, or 25 W for neon lights). The lights are mounted on the sides – a 45-degree angle is ideal. At the beginning of a reproduction series, you should adjust the white balance. Alternatively, you can use the light of a large window, or, as mentioned previously, a strong neon light with daylight characteristics. Also suitable is the light of a 500–1000 W spotlight bounced off a white wall or ceiling. Avoid mixed lighting with different color temperatures.

You can use an old enlarger frame for a tripod, which you may still have around from the old darkroom days; or use a conventional tripod that allows you to mount the camera on the bottom of the center post (see figure ①). This setup lets you photograph perpendicularly from above.

A remote control or cable release is useful to avoid camera shake when pressing the shutter button, or you can use the self-timer. Once you focus, deactivate the autofocus, if possible, to save time, and energy. When setting up the camera, try to get the least amount of perspective distortion possible.

If you photograph a large number of pages, changing the rechargeable batteries can be a nuisance. However, you can connect the camera directly to the wall outlet with the appropriate cable. These adapters can be bought relatively inexpensively in photo stores from third-party manufacturers.

First, you will have to determine the correct aperture and shutter speed. We recommend an aperture between 8–11. This setting will give you enough depth of field to deal with slightly curved pages as well as with the change in distance when turning the pages in a book. If you work at the beginning of a thicker book you will have to place something below the thinner part to get an even surface to photograph. With high-resolution cameras you can photograph a two-page spread simultaneously.

Once you determine the correct exposure, deactivate the auto exposure mode. Your image series will be evenly exposed, without slight changes in brightness from the auto exposure mode. You should choose the lowest ISO setting available for the best contrast and to minimize noise. You may have to choose a longer shutter speed to make up for the loss of light sensitivity.

During image editing, first crop the image, and then intensify the contrast. Then convert the image from RGB to gray scale. Next use the *Unsharp Mask* filter to sharpen the image and save it as a TIFF file. Now you can run an text recognition / optical character recognition (OCR) software program

on the page. OCR programs (sometimes the "light" versions) are usually included in scanner packages. Otherwise, you can buy acceptable OCR software packages for about $100, even if these are not the latest program versions.

When working with a whole series of pages, it is worthwhile to program an action script for all the steps of image editing that are repetitive, such as cropping, contrast adjustment, conversion from RGB to gray scale, and saving the image as a TIFF file. Then all pages can be processed according to these specifications in batch mode.*

* See section 5.22.2, page 218.

You may also want to photograph old certificates, other similar papers, or old books. When photographing several pages, you can usually do it faster with a camera, and preserve the original better. In addition, many of the new compact scanners cannot handle curved pages because they have a very shallow depth of field.

Digital cameras featuring resolutions of 8–8 megapixels can also handle the processing of pages larger than letter size, which consumer scanners can only do by making several scans and stitching them together.

Larger originals that you want to reproduce in high resolution, can be photographed in several pieces and then stitched together into a large composite image, as described in section 4.11 (page 105). You can produce large posters of your originals using this method. Again, you need to make sure that your individual images do not show much perspective distortion. Therefore, do not tilt your camera to the positions, but change the horizontal position of the camera by moving it to a new location.

When working with reproductions for successive OCR processing, you need a high contrast image. However, when reproducing old certificates or books, you want to preserve the character of the original with as much detail, and as true to the original color as possible. Therefore, we included a color control strip in the image of an old Fire Ordinance as a reference for the following color correction. Before finalizing the image, this control strip was cropped out.

Paper deteriorates over centuries, but you can preserve the document photographically.

4.15 General Photo Tips

The following general photo tips may appear simple. However, they help to create interesting images.

▲ *The same object cropped differently.* ▼

1. **View the Object with Different Eyes**
 A picture is two dimensional and flat, and is clearly different from what our eyes perceive. The view through an empty frame – for example, shaped by your hands and viewed with squinted eyes – will give you a good first impression of what the camera would capture. It allows for a quick first glance at the right cropping – even without unpacking your camera.

2. **Finding the Right Angle of View and the Right Light**
 The most important compositional elements in a picture are the angle of view, the appropriate cropping, and the right lighting. Walk around the object, search for good, or special, lighting directions, and think about in which light the object appears at its best.

 Show flexibility and patience when photographing, and most of all, move around. Sometimes it is better to wait until a cloud hides the sun, or until the sun comes out from behind a cloud, or until people or cars have moved a little. Good landscape photographers even come back to the same spot several times – e.g., in the morning and again in the evening –, often times month after month. Consider the best time of day that would result in the best lighting or the proper mood for a scene.

 If the background is distracting, use a small aperture value (large aperture opening), and thus render the background blurry, or change your position, so that a calm background becomes visible in the image. Try to imagine the finished picture while taking the photograph.

3. **Use objects and colors sparingly**
 Placing one, or a few, objects that fill the frame in your images is, generally, better than showing a large variety and chaos. Compose your picture so that the central object dominates the image, covering at least one quarter, or more, of the image area. In most cases, this means that you have to position yourself very close to your object. Thus, a friend and the complete Eiffel tower are difficult elements to compose together into a balanced image.

4. **Search for Patterns, Structures, and Special Color Combinations**
 Small things make for interesting photos. Look for patterns, interesting structures, unusual or attractive light plays, or reflections. In larger scenes, you should pay attention to such structures, and make sure they are not cut off in an inappropriate way.

 The structure of an image does not need strict forms; it can also be composed by using colors, color gradations, or color combinations. Low contrast, or harmonious colors, have a better effect than wild color

combinations. Avoid colorful images, in which many different color tones appear in similar sizes and intensities.

5. **Think in Terms of Collections or Themes**
Sometimes collecting individual images into themes becomes impressive, such as people, doors, archways, signs, landscapes, or mailboxes – as shown in the example. The individual images only reach their full potential as a part of the whole collection. In addition, pursuing such projects can school your eyes and your awareness.

6. **Capture Moods**
In many situations you can capture a specific mood. Consider which element is the most important for the mood – the color, the composition, the contrasts, the shadows, the space in a sparsely furnished room, or the faces of people? Try to capture those elements that are the most important. Colors have the strongest effect on mood. At times you may want to underexpose slightly to capture the mood more impressively.

The backlighting emphasizes the water drops.

Calf of a die-hard Canadian ice hockey fan,
predestined for a slideshow about Canada.

7. **Create Comparisons**

When photographing very small, or very large, frame-filling objects, the viewer may need a comparison to judge the size of the object correctly. Consider including a person or a car at the base of a mountain, a match, a coin, or the tip of a finger.

For technical detail work, you can include a ruler to help the viewer judge the size effectively.

8. **Images in Low Light Conditions**

Of course you want a well-illuminated image with detail in all areas. But rain, fog, dawn, dusk, or even night can be opportune times to create interesting pictures. The focus in such images is on the mood, the muted colors, or the light. Often only these aspects make a scene interesting at all. Contours, individual lights, or soft color gradations are essential components.

In most cases, you will need longer shutter speeds, and should use a tripod or find a support for your camera. Let the camera choose the color temperature – at least outside. You can always correct it slightly during image editing.

9. **Utilize Backlighting**

For technical details, panoramas, or passport pictures, you want the light to come from the direction of the photographer. For moody pictures, and nature photography, you can also use backlighting, but you will have to carefully choose your exposure. We recommend that you bracket your exposures.

The attraction of an image can come from a silhouette, the streaks of light, or the color play of broken light rays. The backlight can also bring structures into their full expression, such as the water drops on the fern.

→ **Never ever photograph directly into the full sun, because it can cause irreparable damage to the camera's sensor!**

10. **Think About the Purpose and the Viewer of the Image**

As mentioned at the beginning of chapter 3, an image is generally intended for a purpose, or a particular viewer. Therefore, it is important to figure out which components are necessary in the image, and which can be omitted. In some cases, an image can be adapted to a specific purpose after the image has been already taken, as long as all the essential information is present in the picture. Such an adaptation can be a frame, for example, which may be captured in the same surroundings at the same time. Sometimes an image will only display its full informational context by including the place, time, or occasion.

Sometimes you can use symbolic elements, such as the maple leaves of the Indian summer in Canada. During this time of year, after the first cold days, maple leaves turn yellow or red. The image above also uses a

symbolic element, in which an ice hockey fan tattooed the symbol of the Canadian ice hockey team onto his hairy calf. I took this picture unobserved in line before entering an airplane.

Try to think in themes, and which pictures are still missing in your theme assembly, or into which theme a particular image might fit. Adapt your images accordingly.

Image for a fall greeting card from Canada.

4.16 Applications

Digital photography is useful for more than just family and vacation pictures – even if it is the beginning for the budding photographer. Digital photography's fast and cheap method of capturing images, and easy electronic usage, create new options. Often, new and useful applications only occur to you after some time has passed. Therefore, this chapter offers you some suggestions to bear in mind regarding the camera and image usage. This section is meant to give you ideas, not specific instructions.

4.16.1 Documentary Photography

Besides creating memories, documentation is a large part of photography. Digital technology has made this process significantly easier. The field of documentary photography is comprehensive and spans from images of reports, to documentation of accidents, damage, or collections. The following themes are only examples, and you can probably add several from your own personal or business life. Also, the photographic preservation of the German Fire Ordinance from 1752 on page 115 is an example of documentary photography.

Example: Part of an excavation documentation of bone deposits at the building site of a Spanish hospital (Panama la Vieja. Photography by: C. Knipper, University of Tuebingen, Germany). Because an archaeological dig destroys its own sources, exact documentation is crucial. Photography is an essential component of this process. Presently digital photography has replaced transparencies and negative films.

The compositional rules for documentary photography, as mentioned previously, are dependent on the purpose of the image. Pictures for technical documentation do not need to be pretty, but they need to be concise, and recognizable. In individual cases, you may sacrifice the authenticity of an image (an unchanged photograph) to make the essential component more visible;

Cut through the floor of a medieval homestead. Source: University Tuebingen, Germany.

or you may neglect an aesthetically pleasing composition in service of technical documentation. Objects photographed for sale, or an exhibition of a collection, should be presented in a good light. Images for insurance purposes need to be authentic, show the value of the object, or clearly depict the damage in question.

Otherwise, the compositional rules already mentioned are followed, especially concerning the focus on the main object, with the least amount

of distractions visible in the image. Sometimes this is only achieved by cutting out the object during image editing, as described with the cupboard on page 112, or the chair on page 113.

When planning to do so, make sure that the background has enough contrast to the object, and that all unnecessary elements are removed before taking the picture so that selecting and cutting out the object during image editing can happen with the least amount of effort. In the example of the chair, we created a white background with the help of a cheap roll of paper tablecloth, and photographed the chair outside under an overcast sky. Cutting out the chair in the image editing program was almost effortless due to the high contrast, and was done mostly by using the Magic Wand and a little touching up with the Eraser tool.* Cutting out complex forms is more work and is described in sections 5.16 and 5.17.

See section 5.3, page 143.

4.16.2 Evidence for Insurance Companies

① *Damage to a car. We underexposed by 1.5 exposure stops to make the damage to the white metal more visible.*

② *A simple necklace: compositionally not pretty, but practical and concise.*

Insurance companies process claims of loss much faster if the claim presentation is persuasive. Photographs can contribute considerably in showing, for example, the damage to a car, items lost in a burglary, or a storm-damaged building.

You should create photo documentations of valuables such as paintings, furniture, fine porcelain, insured jewelry, or coin collections **before** a (potential) loss. It helps to document that you actually owned the objects lost in a burglary or fire, and in which condition they were when the image was taken.

If you photograph objects whose size is not evident, you should add an object for comparison, or even better, add a measuring tape to images of the necklace (as can be seen in figure ②) or the rare piece of furniture.

Images for insurance purposes do not need to be artistically composed. Other aspects are more essential, such as even illumination, and the differentiated depiction of the most important details that give the object its value. For larger objects, such as a table, or closet, take several images from different vantage points. Daylight or lighting with daylight-balanced colors – e.g., using a flash – is the best for images of jewelry, carpets, and paintings.

You can cover the distracting backgrounds of larger objects that cannot be moved easily with tablecloths, or sheets. The tips given in section 4.12 (page 110) apply to the images of jewelry and porcelain. In images of furniture taken for insurance purposes, it is acceptable if part of the environment is showing in the background.

Objects that require concise and true color reproduction can be photographed together with a color and gray scale strip as a reference. Color scales and gray scales can be found in photography stores. They help in color correcting the image, and can give the viewer a

useful reference in evaluating the color of the object. In the shot of figure ② I used such a color reference card to achieve correct colors. These control strips are unfortunately quite expensive (about $20 to $50).

With large objects of value, it might well be worth taking additional shots showing the objects from several vantage points.

Additionally, images taken for insurance purposes should have a sufficient resolution to print up to letter size. Besides the advantages of electronic images, you may want to consider adding prints to your insurance records. When filing a claim it may be difficult to find the images on your computer. However, you could also put a CD with the digital images with your documentation.

4.16.3 Collections

Images of collections are not only useful in potential insurance cases, they are more often used to present the collection to other collectors, to merchants for assessment, to interested buyers, and on the Internet. In some cases you can create beautiful posters of some of the objects. To print a 15" × 30" poster with adequate resolution, I photographed the individual segments of a collector's case separately, and used stitching software to create one high-resolution image (see the copy on page 124).

4.16.4 Images for Internet Sales

Those who have bought things on the Internet know the value a picture brings to an object for sale. Especially in the case of used objects, a picture allows the buyer to evaluate the condition, and the value, of an object. Therefore, it is useful, and even necessary, to have an image of the article for sale. This image should show the object in a good light, and needs to be correct. Thus, scratches on a camera or a piece of furniture cannot be removed; otherwise you may be accused of fraud.

Sometimes it makes sense to have two shots: one showing details of the object and the other one placing the object in its intended environment, e.g., with a patch-work blanket: A close-up shot showing the patch-work details and another one showing the blanket covering a bed.

Small portion of a collection of beer bottle closures.

An artistic dish photographed for an Internet auction.

Before ▲ and after ▼ image of a planned remodel.

4.16.5 Construction Documentation

In architecture, there are several applications for photography. In old buildings, for example, you can photograph the original condition, to document the basis for a remodel.

Future View • With a little skill in image editing, you can show the planned remodel of the building before construction. These images can help to solidify your own ideas, explain your plans to the building authorities, and help to get your plans approved, especially for old or historical buildings.

Electrical and Plumbing Diagrams • After the building is completed, it is extremely useful to know where electrical lines are, and where water or heating pipes are located. Photographed at the right time, it is fairly easy to capture these locations before plastering. If you add a measuring tape that shows the distance to a reference point that can be recognized later on, it becomes relatively easy to read exactly where these lines are located from the photograph.

Documenting the Building Progress • Often banks will pay the building loan depending on the progress of the construction. Documentation with current photographs makes this process simpler. In addition, these images, in combination with the date information in the EXIF data in the image, document nicely the adventure of building.

** The list of useful images that can be taken during construction can be continued.*

Documenting Mistakes • During construction there are almost always small or large troubles, which may be due to sub-standard craftsmanship, out of spec material, or damage done. All this information can be easily and quickly documented with a few images, and is useful for potential court cases.

4.16.6 The Mobile Copy Machine

Digital cameras are like mobile copy machines, provided that their resolution is high enough. You can quickly photograph an original document or image, and later print it, after uploading it to the computer. This technique is useful for papers, magazines, books, posters, black board diagrams, or notes on a flipchart presented during a meeting. Images of notes can easily be used as part of a meeting log and sent via e-mail, after the contrast of the images has been increased.

You can even photograph informational boards or maps and use them for reference, especially if the camera display allows you to zoom in on the display images. If not, you can copy the information, enlarged piece by piece. In addition, memories from vacation trips, such as menus, directional signs, city signs, and maps are good subjects for photography. The typical rules apply to these images:

A photocopy of a (German) menu as a memory of a nice evening.

▸ The illumination should be as even as possible without any reflections (diffuse light under 45 degrees is best). If the surface is not reflecting,

you can use the internal camera flash as a fill-in flash. In this case you should keep at least 5–10 feet distance from the object to create an even lighting situation. External flash units usually reach much further.

▸ Photograph the object perpendicular (at 90 degrees to the surface) to avoid distortions.

▸ Use a medium aperture value (between 4–8) and a medium focal length (about 50–100 mm, converted to small film format) as long as the object can be photographed so that it fills the entire frame. Avoid wide-angle settings, because they distort the picture.

4.16.7 Ideas for Presents

Every year there are presents to give to parents, partners, friends, and relatives, at holidays such as Christmas, the New Year, Easter, birthdays, and anniversaries. After a few years, your ideas might run dry. A calendar with your own pictures is no longer a new or innovative present, although it is a very individual one. In your family circle, it is usually pictures of your family or children that fill the calendar. If you think about it throughout the year, you most likely have enough pictures that do justice to your family, as well as fit the

Map of the Kaibab Trail at the Grand Canyon, shot from a sign at the head of the trail.

different seasons of each calendar page. Even for friends, a calendar with pictures from the vacation spent together can be a nice present for Christmas, or New Year's. Choose a large neutral image for the cover, or one appropriate to the season.

Nicely decorated albums, hand-made greeting cards, and well-designed e-mails are almost always welcomed.

There are many freeware, shareware, and commercial software programs available that help you design greeting cards and calendars for print, as well as electronic form. You can find more details in section 7.5.

The range of possibilities to say thank you with a photograph or to give a gift is broad. How about a photo postcard, perhaps more discreetly delivered in an envelope, as a thank-you note for an invitation – of course with a picture of the occasion? Small magnets are useful for placing the memory on the fridge with a small glued-on photo. You can cover it with photo finishing spray to protect it from damage. Images on heavier, photo-quality cardstock can be made into bookmarks for presents.

Benefit Christmas cards created with a photograph of Regine Landauer.

Several images combined (shots from a 5 megapixels camera using stitching software) into one poster.

How about creating a poster for a friend showing his most precious collection pieces? An example can be seen on the left side.

You can also place photographs on cups, T-shirts, and mouse pads. There are three options:

1. You can buy special foils in an office supply store, onto which you print the photo with your inkjet printer. This is then transferred to the mug, or ironed onto the T-shirt or mouse pad.

2. Some photographic development stores also offer these services, where the quality is usually better and the images are more durable.

3. Many T-shirt shops will transfer images, from an original that is large enough, to T-shirts and mouse pads.

Original photographs for T-shirts should be as large as possible, but do not need high resolution. The opposite is true; a coarse line screen with high contrast is better than fine details and subtle color gradations, which cannot be reproduced well on the coarsely textured fabric. Strong colors and clear, sharp contours are more suited for this type of printing.

How to have images printed at a digital photo service is described in section 7.1 beginning on page 259. Some Internet addresses of photo service providers can be found in Appendix C.5 beginning on page 347.

4.17 Privacy and Publicity Rights

When taking images of people, the legal situation can be a little tricky for the photographer. Privacy laws allow individuals to file a claim against the photographer, if they feel their privacy has been invaded, or if the image discloses private information. About half the states in the US acknowledge the law of publicity as well, which requires the photographer to get permission to use the name, face, or image of an individual for commercial gain. Thus, if you want to openly show images of people, even to your friends or acquaintances, or to post them on your website, or publish them in a book, you will need to have the individuals in question sign a release form. If you approach them with a copy of the photograph and explain in which context the image will be shown, you will often get their permission to use the image, as long as it is not embarrassing to the individual. The costs for the photographer from a lawsuit for ignoring privacy or publicity rights can be very

high, in addition to all the trouble a legal battle brings. Permission is always needed when the person in question is clearly recognizable in the picture. Magazines and newspapers publish photographs of people under the Fair Use law.

Permission to be photographed can be given implicitly through an action, such as posing for a group photo. Also, if the photographed person accepts any form of payment for the image, he or she implicitly gives permission for the use of the image. However, it is recommended that you always get written permission before using such images commercially.

You can take pictures at public parades and demonstrations and publish them. However, to use such an image commercially you would have to get permission.

You do not need permission to photograph buildings if the building is located in a public place or visible from a public place, such as a street. However, you do need permission to photograph artwork, not from the owner, but from the artist who holds the copyright to the work. In museums, you will most likely have to get permission before being allowed to photograph as flash and tripods are usually prohibited. If you are photographing private property, you also will need permission from the owner to publish the images.

Generally, the rules for photographing public buildings have become stricter since the attacks of September 11, 2001. Due to the fear of terrorism, photographing embassies, train stations, and airports has become much more restricted.

Also, be aware that other countries are governed by other rules. For example, photographing in mosques in Islamic countries can be prohibited, and photographing people, especially women, is forbidden.

Taking a photograph of the Eiffel Tower in Paris during daylight is permissible, but shooting the Eiffel Tower at night, while it is illuminated, requires you to obtain permission because the right to these pictures is in the possession of a French company – very curious, but that's the way it is.

Image Editing

5

Image editing on the computer opens up a new dimension to work with digital or scanned images: you can improve them, add to them, or create completely new images. Photographers who avoid image editing do not utilize one of the major advantages of digital photography. At the very least, you should be familiar with tonal, contrast, and color corrections, which are partially automated functions, and use them when needed. With a little bit more effort, many more opportunities open up for you.

This chapter demonstrates the most important options of digital image editing, and shows diagrams of workflows. However, it tries to show concepts and ways of working, instead of being a manual for editing programs.

This chapter only provides an introduction to digital image editing for photographs using Photoshop Elements version 6. For more in-depth software-specific information, check the reference section. Preferably, you should choose a book that covers the specific editing program you own.

5.1 Image-Editing Software

There are many image-editing programs available, and it seems as though the choice of which one to use is becoming less manageable every day. Table 5-1 gives an overview of some popular programs. To start, you can often get older versions of the programs for free in magazines, or buy them cheaper on the Internet.* Upgrading to the newer version is then often cheaper than buying the new version in the store.

On the other hand, new versions have been improved with additional, useful functions for editing photographs.

Concerning simple, automated image corrections, many beginner programs offer more options than the expensive versions. High-end programs, however, offer better controls for processing and color modes (i.e., CMYK, and 16-bit color), and adjustments (i.e., color, and alpha channels), which are not included in beginner programs. However, many of these options would be too advanced for the beginner. Also, only the high-end programs offer batch processing, and a history palette, which allows you to undo your steps later. By now, practically all programs offer RAW format processing (if you need it).

→ *A plug-in is a program module that expands existing programs with new functions.*

Besides the actual image-editing programs, there are a large number of specialty tools available, such as filters – which often come as plug-ins for the image-editing programs. Because Adobe Photoshop is the standard program for this industry, and is well documented, plug-ins are usually

Table 5-1: Examples of Popular Image-Editing Programs

Program/Vendor	Platform	Category	Notes
Adobe Photoshop CS3 www.adobe.com	Win, Mac	Professional Approximately $ 650	Reference for other programs; CMYK, 16-bit color, batch, and more; many functions for photo editing
Corel Photo Painter www.corel.com	Win, Mac	Professional Approximately $ 400	Part of the Corel Graphics Suite; powerful
Paint Shop Pro X www.corel.com	Win	Semiprofessional Approximately $ 90	Many useful filters; weak CMS and CMYK support. Supports RAW files as of version 9
Picture Window Pro www.dl-c.com	Win	Semiprofessional Approximately $ 90	Powerful for the price tag, simple interface, album function, 16-bit processing, no CMYK
GIMP 2.x www.gimp.org	Win, Mac, Linux	Semiprofessional Free	Powerful, but unfamiliar interface
Ulead PhotoImpact www.ulead.com	Win	Semiprofessional $ 50	Focus: web design; offers image management, special effects, and calendar creation functions
PhotoLine 32 www.pl32.com	Win, Mac	Semiprofessional $ 70	Powerful and affordable, a little slow; supports CMYK, 16-bit color (as of V. 10), batch, recorder, plus more
Adobe Photoshop Elements www.adobe.com	Win, Mac	Semiprofessional $ 85	Often bundled with scanners; many auto functions; easy to use, RAW file support as of V. 3. No CMYK. Includes image management (for Windows).
MS Picture It www.microsoft.com	Win	Beginner Included in MS Vista	Internet design; calendar function; album, and archiving, function; simple interface
Apple Aperture www.apple.com	Mac	Professional $ 300	Multifaceted. All-in-one program including image editing (also RAW), and image management
Adobe Lightroom www.adobe.com	Win, Mac	Professional $ 300	Professional All-in-one program including image editing (also RAW) and image management

Photoshop plug-ins. Many other programs also support Photoshop plug-ins.* Therefore many of these plug-in modules are also usable in other programs. Part of this group is the group of (electronic) filters and tools for selecting partial image areas. You may also hear them called *knock-out programs*. These sometimes very expensive modules are really only worth their cost for the professional user. Filters for special effects can also be quite expensive. Amateurs and semiprofessionals are usually satisfied with freeware or shareware versions (and a little more time).

In the meantime, the trend is leading to all-in-one photo programs. They include image capturing, editing, and managing capabilities, as well as presentation tools for printing, Internet galleries, and e-mailing images. Beginner programs were the first to bundle image management and editing functions, but by now, even the professionals have good programs available with Apple Aperture, and Adobe Lightroom. They integrate management and editing better, and make the workflow more comfortable with more professional features (although they are not necessarily easier to use).

There is also a group of programs for converting file formats, which allow you to systematically convert your images from one format to another, usually for several image files at a time (for example, all the files in one folder). In addition, you can carry out tonal corrections, scaling, changing the image curve, or transfer the picture into another color space (i.e., from RGB to CMYK for book production). These functions belong to the standard repertoire of professional and semi-professional programs.

Programs keep improving with more and more features. Often, you will not need all the newest additions. This trend blurs the divisions between program categories. Most of the newer image-editing programs already include a basic image browser, with a seamless transition to managing your images (for better or worse).

Practically all programs offer a free trial version on the Internet, which typically allows you to use the program for one month. We recommend taking advantage of these offers before buying the product, to see if you like working with the program, and to see if it supports the RAW program of your particular camera.

In the following image-editing examples, we use Photoshop Elements (version 6),** the stripped down version of Adobe Photoshop, which is most popular professional tool for image editing. At about $85, Photoshop Elements is significantly cheaper than its big brother, while offering Photoshop's most important features for image editing. Transitioning from Elements to Photoshop is relatively easy. Some often-used procedures for photographic image editing are even simplified. Because Photoshop is the standard program for image editing, many of its functions and workflow procedures can also be found in other programs. However, you may have to become familiar with different terms, and search for functions under different menus.

*This list includes, for example, Paint Shop Pro, and Photo Paint.
However, check on which computer platform(s) the filters or plug-ins run before buying.*

➡ *Significant differences can be seen in the speed with which image-editing programs finish essential processes. Adobe Photoshop and Photoshop Elements are two of the fastest.*

Some image processing can take a lot of computing power – especially when the image file is large, and has many layers. Therefore, you may need some patience. The preview function can be especially slow, which is made even slower by slow computers and small hard drives!

** *Photoshop Elements supports 16-bit processing since Version 3, as well as the RAW converter (Adobe Camera Raw) described in chapter 6. The Windows version also includes the Organizer, an image-management tool. Unfortunately, this tool is missing in the Mac version.*

Our intention in this section is not to give a program description – you will find better and more current information in the user manual or the online documentation. Instead, we will give workflow procedures and diagrams that can be used in many different programs. Therefore, we do not describe all functions, but only those that we use regularly in our own photo-processing workflow. There may be some differences compared to your software version or configuration, but the concepts should stay the same and should be easily transferable.

The difference between Versions 3 and 4 is less pronounced, even though Elements 4 can use the newer version of Adobe Camera Raw. As of Version 5, image management is integrated into the Windows version. Adobe refers Mac users to the respective tools from Apple.

5.2 Image-Editing Procedure

Even though the processing of a photograph for a specific purpose can be handled individually, there is a basic procedure to follow. The image editing workflow is based on experience, and on the knowledge of how different processes influence each other. At times, some steps can be omitted, because, for example, they were already completed during image capturing, or they are simply not necessary. Whenever applicable, you should stick to the basic sequence of the image-editing workflow.

This book is only an introduction to digital image editing. Therefore we recommend that you look at additional literature. A list of useful references can be found in Appendix C.

As shown in figure ① on page 131, the sequence for electronic image editing is only a part of a much larger digital photo workflow, which is as follows:

1. Transfer the files from the memory card (we recommend using a card reader).

2. Give the image file a descriptive name and place the image into an image database. Do not delete the extension of the file name (for example *.jpg, .tif, .raw,* etc., including the period)

3. Make a backup copy of the images to another disk or a CD or DVD.

4. Examine and rate the pictures in the image browser. Delete those pictures that are completely unusable, to preserve storage space and spare you from looking at them again and again.

 If the image browser or management program supports metadata (categories, image titles, and key words for searching later on), you should add this information at this point.

5. Rotate the image (by 90 or 180 degrees) if necessary. Most image databases support this feature directly.

6. Make a working copy of the image file now – preferably in a format that uses a lossless compression method (TIFF or PSD) on which you will perform all your changes.

 If the image exists in RAW format, you need to convert it to an editable format (see chapter 6).

7. Straighten the image (for example: straighten out a diagonal horizon line).

8. Roughly crop by removing all unnecessary parts of the image. The image file becomes smaller, and image editing faster.

9. Color correct the whole image. Do the white balance and remove color casts.

10. Make tonal and contrast corrections (including Shadows/Highlights).

11. Perform the actual image editing: retouching, selective corrections, collages, perspective corrections, use of filters, etc.

12. If you need the image in another resolution or mode, make a copy of your edited image and do the resizing and mode changing on this copy.
 Now change the resolution of the image copy depending on its purpose, as well as the color mode (i.e., to indexed color for Internet GIF images, or from RGB to CMYK for magazine or book printing).

13. Sharpen the image (if necessary).

Image editing of photographs should occur in the RGB mode. If necessary, convert the image to another format after editing.

Fine tuning an image can take time. Therefore don't forget to backup your edited versions of the image!

These steps are independent from individual programs and can be carried out in all serious image-editing programs. Some of them (rename, rotate, and crop) are also available in image databases, although usually only in standard formats.

While steps 1-3 are self-explanatory, the actual work begins at step 4. You should not forget to save your file in between, so you will not lose hours' worth of work if your computer or the program crashes. Save in a lossless format, which also saves layers and other adjustments.

When working in Photoshop and Elements use the PSD format, because it also saves layers and adjustments. Paint Shop Pro uses the PSP format. You can also use the TIFF format, although it has some limitations.

Considerations Prior to Image Editing

Before editing your images, you should ask yourself a few questions:

1. What bothers you about the image, and what would you like to improve?

2. What is the purpose of the image?

3. How do you want to present the image?

These three questions seem simplistic, but the answers certainly affect how to proceed.

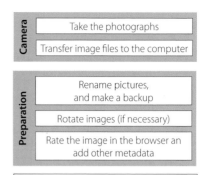

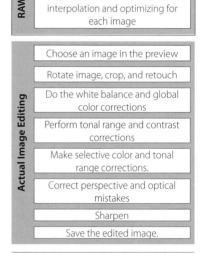

① *Workflow sequence for image editing*

What do you want to improve in the image?

Take some time to look at the photograph. Check if the cropping works for the intended purpose, if the image has a color cast, if there are dust spots that need to be removed, if annoying elements need to be retouched, and if other color corrections are necessary – which often can only be seen after the initial color cast has been removed. Are perspective corrections necessary? Do you need to remove optical distortions of the lens, or vignetting?

Vignetting is an effect where some areas of a n image are less illuminated that others. Most camera lenses show "optical vignetting" to some degree, mostly at the out edges, but stronger when the aperture is wide open.

If you need to undertake several complex image corrections, you should instigate a plan. Follow this rule: *Make overall corrections first, and then work on fine and selective corrections* – those that only affect particular image, color, or contrast areas.

At first, do not increase the contrast of the image too much. While it is easy to increase the contrast of an image, it is difficult or impossible to reduce a contrast ratio that is too high.

Generally, if necessary, you should soften (blur) the image early in the editing process, and sharpen only at the end. Blurring an image slightly can be necessary to reduce noise or moiré patterns. You can do this in the RAW conversion program, or early on during image editing (for example, in Photoshop Elements). Many editing functions increase the contrast, and therefore, the visibility of noise. Therefore, you blur the image before using the other functions. For the same reason, you sharpen the image only at the end of editing, because other processing may further increase the contrast and lead to an over-sharpening of the image, which can be seen in a *halo* effect. Halos are distracting color or brightness jumps at the edges within an image.

Actually, every image that was taken with a digital camera or scanned needs to be sharpened at least a little bit. Sharpening at the end does have a disadvantage though: All through editing you see an unsharpened, somewhat soft image, which can make it difficult to evaluate the image quality.[*]

** Photographs that have been saved as JPEG files in the digital camera will already be slightly sharpened. Therefore, they often look a little better to begin with than do RAW images from the camera.*

It often makes sense to sharpen in two steps: sharpen slightly at the beginning, to get a sense of how sharp the image is; the second time, sharpen the image at the end of editing, to adjust the sharpness of the photograph for the presentation method. Images that are shown on a computer screen or printed at photographic service providers do not need to be sharpened as much as images that are printed on an inkjet printer or are used for magazines or books. These printing methods decrease the sharpness of the picture slightly, which you can compensate for by sharpening the images beforehand.

Scale, enlarge, or reduce the size of your image only at the end of image editing, when the photograph is optimized. First save the image as a *master file*. Then make a copy that you can scale. If you need the image in a different size for a different purpose at some point, you surely do not want to repeat the whole process of image editing again.

Do not overdo image corrections – otherwise, you can end up spending many hours in front of the computer, which is only worth your time for especially good images that you want to print large scale (because some fine nuances get lost during the printing process).

Carefully rate your images in the image browser (mentioned on page 131), so you will not waste much time with unimportant pictures. Refrain from using high ratings. At first only a few images should receive the highest ranking. The number will increase in time. It is the highly rated images that you should spend your time on, while only correcting the other images roughly, to evaluate and show them.

Keep the originals of all those photographs that you do not delete right away, be they JPEG or RAW images. Make a copy of JPEG images first, and then do your image editing on the copy. (RAW conversion programs generally do not change the original RAW files!) Photoshop Elements automatically saves the edited image in a different file. Other image-editing programs do not have this feature, and you will have to make a copy before you start working on the file. The best format for storing the original digital image is the RAW format for images shot in Raw, and TIFF format for images shot in JPEG. The optimal format for edited pictures is also the TIFF format because it allows you to save the file with a lossless compression method.[*]

*The intended purpose of the photograph affects the last image-editing steps – for example scaling the image up or down, and how much it should be sharpened. It also determines to which format the image should be converted. To send files via e-mail, or for an Internet presentation, you would use a JPEG with higher compression, while for printing, you would use a slightly compressed JPEG.

** JPEG images are compressed each time you save the file. You lose image quality from version to version. Therefore, it is recommended that you save a JPEG as a TIFF immediately after first opening it.*

5.3 Basic Functions

5.3.1 Preparation

It is important to create an appropriate work environment for image editing, which should include the following elements:

▸ **Correct color depth of the monitor** (color depth ≥ 24 Bit/64 million colors)

▸ **Calibrated monitor**
The screen should be warm for working with colors, which means it should run for at least 30 minutes, because color depiction depends on the operating temperature. LCD (*Liquid Crystal Display*) monitors need less time to warm up. Calibrating and profiling is described in section 5.23.

The monitor should be at least manually calibrated (using software).

▶ **Suitable lighting conditions**

To work with colors, you should create consistent lighting conditions by using a neutral light in the environment, a monitor that does not reflect any lights, and a calm, color-neutral background behind the monitor and on your desk. You will get the best results if you surround your monitor with a screen that blocks light from the sides and the top.

▶ **Suitable monitor background**

The colors on your desktop influence how you perceive colors. Therefore, your desktop should be neutral (gray), and not too bright. If you maximize your image-editing program to fill the whole screen, this step can be omitted.

A neutral background (right) helps when evaluating, and working with, colors.

▶ **Personalize your image-editing program**

Your image-editing program needs a certain amount of personalization, including the place where it saves temporary data.

Setting up your image-editing program correctly is essential for an efficient workflow.

Working with high resolution images takes a lot of storage space, and at times, parts of the working data will need to be stored. Other settings include the standard color mode in which you want to work (i.e., RGB),

the standard measurements, as well as the color and width of on-screen guides, including the settings for color management (see page 162). Make sure your computer system has enough memory for image editing: 512 MB is the minimum, 1 GB is certainly not too much. Current programs also need computing speed for fast processing – greater speed means less time waiting for the computer to finish processing a command.

▸ **Prepare a file for image editing**
Give the file a self-evident file name. *2007-Hanna-Birthday-01.jpg* is better than *P7120374.jpg.*[*] Then, work on a copy of the original and add to the name, such as *_a*, *_b*, etc. Make sure that the file retains its correct file extension, such as "*.tif*" or "*.jpg*".

** It is even better to convert JPEG files to the lossless TIFF format so that you do not lose image quality every time you save the file. TIFF files need a lot of storage space, though.*

5.3.2 Browse, Rate, and Sort

First, download the image data from the memory card. I always use a card reader connected to the computer with a USB cable. Transferring the files can be done with a system browser using the drag-and-drop method, or you can use the automatic downloader that comes with most image-editing and management software. I never use the automatic downloader though, because I have a specific structure to our file system and want to maintain it.[**] I want to decide when to download the images and exactly where they shall go. (By default, most programs copy image into a folder, often called "My Pictures".) I also want to determine what happens when the files are downloaded, e.g. rename them as part of the downloading process, automatically create a backup copy and, if supported by the downloader, immediately add some metadata to the downloaded files. Therefore, I deactivate the automatic downloader (i.e., in Photoshop Elements).

*** Most programs by default copy the images into a large – for us, unmanageably large – folder (generally into "My Pictures")*

The structure of our folders looks like the structure figure ① shows. Pictures from a specific year are located in one folder. Within this folder are subfolders each comprising one shooting. These folders also include the year, a photo shoot number, and the subject matter or occasion. If needed, these folders can have further subcategories. This method creates an organized structure for your images.

You should only erase the images on the memory card once you have transferred all your image files to the computer without errors and have created a backup copy. We format the memory card to erase all images, but only do in the camera and not in the computer.

Next, we open a folder with a particular photo shoot in the image management program. It will now take some time before the program has captured all the files in the folder and created the preview images. Because this can take a lot of computing power if you have many large images in one folder, the computer may be quite slow to react to commands. It is better to wait until the program is finished loading the images before beginning any serious work.

① *One way to organize your image file structure*

Naming Conventions

Now we name the images systematically – if it has not yet been done – and use the following convention for each image file:

Suggestion for a naming scheme: ▶ *Year_Month_Subject(Name-of-the-Shoot)_ConsecutiveNumber.File-Extension*

For example: *2007_08_Wedding-John_0016_a.JPG* for the first edited version of image number 00116 of John's wedding, which we shot in August of 2007. The original file will be missing the "_*a*" component.

Other naming structures are also possible; however it is important to work with a systematic convention, and much discipline, or you may have regrets later.

Figure 5-1 shows the image browser of Elements 6 in the Windows environment. It is called the *Organizer*. As of version 6 the numerous functions are grouped under four tabs: ORGANIZE, FIX, CREATE, and SHARE. You will also find these items in the various menus. Here are a few of the basic functions, most of which are fairly self-evident with a little experimentation. File ▶ Get Photos and Videos lets you import image data from the camera, a card reader, scanner, or a normal folder on the hard disk; Ctrl - P prints to your local printer; 📧 is used to send images via e-mail; *More Options* will offer you functions that let you create cards, calendars, slide shows, and other presentations; and finally, 🖊 opens the actual image-editing program – which is what we will be looking at more closely in this chapter. This button can open the Photoshop Elements internal image editor, or another editing program.

Figure 5-1: Browser window (here, Photoshop Elements 6 in Windows) ▼

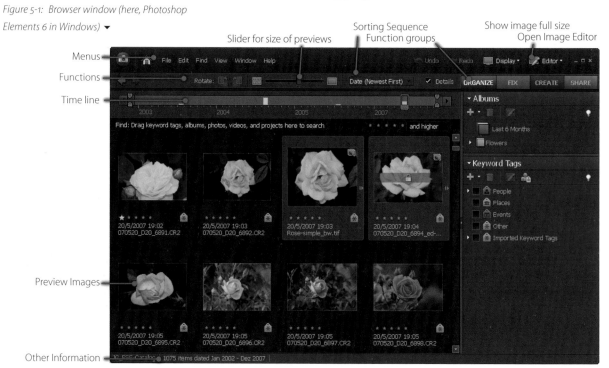

First, we adjust the preview-size slider to set the size of the preview images, small enough to keep a clear overview, and large enough to determine image quality.

Using F11 you can enter *slide-show mode*, which shows the images one at a time, large, and with a black background. Slide-show mode is a nice, efficient way to examine your images, in which the image fills almost the entire screen.

▲ *Functions in the slide show mode.*

By using the slide show tool bar, you can rotate the image by 90 degrees (▤, ▤), delete it (▤), compare two images side-by-side (▤), inspect it at different zoom settings with the loupe tool, as well as rate it by clicking on the stars (as of version 6). The ▤ button scales the picture so that one image pixel corresponds to one screen pixel. The ▤ button returns you to the normal view.

The slide show runs automatically, and you can set how long each image is displayed in the dialog box before it starts. Esc ends slide-show mode and returns you to the browser window. You can also rate your images in this slideshow mode by clicking the appropriate star setting (to the left).

Back in the browser, you rate your images by dragging the star rating to the image. It is also possible to select several images and then drag one of the rating or category icons onto one of the images to apply that rating to the selected images. The rating – here 1–5 stars – is noted below the preview image. You can classify all of your images in the same way.

In Photoshop Elements using keyboard shortcuts is a fast way for assigning the star rating. Use 1 to 5 to assign corresponding stars, or 0 to set the rating to zero.

Instead of deleting images individually, I recommend the following procedure: Mark all images to delete with 1 star. Then, click in the box next to the 1 Star rating, which shows all images that have been rated with one star. Then, with one click on the trash bin, delete all of them.

Many functions can be called up by right-clicking on the selected image – which is why we recommend all Mac users to treat themselves to a PC 2-button mouse with a scrolling wheel.

① *In the properties box, you can add an image title and key words.*

One of those useful functions is the Properties feature (figure ①). To call up the properties box use Alt-ENTER (Mac: Alt-↵) in Photoshop Elements. You can, for example, enter an image title (not the same as the file name, but an entry of IPTC data described on pages 42 and 318).

The ▤ button of the Properties dialog box shows some EXIF data for the image (see figure ②). For images that are captured with a digital camera, this information includes with which aperture, shutter speed, and focal length, etc., the image was shot.

Do not underestimate the importance of the examination and classification phase! If you do not add any information to the metadata – such as image

② *An example of metadata; here, camera EXIF data is displayed.*

title, key words, star ratings, and information about the place and occasion – you will be missing necessary keys for locating the image later in your image database. While it is relatively easy to find images visually at the beginning, it is not time-efficient to look through each image in a catalog of 10,000 to 100,000 pictures. And these numbers are certainly realistic!

Of course you can add key words and classify the images later; but really, now is the ideal time. Experience shows that it is very rarely done later. In addition, you should become familiar with another classification, *tags,* in Photoshop Elements. It allows you to add new categories and subcategories.

5.3.3 Image-Editing Screen

The image-editing screen differs from one image-editing program to another, but a general scheme has been established over time, and many programs look and feel very similar. This chapter shows basic image-editing workflows, using Photoshop Elements as an example.

The following figure shows the editing screen of Photoshop Elements 6.0. In Elements you call up the image editor by selecting the images you intend to edit and then either use 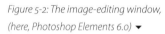 ▸ Full Edit or Ctrl - I .

The editing window should be maximized so that all of the screen can be utilized for image editing. After that, you should organize the necessary

Figure 5-2: The image-editing window, (here, Photoshop Elements 6.0) ▼

palettes and tool bars so that they are easy to access, but do not cover up the image you are working on. If the image is not too large – images from the latest digital cameras are always larger than the screen – you can examine the image at a scale of 1:1. This size allows for an objective examination.

The monitor is never big enough for editing images. If you can afford it, it is much more efficient to work with two monitors. The image is placed on one, and the palettes and tool bars on the other.

Image Window • The image window shows the image to be edited. This window can also usually be maximized – in Photoshop Elements by clicking on the Maximize button (■)in the upper right hand corner. The menus and tool bars are not affected and stay on the screen.

While working on an image, you should always make this window as large as possible, so you can see more details. If the image should be larger – and can be shown larger in the window – you can change the view through the navigation palette (or with the Hand tool – accessible by pressing the space bar), or zoom out to look at the whole image. The listed shortcut keys for zooming in and out should be memorized, because using the View menu or the zoom tool is much slower.

Photo bin • Instead of opening each image separately from the image browser, it is more efficient to select several images and then activate the image editor. These images will then show up in the photo bin as icons. Clicking on one of the icons will open this image for editing.

Options • In the options palette you can set parameters for the currently selected tool. For the pen, for example, you can choose the size of the tip.

Palette bin • The palette bin is specific to Adobe Photoshop and Photoshop Elements. From here, you can open palettes and close them. (For more information on palettes, see page 146.) In most other programs, palettes are activated and deactivated under the View menu.

Palettes • All image-editing programs offer a multitude of palettes – some informational, such as the *Info palette,* shown in figure 5-2 – and each palette offers choices, such as for colors or patterns. An example for this is the *Color Swatches palette.* Some palettes allow you to start new processes. The *Undo History palette* for example shows the last editing steps and allows you to undo them (see section 5.22 on page 218).

Canvas area • The canvas is the working area of an image that you can draw on. At the beginning of editing it is as big as the image. However, sometimes you may have to enlarge the canvas area, i.e., to expand the original image or to include a frame that should become part of the new image.

Tool bar • The tool bar houses the most important tools, and they can be activated here. Some programs place the tools into a palette on the left side of

PSE keyboard shortcuts for zooming

Function	Windows	Mac
Zoom in	Ctrl - +	⌘ - +
Zoom out	Ctrl - -	⌘ - -
Fit image in window	Ctrl - 0	⌘ - 0 (zero)
Pixels 1:1	Ctrl - Alt - 0	⌘ - ⌥ - 0 (zero)

Palette bin with collapsed palettes

A more in-depth description of the tool bar can be found on page 140 .

the working area, which cannot be moved. The tool bar in Photoshop Elements can either be attached to the left side, or it can be a free-floating palette. To change from one view to another, you click and drag on the palette's upper handle.

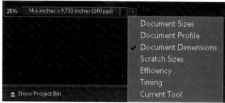

Status bar choices in Photoshop Elements.

→ *Many image-editing programs' popular functions have keyboard short cuts that allow for a more efficient workflow. Some of these shortcuts are mentioned in the text.*

Status Bar • The status bar shows information about the current image-editing process (in Photoshop Elements, for example, the magnification), and gives tips regarding the chosen tool. In Photoshop Elements, you can choose which information is displayed on a menu (by clicking on ▶).

5.3.4 Tools for Image Editing

A standard set of tools has been established to handle the most important image-editing steps. Most programs keep them combined in a tool bar which can be a free floating palette or attached to one of the screen edges.

The symbols, and their order, vary from program to program, but there are many similarities. Therefore, the following diagram of the Photoshop Elements toolbar and its organization is meant to give you a general overview of available tools, for a quicker understanding of your

Figure 5-3: The tool bar and subordinate tool palettes (here, Photoshop Elements 6.0) ▼

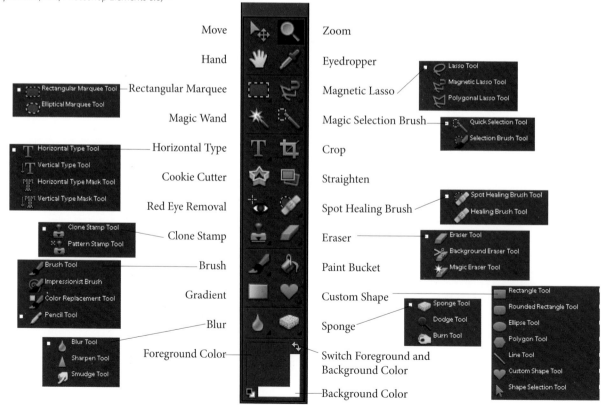

own program. Important operations and functions will be described in more detail later.

Many processes have additional options that can be selected in the options bar once the tool is selected. Other programs might feature separate palettes and dialog boxes for tool options. Some tools have additional variations under the ◢ icon.

In the options bar, you can choose parameters for many of the tools.

The look of some components has been changed in each of the Photoshop Elements versions. For example, as of version 3, the tool bar can be floating or docked to the edge of the screen.

We will only describe the tools we are using for our own photographic workflow; we'll ignore the cookie-cutter and custom-shape tools, for example.

Zoom and Move

Move Tool • The move tool allows you to move a currently selected object (i.e., a partial image area or text) – with either the mouse, or with the arrows on the keyboard. If you press the Alt-key (the option key on the Mac) while first moving the object, a copy of the object is made (and moved).

Zoom Tool • The zoom tool allows you to zoom-in to an image, or (if you hold down the Alt-key) to zoom out. Zooming is often done faster using the navigator window or the key strokes: Ctrl-+ (⌘-+ on the Mac) and Ctrl-- (⌘-- on the Mac).

Hand Tool • With the hand tool, you can move the visible image area quickly. You can access the hand tool even faster in Photoshop Elements (and many other programs as well), without having to change the current tool selection by pressing the spacebar on the keyboard; move the image area with the hand tool that appears. The navigation palette also lets you move the image area quickly.

Eyedropper Tool • With the eyedropper tool, you can pick up a color from the image, i.e., to fill an area or to use it as a fill color for text, pen, or graphic objects. When you hold the eyedropper tool over an image pixel, the RGB values for this pixel are displayed in the info palette. In the options bar, you can choose how many pixels the tool uses for sampling.

Selection Tools

The second block of tools on the tool bar helps you to make specific selections of image areas. Subsequent commands (such as cut, copy, delete, crop, fill, change contrast, etc.) will then only work on the specific area selected and not influence the whole image or layer. The selection tools are shown to the right, in their expanded, subordinate palettes. Because they are basic tools for image editing, they are described in more detail in section 5.3.6.

 Crop Tool • The crop tool is used to select a rectangular image area and cut off all image areas that lie outside of the selection. The crop tool ()is better suited to this task than the marquee tool (■), because it darkens the areas to be cut off, and allows you to still make changes to the selection after you have drawn it. To change the selection you click-and-drag with the mouse on the respective edge of the selection. Cropping is only completed when you press ENTER (↵) or double click in the selected area. (You can also Ctrl-click on the area and choose *crop* from the popup.) You can also rotate the selected image area before committing to the crop. To rotate the image area, move the mouse just outside of the selection corners and click-and-drag the double-headed, rounded arrow cursor.

 Straighten Tool • The straighten tool is used to straighten out slanted horizon lines and edges of buildings. Using the mouse, you draw a line that should be horizontal or vertical after using the straighten tool. You can simply follow the slanted edge with the mouse. Photoshop Elements then rotates the image accordingly. Afterwards, you crop the image so that no white canvas areas are visible.

Drawing Tools

The drawing tools allow you to draw in your image, which means you can add new elements – graphic objects, text, lines, brush strokes, or fill areas – or erase them. The image areas drawn on will have the fill color of the current foreground color – the eraser tool erases what you've added and lets the current background image show through.

 Custom Shape Tools • This set of tools offers various basic shapes that can be used to create objects. These objects are automatically placed into their own layer and do not consist of pixels, but are scalable vector objects. They can be moved, scaled, rotated, distorted, filled, deleted, and changed in other ways (see vector graphics on page 203.). Only if you merge their layer with a pixelated layer (typically the background layer) will the vector shape be converted to pixels.

 Once you have drawn the shape, you can make changes to it by moving it or dragging on the corners with the shape-selection tool selected.

 Type Tool • This tool is used to add type to the image. Text is automatically placed on its own layer, and as long as this layer exists, the text can be corrected, scaled, rotated, or colored. Type face, size, and direction can be chosen in the options bar. Under the Style pull-down menu, you can add special effects, such as beveled or rounded edges, to give the text the appearance of being 3-dimensional.

Paint Bucket Tool • This tool allows you to fill a selected area of the image with the current foreground color. There are many settings in the options bar for this tool. To fill an area with a gradient, use the gradient tool ().

Gradient Tool • A previously selected area is filled with a color gradient – typically from the foreground color to the background color. You can define other gradients and save them in the pull-down menu.

We use the gradient tool to add a color gradient to a vector graphic, but much more often we use it to give a gradient to a layer mask, so that in the dark area of the layer mask, the area of the current layer disappears.[*]

** More information on layers and layer masks can be found in section 5.3.8.*

Brush Tool • The brush paints pixels with the current foreground color and a soft edge into the selected layer. Options such as size, shape, opacity, and mode can be selected in the options bar. In the *mode* option you can set various types of methods with which the brush strokes will interact with the image – from *normal,* to *dissolve,* to changing the brightness values with the *luminance* mode. Additional fine tuning can be done under *More Options.* Pressing the ⬆ key while clicking the mouse will draw a straight line between the last mouse position and the current one. We rarely use the brush in photographs, but will almost exclusively to create soft layer masks.

The pencil tool is like the brush tool (without the soft edge), but offers fewer options. It is mostly used to draw straight lines and to correct small pixel errors. As with the brush tool, pressing the ⬆ key while clicking the mouse will draw a straight line between the last mouse position and the current one.

We do not use the impressionist brush 🖌 in photographs, and very rarely do we use the color replacement tool 🖌. Although, you can use the latter to replace red eyes with a different eye color.

Eraser Tool • The eraser tool has three variations. The standard *eraser* 🖌 works just like a real eraser but on a pixel layer; it deletes the pixels of the selected layer and allows pixels from lower layers to show through. When used on the background layer, it fills the space with the background color.

The *background eraser* 🖌 cuts out; that means it creates holes in the selected pixel layer. Thus, the layers below become visible. If there are no layers below the selected layer, you will have transparent holes in your image. So, either the background page, or other elements below the image, will become visible. However, not all image formats support transparency.[*]

** Table A-2 on page 332 shows which image formats support transparency.*

The *magic eraser* works similarly to the magic wand, except it not only selects the neighboring pixels with similar colors, and it also deletes them immediately. The options for this tool are similar to the magic wand.

Red-Eye Removal Tool • This tool is useful for removing the red-eye effect in pictures that were shot with flash. To remove red-eye, paint with the mouse over the red parts in the person's eyes. The brush replaces the red (and only the red) with a replacement color – typically black. Other methods to remove red eyes can be found on page 200.

Tools for Image Corrections

Many corrections such as dodging and burning, or blurring and sharpening, can be applied to the whole image or to selected parts of it. To apply these corrections to the whole image you would use the appropriate filter or adjustments under the Enhance menu.* To correct a few small areas, edges, or transitions, you can use the following tools. For more control of these tools it is better to keep their strength low in the options bar and, if needed, use them several times.

** See page 172 and page 189.*

Blur Tool • This tool blurs image areas, which means it softens brightness and color differences. Use the *blur filters* to soften larger areas.

Sharpen Tool • The sharpen tool increases differences between brightness and color differences and, therefore, renders them harder. Use the *sharpen filters* to sharpen larger areas or the whole image (see page 181).

Smudge Tool • The smudge tool allows you to smudge colors and shapes, as you do when you drag your fingers across a wet painting. It has only limited use in photographic editing as the resulting striations appear unnatural in a photograph.

Sponge Tool • With the sponge tool you can increase or decrease color saturation, depending on the choices you make in the options bar. In gray scale, it lightens or darkens the pixels.

Dodge Tool • If only some image areas are too dark, you can selectively lighten them with the dodge tool. Set the *exposure* parameter in the options bar to 10%, and if needed, rework the same area several times to keep better control over the result. Use a relatively large brush with a soft edge to reduce unnatural looking breaks in exposure. In the drop down menu *Range* you can choose if you want to affect the *shadows, midtones,* or *highlights*.

Burn Tool • Burning is the opposite process of dodging. It darkens those image areas that you paint with the burn tool, which produces the same results as in analog photography by longer exposure of the photographic paper in the darkroom.* However, clean white areas remain white, because if no image data is there, nothing can be burned in.

* *It is better to use the levels (tonal range) dialog box to correct larger areas, or the complete image (see page 168).*

Clone Stamp Tool • The standard *clone stamp* copies the pixels from a source area to the destination area which lies beneath the current position of the mouse cursor. The *pattern stamp* tool copies a previously chosen pattern to the areas you paint with the pattern stamp tool. For a more in-depth description of the clone stamp tool, see page 187.

Foreground and Background Colors

Many times you will want to paint an object or fill it with color. There are two colors that play an important role here: the *foreground color* and the *background color*. If you draw with the pencil, the brush, or one of the custom shape tools, the foreground color is used. If you use the eraser or delete something, the cut areas are filled or replaced by the background color. If you work with layers, (see page 152) the effect of the background color only works on the background layer, and on those layers whose transparency is locked. You can switch the foreground and background colors by clicking on the double-headed arrow 🔁. Using the keyboard stroke ⌨D (with the mouse over the tool bar) Photoshop Elements will replace the fore- and background colors with black and white.

foreground color

background color

The foreground and background colors can be selected by clicking on the foreground or background color swatch in the tool bar, which opens the color-picker dialog box. First, use the mouse to adjust the white slider ▶ ◀ to the approximate color range on the color scale, then pick the desired color in the large color area on the left. If you

Color Picker in Photoshop Elements

know the color values, you can enter them directly into the appropriate fields.

Various programs have different color pickers – sometimes even several different variations to choose from.

If you pick a color from the image with the eye dropper tool, it automatically becomes the foreground color.

5.3.5 Informational Windows and Palettes

Image-editing programs offer a series of palettes that simplify orientation, navigation, and information. Become familiar with these tools and organize your work window with those palettes and information boxes that are most useful to you.

Grid lines (here in green) help when straightening, and rotating.

Guides

Guides are useful for a number of editing functions. They help you orient yourself while rotating parts of an image, and help you to estimate lengths and perspectives better. These guides are only present on the screen and do not print. They are activated under View ▸ Grid. In the program preferences you can select the color and the line style used as well as their spacing. They are rather distracting, though, for fine retouching and for evaluating the whole image. Thus, for these purposes, you want to hide them again. Adobe Photoshop and Paint Shop Pro also let you pull individual guides out of the rulers.

Info Palettes

Undo History Palette (Photoshop Elements)

Palettes and info fields help you to gather information quickly, and keep an overview of image editing. First, inform yourself where these palettes can be located in your particular image-editing program (i.e., through online help sites). Here we give a few examples from Photoshop Elements, in which the palettes can either be found in the palette bin or activated through the View menu.

Info Palette • This information palette is very useful, because it shows color values picked with the eye dropper tool in two different color modes, the size of a selection or of an object while selecting or drawing, as well as the position of the cursor. The ruler units can be set under *More*. Use F8 to switch it on or off.

Navigator Palette • The navigator palette – use F11 to open or close it – shows the position of the current image area view in relation to the complete image. It is quick and easy to move the current image area view with the mouse, and is faster than using the scroll bars. Using the slider, you can zoom in and out much quicker than using the zoom tool.

Besides the palettes already introduced, there are several more, such as for color swatches, layers, and undo history. Stay organized by only keeping open those palettes that are useful and needed regularly.

Navigator Palette (Photoshop Elements)

5.3.6 Selecting and Masking

One of the most often used operations in image editing is the selection of an area to be worked on – this may be to copy it, to delete it, or to apply adjustments and corrections to it. Once you have made a selection – with one of the following tools – all changes made only affect the area within the selection. If you add a new adjustment layer with a selection active, the selected area automatically becomes a layer mask.

You have various tools available for making selections. To select the whole image, press Ctrl-A (Mac: ⌘-A), or use the rectangular marquee. To select smaller areas, or more complex shapes, you use the lasso, the magic wand, or the selection brush. The selection tools can be combined by using one after another and the affected areas are combined by adding, subtracting, intersecting, or inverting. The selection can still be moved with the arrow keys (↑, ↓, ←, →) on the keyboard. This is useful for fine tuning your selection.

Rectangular and Elliptical Marquee Tools • These tools allow you to select a rectangular or oval area of your image. While selecting, if you press the ⇧ key, a square or circle will be selected. If you do not want a hard selection edge – as is most often the case in photographs – you can set how many pixels wide the edge should be, through the feather function in the options bar. The elliptical marquee tool, and the lasso tools also have this feather function.

Lasso Tools • The lasso tools are more flexible than the marquee tools. You can draw (almost) all types of shapes with it. Especially important is that you can set a wide feather radius, which will give your selection a soft transition when copying or deleting it. Double clicking, pressing the ENTER key, or reaching the starting point will close the shape of the lasso selection. In most programs, the lasso tools comes in three variations:

(Normal) Lasso • This tool follows the mouse when you hold down the left mouse button while drawing the selection shape, allowing you to draw complex shapes and lines.

 Polygonal Lasso • Draw a polygonal shape with this lasso tool and click the mouse button only at the corner points to set a new anchor point. With this technique, you can quickly follow straight edges.

 Magnetic Lasso • The magnetic lasso tool works like the normal lasso; however, the program automatically finds the edges (contrast and color transitions) near the mouse cursor, and lays down the selection path on these borders. To change the direction, set a corner point with a mouse click. Clicking the mouse button while holding down the ⇧ key draws a straight line between the last mouse position and the current one.

 Magic Wand Tool • The magic wand allows you to select pixels that have the same or similar colors without having to draw an outline first. In the tolerance field in the option bar, you can set which pixels will be seen as similar. A value of zero means that only those pixels are selected that have exactly the same color, tonal range or color saturation as the one you clicked on in the image.

You will have to experiment with the tolerance value to get the selection you desire. If you hold down the ⇧ key while clicking on an additional pixel, the new area will be added to the selection, allowing you to select areas that are not related. If you deactivate the option *Contiguous*, all areas in the image with a fitting color value will be selected.

 Selection Brush Tool • The normal selection brush is better suited to select diffuse soft shapes of your images than the marquee or lasso tools because you can paint over the object with the brush and set the size and feather radius in the option menu. (The magic selection brush tool is available in Photoshop Elements, but is missing in Adobe Photoshop and Paint Shop Pro.) The painted areas will be selected or added to the selection. You can select a small flower, an edge, a cup, or similar objects this way. The transition between the selected and non-selected areas is called *Hardness*.

If you select the *Mask Mode* instead of *Selection Mode*, the painted area will be protected from any image adjustments you make subsequently, marked by a masking color covering the protected area.

Quick Selection Brush Tool • In Photoshop Elements 4, the *Quick Selection Tool* was added. It automatically finds the edges of a roughly painted image object after you release the left mouse button. Try this before you work with the standard selection brush.

Increasing and Decreasing the Selection • Because the basic selection tools are sometimes not enough to make a particular selection, you can add, subtract, or inverse the selection. In Photoshop Elements, you can set preferences in the options bar for how the selection is handled ▫▪▫▫: *New Selection, Add to Selection, Subtract from Selection,* or *Intersect with Selection.*

Alternatively, you can change selection parameters with keyboard shortcuts, which you keep depressed while using the selection tools. Because these functions are used regularly, you may want to make a note of these keyboard strokes.

It is usually much more efficient to use the shortcuts than the ▫▪▫▫ buttons in the options bar, and leave the setting in the *New Selection* ▫ position. If you forget to change the buttons, you may get surprising results.

Feathered Edges ▸ In many cases you may not want to have hard selection borders; instead you may prefer soft edges with smooth transitions. To achieve this effect, set the feather parameter in the options bar to the desired pixel width for the transition. The appropriate size of the transition depends on the resolution of the image, the size of the selection, and the adjustments and corrections you plan to carry out. Usually a feather of 3–8 pixels is sufficient. Feathered edges can be set in almost all of the selection tools (i.e., rectangular and oval marquees, lassos) as well as in the painting tools. Feathered edges need to be set **before** you make a selection to have any effect!

Photoshop Elements: Changing the selection in Windows:

Add:	⇧
Subtract:	Alt
Intersection:	⇧-Alt
Inverse:	⇧-Ctrl-I
Deselect:	Ctrl-D
Soft/hard edge:	Alt-Ctrl-D
Select All:	Ctrl-A

Photoshop Elements: Changing the selection on a Mac:

Add:	⇧
Subtract:	⌥
Intersection:	⇧-⌥
Inverse:	⇧-⌘-I
Deselect:	⌘-D
Soft/hard edge:	⌥-⌘-D
Select All:	⌘-A

→ *The selection can be fitted to an object via the Transform Selection command in Photoshop (but, unfortunately, not in Photoshop Elements).*

After all the selection theory, we will now give a practical example. In figure ① we want to select the sky to saturate the color slightly. Because the color is relatively uniform, we can use the magic wand tool. Clicking once in the sky gives us the selection of figure ②. The selection is marked by the white and black line surrounding it. Because it seems to move, this line is also called "marching ants". The selection is good, but a small piece in the lower right corner is missing.

Instead of changing the color tolerance, we simply click in the remaining part of the sky while holding down the ⇧ key (which adds to the current selection); so we quickly and easily selected all of the sky (figure ③).

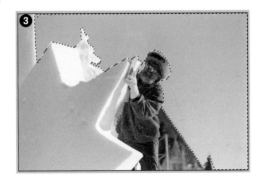

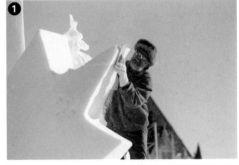

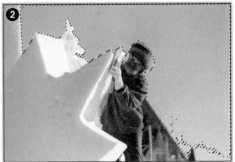

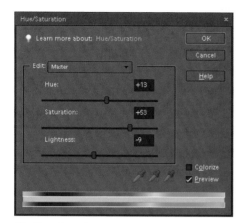

④ *Photoshop Elements Hue/Saturation dialog box.*

⑤ *Layers palette with the adjustment layer*

Increasing the color saturation is done in the Hue/Saturation dialog box. This function can be found under Layer ▸ New Adjustment Layer ▸ Hue/Saturation. The dialog box is shown in figure ④. We now drag the saturation slider to the right to increase color saturation. Experiment with the hue slider to get a stronger bluish color, and reduce the lightness by dragging the appropriate slider to the left. This renders the sky even darker and more saturated. The result can be seen in figure ⑥.

With these steps we have already made a fairly complex correction, which is also selective due to the area we selected beforehand. This area automatically becomes a selection mask in the adjustment layer. The adjustment layer can be seen in the layer palette, with a small icon, and the title Hue/Saturation.

The beauty of adjustment layers is that they are not permanently committed to the image, but can be changed at any time. Double-clicking the 🖥 icon in the layers palette opens the Hue/Saturation dialog box again and the sliders can be readjusted. You can also hide the correction by clicking on the eye symbol of this layer in the layer palette, which lets you compare the before and after pictures.

If you click on the layer and drag it to the trash bin with the mouse, the layer, and with it the correction, is deleted.

Actually, we got a little ahead of ourselves talking about layers. More information on layers – and especially about adjustment layers – can be found in section 5.3.8, with a continuation in section 5.20.

To the left (figure ①) the original image, and to the right (figure ⑥) the picture in which the color of the sky is now more saturated.

Masking

Masking protects an area you choose from any adjustments or corrections you may perform on the image. In the darkroom you cut out and place a paper mask on the area you want to protect. In electronic form, if you want to lighten up only parts of an image, you mask those areas that you do not want to lighten beforehand. The masked areas are marked with a color; in Photoshop, and Photoshop Elements, this color is generally red.* Afterwards, you can hide the mask again.

* *The color that represents the masked area can be defined, independent of the current foreground or background color. It simply marks the masked area.*

Some programs – i.e., Photoshop and Paint Shop Pro – also have layer masks that hide the masked areas in the layers below those you choose to be affected by the layer mask. These masks can be saved and exported so they can be reused in other image files. Photoshop Elements also uses masks in layers (see description on page 152), but does not have separate layer masks. However, in Photoshop Elements, an adjustment layer can have a mask.

If you activate a selection, the area surrounding the selection automatically becomes a mask (without marking it with the masking color!). Subsequent painting is only visible **inside** the selection!

→ *If a tool is not working, it may be because you are trying to use it outside of a selection area.*

5.3.7 Tool Cursors

Many tool cursors can be customized;** that means their shape, type, size, and hardness can be changed. These adjustments are possible for each tool separately. Some cursors are already predefined, depending on their use. Generally, you can set the size and hardness individually. Photoshop Elements lets you do this in the tool's options bar:

** *For example, with the pen, brush, eraser, blur and sharpen tools, sponge, smudge tool, dodge and burn tools, clone stamp, or selection brush.*

Additional brush cursors can be defined by the user – in Photoshop Elements, under button Ⓐ, in Presets Manager.

Even if you do not wish to define new brush tips, you should become familiar with the settings of this function, and especially, set the size and hardness of the tools you use. For example, when you paint your image, soft edges are desirable in some instances and undesirable in others. When working with the eraser tool, or the sponge, dodge or burn tools, you should also make use of an appropriate opacity, which allows you to decrease the effect of the tool. The same is the case when working with the clone or pattern stamp or with the brush or pencil. You should experiment a bit with the effect of the opacity setting with these tools.

A tool tip can take a specific form (though this is not used in photo editing very much), for example, the shape of a figure or a pattern, such as a butterfly. When drawing with the brush, the pattern is repeated along the path of your brush stroke. The distance between the repeated pattern can be set under *More Options*.

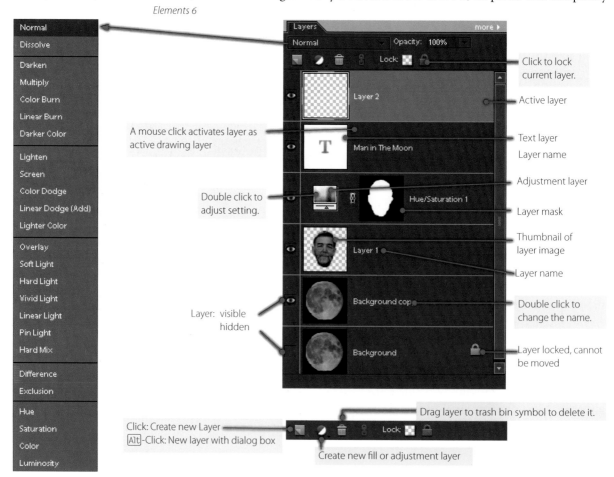

Text layer

Background layer Drawing layer

*Layers are like transparent sheets stacked
above one another.*

▼ *Figure 5-4: Layers Palette in Photoshop
Elements 6*

5.3.8 Layers

Layers are an important concept in image editing. They are therefore supported by all serious image-editing programs. Here, we will explain layers as they are used in Photoshop Elements 5.0. However, the procedures in other programs, such as Paint Shop Pro, Picture Publisher, or PhotoLine 32, are similar.

When you work with layers you should activate the layers palette to keep an overview of your work. Figure 5-4 shows the layers palette of Photoshop Elements 5.0 with the most important symbols.

You can imagine layers to be like transparent sheets stacked on top of each other. Image elements of layers that lie above, therefore, more or less cover up layers that lie below. If you copy an image element and place it into the same image (or another image file) it is placed on to its own, new layer. The same is true for text or vector objects, which are also automatically placed on their own layer. The first layer (the lowest) is generally called the *background layer*.

The transparency of a layer can be set in the Opacity slider box, and can be changed at any time. If it is set at 100%, its pixels will completely

Normal
Dissolve
Darken
Multiply
Color Burn
Linear Burn
Darker Color
Lighten
Screen
Color Dodge
Linear Dodge (Add)
Lighter Color
Overlay
Soft Light
Hard Light
Vivid Light
Linear Light
Pin Light
Hard Mix
Difference
Exclusion
Hue
Saturation
Color
Luminosity

Layers more ▶
Normal Opacity: 100%
 Lock: Click to lock
 current layer.

Layer 2 Active layer

A mouse click activates layer as
active drawing layer
 T Man in The Moon Text layer
 Layer name

 Adjustment layer
Double click to
adjust setting. Hue/Saturation 1
 Layer mask

 Thumbnail of
 layer image
 Layer 1
 Layer name

Layer: visible
 hidden Background cop Double click to
 change the name.

 Background Layer locked, cannot
 be moved

 Drag layer to trash bin symbol to delete it.
Click: Create new Layer
Alt-Click: New layer with dialog box Lock:

 Create new fill or adjustment layer

cover up all layers below; if the opacity is set at less than 100%, the layer will be more or less transparent. When the top layer is partially transparent* the layer(s) below will show through to a certain degree, depending on the opacity and fill percentage of the top layer.

* This means the opacity of a layer is < 100%.

Most programs support a number of layers – Photoshop Elements supports up to 8,000. The layers can be named and renamed. When using multiple layers, it is useful to give recognizable names to the layers to stay organized.

→ Because layers take up a lot of storage space, it is better to limit the number of layers if you do not have high storage capacities.

Photoshop Elements layers are made visible or are hidden by clicking in the first column of the layers palette, and are activated by clicking on the layer name. Only the currently active layer (marked in color in Photoshop Elements) can be modified. In adjustment layers (as we will describe later), the adjustments can be changed any time during image editing.

→ There is only one active layer at any given time.

Several layers can be linked together, as shown with the ▣ symbol. Linked layers are treated as one. They can be copied, deleted, moved, or transformed together.

You can also group layers. Grouped layers are indicated by their indent in the layer palette. The lowest layer in a group is the base layer. It defines the opacity of the group and acts as group mask.

In Photoshop Elements two neighboring layers can be linked by clicking on the border between the two layers and holding down the Alt key (they are unlinked in the same way).

Several layers can be merged into one layer. The pixels of the different layers are computed into one, and graphical objects, such as text, are converted into pixels. Individual layers can also be copied, deleted, or printed separately.

Aside from the opacity, there are other layer parameters that can be adjusted, for example the layer mode (see figure 5-4, page 152). The layer mode determines how the pixels of a layer interact with the ones of the layer(s) below. In the *normal* mode the pixels of the top layer cover up (depending on their opacity) the layers that lie below. In the mode *linear burn* for example the covered up area shows as burned in (and therefore darker), the darker the pixels of the top layer are. If you placed a gradient in the top layer, the burning in of the lower layer follows the gradient.

Besides normal image and graphical object layers, there are also adjustment layers and fill layers. They can be accessed in Photoshop Elements under Layer ▸ New Adjustment Layer or Layer ▸ New Fill Layer.**

** You can do this faster by clicking on the ◐ icon in the layer palette.

Adjustment Layers ▸ In complex image-editing cases, a number of corrections are applied one after the other, including *levels*, *brightness/contrast* corrections, changes in *color saturation*, or *invert*, *threshold*, or *posterize*. At times you may want to go back and change corrections you made previously, without having to undo all the subsequent steps. Adjustment layers allow just this kind of correction. The adjustment layer is not a pixel layer, but a correction layer which affects the layers below. The settings of the correction can – as long as the adjustment layer exists – be changed or deleted (by deleting the adjustment layer), without having to recalculate the image layers; the actual pixels of the image stay unchanged (unless you edit the image pixels with painting tools).

Image corrections such as levels (tonal range) corrections, changes in brightness and contrast, and similar adjustments, should always be done through adjustment layers, because they allow you to change the settings later on.

The effects of corrections can be limited to particular areas by using a *layer mask* – similar to carrying out the corrections directly on the pixel layer inside of a selection. If you make a selection in a layer and then create a new adjustment layer, the selection will automatically be converted to a layer mask in Photoshop and Photoshop Elements, which limits the effect to the selected area. You can alter the mask by painting in it, or deleting areas. (This is only possible in Photoshop, not yet in Photoshop Elements.)

In the areas that were deleted (and made transparent) the adjustment takes effect; while in the painted areas, there is no effect. In partially transparent areas (i.e., as created by a gradient), the adjustment has a reduced effect. The color you use to alter the layer mask is not important, rather it is the gray value that is important. When painting in the layer mask, this will only effect the visible parts of the layer(s) below. The mask is seen as a small thumbnail in the layer palette.

Photoshop Elements provides a somewhat restricted version of layer masks. To create a layer mask in Elements, you first have to create a selection and only then create the new layer. The selection will create a layer mask (the selection is white, the outside is black). But you cannot edit the mask after creating the layer. This is a severe restriction for the use of masks.*

Only the commands Merge Visible or Flatten Image combine all layers together into one layer and change the pixels in the image. To stay as flexible as possible, you should not perform any adjustments directly on the background (image) layer, but rather create separate adjustment layers. It is best to also create a copy of the background image to prevent accidentally altering the original image. The layers are only merged when image editing is finished.

Fill Layers • A fill layer is a layer area filled with a solid color, a gradient, or a pattern. Linked with an adjustment layer, the effect can be controlled by the tonal value of the fill layer – the stronger (darker) the fill, the stronger is the effect of the adjustment layer. Because you can also erase and delete in a fill layer, you can limit the adjustment layer effect to the filled area in a type of reversal of a mask.

Saving Layers

Saving your picture with the layers preserved* is only possible in certain file formats. Table A-2 on page 332 gives an overview of programs that support layers. Photoshop and Photoshop Elements can be saved in TIFF format, however the included layers may not be recognized by other programs. Therefore, the PSD format is a better choice for transporting files between different systems, because it is supported in most image-editing programs. If you save a collage (an image with layers) in the JPEG format for example, all layers will be merged into the background layer.

When saving layers, you should compress them to save storage space. For this purpose, LZW compression is useful.

The layer mask can be recognized by the mask symbol in the layers palette. The adjustment is effective in the white areas of the mask.

Layer mask

** To find a way around the restriction, see the description of Sue Chastain at: http://graphicssoft.about.com/od/pselements/qt/layermasks.htm*

Fill layers support different types of fills, and different modes.

** Perhaps to continue working on the image another time.*

→ Saving image files with several layers in TIFF or PSD formats can create large files – easily 100 MB and more!
→ We only covered some layer basics in this chapter. You can find more on layers in chapter 5.20.

5.4 Color Modes and Color Management

Images can be in one of several different color modes, and these modes can be saved in a number of different file formats: TIFF, JPEG, PSD, GIF, and PNG. The *color mode* determines how the colors of the image pixels are described mathematically. The *color depth* gives additional information, or more precisely, which number value each color component can have. A *color space* is a color mode supplemented with information such as where the white point is located and which colors can actually be rendered.

5.4.1 Color Depth

Generally, an 8-bit value (1 byte) is used for each color component, which can have a value from 0 (not existing) to 255 (full color). Because the RGB mode uses three colors - one each for red, green, and blue -, one image pixel is described as 24-bit.[*] This allows the rendering of 16.77 million different colors. At this time there is no camera or scanner that can capture that many colors. However, this color depth description is usable, easy to calculate, and represents the standard. The color information is called bit depth and describes the color depth, and thus we speak of an image with 8- or 24-bit color depth.

Semiprofessional and professional programs can also work with color depths larger than 8- or 24-bit. Some use 16 bits per color component (that means 48 bits total for an RGB image), even if only 10 or 12 bits of the 16 bits are used. Images saved with this color depth need twice as much storage space as 24-bit images need. There are not too many devices that can even depict the color range that this makes possible. Even in the high-end Photoshop program, some processes cannot be completed in 16-bit mode.[**] (Photoshop CS significantly improved color depth support. Photoshop Elements can also process 16-bit color as of version 3, but quite a few of the Elements' filters and other operations do not!) Despite this, working in 16-/48-bit color depth makes sense if, for example, high-end scans or data from professional digital cameras in RAW format (with more than 3×8-bit) are processed. Tonal range, color, and contrast corrections can thus be optimized. Afterward, the image can be converted from 16-/48-bit to 8-/24-bit for additional image editing steps.

5.4.2 Color Modes

The *color mode* defines how a color is described – which components make up the color and how the values are saved. Digital cameras and scanners almost always supply images in the RGB mode. RGB describes colors through the color components red, green, and blue. For printing, the CMYK mode is used most often. For one-color images, the grayscale mode is used. There are also other models such as the Lab mode and the indexed color mode; the indexed color mode is used most often on the Web with the GIF file format.

→ *Color management is not an easy subject. Beginners may want to skip section 5.4 for now and come back to this section later.*

→ *Not all file formats can save all the described color modes or other data (see table A-2 on page 332). GIF, for example, is suited only for indexed colors.*

* *CMYK (with its four color components) comes to 32 bits.*

Most beginner programs such as Photoshop Elements, Photo Express, and PhotoDesigner Pro only process colors up to 3 x 8-bit and black-and-white images with a maximum of 8 bits; 16-bit per color components are supported only by (semi) professional image editing programs.

→ *All the examples in the following part of the chapter will be based on using 8-/24-bit color depth.*

Additive color space in the RGB system. Equal parts of red, green, and blue result in neutral gray or white.

8-bit (256 steps), 200 ppi

4-bit (16 steps)

Black and White, 1-bit (1,200 ppi)

Black and White, 1-bit with dithering (1,200 ppi)

RGB Color System

In the RGB color system, a color of an individual image pixel is described in three values, one each for red, green, and blue. They can be individually described with either 8- or 16-bit color depth; the standard is 8-bit. The RGB system is based on colors being emitted from an illuminant, such as can be found in monitors. In CRT devices, a stream of electrons causes the phosphor of the monitor to glow. In LCD monitors, the white background light is filtered with color filters. The color system is described as an *additive color system* because each color component adds light and all three colors at full strength result in the color white. The RGB color system cannot display all the colors the human eye can recognize, but it has a much larger range than the CMYK system described later.

Grayscale Mode

When you're working with black-and-white photographs, only 8 bits (in the most popular mode) are needed for the luminance (brightness). This results in 256 degrees of brightness between 0 (pure white) and 255 (darkest black). Also, this mode can have larger depth (i.e., 16-bit); however, the extra bits are rarely used and only supported by high-end programs. When you convert a color image to a grayscale image by changing the mode, the color values are recalculated into luminance values. For some images, you should use other, more differentiated methods of conversion (see page 173). Grayscale images can also come in color depths less than 8-bit, but these formats are not supported by all programs or functions.

Bitmap Mode

If the color information is reduced to pure white and pure black, 1 bit per image pixel is enough and the storage requirements drop to about one-eighth of an 8-bit grayscale image. These bitmap mode images are also called line drawings or bitonal images. The color used does not have to be black. Many image editing functions cannot be carried out in the bitmap mode (such as distorting, as well as many filters). If you want to scale a bitmap image, you should first convert it to grayscale mode, scale it, and then convert it back to bitmap mode.

Lab Color Mode (or CIE-L*a*b)

The Lab (or L*a*b*) color mode saves colors with three components, like RGB. However, instead of using R, G, and B components, it uses luminance (brightness) as well as two color values (chromatic values) a and b; a is a green-to-red component, and b is a blue-to-yellow component.* (For the individual lab components, 8- or 16-bit values can be used.) The Lab model is based on a color standard that was defined in 1931 by Commission Internationale d'Eclairage (CIE) and has been renamed in the meantime to

CIE-Lab. An essential characteristic of the Lab color mode is that it is device independent. Therefore, it is used when colors are converted from one mode to another as a (intermediary) *transfer color space*. Images can be converted from other modes into the Lab mode and back with almost no loss. (Small mistakes develop due to rounding errors in the calculations.) However, not all programs support the Lab mode. Photoshop Elements does not support the Lab mode.

LAB color model

Indexed Color Mode

Large color ranges are not always necessary, and oftentimes the necessary storage space and amount of data are too much for an efficient transfer - for example, for simple graphics on the Web. One solution is to use indexed colors. The data in this mode is in a small table, and each color used has a specific place in the table. The position in the table holds the values of the individual color components for each specific color. Typically, tables have 256 or fewer colors. An image can thus have any color possible, but only 256 (or fewer) together at a time. Every image pixel therefore only holds 8 bits. Instead of showing the color, the image pixels refer to the position of the color in the table. This method is used in the GIF and PNG-8 file formats used on the Internet.

Original, RGB, 24-bit LZW-TIFF, 300 ppi, 488 kB

The table is saved as part of the image data. So you don't have to spend much time building this table yourself; the image editing or conversion program takes care of it automatically, but you can make certain adjustments (see page 215). If you need fewer colors, you can create a smaller table with fewer than 8 bits per pixel. For Web graphics, some of these 256 possible colors are occupied by colors used for the operating system, and thus the possible colors used for the image shrinks to 216 (including 1 for transparency); 39 are reserved for the system.

Color table of the following image with 256 entries

While photographs with few colors and gradients can be converted to the indexed color mode without too many visible losses, images with fine gradations and many subtle colors will lose significant image quality. Black-and-white images can be converted with very little loss, oftentimes with a color depth smaller than 8-bit.

When converting images from RGB to indexed colors, you can indicate if dithering should be used. *Dithering* simulates colors that are cut from the image by using a pixel raster of neighboring colors. At times this will visually improve color perception and reduce stark color breaks.

Indexed colors, no dithering, 8-bit GIF, 156 kB

Indexed colors, with dithering, 8-bit, 184 kB

Indexed colors, no dithering, 6-bit, 76 kB

Indexed colors, with dithering, 6-bit, 132 kB

* For example, Photoshop Elements does not support the gradient tool in images converted to indexed color mode.

Subtractive color system of CMYK

** A 16-bit value is also possible.

Not all image editing programs support the CMYK mode. Some beginner programs such as Photoshop Elements cannot handle this color mode.

Some filters cannot be used and some image editing functions cannot be carried out on images in the indexed mode.* Therefore, it is better to work on photographs in the RGB mode and only convert the finished image to indexed colors for integration on a website and export it as a GIF or PNG-8 file. Most programs offer special settings that optimize the image during exporting.

CMYK Color Mode

Pictures are printed using offset printing in books and with laser printers with the four-color method CMYK, using the base colors of cyan, magenta, yellow, and black. Black is called the key color. Most ink-jet printers also use these colors.

The CMYK system is a subtractive color system. Every color absorbs parts of the light and reflects only the remaining parts. All three base colors together absorb almost all light and therefore result in black. Due to impurities, the combination of the three base colors of CMY results in a dirty brown. Therefore, black is added as a key color.

Photographs and other images are prepared for printing by converting them to the CMYK mode. Typically, an 8-bit value is used for each of the four color components.** The storage space requirements are therefore one-third larger than in the RGB mode because now 4×8, or 32 bits, are saved per image pixel.

Color images are – if they are meant for printing – edited and saved in the RGB mode and a copy of the final image is converted to CMYK for printing.

Other Color Modes

Image editing programs offer a number of other color modes. This includes, for example, HSL, which has some similarities to the Lab mode. The color is described by hue, saturation, and luminance. The color is indicated by a degree that represents a position in a color wheel. A similar color mode is HSB (hue, saturation, brightness). This mode is not directly supported by either Photoshop or Photoshop Elements. You'll see this mode in some dialog boxes in which you can adjust the color temperature or hue.

5.4.3 Color Reproduction, Color Management

This section includes a simplified explanation of color reproduction and color management, but it's a complex subject and perhaps confusing at first. Therefore, you may want to skip it now and come back to it when you are more familiar with the other aspects of image editing.

The color handling of monitors and printers was briefly touched upon in section 5.4.2, but it needs to be explained in more detail here because it is the reason color management is so important.

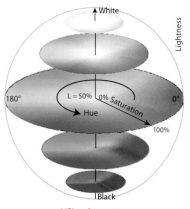

HSL color system

The devices used in the digital image editing process - such as cameras, scanners, monitors, laser and ink-jet printers, photo printers, and offset printing presses - have the unpleasant tendency to *see* and produce colors differently. A CRT monitor produces an image pixel by means of an electron stream that makes phosphor particles glow. The color of a particular image pixel is created by activating three phosphor points with different intensities. If all three are activated with the maximum intensity, the three light effects of red, green, and blue combine and produce the impression of white. If all three points are activated at the same level but at a lower intensity, a gray image pixel is created. This is called an *additive color method*. In an LCD (TFT) screen, three crystal filters filter the white background light, creating colored, glowing points. Their light spectrum is different from the phosphor method though, and this is why the color behavior of TFT screens differs from cathode ray tube (CRT) screens.

The color build-up on printed matter is completely different. Image pixels do not glow as they do on a monitor, but the color applied through printing reflects light. Ideally, we would assume that pure white light is hitting the printed surface. The color absorbs some light rays. If all is absorbed, the area will appear black; if (almost) all the light is reflected, the color appears as white. Therefore, this type of color method is called a *subtractive color system*. A much smaller number of colors can be printed than the human eye can perceive and even a few less than the monitor can reproduce. Within the printing world there are additional differences between monitors (for example, due to different mixtures of phosphor) and printing methods (depending on the whiteness and reflection characteristics of the paper). Therefore, even if the same printing method is employed, the colors will need to be adjusted for the paper used.

Color management is a complex subject, and this is only an introduction. For suggestions for more resources, see appendix C.

Color Management

The job of color management - also called *color management system,* or CMS – is to transform a given color for a specific reproduction so that the (mathematical) color value of the original is as close as possible to that of the reproduction device.

Another term for color management is ICM (image color management).

For this purpose, the color characteristics of a device are measured and recorded in a *color profile*. This profile describes the color characteristics of the device (or of a virtual color space) in the shape of a table or matrix. The profile used most frequently is the *ICC profile*.

When a photograph from a digital camera is opened, the system remembers – if a color management system is used – the ICC profile of the camera or assigns an sRGB profile. It embeds the camera profile into the image file. The profile describes the color system of the camera in terms of the ideal transfer color space (usually CIE-Lab). If the image is printed, the color management system temporarily converts the image from the image color space, while considering the camera profile, into the transfer color space and from there into the desired color space of the printer, while

ICC stands for "International Color Consortium", an international committee that focuses on true color processing.

considering the printer profile. The original file is preserved independently of the device.

The color profiles are either embedded into the image file, which is preferred for professional color processing with true colors, or they are assumed, as is often the case in the Windows environment. The color management system of Windows assumes that images without their own color profile belong to the sRGB color space.*

** Omitting the color profile saves storage space and is therefore done for Web images.*

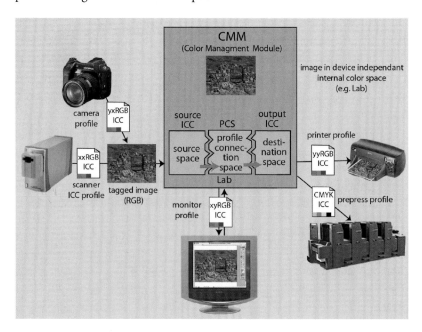

Diagram of CMS process.

The color management system is made up of *color management modules (CMMs)*. An operating system, or more precisely a color management system, can offer several CMMs. Ideally, color management is an integral part of the operating system, so it is available to all programs that want to use it. Windows includes such a system as of Windows 98 (also in Me, 2000, XP, and Vista). It is called *Image Color Management (ICM)*.

Mac offers a mature color management system called *ColorSync* in Mac OS 9.*x* as well as Mac OS X.

If you are using a good image editing program, it should support the color management system of the operating system and make certain settings available, especially the settings for color spaces. These settings are discussed in the next section.

5.4.4 Color Spaces

A color space is a color model with additional information about not only which colors can be mathematically described, but also which colors can actually be reproduced on a particular device of a particular class. Not all mathematically described value pairs of a color mode are actually visible to

the human eye or can be reproduced on a device. Therefore, color spaces are an integral aspect of a color management system.

The most comprehensive color space is the CIE-Lab color space, which covers all the colors the human eye can perceive. Figure 5-5 shows it as the largest color space in comparison to other color spaces. Its range was defined by the CIE (Commission Internationale del'Eclairage, an international committee established to standardize colors) through measurements with many participants. Conversions into the CIE-Lab color space (and perhaps back) are therefore lossless. This is the reason the CIE-Lab color space is used as transfer color space between different color models.

Monitors, on the other hand, cannot reproduce all visible colors. Even though all screens work with the RGB color mode, there are several RGB color spaces that all use the RGB color model to describe colors. Even more limitations apply to the reproduction of colors in print, for which the CMYK color space is used most often. Thus, when an image with saturated colors is converted from RGB to CMYK, it becomes paler and oftentimes darker because many of the light and glowing, saturated colors of the RGB color space cannot be printed. They are converted to similar but printable colors. Therefore, it is better to avoid unnecessary color space conversions or to only do them once.

Good image editing programs* can set a particular color space. This is the color space that is used for editing if no other settings have been activated. The colors in the color picker are matched to it and the image is displayed within it. The RGB color space should be used for working on a monitor.

Monitors and RGB images most often work with the sRGB color space, and many digital cameras deliver the pictures in this color space without explicitly indicating the image file's profile. A device's profile – e.g., of a camera – shows which color reproduction characteristics the device has. sRGB comprises the colors that are reproducible by most monitors. The sRGB color space is probably the best for printing images on your own inkjet printer or on the photo printer at the lab. The Adobe RGB (1998) color space is larger. Other RGB color spaces are, for example, Apple RGB, ColorMatch RGB, and PhotoPhoto RGB (a very large one). The latter two are larger than ECI and Adobe RGB.

The ECI RGB color space (see Figure 5-5) is even more comprehensive and better suited to working with photographs that are going to be printed on an offset printing press. It is used for working with images in the prepress environment because it includes all the monitor colors as well as all printable colors. So far it is not included in most image editing programs. However, you can find a profile on the ECI website [10]. For printing and color separation, the images are converted after image editing to the CMYK color mode. The color profile you use must match the printing method and the paper used.

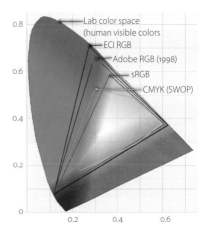

Figure 5-5: Color range (gamut) of different color spaces

* For example, Photoshop, Photoshop Elements, and Photo Paint. Paint Shop Pro added this option in Version 8.

sRGB stands for "standardized RGB".

→ Adobe RGB and ECI RGB have a similar color range but different white points: Adobe RGB uses 6500 K (D65), suitable for printing photographs on photo printers, and ECI RGB uses 5000K (D50). ECI RGB is suitable for photographs in a prepress environment.

ECI = European Color Initiative, an association for the standardization of color processing, especially in the prepress environment. On the ECI website, you can find a number of profiles for printing (see [10]).

The easiest way to obtain this color profile is from the print shop, matching the printing method and the paper. Otherwise, you can use a standard profile. This may be *Pantone process coated* for smooth glossy papers typical in books or brochures or *Pantone process uncoated* for simpler papers. For grayscale images you should pay attention to the *dot gain*. It results from the black color spreading slightly during printing and thus the resulting image will appear darker than on the monitor. The dot gain can also be described in an ICC profile. Without an appropriate profile, you can assume a dot gain of 10 to 20 percent (in the darker image areas) and set this in the standard profile during conversion.

Color Management Settings for Image Editing

The image editing program should of course use the color management system of the operating system (or come with its own, as do Photoshop and Photoshop Elements) and offer appropriate settings.

In Photoshop and Photoshop Elements, you can find this feature by choosing Edit ▸ Color Settings. You can determine whether you want to use color management and for what purpose. At the same time, you can set the color space you want to work in and the color spaces or color profiles that should be used during color space conversions. Elements offers only sRGB and Adobe RGB. Both are suited to work with photographs, but Adobe RGB* has a larger color space and images that come from high-quality cameras have large color spaces as well. sRGB cuts some of these colors.

Adobe RGB is correctly written as Adobe RGB (1998).

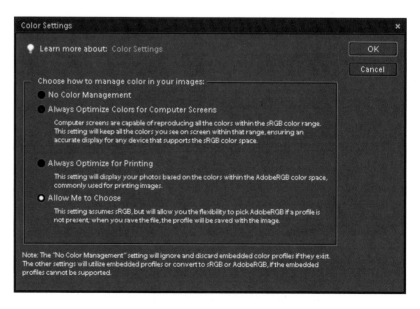

Photoshop Elements offers only simple CMS settings.

These settings are found in different places in different programs and should be set when you are personalizing your work area as mentioned on page 134.

5.4.5 Color Mode Conversions

At times the color mode of an image needs to be converted form one to another. For example, photographs might need to be converted from RGB to CMYK. This automatically includes a conversion of the color space. During a conversion from a larger color space to a smaller color space (or not completely intersecting color space), the image can loose color definition, and that cannot be undone when the image is converted back to the original color space. This is the reason such conversions should be avoided or at least be limited to only one time. The conversion of a color mode (and color space) into the CIE-Lab mode and color space is practically lossless.

If an image is converted to a specific color space – and unfortunately not all image editing programs support this feature – a color profile with the appropriate color space is added to the image file. This is the only way a program has to determine how the colors are to be reproduced in the RGB mode and which colors (i.e., of those you want to add) lie outside of the reproducible color range.

Photoshop, as well as other programs, allows you to activate and choose a color for the gamut warning, which identifies those colors that cannot be represented in the target color space (see page 160).

Some programs (like Photoshop) can then give a *color range warning* (*gamut warning*). The profile accompanies the image from then on. If it is removed, the image might (under certain circumstances) lose important information about how the color should be displayed correctly.

Different color spaces come with different white points. The *white point* is the color value that is defined as pure white (corresponding to color temperature).* sRGB and Adobe RGB have a white point of 6,500 K; ECI RGB has a white point of 5,000 K.

** More on the subject of color temperatures can be found on page 50.*

If the conversion is not possible without loosing true color representation, you can enter a setting that determines which should have *priority* during the conversion. This is called *intent*.

Rendering Intents – Conversion Priorities

Because colors are displayed so differently on various devices, there is no one best method for a conversion; instead, you choose what should have priority. For example, you can indicate that a color that can be displayed on both devices (or in both color spaces) should be represented 1:1. However, this can lead to the difference between two similar colors disappearing if the second color cannot be displayed in the target device and therefore its value would be matched to the first one. The colors of the original color space could also be reproduced in the new color space with a consistent color distance in the color range so that the color differences are maintained even if the color displayed in the target color space has to be adjusted slightly.

These rules for conversion are called *rendering intents*. Color management systems generally offer four different methods:

➜ *The rendering intents "Perceptual" and "Relative Colorimetric" are the best choice for converting photographs from one color space to another.*

➜ *If the white point should be matched in the conversion, "Relative Colorimetric" is used.*

▶ **Perceptual**
Colors are converted into the target color space keeping the *relative* (visual) *color relationship* the same, which means that the colors are compromised as necessary. This is generally the best method for converting photographs, especially, if you have a lot of highly saturated colors in your image.

▶ **Relative Colorimetric**
The white point of the original color space is matched to the target color space. This method is used when there are no significant differences between the two color spaces. This is a good alternative to *Perceptual* for converting photographs. I use it, when I convert the image to a large color space (which is rarely the case) or if I convert to a smaller color space and there are not many out-of-gamut colors in my image (e.g., not many highly saturated colors)

▶ **Absolute Colorimetric**
Reproducible colors are transferred 1:1; colors of the original color space that are not present in the target color space are converted to the closest color value (at the edge of the target color space). This method is used for logos and documents in which particular colors need to be reproduced as accurately as possible.

▶ **Saturation**
This method works with a high (similar) saturation in the target color space as in the original color space, while color accuracy is not so important. This is used for presentations and transparencies with diagrams or logo graphics.

Gamut Warning

By entering color values directly or changing color values through different functions, you can create colors that cannot be displayed in the various output media. This is especially true for printing, where you'll see a significantly smaller range of color (gamut) than monitors can show or digital cameras can capture. During image editing, it might thus be useful to see which colors can and cannot be reproduced accurately in the target color space. This is called *gamut warning*. With this indication, you can change a color that cannot be displayed correctly in the target color space to one that can be displayed. For printing this often includes reducing its saturation. This usually offers you better control than the automated processes of the print driver's color matching method or a conversion through a specific color profile.

Photoshop Elements, just like most other beginner programs, does not offer any settings for the gamut warning. For this function, you need to use the full version of Photoshop. On the other hand, the beginner is often overwhelmed or confused by these choices.

5.4.6 Color Channels

As explained earlier, image pixels are described by several values. Depending on the color mode, they are described with one (grayscale/indexed colors), three (RGB or Lab), or four (CMYK) values. Every one of these values can have a separate layer. However, they are not called *layers*, but *channels*. An RGB image thus consists of a red, a green, and a blue channel plus an additional channel for the whole image. The latter channel is called a *composite channel*. A CMYK image has at least four (or five) channels. These channels can be worked on separately, just like layers.

➔ *Color channels are an advanced subject in image editing. If you are a beginner, you may want to skip this subject at first, especially because only professional programs allow you to work with channels.*

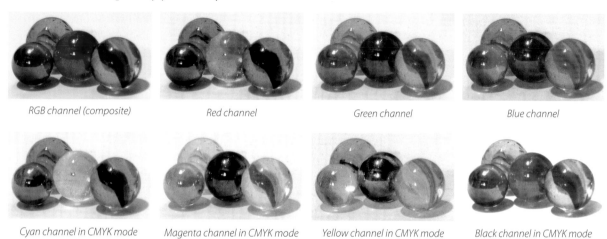

RGB channel (composite) Red channel Green channel Blue channel

Cyan channel in CMYK mode Magenta channel in CMYK mode Yellow channel in CMYK mode Black channel in CMYK mode

In photographs, the blue channel often shows more noise than the other channels. If you sharpen an image, the blue channel will show even more noise. Therefore, it makes sense in an RGB image to run the sharpen filter only on the red and green channels instead of on the whole image (all channels). Alternatively, you could convert the image to Lab mode and only sharpen the luminance channel (lightness values) and then reconvert the image back to an RGB file. Some images will look better if you reduce the noise in the blue channel by blurring it.*

➔ *The individual channels contain the respective color in a grayscale image.*

Not all image editing programs support working with color channels. Photoshop, and Paint Shop Pro support channels, while Photoshop Elements does not directly support channels through a Channels palette. However, these settings become available indirectly, for example, in the levels dialog box (tonal range correction – see Figure 5-6-Ⓓ on page 168), where you can choose the channel to which the correction should be applied.

* *More about "blurring" on page 191.*

Color management, if done perfectly, is certainly not easy. It requires a lot of know-how and experience. It is, however, well supported in current operating systems, and it's becoming easier. In addition, the programs that allow a smooth color workflow are becoming better and, just as important, cheaper.

➔ *The description here goes beyond the available settings in Photoshop Elements and other beginner programs. These functions typically exist in these programs, but they cannot be adjusted by the user.*

One of the simpler and most essential components in working with colors is the correct representation of colors on the monitor, because this

** *Even if you don't plan on doing any color management.*

is where we examine and evaluate photographs and where we carry out color corrections. Therefore, it is extremely important to calibrate and profile your monitor.** This is described in section 5.23, page 220.

5.5 The Actual Photo Editing Workflow

Now that you have learned some basics, we are ready to look at the actual image editing or photo workflow. The first thing to do, while you're taking the pictures, is to decide if you want the camera to save the image in RAW or JPEG or (perhaps) in TIFF format. Beginner and most compact camera models make the decision for you; they offer only JPEG. The better cameras – meaning more expensive with more features – allow you to save images in RAW and JPEG (and sometimes in TIFF). Practically all digital SLR cameras offer the RAW format.

For the first examples, I recommend that you use JPEG. Advanced users and professionals should always use RAW. Some cameras allow you to write both formats together onto the memory card. This can be useful: the JPEG files can be used for quick reference and the RAW files can be used if you want to optimize the image in the RAW converter and extract every last bit of quality from it.

In the following sections, I'll assume that you are working with JPEG or TIFF, either because that is how they came from the camera or scanner or because you already converted your RAW image in a RAW converter program and are now ready for image editing. RAW conversion is described – a bit out of order – in chapter 6. Even if you are working with only RAW files, you may still want to read the rest of this chapter before delving into the conversion process because some of the techniques described here are also common in RAW conversion programs.

Another question regarding color depth arises if you work with TIFF or RAW, either from a RAW converter or from a high-quality scanner: Do you select 8 or 16 bits (per color channel)? Again, if you have some knowledge, I recommend the larger color depth: 16-bit (or 48-bit in an RGB composite image).* It gives you more room for image corrections without loosing (visible) image quality, and it's especially important if several image corrections are carried out one after the other.

* *This requires an image editing program that can handle 16-/48-bit images, such as Photoshop CS, Photoshop Elements since version 3, Paint Shop Pro, Picture Windows Pro, or GIMP 2. A RAW converter module can be downloaded for the free GIMP program.*

JPEG allows only an 8-bit color depth, which I recommend for beginners; the program handles the file faster, the files need less scratch disk and hard disk space, and you can use any image editing program. The workflow described on the following pages is hardly affected. The professional should use 16-bit files as long as possible but will need a fast computer with a large hard drive. At the very end, when images are prepared for the Web or for printing, they are reduced to 8-bit and copied to a new file.

The actual image editing starts with contrast and color corrections, small retouching jobs, and perhaps image manipulation.

➜ *Please refer to the sequence of image editing steps on page 131.*

5.6 Straightening Images

If you take a picture of something that has clearly horizontal or vertical lines – a typical example is the horizon line of the ocean or the vertical lines of an architectural image – they should be horizontal or vertical in the image. Therefore, the objective is to *straighten* the main lines in the picture. This step is best done at the very beginning of the editing process, because the rotation introduces rounding errors into the calculation, which lowers image quality slightly, an effect that needs to be taken into consideration in subsequent steps. Additionally, rotating the image (in any degree other than 90 degrees) causes the image to be cropped on the corners and white areas to appear (see figure ②).

① *Original image with slightly slanted horizon*

You can rotate the image by entering a numerical value or freely by dragging. Because it is difficult to estimate the exact angle numerically, free rotation is preferred. Before doing so, activate the *grid lines* (in Elements use View ▸ Grid, see page 146) or drag *guidelines* from the rulers to help you line up your image (guidelines, however, are not available in Photoshop Elements).

Before continuing with other image editing steps, you should crop out the white areas. If the white areas are small, you may be able to fill them in with the clone stamp tool (see page 187).

② *Image after transformation (rotation)*

To rotate or straighten an image in Photoshop Elements, select the whole image (Ctrl-A). Zoom out so the image is surrounded by empty space in the work area. Then choose Image ▸ Transform ▸ Free Transform (or use the keyboard shortcut Ctrl-T). The image can be rotated freely with the mouse by placing the cursor near one of the corners. The cursor takes the form of the rotation cursor ↰. The change to the image is carried out only when you press the ENTER key (↵) or double-click inside the area. Therefore, you can drag to rotate the image more than once without loosing any image quality.

③ *Image after rotating and cropping*

Photoshop Elements offers an automatic function for straightening images (choose Image ▸ Rotate ▸ Straighten Image, optionally with additional cropping). This is worth a try, but it doesn't always produce the desired result.

Alternatively, you can enter a numerical value for the degree of rotation during the free transformation function (in Photoshop Elements in the options bar for the transformation function or by choosing Image Rotate). Guessing the correct angle is difficult though. If the result of the rotation was not optimal, the rotation should be undone. Try again with different parameters because the rounding errors that occur due to the rotation calculation add up and can cause more image deterioration.

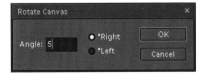

In Photoshop, the angle can be determined with the measuring tool (under the eyedropper) by moving along a line/edge that should be straightened out. The info palette will show the degree, which can then be used to correct the image.

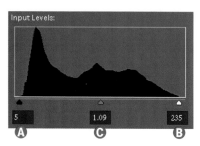

② *Result of the Photoshop Elements auto levels command.*

5.7 Tonal Range Correction (Levels)

After the image is cropped, tonal range correction is one of the most important and most often used image editing steps for digital photographs. It is not only relatively easy, but also quite effective, plus almost all image editing programs offer an automatic tonal range correction function. It allows you to improve scans that are too dark (as the slide used in the example) as well as underexposed, flat photographs.

For the beginner, it is easiest to try the auto function. In Photoshop Elements, the auto function can be found under Enhance ▸ Auto Levels. If you don't like the result, you can undo this step and make the correction manually. The tonal range correction is based on the histogram of the image (in Photoshop Elements and Photoshop, the histogram can be accessed by pressing Ctrl-⌘-L, ⌘-L on the Mac). The histogram shows the distribution of lightness values in the image. A bar chart shows how many times a particular brightness value occurs in the image. A tall bar signifies that many image pixels have this brightness value.

Figure 5-6:
Photoshop Elements Levels dialog box. In Photoshop Elements, it can be found by choosing Enhance ▸ Lighting ▸ Levels *(or* Ctrl-L, ⌘-L *on the Mac).*

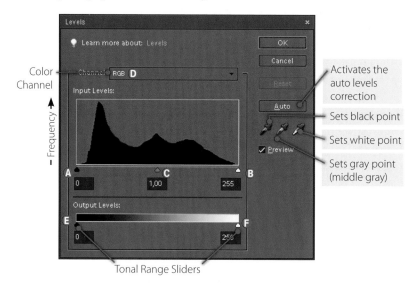

On the left side of the diagram you can see the frequency of dark pixels and on the right side you see the light ones. If the curve is rather flat, as in Figure 5-6 on the right side, it means that no or only a few white areas occur in the image; if the diagram shows an empty space on the left side, it means that black and very dark image areas are missing. The levels correction allows you to spread out the tonal range.

Move the left slider Ⓐ to the right until it touches the beginning of the "mountain".˙ All those (dark) brightness values lying to the left of this point become black. The slider on the right Ⓑ defines at which brightness value white should be. It is moved to the left to the edge of the mountain and comprises the white point. All gray areas on the right of this point become white. The slider in the middle Ⓒ regulates the mid tones (those with

Slight correction with the slider

the brightness value of 127, the gray point). It can be used to lighten (slide to the left) or darken (slide to the right) the whole image. You should be a bit careful with this slider.

If under certain circumstances you want to limit the tonal range of the image, you can do this with the sliders (Ⓔ and Ⓕ). Values to the left of (Ⓔ) and to the right of (Ⓕ) will no longer be present in the image.

If the preview is activated (which should always be the case), you can immediately (after a slight delay) see the changes in the image.

For the original image (figure ① on page 168), the right slider was moved considerably to the left. As a result, some of the detail in the light areas of the sky was lost, but the image got more detail in the structure of the waves and overall became a little lighter (supported by moving the mid tone slider Ⓒ, figure ③). The overall picture should not become too bright, though, to maintain the mood of the evening. The corrected image still has a color cast, which will be corrected in the next step (see section 5.8 on page 169). If you look at the histogram after the levels correction, you can see that the tonal range was spread out over the entire area, even though small breaks resulted in the histogram mountain.

Instead of moving the sliders, you can set reference points with the eyedroppers in the Levels dialog box. The 🖊 eyedropper sets the point or area that should appear black (the *black point*), and the 🖊 eyedropper sets a point that should become white (the *white point*). The middle eyedropper 🖊 defines the mid tones (the *gray point*). You can set the points with eyedroppers several times (same goes for the sliders) and the correction becomes permanent only when you click OK. Thus you can experiment with different values before saving your changes.**

Instead of applying the correction to all color channels (in RGB to red, green, and blue), you can also limit a correction to one channel. This enables you to make finer adjustments. In the example, you could correct a large part of the red color cast by making individual corrections in the blue and green color channels, but beforehand you should carry out a white balance!

Use the Channel drop-down menu in the Levels dialog box to apply a correction to a single color channel (this is also possible in Photoshop Elements). The channels can be corrected individually, one at a time. Continue examining your image during these corrections; to do so, you need to check the Preview check box!

5.8 Color Corrections

Color correction is probably the most important adjustment for digital images after the tonal range correction – while the tonal range correction already often yields a visible improvement of the color.

The best method for color correction besides a correct exposure is to set a good white balance in the camera. This may happen automatically in

③ *Image after manual correction using Levels*

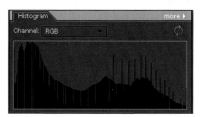

Histogram after tonal range correction

** ⌥ *or Cancel closes the Levels dialog box without making any corrections. The Reset button returns all settings to the defaults.*

→ *The corrections described in sections 5.8.1, 5.8.2, 5.9 and 5.11 can be applied either to the whole image or to a selected area.*

* See section 6.3, page 239.

the camera or by choosing the color temperature (see page 50). Or perhaps it will happen in the RAW conversion program if the image files are present in RAW format.* If the image is already present, from the camera or a scanner, color correction occurs during image editing.

When you're making color corrections, it's important to keep the settings for the monitor and work environment in mind, as described on page 133. Only the right settings allow you to correctly evaluate colors and color casts.

The color mode and working color space are also important for making color corrections. In the following examples, an RGB working color space,** which is most suited for photographs, will be used.

5.8.1 Removing Color Casts

In an image, color casts can be seen best in image areas that should be gray, such as a gray shirt, a white shirt with gray shadows, and gray in the clouds of the sky or in surfaces. The color cast is most visible in the mid tones.

Once you have located an area that should be gray, you can measure the RGB value with the eyedropper and view it in the info palette. In areas that should be neutral gray – without color cast – all three RGB components should be almost equally strong. This method gives you good information about a color cast, its strength, and the color direction. In this example, I took a reading with the eyedropper in the gray area of the sky, which resulted in an RGB value of R148, G120, and B121. Here red dominates by about 20 percent.

There are several options for making color adjustments:

① *Image with a clear red color cast*

Eyedropper RGB values from
image ① at point A

▸ Auto color correction, available in almost all programs
▸ Color variations, which is featured in many programs
▸ Color balance adjustment
▸ By changing the color saturation and hue
▸ By making selective color corrections

Almost all image editing programs offer an automatic color correction function. In Photoshop Elements, it can be found by choosing Enhance ▸ Auto Color Correction.

This feature is worth a try. If you are not satisfied with the result, you can undo the correction and work on a manual or half-manual correction.

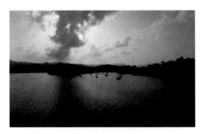

② *Image after auto color correcting with*
Photoshop Elements

Color Variations

Many programs already offer color variations that change the image in different color directions and show the results. The user repeatedly chooses the best version. You click yourself, so to speak, toward the best solution.

In Photoshop Elements, this option is available by choosing Enhance ▸ Adjust Color ▸ Color Variations. Here you can choose which tonal values

you want to work on. It is best to start with the mid tones in a medium strength. In this example, I first reduced red and then chose to lighten the image. Photoshop Elements shows different variations under the image and notes how each was corrected. Click on the variation you like the best. Elements corrects the image temporarily and shows new variations building on your choice. This way you click your way to a color-optimized image.

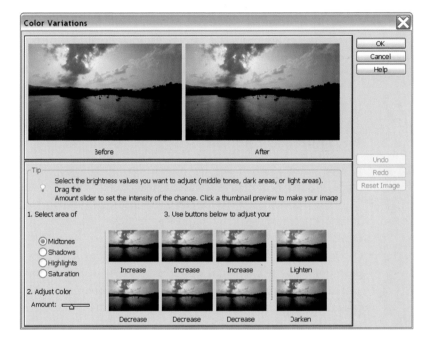

Photoshop Elements Color Variations dialog box

If you are shooting RAW files instead of JPEG, all basic color corrections – the white balance – should be done in the RAW converter (see chapter 6). In the RAW converter the white balance can be done without any loss of image quality (you will loose some image quality when correcting your white balance in standard editor working images with 8 bit color depth). Also try to do just **one** basic correction instead of repeating the same correction several times.

Changing the Color Balance

The previously described color variations are nothing more than the results of changing the color balance. You can make finer adjustments by using the color balance adjustment in Photoshop and Paint Shop Pro.

In Photoshop you find this function by choosing Image ▸ Adjustments ▸ Color. Each individual value can be set. If you have taken a color measurement with the eyedropper as described earlier, you can roughly calculate the percentage of correction necessary. To make the actual change, you move the slider to the complementary color of the color cast. Because

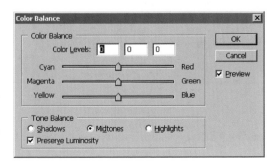

Photoshop Color Balance dialog box

the picture in the example has a red color cast, you would drag the slider toward *cyan*. Generally, you will want to keep the luminosity level because this correction is done after the tonal range has already been adjusted.

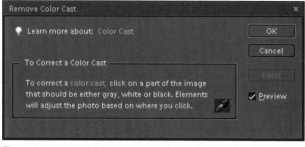

The easiest way, yet solid, to remove a color cast in Photoshop Elements

A simpler variation of this method is found in Photoshop Elements in the Remove Color Cast dialog box (Enhance ▸ Adjust Color ▸ Remove Color Cast). Photoshop Elements asks you to use the eyedropper to click on an image area that should be neutral gray. From the color values at that point, Photoshop Elements calculates the correction values and uses them on the image. Because you can click more than once with the eyedropper and see the result in the preview, this method is in most cases the easiest.

5.8.2 Hue, Saturation, Lightness

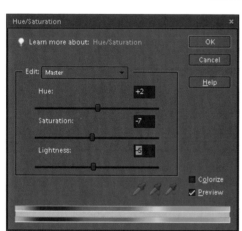

Hue/Saturation dialog box

If no color cast is present but the colors are simply too strong (saturated) or too pale, you can carefully adjust the color saturation. In Photoshop Elements, choose Enhance ▸ Adjust Color ▸ Adjust Hue/Saturation (or Ctrl-U); in Photoshop, choose Image ▸ Adjustments ▸ Hue/Saturation.

Here you can adjust the saturation (-100% is equivalent to the saturation in a black-and-white photograph) as well as the luminance of the image with the lightness slider. A color cast can be adjusted with the hue slider, but this function is not as intuitive as the color balance adjustment.

You can correct the overall color (master) as well as individual colors (red, yellow, green, cyan, blue, magenta). This allows for very detailed and subtle adjustments of individually colored areas without affecting other colors. The color area to be corrected can be defined in detail.

This is done by choosing a color area from the Edit dropdown menu in the Hue/Saturation dialog box, which causes sliders (▰▰▰▰) to appear at the bottom of the window that show the color area that will be affected. These can be moved with the mouse. The area between ▰▰▰ is the central area. The triangular sliders reference a transition area in which the effect slowly fades out from the center outward. If you move the sliders close together, only a small color range is affected by the correction. With the eyedroppers, you can pick up a color from the image as well as add or subtract certain color ranges.

Another type of color correction can be performed with the tools described in section 5.13.4 (page 189): sponge ▨, burn ▨, and dodge ▨. These are only used on small, specific areas for subtle corrections.

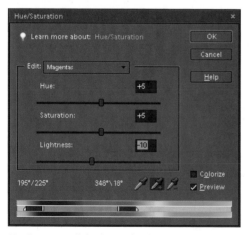

Hue/Saturation dialog box with color range selector

5.8.3 From Color to Black and White

At times you may want to have a black-and-white image, even if the original image is in color. If your camera has a setting for black-and-white photographs, you can use this option because the resulting image files will be significantly smaller. However, this conversion is also possible during image editing, generally with more control and better results than the camera option provides.

The easiest method is to change the mode of the image file – i.e., from RGB to grayscale. In Photoshop Elements, this is done by choosing Image ▸ Mode ▸ Grayscale. The system calculates a luminance value from the individual color components and uses this brightness as a tonal value. In most cases, this method does not deliver the best results. The image usually turns out flat and too dark. This is due to the fact that all color channels are figured in the calculation equally and the brightness value is then converted into gray.

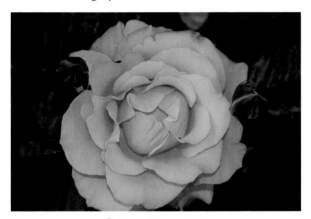

① *Original image (RGB)*

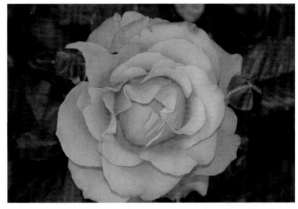

② *Converted to black-and-white using* Image ▸ Mode ▸ Grayscale

If the original image is a RAW file, you can create a black-and-white image by moving the saturation slider all the way to the left in Adobe Camera Raw, which results in a desaturated image (the resulting file is still an RGB file, even if it looks black and white). Further fine-tuning should also be done in the RAW converter. You can also use the Adjust Hue/Saturation dialog box in Photoshop Elements for the same purpose.

The standard method for a high-quality conversion from color to black and white is the channel mixer. It is offered in Photoshop and Paint Shop Pro, for example (but not in Photoshop Elements). The channel mixer makes it easy to combine the individual color channels into an optimized grayscale image and preview the result. In Photoshop, choose Image ▸ Adjustments ▸ Channel Mixer.

Before the conversion, look at the individual color channels and decide which channel produces the best range of

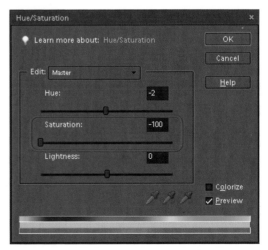

Black-and-white conversion by desaturating the image

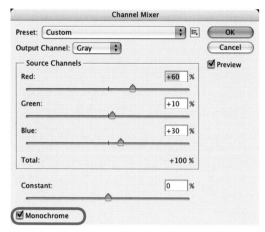

Photoshop Channel Mixer dialog (here with Mac OS)

brightness. This is typically the red channel, especially for portraits or other images with skin colors. But you can also mix the individual channels and experiment. In the image of the rose the highest level of information can been found in the green and in the blue channels.

Information in the three (RGB) color channels

In the Channel Mixer check the Monochrome box and mix the percentage of the channels with the slider bars. A good place to start for most images is 60% red, 30% blue, and 10% green. In general the total of all three channels should add up to about 100%. You can also use a negative value in a channel. The *Constant* value adds or subtracts a constant tonal value to the result.

A few (separate) filters have been specialized to convert colors to grayscale with much flexibility and control – for example, the free Windows plug-in Chrome filter from the Photo Image Filter collection by Nikonians [76]. Another Photoshop-compatible plug-in filter with a good black-and-white conversion can be found at Fred Miranda's website [82].*

** An alternative: "B&W Conversion" filter, which can be found at www.photo-plugins.com*

Since version 5, Photoshop Elements also offers a tool for converting to black and white. It can be found by choosing Enhance ▸ Convert to Black and White. Like many other filters and functions, this only can be activated in Photoshop Elements if your image is in RGB 8-bit mode.

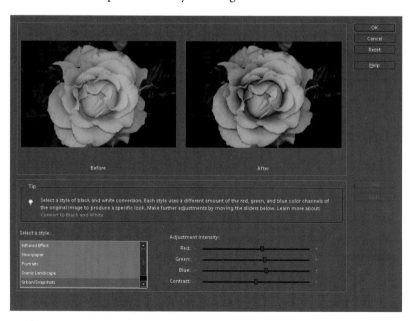

Black-and-white conversion function of Photoshop Elements.

Its structure and scheme are similar to the Color Variations option described on page 171. Again, the result is still an RGB image, as is the case with the channel mixer.

If you truly want an image in grayscale mode, you will have to convert the mode from RGB to grayscale (Image ▸ Mode ▸ Grayscale).

Photoshop CS3 comes with a new function for black-and-white conversion (actually, it is very similar to the Grayscale function of Adobe Lightroom). While the Channel Mixer provides three sliders (R, G, and B), Black and White has six sliders and allows for a very fine tuning of your black-and-white image. As with the Channel Mixer, the resulting image is still an RGB image. The function has some intelligence in keeping the total brightness level of the resulting image constant (you don't have to watch for the total percentage).

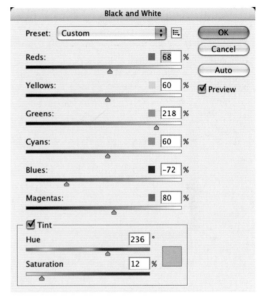

If the dialog is open and you click on a spot in your image, the cursor will take the form of an eyedropper and the slider controlling the dominant color at that spot is briefly highlighted. Pulling that slider to the right will brighten that color (and area), pulling it to the left will darken the corresponding colors in your image. You no longer have to guess the dominant color of an area that you would like to darken or brighten.

In the lower part of the dialog box you will find the *Tint* sliders. It allows you to tone your image (it's still in RGB). First set *Saturation* to about 10 %, then set the color of your tint, and finally adjust the Saturation to your liking; A value of 5 %– 10 % will usually do.

Black and White *dialog of Photoshop CS3 (Mac OS).*

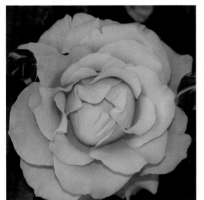

Rose converted using Photoshop's Black and White function. Both versions use a tint.

There is a number of predefined settings. Use the drop-down menu *Preset –* to recall them. They simulate various photographic filters (e.g., an Infrared or a Yellow filter).

Because a setting often suits a number of images, Photoshop allows you to save settings and recall them later from the *Preset* menu. Use *Save Preset* and *Load Preset* from the ▤ fly-out-menu of the dialog box for this.

5.9 Curves

A curve adjustment allows you to lighten or darken individual brightness values and recalculates the image or pixel layer. A curve determines which brightness values of the original image are reproduced in which brightness values of the final image.

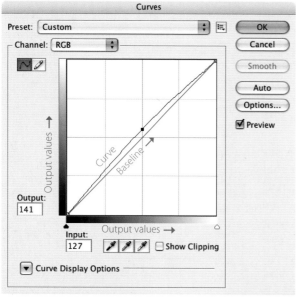

Photoshop Curves dialog box

With a curve, you can make relatively subtle contrast changes; for example, you can darken light areas slightly by moving the curve down (make the curve steeper) in the light value area on the right side or lighten dark areas by lifting the curve on the left side, just as other adjustments curves can be applied to the whole image or partial image areas. If you use a curves adjustment layer, you can still make changes to it at a later time. A layer mask lets you limit the effect to a specific area. Curves can be found in Photoshop (full version) by choosing Image ▸ Adjustments ▸ Curves. (Photoshop Elements does not yet provide *Curves*). The curve is at first a straight line in a 45° angle (see green line in the figure with the Curves dialog), and the only points on it are the beginning and end points. With this straight 45° line, no change takes place.

Let's see what happens to our image (figure ①) with different curves.

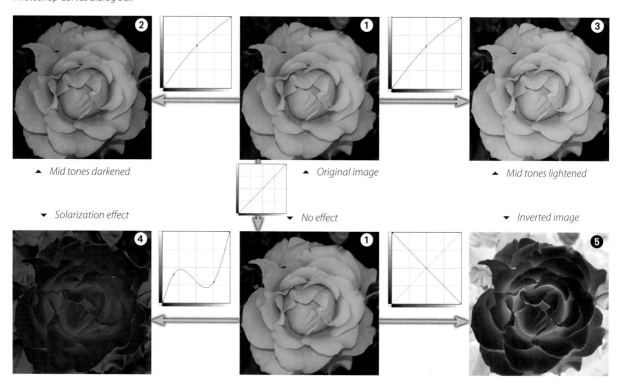

▲ *Mid tones darkened* ▲ *Original image* ▲ *Mid tones lightened*

▾ *Solarization effect* ▾ *No effect* ▾ *Inverted image*

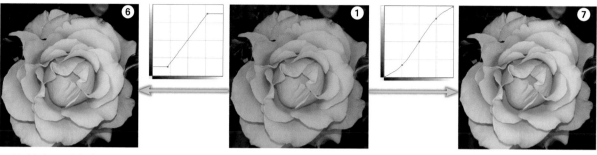

| Highlights and shadows cut | Original image | Mid tone values steeper (more contrast) |

If you click with the mouse on any part of the line, a point is set. These points can now be moved – either using the mouse or your arrow keys. If you lift a point above the 45° line, the appropriate tonal values become lighter (see figure ③); if you move it down, they become darker (see figure ②). Wherever the curve is steeper than 45°, the contrast becomes higher (see figure ⑦); flat curve portions lower the contrast. With specialized curves, you can create solarization effects (figure ④) or invert the tonal range (figure ⑤). Typically, the curves should not be as extreme as the examples show. One of the curves used most often is the classical S curve shown in figure ⑦ or ⑨. (Optimizing the contrast with the classical S curve is often one of the first image corrections (after correcting the tonal range). With this, the color saturation is increased a little as well, so that further overall saturation adjustments do not have to be made.

Unfortunately, Adobe cut the curves adjustments from Photoshop Elements. Therefore, you will have to use Photoshop, Paint Shop Pro, or the free GIMP program to be able to use the curves function. The free tool Oriens Enhancer [84] also offers curves adjustments. As of Elements version 6, however, there is a simplified version available: Enhance ▸ Adjsut Color ▸ Adjust Color Curves.*

You will have to play and experiment with the curves command to develop a feel for it.

In those programs offering curves, the command can be applied to the whole image as well as to individual color channels; depending on the color mode of the image, this could be R, G, and B or C, M, Y, and K or L, a, and b. Curves can also be used on grayscale images.

At times, you'll create curves that you might want to use again. They can be saved (with a recognizable name), loaded back into the curves dialog box, and if needed, further adjusted. Generally, I do not use the curves adjustment directly on a pixel layer, but use them by means of a curves adjustment layer (as described in sections 5.3.8 and 5.20).

The curves adjustment is one of the most powerful image editing tools. It combines the functions of many other tools within one dialog box (although using it might not be all that intuitive): Brightness/Contrast, Color Balance (by using curves in individual color channels), Invert (figure ⑤), Threshold, and Posterize (by using a staircase curve).

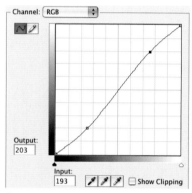

⑨ Typical curve to increase the contrast in the mid tones

* You can also find free plug-ins on the Internet which provide the Curves function for Photoshop Elements, e.g., at: http://free.pages.at/easyfilter/curves.html.

⑩ Like most adjustments, a curve can be saved and loaded again later to apply it to other images with similar characteristics.

5.10 Shadow/Highlight

Sometimes the contrast of the photographed scene is so high that the camera can hardly or not at all capture the complete tonal range. In these cases, you will have to decide if you want to expose for the shadows or the highlights and accept a loss of detail in the opposite tonal range.* But even if the scene doesn't have so much contrast, you may still find almost blown-out highlights or clogged-up shadows in your pictures. Because some of these areas hold important image information, you may want to correct them so that the shadows become a little lighter and the highlights darker so that detail is still recognizable. But not all light or dark pixels should be changed, only those that are located in a light or dark *area*. This is exactly what Photoshop's Shadow/Highlight function does. It is useful – as mentioned in the workflow diagram on page 131 – after the image is corrected with curves.

** Or you can use the HDRI technique. This technique is too advanced for the beginner.*

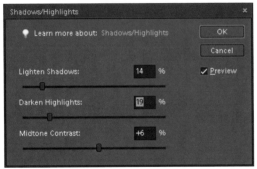

① *Photoshop Elements Shadows/Highlights dialog box*

This function was introduced quite late – in Photoshop since Photoshop CS and in Elements since version 3 (the latter only comes with a simplified version). It allows you to make very subtle corrections in the details for the light and dark image areas separately.

Photoshop Elements offers only a simplified form (figure ①) of Shadow/Highlight, but it contains the most essential functions. In Elements you can call up the dialog box by choosing Enhance ▸ Adjust Lighting ▸ Shadows/Highlights. The slider bars are pretty much self-explanatory. With the midtone contrast slider, you can subtly increase the contrast of the mid tones and thus imitate (to a certain extent) the curves function, which is missing in Photoshop Elements (see description on page 176).

The parameters can be set in more detail in Photoshop, which I will use to explain this function.

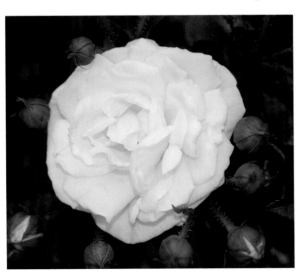

The shadows are a bit dark and the highlights too bright

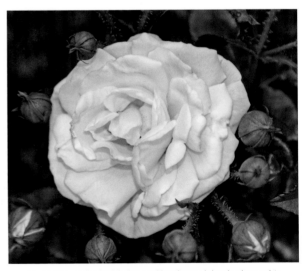

I tuned down the highlights and brightened the shadows a bit.

Choose Image ▸ Adjustments ▸ Shadow/Highlight to open the Shadow/Highlight dialog box in Photoshop. You should check the *Show More Options* box, otherwise you only get the short version, as shown in figure ②.

When making adjustments, always carefully observe the effects in the image. If your computer is a bit slow, you should move the sliders slowly!

In the expanded dialog box (figure ③), you can set many options all at once:

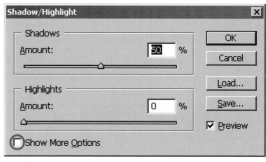

② *Photoshop Shadow/Highlight dialog box (short version)*

▸ Light image areas can be darkened without darkening the whole image. This causes more details to show in the highlights – for example, in the light sky – which is often an improvement because it gives life to the photograph. Improvements are only possible in areas that are not completely white (blown out).

▸ The shadows – often the shadowed areas in the image – can be lightened. Details become more visible which is generally desirable. If you lighten a shadow too much, you may get distracting color noise. This correction does not include single dark pixels on the edges.

▸ Mid tones can be increased in contrast.

▸ In the expanded version, the color saturation can also be increased or reduced.

The beauty of this tool is that you can make fine adjustments to each individual area (highlights, shadows, mid tones) separately.

The range of what is considered light can be determined with the Tonal Width slider (same goes for the shadows), and the Amount slider determines how much the area is darkened (or lightened).

The Radius parameter measures the radius of neighboring pixels that should be taken into account for the adjustment. The optimal value for Radius strongly depends on the image resolution; higher resolutions can have higher radius settings.

So that the blacks and whites are not cut (clipped), you should set the Black Clip and White Clip boxes to 0.

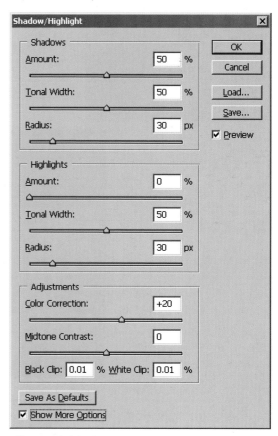

③ *Expanded Shadow/Highlight dialog box in Photoshop CS3*

There are hardly any standard recipes for this tool. You will have to experiment a little. Your personal taste also plays a role in this adjustment. One recommendation is to make increasingly stronger adjustments until the desired effect is clearly visible and then reduce the Amount slider. The parameters in this dialog box influence each other.

Therefore, you may have to take down the Amount a little if you increase the radius.

The Color Correction slider should be used with caution because it can easily cause undesirable color shifts in your image. If you set it to 0, a change of contrast of the mid tones does not affect the color.

Because Shadow/Highlight makes a number of image corrections at the same time, it should be used on 16-bit images.* The sliders should be used carefully because if you don't pay attention, high-contrast edges can show a so-called halo effect.

Figure ⑤ shows a prepared original (tonal range correction already carried out). I would like to bring out some of the details (onion foliage) that lie in the shadow to the right. Shadow/Highlight is suitable for this task, even though I only want to lighten the shadows slightly and keep the highlights unchanged.

Because I am only interested in the shadows on the right side of the picture, and not the left portion of the image, I selected the onions and the right side of the image with the lasso tool and set a soft feather. This limits the effect of the correction to the inside of the selection. The result can be seen in figure ⑥, after – as we will show in the next section – the image was sharpened. The correction without making the selection is shown in figure ④. Some details showing in the background are too distracting.

Instead of making a selection with the lasso tool, I could have also used a layer mask in Photoshop.** For this purpose, you create a composite layer in the layers palette (Ctrl-Alt-⇧-E), which includes all the layers below, or if no other correction layers are present, you can drag the current layer to the new layer icon in the layers palette. Then you make the Shadow/Highlight correction, create a layer mask, and paint inside the layer mask with a soft black brush over those areas that should be protected (masked) from the correction.

5.11 Sharpen and Unsharp Mask

Sharpening should be the last step of image editing (although some sharpening might be done in the RAW converter when working with RAW images). Sharpening increases the contrast on edges and in transitions with a special operation so that the image appears more sharp and crisp. However, it will not (or just only slightly) correct blurry images due to camera shake, wrong depth of field, or other errors.

Scaling an image or image areas also leads to some blur, which can be partially compensated for with sharpening.

Digital cameras already sharpen the images to a certain degree when saving them. If possible you should turn this feature off, if possible, because you can control sharpening better in an image editing program, plus some images don't need to be sharpened and sharpening them leads to artifacts. (If you save your images in the camera as JPEGs, unsharpened images result in a slightly better compression.)

Many programs offer various methods for sharpening. In Photoshop and Photoshop Elements, these are as follows:

▸ **Auto Sharpen**
This is worth a try (at the very end of image editing) because it can be undone (immediately afterward). Often, this option sharpens the image too much. In this case, it is better to do the sharpening manually with the Unsharp Mask.

▸ **Sharpen Edges**
Attempts to limit the sharpening effect to the contours.[*]

▸ **Sharpen**
Sharpens all image areas moderately.

▸ **Sharpen More**
This option usually sharpens the image too much. In most cases, this method should be avoided.

▸ **Unsharp Mask**
This is the most flexible method for sharpening, even if the name is not self-evident. I will describe it a bit later.

▸ **Smart Sharpen** (Photoshop), **Adjust Sharpness** (Photoshop Elements)
This is a variation of the Unsharp Mask.

Another variation is the sharpen tool (▲), which you can use to sharpen small areas with a type of brush. This is mainly used selectively to sharpen edges (see page 189). I prefer to use the selective sharpening of a helping layer,[**] which you sharpen with the Unsharp Mask or the Smart Sharpener or Adjust Sharpness filter, and then limit the area to be sharpened with a layer mask.

➡ *Sharpening too much leads to visible artifacts. Therefore, sharpening should be done carefully!*

Sharpening artifacts (halos), enlarged

Sharpening can be done several times.

* *This prevents, for example, individually distracting pixels from being emphasized even more.*

** *You can do this by bringing all layers into one composite layer, as described on page 213.*

① *Rose before sharpening*

② *Rose after using USM with Amount = 134,*
Radius = 0.9, Threshold = 0;
this is too much sharpening.

③ *Rose after using USM with Amount = 134,*
Radius = 0.9, Threshold = 18;
this is better, preserving some fine gradients.

With all sharpening methods select an area of interest and zoom to 100%. This is a must in order to get a good preview of your sharpening control settings!

Unsharp Mask

The Unsharp Mask (USM) function has a confusing name, which goes back to how sharpening worked in a photo lab; however, it sharpens the image. This method offers the best control and is the best choice for sharpening most images. The function can be found in Photoshop by choosing Filter ▸ Sharpen and in Photoshop Elements 5 under Enhance. In addition to the adjustment sliders, the dialog box has an important preview feature. It needs to be activated for the visual control of the effect. Click with the mouse into an area of the image that you would like to see in the preview window. The enlargement of the area can be regulated with the + and − buttons below the preview. The best view is at 100%.

The sliders have the following functions:

Amount • The value for *amount* determines how strongly an image should be sharpened. First try values between 50 and 100%. At times, values up to 200% can be appropriate. The result can be seen in the preview image.

Radius • The radius determines the number of neighboring pixels that are affected by the sharpening. Often a value of 0.5 to 1.0 can be sufficient. The *appropriate* radius depends on the resolution (higher-resolution images can have a higher radius setting) and on the structure of the image. A radius that is too high leads to artifacts and harsh contrast. In very high-resolution images, a value of up to 2.0 can give good results.

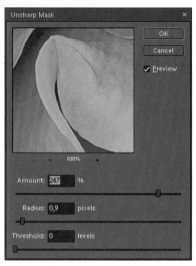

Unsharp Mask dialog box in Photoshop Elements

Threshold • The threshold slider defines how many pixels are considered as belonging to an edge. You can begin with 0 here. A larger value leads to the effect of edge sharpening without emphasizing small distractions. If soft color gradations are part of the image – for example in the sky – a large value (approximately 5 to 10) can prevent the destruction of the subtle color gradations through sharpening.

Sharpening can be limited to a partial image area by previously selecting the area – for example, the hair and eye area of a portrait. In most cases, you would choose a soft, wide feather for the edge.

In Photoshop (but not Photoshop Elements), individual color channels can be sharpened. In digital images, the blue channel often shows more noise, which only becomes more pronounced through sharpening. Therefore, it can be better to sharpen only the red and green channels. An alternative is to convert the image to Lab mode (not available in Photoshop Elements), sharpen only the luminance channel, and then convert the image back to RGB. Our eyes react strongest to differences in brightness.

Image unsharpened, enlarged

If the image needs to be converted from RGB into CMYK for printing, the sharpening should be carried out only *after* the conversion.

If an image needs to be scaled again for another purpose (for example, for the Web), you may have to sharpen the image again after scaling because scaling an image causes some blur.

Beginners tend to oversharpen images. Therefore, it is best not to sharpen too much and then to examine the picture 1:1 on the monitor. If

Oversharpened, artifacts are clearly visible.

Image sharpened with the Unsharp Mask filter, 100%, Radius 4.8, Threshold 2

you sharpen too much, artifacts tend to show in your image. This happens especially if the sharpen tool ▲ is set too strong.

Often you don't want to sharpen the whole picture. For example, sharpening the sky doesn't make any sense, nor does sharpening the shadows, which will only cause them to show more noise.

This is why I usually sharpen on a new layer. You can create a new composite layer by selecting the top layer in the layers palette and press the keyboard combination ⇧-Ctrl-Alt-E (Mac: ⇧-⌥-⌘-E). If there are no layers other than the background layer, you simply drag the background layer to the new layer icon in the layers palette.

Next you sharpen the layer, often quite strongly. In the layer mask – not available for pixel layers in Photoshop Elements – use a soft black brush to paint all those areas dark that should not be sharpened. Afterward, you can control the sharpening effect by regulating the opacity of the layer.

The concept of sharpening too much and adjusting the effect by reducing the opacity of the layer will be described in more detail in section 5.20.1.

If you want to sharpen only a small area in the image, you simply invert the layer mask. What this means is that you first fill the whole mask with black with the paint bucket tool and then choose a white brush to pull out the areas you want to sharpen.

In Photoshop, the *Smart Sharpen* filter works similarly. In Photoshop Elements, it is called Adjust Sharpness and can be found in the Enhance menu. The setting *Gaussian Blur* corresponds closely to the function of Unsharp Mask.

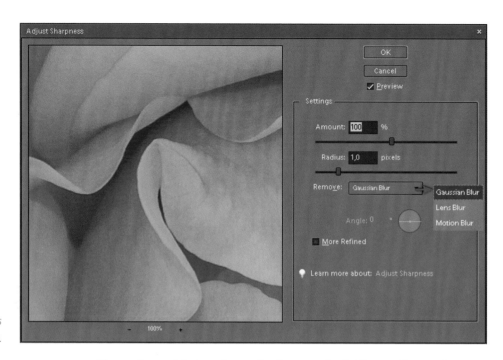

① *Photoshop Elements filter: Adjust Sharpness.*

If you choose *Motion Blur* under Remove, both filters will cancel motion blur to a certain extent. However, you will have to use the angle setting to tell the filter the direction in which the blur occurred. With the setting *Lens Blur*, Photoshop Elements tries to find the direction of blur automatically. These corrections are only useful to a certain extent.

You will find the very same controls in Photoshop (full version) since Photoshop CS2 when using Filter ▸ Sharpen ▸Smart Sharpen (see figure ②). Additionally, in Smart Sharpen you can adapt the sharpening to shadows, highlights, and midtones.

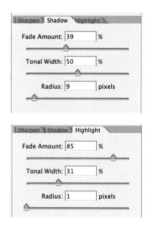

② *Photoshop's Smart Sharpen Filter allows to set different sharpening for midtones, shadows, and highlights.*

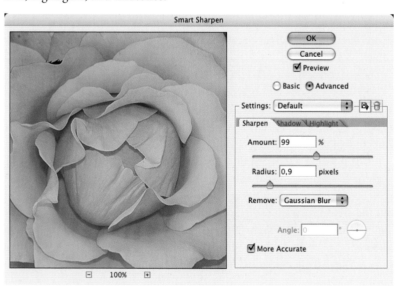

5.12 **Text/Type Tool**

Text is usually created in a desktop publishing program and not in an image editing program. However, at times you may want to add some text to an image. Image editing programs feature the text tool for this purpose. It's different from program to program with different features and varying ease of use.

The options bar in Photoshop Elements shows the typical options used to enter text. This includes *font family, font style, font size, normal/super-script/subscript, underline* and *strike-through text, text orientation, color,* and *warped text.* In Photoshop Elements, you can choose a specific type tool if you want the text to run horizontal (T) or vertical (T) and if you want the text to be a graphic (T, T) or a mask (T, T).

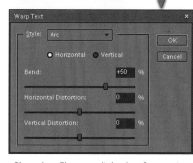

Photoshop and Photoshop Elements automatically create a new layer for graphical text, and the text is treated as a graphical object and not a pixel image. At this stage, you can still make changes to it (by changing the text style to italic, for example). It is more efficient, though, to set the text parameters in the options bar before you begin typing. If you want to rotate the text, you select the text in its text layer and use the *Transform* command for the rotation. The text warp tool (T) in the options bar can be used to fit text to simple shapes through the Warp Text dialog box. You can choose from several font styles in a drop-down menu.

Some programs, such as Photoshop, offer more options for manipulating text, as the adjoining dialog box shows. It can be opened by clicking the ▤ icon in the options bar.

Only if you *rasterized* the type, the text is converted into pixels. After this it can no longer be edited.

The *text mask* (T, T) is a text outline that functions as a selection or mask. It can be seen on the masking color (in figure ① with ■, where I use the image of tree bark as a basis for my cut-out text). The text mask does not create a separate text layer.

Copying the selection will place the pixels within the selection into the clipboard. You can then paste it to a different area or into another image. This is a simple way to create theme-oriented, filled text – for example, with a pattern of water, sand, or as shown here with bark.

Photoshop Elements dialog box for warping text.

① *Entering text in the text mask mode* ② *Text copied from the mask*

5.13 Retouching

Whether an image is transferred from the camera, captured by a scanner, or is a scanned transparency, there are almost always little areas to correct. This

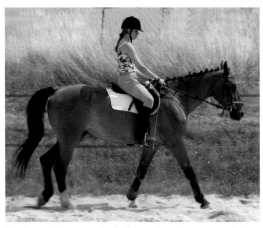

includes, for example, dirt on the original, scratches and dust on slides, bends and tears in paper originals or old photographs, an annoying telephone wire in a landscape image, skin impurities in portraits, and cars in architectural pictures.

The difference between correcting flaws and image manipulation is a gray area (also see the remarks on page 230). Before beginning any work, you should figure out what you want to achieve, if it will be appropriate for the purpose of the image, and how much time and effort you are willing to spend.

As usual, there are a whole range of tools for retouching with different applications. The following are the most important:

The fence is distracting in the figure above. It was retouched in the figure below using the clone stamp using source image material from areas nearby the fence.

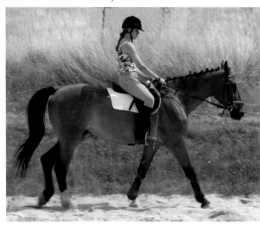

▸ Copying image areas and reinserting them into the same image or into another image
▸ Using the clone stamp tool 🖫 or pattern stamp tool 🖭 as well as the healing brush tools (◩ or ◪)
▸ Using the brush or pencil (◪ or ◪)
▸ Noise filters (to remove scratches or to smooth out noise or grain)
▸ Blur and sharpen filters (to de-emphasize or emphasize certain parts or edges)
▸ Distortion and removing distortion
▸ Retouching with interchanging larger image areas

Always start with the worst problems and disturbances and only then continue to fix the minor issues. If there are distortions or you have to correct the perspective, start with that.

5.13.1 Copy and Cover Up

➔ *Larger retouch projects need to be planned because they take a lot of time. Think about what you want to retouch, guess how much time it will take, and figure out the methods and sequence you will use.*

➔ *Only carry out retouch work on a copy (or several copies) of the original layer.*

When you want to remove unwanted elements in an image, it makes sense to cover them up with image elements that are similar to the affected area. For example, you can add a window to a house wall to replace a window that's covered up with brick. Or you can replace a hole in plaster with another piece of plaster, cover up an electric wire in the sky with another piece of sky, or replace a missing button with a copy of another button.

Selecting, copying, and inserting is done quickly. The fastest way is with the keyboard combination of Ctrl-C (Mac: ⌘-C) to copy and Ctrl-V (Mac: ⌘-V) to insert. You can also copy parts of other images. Even faster when working within one image is to use the move tool ⊹ to

reposition a selection while holding down the Alt key (this will automatically copy and paste the selection to the position you drag it to).

In most cases a soft edge (feather) is preferable for the copy selection because it results in softer, less-visible transitions. The feather and width of the transition cannot be changed after the copy has been made; therefore, you should set these parameters before making the selection! The inserted copy is automatically placed onto a new layer that becomes the active layer. While this is practical, it can be confusing at first when you're trying to copy again and *nothing* is selected. This is because the new layer is transparent except for the inserted area, but it (invisibly) covers up the layers below.

To maintain a clear overview, it is useful to have the layers palette open during copying.

The new layer can be moved, even in a way that the inserted copy may only partially be placed in the visible image area. The copy still exists completely (as an *overhang*) and can be moved back. If the copy does not suit your needs, you can simply delete the layer.

The image areas in this layer can be edited just like other image areas; for example, they can be changed in brightness, contrast, or color. If you erase or delete in this upper layer, only the visible (not the transparent) layer elements are deleted and the layers below show through. Nothing has changed in these other layers.

The opacity of the layer copy is set to 100% at the beginning, but it can be changed in the layers palette at any time. When you repair areas with a copy layer, in some cases setting the opacity to less than 100% can give you better results. The lower layers are only affected when you *merge* the layers into one.*

For a description of the layers palette, see figure 5-4 on page 144.

* *I.e., with the function* Layer ▸ Merge Visible.

5.13.2 Clone Stamp and Pattern Stamp

Using the *clone stamp* tool is less conspicuous than *copying and inserting*. The stamp copies pixels from a point of origin to a target area (the place where you drag the mouse cursor).

A typical example is a red pimple near the eye in a portrait as in figure ①. It it very easy to retouch it using the clone stamp by just superimposing a bit of skin from a nearby area over the pimple near the eye.

Before we can copy, the cursor needs to be placed into the area of origin and the point of origin must be defined by clicking with the Alt key (Mac: ⌥) pressed. Now set the opacity of your clone brush – in this case I used an opacity near 100%. The brush tip should be slightly larger than the pimple and I use a soft brush edge. Then I move the cursor to the target area and click the left mouse button. A click copies the area of origin into the target area. If you drag the mouse, the mouse origin cursor (marked with +) follows the target cursor (◯) with the chosen displacement. (This refers to the distance chosen between the first point of origin and the first target point.) If the

Target

Origin

Aligned check box is checked and you click again with the mouse, the area of origin is also placed again (with the old displacement). Without this option, the point of origin will stay the same until it is redefined. The stamp size, edge hardness, and opacity, as well as the mode, can be set in the options bar.

→ *A clone stamp with an opacity lower than 100% may give you a better result because parts of the original structure are preserved.*

When the stamp is in *Normal* mode, everything below it is copied. However, you can limit the copy to, for example, *Color*, *Luminance*, or *Color Saturation*. If you want to copy the structure but not the color, you would choose the *Luminance* mode.

The tool needs to be adapted (size, hardness) to the purpose and the image you are working on. This means you will have to experiment a bit to learn how to use it in a well-balanced way. If the target area needs structure, it is often necessary to choose several different points of origin. Sometimes several mouse clicks with a soft stamp will yield a better result than if you drag the mouse, especially if you are trying to cover up a small spot. Often it will make sense to choose neighboring pixels to make a correction,* but at times other areas of the image or even areas from another layer can be used. The points of origin and the target area can lie in different layers or even in different images!

* *These generally have a similar color and structure as the area to be corrected.*

Instead of picking pixels at a point of origin, you can also add a pattern. The *pattern stamp* tool is suited for this. If the predefined patterns do not work, you can create your own or pick one from an image area.

In Photoshop Elements Version 3, a new *healing brush* tool was added. In Photoshop, it has existed since version CS1. It is easier to use and more functional for small retouching work than the clone stamp tool because it automatically adjusts the copied pixels to the new environment and therefore the transitions are less visible. The tool comes in two variations: the *healing brush* tool and the *spot healing brush* tool. Both can be found in the tools palette.

First activate the healing brush tool and then choose the point of origin – that area in the image with which you want to repair the image – while holding down the `Alt` key (Mac: `⌥`). You can also set the size and hardness for the healing brush tool.

Then you paint the area that needs correction with the brush. Photoshop Elements copies the area of origin to the target area, but automatically adapts the structure and color to the target area.

The *spot healing brush* does not need a place of origin. You simply brush the area to be repaired and Elements replaces it with a color and structure from the neighboring pixels. Again, you can set the size and

hardness in the options bar and determine how the repair is structured with the Type parameter. This tool is often easier to use for repairing tiny distracting areas and create an even environment.

5.13.3 Brush and Pen

The *pen* and the *brush* are the easiest tools for small corrections. Both paint in the currently active foreground color in the chosen strength and mode.* The pen always has a hard edge. It is used to correct or fill in small edges and lines or to paint a one-color border or add single pixels in the desired color.

The brush is used for small areas and soft edges or transitions. Choosing the appropriate tool tip, it can be used to create fading lines and airbrush effects (in Photoshop Elements in the options bar with the button).

The brush has (at least in Photoshop Elements) various settings available under More Options in the options bar.

** Typically, this is normal mode, but there are several useful variations (or options) in Photoshop Elements: darken, lighten, hue, saturation, color, or luminance (and a few more). It is good to experiment with the different options in this mode to become familiar with the different applications.*

Photoshop Elements also offers a variation to the brush – the *impressionist brush* . It paints the available colors in the impressionistic style and therefore acts like a filter (local). Many different styles are offered; they can be set in Photoshop Elements in the options bar under brush presets.

The effect of the brush, and the impressionist brush particularly, is a painted look and not photographic, so it should be used only sparingly to correct photographic images. How to use them is pretty much self-explanatory.

Image area before (left) and after (right) editing with the impressionist brush

5.13.4 Dodge, Burn, and More

If small image areas are too dark, too light, too strong, or too pale in color, if they're too sharp or too blurry, the adjoining correction tools are used. They allow you to make selective corrections and, if desired, soft transitions. Start with low settings – approximately 10 to 20% – and if needed go over the area several times.

In the following example I will show the effects of the different tools on an image of an eye (you just see a small part of a portrait). I used them at full strength and worked on the area marked green in figure ①, using a brush size indicated by the circle in figure ① with a soft edge.

The blur tool flattens contrasts by creating softer luminance and color transitions; the sharpening tool ▲ strengthens them. While the blur tool can be used without problems, the sharpening tool needs to be used with caution because above approximately 50% strength, it produces unusually colored pixels (artifacts).

① Green shows the area I worked on.

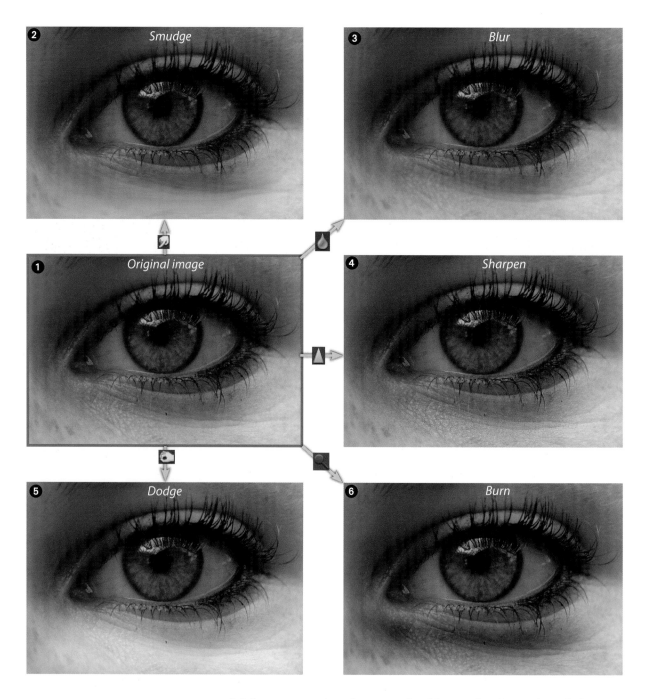

It is best to zoom into the area to be able to judge the result, and if you are not sure, it is better to use the Unsharp Mask filter (see page 181).

The smudge tool ⬚ does not quite fit the category because, instead of correcting structures, it distorts and smears them. It should not be used or it should be used only very carefully in photographs because it tends to look artificial.

In the options bar, you can choose whether the dodge tool , which lightens, and the burn tool , which darkens, should affect the highlights, mid tones, or shadows (dark tones).

The sponge can – depending on the settings in the options bar – increase the color saturation as well as reduce it. When the saturate mode is selected, brushing over colored areas will increase the glow of the colors (i.e., the red of lips) or create more saturated colors for otherwise dull flowers in the shade.

Reduce Saturation — Original image — Increase saturation

Reduce — Increase

For all listed tools, it is best not to make all the corrections in a single stroke. It is better to lift up and click again because it allows you to undo undesirable effects in smaller steps. You can undo more than one step at once in the history palette.* Of course, you can also choose Edit ▸ Undo several times.

If you want to protect neighboring areas (i.e., edges), select the area you want to work on and all other areas will be protected.**

The tools described above are used for corrections in smaller areas or of lines and edges as well as for selective dodging, burning, lightening, and so on. When you want to make corrections on larger areas, it is better to use adjustment layers (see page 153). They also can be limited to specific areas (usually larger areas, though) by using a layer mask.

* See description on page 218.

** Alternatively, you can mask the areas to be protected – in Photoshop Elements, for example, with the selection brush in the "mask" mode.

5.13.5 Blur Filter

Sometimes structures seem too harsh in your images – for example, skin details or small wrinkles in a face – or sharp background elements appear distracting. In these cases, you want to make them softer or more blurry. In small areas, this can be accomplished (carefully) with the smudge tool or even better with the blur tool .

Generally though, it is better to smooth the area with a blur filter, which provides a better preview and more control. Photoshop Elements and Photoshop offer several options. The Gaussian Blur filter is the right choice for skin. The appropriate radius strongly depends on the image resolution; the higher the resolution and the more that needs to be blurred, the larger the radius has to be.

In the relatively small portrait (figure ① on the following page), I used a radius setting of between 0.5 and 1.0 pixels. I used the magic wand to select several areas one after the other (the lips, the areas around the eyes,

Gaussian Blur Filter dialog box

and on the forehead) and softened with the Gaussian Blur filter. After applying the filter, I reduced the wrinkles on the forehead even more with the clone stamp tool (figure ②).

When using the blur tools, you should use consideration and not blur too much, even if that is desired in portraits (especially from women); otherwise, the image will appear not sharp enough. Some structures exist even in blurry areas and can quickly be removed by blurring. Then the areas tend to become flat and monotonous.

Therefore, limit the blur filters to necessary areas – either by previously selecting the area you intend to apply your filter to or by using a layer mask, and perhaps sharpen slightly afterward.

Smoothing the image with a blur filter is also beneficial when the image sensor produces too much noise in an image, which can happen in close-up images and long exposures. Again, the Gaussian Blur filter is useful in this case (see section 5.13.6 on page 193).

① *Original image* ② *Several areas have been blurred (e.g., see forehead).*

Blur filters can also be used creatively, as shown in the image with the seagull. Instead of using the Gaussian Blur filter, I used the Motion Blur filter. It allows you to set the angle and distance of the motion to be simulated.

Original image *Background with motion blur*

Defocusing with the Blur Filter

Sometimes there will be areas in your image that are sharp but obtrusive because they distract the viewer from the main object. These areas can be blurred so much that they become unsharp, or defocused. An image can gain more order and tranquility and the attention can be focused on the (hopefully) sharp central object.

The hat of the falconer is distracting in the image with the eagle (figure ①), especially so because the falconer's head is only partially visible. The image appears to be out of balance. Because the image should not be cropped any further, the falconer was selected with the lasso tool and a wide soft edge and blurred with the Gaussian Blur filter. In figure ②, he is no longer distracting.

When defocusing images in this way, you will have to pay attention to the perspectives, and perhaps blur objects that lie in a different depth of field with a different strength. In the image with the eagle, the blur does not feel unnatural even though the eagle and the falconer are almost at the same distance from the camera.

The distracting portion of his head could have been removed as well by using the clone stamp tool to copy the already blurry background over it.

5.13.6 Remove Image Noise

Noise in digital images is an effect that is created by deficiencies in image sensors. The neighboring pixels vary in brightness and color that is stronger than is present in the original scene. Noise is caused by small differences in charge of the sensor cells, which in turn can be caused by, for example, static disruptions, manufacturing error tolerances, and signal amplification. Noise is particularly prevalent in dark image areas and when higher ISO settings are used. High temperatures in the image sensor also amplify noise.

→ *Many cameras come with an internal noise reduction filter, which can be deactivated. You should check to see if the result of using it is better than the result of using a noise reduction filter applied during image editing.*

The strength of the noise is determined by the ISO setting, but also by the quality and size of the image sensor. Small image sensors – i.e., from compact cameras with a sensor size of $1/2.5"$ – typically produce higher levels of noise than the larger sensors of DSLR cameras. This is even more pronounced when, due to marketing reasons, the image sensor resolution is pushed up (senselessly) to 8 or 10 megapixel.

Noise is more apparent in dark image areas that have been lightened perhaps with the Shadows/Highlights function, the curves or levels dialog boxes, or too strong a correction was made in the RAW conversion program.

Noise can be seen in an image as color pixel variations in a homogenous area. It is similar to the coarse grain of high-speed film.

There are different methods to reduce noise:

▶ Use low camera ISO settings.

▶ Use the internal noise reduction filter of the camera.

▶ Use a blur filter in the image areas affected by noise.

▶ Reduce the color saturation. This is especially useful in dark areas. Afterward, you may have to darken the area slightly (i.e., with the dialog box *brightness/contrast*).

▶ Use special noise filters or actions to reduce noise.*

▶ If you work with RAW files, you can suppress the noise during RAW conversion. This is usually better than doing it later.

The newer versions of professional image editing programs (for example, Paint Shop Pro 8.0, Photoshop (starting with CS), and Photoshop Elements 5/6) already come with noise reduction filters.

Photoshop as well as Photoshop Elements offer a Reduce Noise filter. Not only can it reduce noise quite effectively, it can also lessen the artifacts created by JPEG compression to a certain degree. When using this filter, it is important to find a balance between a useful noise reduction and losing too much detail due to blur.

** There are several noise reduction filters available as shareware as well as commercially. These include, for example, "Neat Image" [63], the Photoshop action by ShutterFreaks under [77], and Dfine under [83].*

Before the correction (detail)

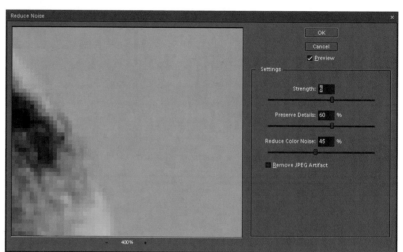

Photoshop/Photoshop Elements Reduce Noise filter for suppressing visible noise in images

I corrected the noise in the following image for clarification purposes. The noise was caused by an increase of the color saturation in the winter scene on page 150.

5.13.7 Noise Filter (Remove Dust and Scratches)

Sometimes there will be small dirt on an image, such as dust or scratches. This happens frequently with scanned images, particularly with slides and black-and-white or color negatives, because these particles will be enlarged and therefore become even more distracting. In addition, you can find noise in the dark image areas when you use high ISO settings. The mistakes can be corrected individually with the copy, brush, and clone stamp tools. But you can do it faster by using the filter *Dust & Scratches*, which can be found in one or another form in most image editing programs.

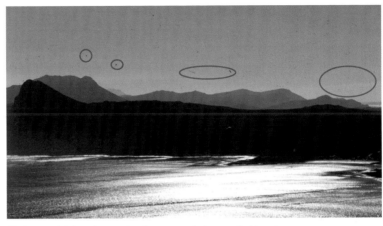

① *Scanned slide with extensive dust accumulation, marked in red*

Other small flaws can also be corrected, such as a thin telephone wire in the sky or a small dent in the hood of the car.

You want to limit the effect of the filter to those areas you select beforehand, preferably with a soft edge. Place the distracting element into the preview window (sufficiently large) so you can control the settings precisely in the dialog box. The blur effect that accompanies this filter should be kept to a minimum and should be limited to the affected area by making a selection beforehand. The function can be found by choosing Filter ▸ Noise ▸ Dust & Scratches.

The function causes a blur effect in the treated area. Therefore, it can make sense to sharpen the area with a low-intensity sharpen filter.

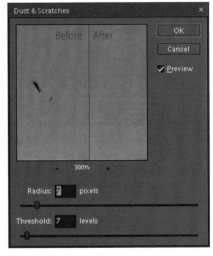

The Dust & Scratches filter reduces dust and moiré patterns.

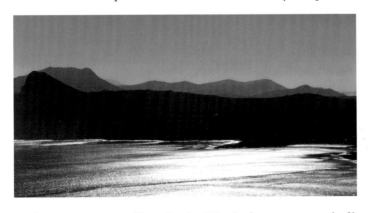

② *Only the sky was corrected with the Dust & Scratches filter (Radius 20, Threshold 7).*

In the category Noise filters (under Filter), there are not only filters to remove interferences, but also to add noise. This is useful to mix up a smooth and continuous surface that appears unnatural, perhaps in areas where you painted with the brush or copied graphical objects. Even in places that have blown out and are pure white, the "add noise" filter can reintroduce small, irregular structures.

Original image *Copied selection*

Again	Shift+Ctrl+T
Scale	
Rotate	
Skew	
Distort	
Perspective	
Warp	
Rotate 180°	
Rotate 90° CW	
Rotate 90° CCW	
Flip Horizontal	
Flip Vertical	

Free Transform
Skew
Distort
Perspective

Photoshop Elements *Photoshop version*
version

5.13.8 Distort, Deskew, and Transform

At times, you may need to correct the proportions of different image areas, perhaps because a nose is too long, a shoe is too large, or the perspective lines in an architectural image are too strong. Most image editing programs offer different variations for distorting, deskewing, and transforming image areas. In the most sophisticated versions, you can place a grid over the image. Each intersection of the grid can be individually altered and very subtle parts of the image can be manipulated. Correcting slanted lines distorted by perspective, as well as scaling and rotating, are the tasks performed most often.

Transformations should be carried out on a separate layer. This allows you to make additional corrections to them later or delete them altogether. Select the area to be transformed and use the Copy and Insert commands to place it onto a new layer.

In Photoshop and Photoshop Elements, the transform process begins by selecting the area concerned and choosing Image ▸ Transform ▸ Free Transform or one of the transform variations; here I chose Image ▸ Transform ▸ Distort (or Perspective, in Photoshop on the Edit menu).

Before transformation *Stretch* *Rotate* *Scale* *Perspective* *Distort*

Photoshop and Photoshop Elements
Keyboard Shortcuts for Free Transform

Windows	Macintosh	Function
Esc	Esc	Stops transformation
Pull within the selection	Move	
Drag outside of the selection	Rotate	
⇧-Ctrl	⇧-⌘	Skew
Drag on one handle	Scale	
⇧	⇧	Scale proportionately
Ctrl	⌘	Distort
⇧-Ctrl-Alt	⇧-⌘-⌥	Perspective distortion

While Distort will let you pull on each corner individually, Perspective moves both corners (either top or bottom) symmetrically, and Skew moves the corners in the shape of a parallelogram.

Because complex transformations may need several combinations, you can switch between the different forms with keyboard shortcuts in Photoshop and Photoshop Elements (see adjoining table).

The free transform tool gives you the most flexibility. The selected area can also be rotated. To do this, you move the cursor outside of the selection. You may have to make your image window larger. When the cursor approaches one of the corner points, it changes to ↷. Then you can rotate the area freely.

Place the cursor into the middle of the selected area and hold down the left mouse button to move the whole selection to a new place.

While you're working with the free transform tool in Photoshop Elements, if you want to pick only one corner point for a transformation

without automatically moving the opposite corner symmetrically, you hold down the `Ctrl` key (Mac: `⌘`).

Using the Distort function, you can not only distort the selected area, but also scale it, while keeping the same resolution. If at the same time you hold down the `⇧` key, the X and Y proportions remain intact.

The type of operation that will be carried out can be recognized by the type of cursor Photoshop Elements displays (see adjoining list).

If you would rather key in numerical values instead of working with the mouse, you can do so in the options bar.

The transformation is shown on the screen, but it is not actually carried out until you double-click inside of the selected area or press the ENTER key.

Using the Distort and Scale functions always comes with a slight loss of image quality, which adds up quickly when several operations are performed one after the other. Instead of making several individual transformations, it is therefore better to carry out all distortion operations (rotating, scaling, distorting) at once before you commit to having the commands carried out by pressing the ENTER key (or double-click inside the selection area). If the result is not pleasing to you, it is better to undo all transformations and start again from the beginning. Otherwise, the rounding errors of the calculations might add up to an unacceptable loss of image quality.

In example figure ①, the use of transformation is shown with respect to buildings. The low camera position in combination with a wide-angle lens (28 mm small film format) distorts the lines of the buildings.

First I copied the background layer to a new layer and enlarged the working window so I would have more room to work. Then I rotated the image to straighten out the horizon line, but I didn't crop it yet (figure ②).

In the next step, the object was distorted (corrected) with the free transform tool so that the trees and the lines of the buildings are vertical (approximately). The correction was quite severe (figure ③). Mainly, I pulled the top two corner points out to the side and slightly to the top. This requires a lot of extra working space in the image window. Then I cropped the image for the final step.

Cursors in Photoshop and Photoshop Elements for the Transform command:

Move:

Rotate:

Stretch, Scale:

Distort, Skew:

① *Original image with slant and distortion*

② *The grid lines help while rotating the image with the free transform tool.*

To avoid cropping too much off the bottom, the empty white areas were filled in with the clone stamp tool from the neighboring pixels. Figure ④ shows the result.

③ *Dragging on the upper corner points "distorts" (corrects) the building and the trees.*

④ *Finished image*

① *This image show some barrel distortion as
well as strong perspective distortion.*

Lens and Perspective Distortions

There are a number of different distortions that can be found in photographs. Some are caused by your angle of view – I am talking about perspective distortions –, and some by your lens. The latter usually occur as barrel ☐ or bottle ☐ distortions. If they are slight, you may ignore them. However, especially in architectural photography, you should correct them. All of these distortions can be corrected in Photoshop and Photoshop Elements using the powerful *Camera Distortion* filter.

Figure ① shows an image that has some barrel distortion as well a strong perspective distortion. Therefore, I started by first correcting the barrel distortion (see figure ②) using the *Remove Distortion* slider.

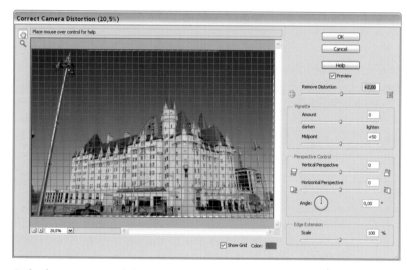

②

*Correct Camera Distortion filter after
correcting the barrel distortion.*

Only then I corrected the vertical perspective distortion, as well as slightly adjusting the horizontal distortion (see figure ③). For this, a grid is very helpful; therefore activate *Show Grid* if it's not already activated.

If working on large images, the filter requires quite a bit of computing power. Therefore, move your sliders very carefully and slowly. The update of the preview will take time. Working slowly avoids over-correcting.

Finally, you may have to crop your resulting image in order to remove superfluous, or unfilled areas.

When working with this filter, I start by first creating a separate layer for my filter-based correction. This allows me to easily go back if the result is not good enough. (Actually I do this when working with any filter.) It also allows to switch back and forward comparing the before and after view by switching the top layer (with the result of the filter operation) off and on. To make a copy of the background layer I simple drag it to the 🔲 icon of the layer palette to duplicate it. If, however, I have already applied a number of adjustments layers, I first have to create a new intermediate composite layer because filters cannot be applied on top of adjustment layers. How a composite layer is created will be described in section 5.20.2.

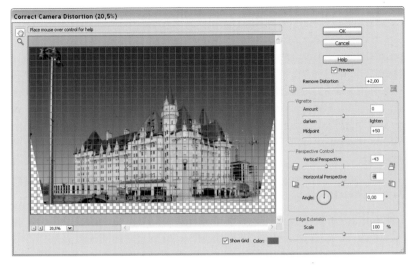

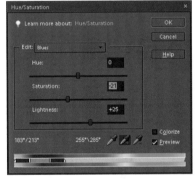

③

In a second step I corrected the vertical perspective distortion. Additionally, I corrected the horizontal distortion slightly.

Figure ④ shows my final image of the Fairmont Hotel (Château Laurier) in Ottawa (Canada). I cropped out the street lamp and most of the crane in the background.

A bit of retouching using the clone stamp tool did the rest. This included first using Shadow/Highlights to brighten up the shadows slightly (see the shops below the arches at the right). Additionally, I applied a bit more contrast in the midtones. Retouching the car and the person in front of the car at the bottom of the image took the longest. While retouching using the clone stamp tool and some copying and pasting, I had to maintain the perspective of the balustrade.

Finally, I desaturated the sky slightly (the high saturation was caused by a polarizing filter). For this I used Layer ▸ New Adjustment Layer ▸ Hue/Saturation, selected *Blues* in the Edit-menu of the dialog box, picked a value of deep blue in the sky using the 🖊 eye-dropper, reduced the Saturation by about 21 % and increased the Brightness by 25 %.

I used a Hue/Saturation Adjustment layer to desaturate the sky and brighten it at the same time.

④

The final image after some additional cropping and retouching.

5.13.9 Removing Red Eyes

The red-eye effect results from photographing people in relatively dark rooms using a frontal flash. In low-light conditions, the pupil of the eye opens relatively wide, so when the eye is hit by direct, strong light – such as a flash produces – the blood-filled retina (back of the eye) becomes visible. This effect can be prevented by using a flash from the side, an indirect flash, or small preflashes, which are supposed to cause the pupil to close more. Stronger ambient light (lights in the room) can cause the pupils to reduce in size also.

Once red eyes are present in a photograph, the point is to remove them by means of image editing. There are several options:

Image taken with flash, showing the typical red-eye effect

1. You use one of the red-eye removal 👁 tools that are part of almost all image editing programs. In Photoshop Elements, the tool can be found in the tool bar and is described on page 144. Just activate the 👁 tool, draw an oval shape with your mouse over the red eye, and set the *Darken Amount* in the tool bar of the red-eye removal tool. Repeat this for every red eye in your image.

 Paint Shop Pro offers several different red-eye corrections, including one for animal eyes. (Animals often have yellow or white eyes due to a different reflection when photographed with direct flash light (see figure ⑤ on page 100).

Image corrected with the red-eye removal tool in Photoshop Elements

2. Reduce the color saturation in the pupil of the red eyes; practically, this means changing it from red to gray. This method can be used in all programs and is quite simple. First select the pupil – i.e., with the oval marquee tool – and reduce the color saturation of the eyes as described in section 5.8.2 on page 172 using Hue/Saturation dialog box (Ctrl-U; Mac: ⌘-U) and perhaps change the color balance.

 You may also want to increase the contrast of the pupil and, if it's not already present, set a light reflection into the eye. The red color can also be replaced with another (dark) color such as blue or green using a selective color correction.

3. Photoshop Elements can search the images while importing them and automatically remove the red-eye effect. This might be practical and easy at the beginning, but I do not trust such automated methods. You will have to experiment with it yourself and gain your own experience.

Animals photographed with flash will often show glowing yellow eyes instead of red ones. An example can be seen on page 100. Method 2 is the best for making this correction, and in addition, you should also reduce the Lab-brightness significantly, until the area is adapted to the grayscale values of the rest of the eye.

5.14 Changing Image Size and Resolution

Digital photographs have image pixels that at first do not have a fixed size. Depending on the method of presentation, a pixel can be displayed smaller or larger. The *size* of photographs (and other pixel images) is therefore given in pixels, in width and height. A 5-megapixel camera produces images with the approximate pixel (image point) dimensions of 2560 × 1920.

However, you want to determine a specific size of an image for displaying it on a monitor or for printing it – to a certain extent – independent of the physical resolution of each device. Most image files therefore have a measurement for the representation resolution of the image – for example, 200 ppi (pixels per inch). It is assumed that the pixels in both directions have the same size (asymmetrical pixel relationships are also possible, for example, in TIFF and other formats).

The initial, irrelevant resolution with which the camera saves the image files varies from camera to camera. The Olympus E 20P, for example, uses a value of 144 ppi, while the Nikon D100 saves the images with 300 ppi. Other cameras have different values.

Because you generally prepare an image for a specific purpose with image editing, you should set this value explicitly and consistently (for your own images).

Be careful with *actual* image scaling, the kind in which the image is recalculated. Generally, it makes sense to not carry out such recalculations on the original image, but only on a copy, because the image loses quality (more so, if the image is enlarged). When you enlarge an image and want to save it as a new file, it happens time and again that you accidentally overwrite the original without noticing. This is an especially unfortunate situation if you have not made any backups of the original.

Image Size Dialog Box

In Photoshop Elements, to open the dialog box for determining image size, choose Image ▸ Resize ▸ Image Size. In the Image Size dialog box, you can change the resolution without recalculating the image, as well as recalculating it by enlarging or reducing its size (that means changing the number of pixels in the X and Y directions).

In most cases you will, however, change the image size for a particular use, and that means the image will be recalculated. If the image proportions should be maintained – which is generally the case – the Constrain Proportions check box needs to be checked (Ⓐ). This is indicated by the chain symbol 🔗 behind the width and height measurements. It is enough to change one of the two values (either width or height); the program automatically calculates the other value.

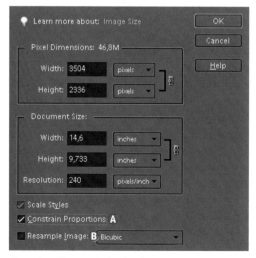

Photoshop Elements dialog box for resizing images

Original image *Nearest Neighbor*

Eye enlarged six times:

Bicubic *Bilinear*

Bicubic Smoother *Bicubic Sharper*

** For example, "plx SmartScale" by Extensis (www.extensis.com) or the free "imageN" from www.pixoid.com.*

*** This is only necessary when the image size or resolution is increased by 50%.*

Because the scaled and perhaps sharpened image can also be exported from Qimage, the program can be used as a special scaling program (under Windows).

Instead of setting the width under the document size measurements, you can set a pixel width in the upper area of the dialog box (under Pixel Dimensions). Using the drop-down menus, you can set different measurement units.

Image editing programs offer various methods for recalculating images. In Photoshop and Photoshop Elements, these are as follows:

- **Bicubic** • This is most often the best method for scaling photographs.

- **Bilinear** • This method offers a medium quality and calculates quicker than the bicubic method.

- **Nearest Neighbor** • This method adds pixels during enlargement that match the neighboring pixels. This results in clearly visible stair steps. This is the method to use if you want to make the pixels visible.

- **Bicubic Smoother** • This method, which comes with only the newest Photoshop Elements versions, is the best method for enlarging an image.

- **Bicubic Sharper** • This is the correct method when you want to reduce the image size.

Other Methods • There are a number of other methods that give better results, particularly when enlarging images. This includes, for example, S-Spline, B-Spline, and the Fractal method. Paint Shop Pro offers a so-called Smart Resize. You can also buy special (sometimes very expensive) scaling plug-ins.* The free program Photo Resizer [80] (for Windows) is well suited for resizing. However, in most cases the amateur will do well with the methods listed earlier.

Scaling by recalculating images always leads to a certain loss of quality due to interpolation, which is larger when the image is enlarged. Therefore, the image may have to be sharpened again after scaling.

If you want to enlarge an image quite a bit, which is only possible with visible losses of quality, you will get a slightly better result if you carry out this task in several smaller steps using the bicubic method and slightly sharpen each in-between step.** Image size can be reduced in one step, but it is good to sharpen the image afterward as well.

Most often, the reason for scaling is to adapt the image to a certain print size. *Qimage*, described in section 7.3.1, scales the image automatically depending on the printer and the desired print size. Qimage offers a number of different scaling algorithms (some of them quite good). At the same time it can also sharpen the image.

5.15 Vector Graphics – Scalable Forms

While complex vector graphics are better created with applications like CorelDRAW, or Illustrator, you may at times want to add a simpler, graphical object into your (raster) image. Most image editing programs offer the custom shape tool for this purpose. As long as they have not been recalculated into a raster image, these vector graphics can be scaled freely (without loss), moved, changed in form, and transformed.

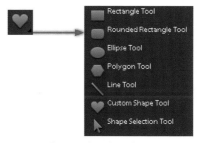

Custom shape tools in Photoshop Elements

In Photoshop Elements, this tool is called the *custom shape tool*. It already comes with some predefined shapes (such as lines, rectangles, ellipses, and similar shapes), and you can create more and add them to the already existing shapes. In the *Style* drop-down menu, you can select one of many different styles for your shape; the simple line ◨ is the standard setting.

Once you have drawn the shape, the object can be selected with the shape selection tool ▶ and then moved, scaled, rotated or otherwise transformed (see page 196).

Just as in the selection mode, a complex form can be created with several different shapes, by addition ◨, subtraction ◨, intersection ◨, or exclusion ◨. This can be set in the options bar.

The shape style, as well as the fill color, can be chosen in the options bar too. The Simplify button converts the vector shape to a rasterized image. It then can no longer be edited as a vector graphic.

Custom shape options bar (Photoshop Elements) with the Style drop-down menu

While Photoshop Elements automatically places the vector object into its own layer, Photoshop gives you a choice of whether to place the vector object into its own shape layer ◱ (just as in other layers, the opacity of a shape layer can be adjusted), use it as a path ◱, or add it as a raster image directly into the image layer ◱. Another expanded type of vector graphic is the path, described in section 5.17.

Not only can you use the shape or vector graphic as a graphical object, you can also load it as a selection. Because the custom shape tool allows more flexibility in its creation, this method might be easier to create a custom selection than using the selection tools.

The Cookie Cutter Tool ★ is for cutting out portions of your image. This cut-out may then be used as a separate layer, or saved as an image to be used for creating a fancy drawing or as an element in another document. First activate the ★ tool, then select the shape you want to use in the option bar. You can also use soft edges by feathering the shape. Now draw the shape over your image. The tool will create a cut-out, only retaining the image part that was inside the shape. This tool is not available in Photoshop (where you would use an alpha channel instead).

*Original image (above) and
extracted rose (below)*

5.16 Extracting Image Areas

Often, you might want to extract certain image areas to copy and insert them into another place or to add them to another background. The typical method is to select the area with the selection tools described in section 5.3.6 (page 147) or to mask the area. If these tools are not sufficient, you will need special tools. There are special add-on modules, either plug-ins or independent programs, but unfortunately they are not cheap.

Many image editing programs have their own filter for cutting out image areas. In Photoshop, it is called *Extract* and it's an option on the Filter menu; in Photoshop Elements (since version 4), it's *Magic Extractor* and it's accessed via the Image menu. If you have a strong contrast between the part you want to extract and the environment, try the ▧ tool, because it is relatively easy to use and rather fast. Assuming I want to extract the rose from figure ① from its green background, then these are the steps:

1. First zoom in so that the object will cover almost the whole window, just leaving a small portion of the environment on each side (see figure ①).

2. Now activate the *Quick Selection* tool ▧ using a suitable brush size and start drawing near the inside of the object edge. Move slowly!

3. With the example of the rose I started with the upper leaf and drew my brush slowly along the outer edge of the rose. The selection is quite quick and jumps from area to area (see figure ②).

4. Soon the whole rose is selected (figure ③).

5. But I intend to omit the lower background leave. Therefore, now I switch to the *Subtract from Selection* brush ▧ (found in the tool's option bar). With this, I remove (subtract) the unwanted leaf from my selection.

*The +-brush allows you to add areas to your
selection, the Minus brush to subtract areas
from it.*

➜ Rather than changing your brush's size using the *Size* slider in the option bar, use Ctrl-] to increase or Ctrl-[to decrease the brush size,

you can use ⇧-Ctrl-⟩ to increase and ⇧-Ctrl-⟨ to decrease the hardness of the brush.

→ *These keyboard shortcuts not only work with this tool, but with all brushes and pens.*

6. Finally, I feather my selection slightly (Select ▸ Feather). In most cases hard edges are not the best solution. You will have to adapt the feathering radius to your image resolution and type of object.

 You can further refine your edges. Open the *Refine Edge* dialog from the option bar of the tool (see figure ④). *Smoothing* will smooth the path of your edges while *Contract/Expand* allows you to expand or reduce your edges by a given number of pixels. Clicking on will mark the non-selected area of your image with the masking color.

7. Now we have two choices: Either invert our selection (Select ▸ Invert) and delete the environment around our object, or copy our extracted (selected) object and paste it into another image (e.g. a new background).

Using the *Quick Selection* tool ▨ makes the task really that simple and fast. You might have to do some additional final corrections on the extracted part, e.g., using the *Eraser* tool ◪), but it's still an easy way of extracting (up to Photoshop CS3 this tool is missing in Photoshop).

④ *Refine Edge dialog for the Quick selection tool*

Occasionally, however, you have more complicated objects to extract, in which case a second Adobe tool may be more suitable for the task. Photoshop, as well as Elements, provide an extracting tool. In Photoshop you will find it under Filter ▸ Extract. In Elements use Image ▸ Magic Extractor. The process is more complicated and more work but allows for finer extractions, e.g., when you extract a face with hairs. Try it, but be prepared to spend more time!

5.17 Paths

Paths are vector objects that can form a selection or be used as a scalable graphic. As opposed to pixel areas, they can be scaled freely and without any losses, they can be moved and transformed, and they can be saved and loaded individually. For extracting complex image areas, paths are a great tool. In addition, they can function as clipping paths or masks. Not all programs offer the paths tool; for example, they are missing in Photoshop Elements. They are so powerful because they can be built from complex shapes, called spline curves. Shapes can be created easily, and can precisely frame a particular image area.

In Photoshop, the path tools ✎ are available to create and manipulate paths. For selecting paths and points on paths, use the path selection ▸ and direct selection ▸ tools.

With the paths tools, you can draw a curve that Photoshop accepts as a path or vector mask. The path can be used for a number of functions.

While beginner programs do not include path functions, they are supported by almost all (semi) professional programs, including Photoshop and Paint Shop Pro.

Paths tools in Photoshop

Paths selection tools in Photoshop

① *Path around the lid of salt shaker*

② *Area inside the path filled with gray color*

③ *The lid is masked in the layer with a vector mask*

These functions are available by clicking the right mouse button, through keyboard shortcuts, or through the path palette (see page 207):

▸ **Load path as selection.**
 This selection can then be saved as a mask or alpha channel. (Photoshop also can convert a selection to a path. This is a function in the paths palette.)

▸ Fill the area surrounded by the path. The fill color is the current foreground color.

▸ Fill the path contour with the tool tip. You can choose a tool for this purpose. The effect is as if you paint over the path with the chosen tool. For example, the area below the path can be sharpened with the sharpen tool or a line can be drawn with the brush or pen.

▸ Save it as a shape with a name. It will then be available in the future as a vector shape.

▸ Create a (vector) mask with it. This is possible on a layer that is not the background layer. It protects those areas that lie outside of the path or the mask.

▸ Transform the path (with the transformations variations, see page 196). The whole path as well as single path anchor points can be transformed.

▸ Save as path and use again in other pictures.

▸ The path can be changed further by moving, deleting, or adding individual anchor points or by changing its characteristics. Paths can be named like layers.

The advantage of spline curves (with which the paths are drawn) is that they can create relatively complex shapes with relatively few anchor points (see figure ①). If you do not yet have any experience drawing paths in illustration programs, it may take some experimenting and some practice to learn how to optimize the anchor point placements. The anchor points, which have been set with the pen tool, connect straight or curved lines. The line between two anchor points is called a segment. In Photoshop, there are two types of anchor points: curve points and corner points:

▸ **Curve points** are the support points of a smooth or curved segment (see figure ④). You can drag two direction points out of the curve point; they act symmetrically to the anchor point. The further you drag the direction points away from

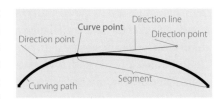

④ *Curve point (smooth anchor point) on a path*

the original anchor point, the smoother the curve becomes. If at the same time you hold down the Alt key (Mac: ⌥ key), each direction point can be manipulated without affecting the other direction point. This is how you can create sharp corners in an anchor point, in effect changing a curve point to a corner point.

▸ **Corner points** have two independent direction points and can therefore create a sharp corner.

The convert point tool �N allows you to convert corner points into curve points and vice versa. (Holding down the ⇧ key allows you to select several points.) An anchor point on a path can later be selected with the direct selection tool ▸ and can then be moved.

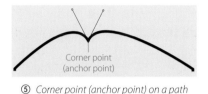

Corner point (anchor point)

⑤ *Corner point (anchor point) on a path*

Path palette • Photoshop has a path palette (Window▸Paths). Here you can activate actions to apply to the paths, such as converting a selection into a path ◔, creating a new path ▣, filling a path with the foreground color ●, filling a path with the tool tip ○, and loading the path as a selection ▣. You can also delete the path ▤ but not its contents.

Paths palette in Photoshop

Dock to Palette Well

New Path...
Duplicate Path...
Delete Path

Make Work Path...

Make Selection...
Fill Path...
Stroke Path...

Clipping Path...

Palette Options...

Because the path can be used as an expansion of a selection as well as a vector shape, you can use the options bar to specify whether the new path should be added, subtracted, intersected, or excluded from the existing path. You can also specify that the path tool will draw a new path ▩ or a new vector shape ▣ in a shape layer.* For the vector shape, you can set the style and the fill color in the options bar as well. The only thing that is not possible is drawing directly into a pixel layer.

** More on vector shapes can be found on page 203.*

Clipping Paths • There may be times when you want to export or print an image and only see those parts of the image that are surrounded by a path. To this end, Photoshop allows you to add a current path as a vector mask in the layers menu (but not while working on the background layer). It will mask everything that lies outside of the path. The image needs to be saved in a suitable format if the clipping path (vector mask) should stay with the image (such as EPS, DCS, or PDF).**

→ Clipping paths always have a hard edge!

*** See table A-2, page 332.*

The image can be printed with the mask or imported into another program. If the desktop publishing program supports clipping paths, only the image area placed within the path will be visible.

5.18 Image Collage

Creating an image collage is an advanced function of image editing: the image is created from several parts in such a way that the transitions are not visible and the completed image has a natural feel to it. The most essential elements of the image collage technique have been covered already: selection, layers, and transformations, as well as the various techniques to adjust the brightness, contrast, and colors.

Even in conventional editing of photographs, there are numerous situations in which the collage technique can be useful. If, for example, you're shooting in an area with too much contrast (e.g., a scene with bright sunshine and dark shadow areas), you could shoot several identical photos with different exposures. Some cameras offer a special function for this called *bracketing*. During image editing, the appropriately exposed areas of each photograph are sandwiched together – this means the dark image areas of the shorter exposures and the lighter areas of the longer exposures are merged together to create a single composite image.

Other situations may call for replacing a dull sky in your image with a more interesting one from another image.

People or cars in architectural images can be distracting. Again, you can take several pictures and cover up those disturbing areas in one image with clear areas of one of the other images, thus creating a final image without any people or cars.

The procedure is always the same. I will demonstrate it with a simple example. I begin with two pictures: an image of the moon and a portrait of the author. Both images should have roughly the same resolution and the objects should be the right size. The moon image needed to be enlarged significantly. The blur that this created is acceptable for the moon image.

1. There is one main image (figure ①, the moon) in which I will collage the new image – the face of the author. This main image is located in the background layer. I make a copy of the background layer and work on the duplicate. This allows me to copy elements from the original to the copied layer later on.

2. The first component to be collaged (the portrait) is copied into a new layer of the collage image. The still distracting areas are deleted in this layer with typical correction tools such as the eraser and selection tools.

It is often useful to hide the lower layers temporarily while adjusting the top collage layer.

Generally, soft edges are better suited for creating an invisible transition between foreground and background.

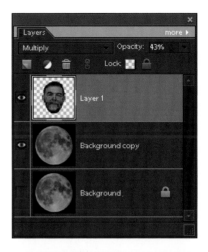

3. After making the lower layer visible again, I make corrections such as necessary transformations of the elements in the new layer, i.e., moving, scaling, skewing, rotating, or distorting.

I can zoom in to see the details better. (I use the navigator palette of the keyboard shortcuts for zooming in and out.)

4. Finally, I set the desired transparency (opacity) of the upper layer. This does not need to be 100%. Collages sometimes look better with a lower opacity, so that luminance, color, and structure of the layers are combined.

You can experiment with the layer modes and learn how to use them sensibly. The normal mode is only the launching pad for creative layer combining. For the collage in this example, you could also use *Multiply* or *Darken*.

The layers are merged at the latest possible stage, which means when the image is finished, if the storage space is not sufficient to save an image with many layers, or the computer starts running too slowly. Then, only merge those layers that are already finished. Merge all layers into the background only at the very end.

While working with layers, it is essential to have the layers palette open on your desktop. Make sure you know all its functions. The layers palette of Photoshop Elements is described on page 152. Layers you want to protect before editing should be locked (in Photoshop Elements with the ▢ symbol). If you observe unusual behavior while working with layers, check to make sure the correct layer is activated (the active layer is highlighted in the layers palette).

In complex collages you may work with a number of different layers. Therefore, it makes sense to clearly name the layers in order to keep an easy overview of your file.

To save an image together with its layers, it is best to save the image in the native format of the image editing program.* Photoshop and Photoshop Elements offer additional compression for the layers in the image, which should be utilized to produce smaller file sizes. Table A-2 (page 332) shows which file formats can save different elements of image editing. If you work with several programs, you may have to check them to see if they accept layers, selections, paths, and channels.

Some desktop publishing programs can import image files with layers and display them correctly. For example, FrameMaker, with which this book was created, recognizes layers and their transparencies in TIFF files that were created in Photoshop or Photoshop Elements.

Merged images using "Multiply" as layer mode and a opacity of 67 percent for the second layer with the face

* *The native formats for the following programs are as follows:*

Photoshop Elements	*PSD*
Photoshop	*PSD*
Paint Shop Pro:	*PSP*

Also see Table A-2 on page 302.

5.19 Filters and Filter Experiments

① *Original: blurry and dull background*

② *Result of Posterize filter (four levels)*

③ *Original image for the following filters*

Image editing programs offer numerous filters for different purposes. I already covered filters for blurring and for removing dust and scratches and the Extract filter. Filters that add noise can also help to make an image look more realistic or to cover up small image flaws.

Besides these, there is a whole range of filters for disfiguring images. One group gives images the appearance of a drawing or painting. The range is so large and the settings of individual filters so vast that I cannot cover this subject here in detail. Instead, I want to give you an introduction and encourage you to experiment with filters and their variations, try different combinations, and develop an eye for which filters are useful for which images. Even if you cannot draw yourself, you can create interesting images from suitable originals.

As the image of the flower (①) shows, a completely unusable blurry image with a dull gray background can be used to create an interesting picture (②). Here I simply reduced the colors to a 4-bit color depth (in Photoshop Elements, choose Filter ▸ Adjustments ▸ Posterize with four levels).

The original of the next example is figure ③, an orchid photographed with a black cardboard as background and a macro auxiliary lens. To prevent an overexposure of the image, I underexposed the image by one stop. The image was slightly sharpened.

The following figures, ④ through ⑨, show some of the filter effects offered in Photoshop Elements. These can be found on the Filter menu. Here I used only the predefined settings of each filter. Experimenting with the individual settings can give you even stronger results, which you should match to a particular image and its resolution.

Another filter that should be mentioned is *Liquify*. Even professional users in Photoshop make use of it to slim the face or the body of persons. I will use it in the example on page 211 to elongate the chin and modify the tongue of the person.

If the preexisting filters are not sufficient for your needs, you can find many more on the Web. A good place to start is the Plug-in Site [68].

④ Filter ▸ Artistic ▸ Cutout

⑤ Filter ▸ Artistic ▸ Rough Pastels

⑥ Filter ▸ Artistic ▸ Watercolor

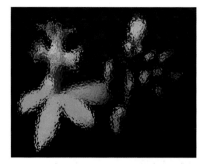

⑦ Filter ▸ Brush Strokes ▸ Sprayed Strokes

⑧ Filter ▸ Artistic ▸ Film Grain

⑨ Filter ▸ Distort ▸ Glas

Of course, not all filters are suitable for all images, and some of the filters are based on effects for natural-looking photographs, sometimes with lively effects.

The Liquify function on the Filter ▸ Distort menu allows you to shape the parts under the cursor as you would modeling clay or to pull your finger through colored jello.

For figure ⓓ, the cat's tongue from figure ⓐ was extracted and added into figure ⓑ. Additionally, the eyes of the cat were cut out and sandwiched into figure ⓒ. The Liquify filter was used to elongate the chin and deform the nose. ⓓ is the final image.

Cat, the original image for the tongue and eyes

Original image to be modified

Cat eyes and tongue inserted

Tongue + chin distorted with the Liquify filter

Some effects can be used on type; as an example I used the chrome filter. The text was first entered into its own layer, then it was converted to pixels (bitmap), and then the chrome filter was applied (in Photoshop Elements choose Filter ▸ Sketch ▸ Chrome).

Numerous other filters can be used on text (previously converted to bitmap), as well as on other image areas. For example, the ZigZag filter under Filter ▸ Distort can create interesting effects. Depending on the strength of the settings and the type of ripples selected, you can create very different effects.

Not all filters can be used on all color modes. The RGB mode is one of the more universal modes in this regard.

ZigZag filter in Photoshop Elements

5.20 More on Layers

The basic functions of layers were already introduced in section 5.3.8. However, the beginner often does not see the significance of layers because almost all image editing can be done without them. Therefore, I want to emphasize the advantages of layers once more, especially in the editing of photographs. While *vector*, *fill*, and *normal layers* have advantages for designers,* *adjustment layers* are very important in editing photographs.

In professional photo editing, most operations are carried out exclusively on adjustment layers, using an individual adjustment layer for (almost) every function. This allows you to make changes to earlier operations, even later on, without having to undo all subsequent steps and begin anew. This includes levels, contrast improvements with the curves function, color corrections with the Color Balance dialog box, and other corrections that can be carried out with an adjustment layer. The number of different adjustment layers increases with each Photoshop version. (In Elements, however, only a few are available. *Curves*, for example, is not part of Photoshop Elements).

The work begins by creating a new (normal) layer that holds a copy of the background layer. When working with layers – practically always when editing photographs – you should have the layers palette open on the screen. It gives an overview of the image and practically displays a history of work steps showing the adjustment layers.

* *Normal (pixel) layers are always useful when you want to run a filter on a separate layer.*

My first step is usually to duplicate the background layer.

→ *To activate a lower layer again – e.g., to make further corrections – click on the thumbnail of the desired layer in the layers palette.*

5.20.1 Muted Layer Effect

The use of layers has another essential advantage: You can easily overcorrect an image (for example, with a color or contrast correction) without worrying about the effect. By setting the opacity of the layer, you can fine-tune the effect to fit the image perfectly. When the opacity of the layer is reduced, the layers below (and the corrections applied to them) show through and allow you to create a very subtle integration of the correction effect of the particular operation. Therefore, you can correct quite clearly (in the adjustment layer) and then experiment with the opacity to achieve the desired result. Of course, the opacity of a layer can be altered at any time.

① *Dull original*

② *With Adjustment Layer Hue/Saturation (Opacity 100%) – It's a bit strong.*

③ *Adjustment Layer Opacity reduced to 67%. This is better*

5.20.2 Composite Layers

Some functions cannot be done on adjustment layers; this includes sharpening and practically all filters as well as the Shadows/Highlights function. In these cases, you have to create a composite layer (a normal pixel layer), which is made up of all lower layers. This is done as follows:

④ *New, empty layer*

1. First create a new layer (figure ④) on top of all the other layers.

2. Then create a composite image by holding down the Alt key (Mac: ⌥) and selecting Layer ▸ Merge Visible, which is the result of all the visible lower layers.

Instead of creating a new layer, or to really merge all layers into one, you are placing the composite image into the empty layer you created in step 1 (because you are holding down the Alt key), as shown in figure ⑤. Now you can perform the desired function (i.e., sharpening). If you now want to make a change to one of the lower layers, you only have to delete the composite layer, make the change, and then re-create the composite layer and the function you applied to it.

⑤ *Composite of all the layers below*

 In Photoshop CS2/CS3 and Elements 5/6, these steps can be shortened by using the somewhat complex keyboard shortcut Ctrl-Alt-⇧-E (Mac: ⌘-⌥-⇧-E). Again, you should have the topmost layer activated to perform this step.

5.20.3 Layer Masks

If the effect of a correction is supposed to work only on a particular image area instead of on the whole picture, you can use a layer mask to make this happen. First create a selection – as described in section 5.3.8 (page 147) – and then create a new adjustment layer with the selection active. The current selection automatically becomes a layer mask of the new layer, visible in the layers palette as a second thumbnail (i.e., ◼). The mask is black and white.

 The areas that are colored black in the mask are protected 100 percent; the areas that are colored white in the mask (the previous selection) get the full effect. In gray areas of the mask, the correction effect on the layer is muted, depending on the gray value. This can create soft transitions for corrections. This can be achieved, for example, by selecting Select ▸ Feather or using the keyboard shortcut Ctrl-Alt-D, (Mac ⌘-⌥-D).

⑥ *The total layers stack.*
The two upper layers have layer masks.

 Once you understand the possibilities of layer masks, this technique can help you a lot in making selective corrections to your images!

 Photoshop Elements only provides a limited version of layer masks. You have to do a selection before creating a new layer. (A solution for this is described by Sue Chastain at http://graphicssoft.about.com/od/pselements/qt/layermasks.htm.) The selection will then form the layer mask (the selected area will be white). In Photoshop, you can also create a layer mask later and then modify it using several tools.

5.21 Saving in the Correct Format

Photographic editing is usually done in the RGB mode. This mode is the best for working on a computer screen and is a good mode for most image editing functions and filters. For special corrections, you can temporarily convert the image from RGB to Lab color* and back without any loss of image quality; however, not all programs support the Lab mode (e.g., Photoshop Elements does not).

** For example, to limit the sharpen function only to the luminance channel and not apply it to the whole image.*

5.21.1 Saving Work Files

Work-in-progress files should be saved in a format with a lossless compression, which means not in JPEG format because every time a file is saved in the JPEG format, it loses some image quality. If you want to continue working on the image at a later time, choose the native file format of the image editing program you are working with. For Photoshop and Photoshop Elements, this is PSD (even though this format uses a lot of storage space) or TIFF, and for Paint Shop Pro it is PSP. These formats maintain layers (including adjustment and fill layers), alpha channels, and clipping paths (if they are supported). This information is then available to you again next time you open the file.

An "alpha channel" is a mask. It is only available in programs that completely support channels.
A "clipping path" is the empty shape of a selection. Clipping paths are not supported in all programs.

5.21.2 Saving Image Files for Archiving

You should choose a more compact format for saving images on which the work is finished, preferably still with a lossless compression and still in the RGB mode. Acceptable formats are TIFF (with a LZW or ZIP compression), PSD or JPEG 2000 with a lossless compression. PNG-24 is also a possibility. If you do not have a lot of storage space available, you will be forced to use JPEG 2000 or JPEG with an appropriate (lossy) compression.

In many cases, RGB or Lab mode and TIFF, JPEG 2000, or PNG will not be appropriate or other settings will be required. For example, images for the Web are saved as GIF or JPEG files with a variation of these formats that builds the image in layers. This is called *progressive* or *interlaced*. The advantage of building images in layers is that the web browser transfers and displays a rough image first.

The viewer can see the image before it is transferred completely, even if in a rough version. With the layers that follow, the image becomes more and more complete, until it is fully and completely visible. This technique is available in JPEG, JPEG 2000, GIF, and PNG. In JPEG, it is called *progressive* instead of *interlaced*.

When shooting in RAW and archiving your files to an external media (like DVD or external disks), you should not only archive your edited images, but also your original RAW files including the sidecar files (".XMP" files)* that contain the metadata you added and all the corrections (the editing) you applied using your Camera RAW converter.

Depending on the chosen format and compression, the space requirements of images can be reduced significantly:

TIFF uncompressed	100%
TIFF LZW/ZIP	to approx. 70%
PNG-24	to approx. 70%
JPEG high quality	to approx. 25%
JPEG medium quality	to approx. 10%
JPEG low quality	to approx. 5%
JPEG 2000 lossless	to approx. 70%
JPEG 2000 high quality	to approx. 20%
JPEG 2000 medium quality	to approx. 5%
JPEG 2000 low quality	to approx. 1%

➔ *The compression that can be achieved depends on the structure of the image. Fine detailed structures (e.g., branches) and subtle color gradations are more difficult to compress.*

** If you use a non-Adobe RAW converter, the sidecar file may have a different extension!*

5.21.3 File Formats for the Web

Perhaps you need to reduce the resolution of an image to prepare it for the Web. Resolutions between 72 and 95 ppi and a pixel count less than the whole screen size is good (so roughly 800 × 600 pixels). Because I cannot assume that all Web users have TrueColor capabilities (24-bit color depth), the color depth of JPEG images can be reduced in many cases to lessen the transfer time. GIF already limits the (total) color depth to 8-bit.

PNG was also constructed for Web use, but it's (not yet) supported by enough web browsers.

The optional metadata that may be embedded in a photograph should be removed for Web images (for example, with *JPEG-Cleaner* [67]). They take additional storage space and increase the transfer rate and may contain private information you prefer to keep safe. An exception can be copyright notices. Color profiles can be removed.

The settings for saving Web graphics differ from program to program. We will only briefly describe Photoshop Elements settings. The most important settings were already covered on page 157. This includes the format to be used (Ⓐ) – here, we use GIF. When using GIF, next set the size of the color table (Ⓑ), the type of dithering (Ⓒ), if transparency (Ⓓ) should be used, or if instead the background should have a specific color (Ⓔ). Finally, you can choose whether an image should be displayed completely or build up in layers (*interlaced*) (Ⓕ). Finally, you should set the scaling (size) for the image. Photoshop Elements offers an appropriate scaling function in the Save for Web dialog box (Ⓖ).

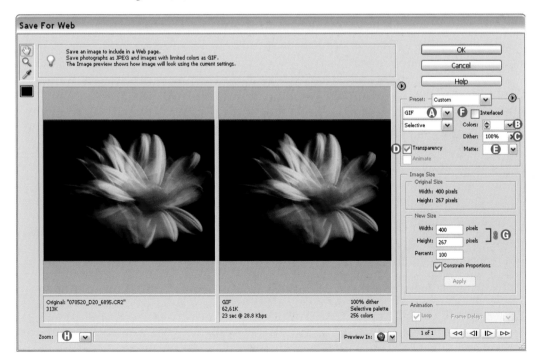

Photoshop Elements Save for Web dialog box

Using the Zoom (Ⓗ) allows you to check (right image) the resulting image quality of your settings.

Several individual pictures can be combined in a GIF file to create a small animation. The Photoshop Elements Help function explains how to proceed.

5.21.4 File Formats for Printing Photographs

JPEG in 8-bit RGB mode is the best format for having photographs printed at a professional photo service. The compression should not be too high to prevent loss of quality in the image (in Photoshop Elements, the quality should be set to approximately 7–8, for large prints, it should be 9–10). Some service providers also accept TIFF files. Color profiles are ignored in most cases and it is assumed that the file is saved in sRGB.

→ Photoshop and Photoshop Elements allows you to save files as JPEG only if they are in 8-bit mode!

For printing photographs on your own ink-jet printer, see section 7.2, page 266.

When printing from your own computer, you don't need to convert any files because you are most likely printing directly from your image editing program. This gives you the most control over the process and offers you many options for print settings.

You should find the version of the image with the highest resolution and reduce it to between 250 ppi and 360 ppi, depending on the printer and the paper. The reduction in resolution can shorten the transfer time to the printer and clearly reduce print time.

As mentioned, JPEG files are used for sending your files to a professional photo service. If the requirements on quality are extremely high, you can also use TIFF, but not all providers support TIFF files. The disadvantage of TIFF files is that they are much larger, even if LZW or ZIP compression is used. In both formats, the image should be in RGB mode with 24-bit color depth. You will get the best results if the images have a resolution between 250 ppi and 400 ppi. Acceptable quality can be achieved with 200 ppi, while 300 ppi is ideal. Larger formats can be printed at 150 ppi if the viewing distance is also larger. The reference number is 300 ppi.

Photoshop Elements dialog box for saving JPEG files

Photoshop and Photoshop Elements offer the adjoining dialog box for saving JPEG files. The slider bar is used to set one of 12 different quality/compression levels (Ⓐ) – the higher the quality, the lower the compression. In the *High to Maximum* (8–12) range, the loss of quality can rarely be perceived in the image. *Medium* (5–7) is still acceptable for many images and reduces storage requirements significantly. Lower settings should not be used for photographic print files.

The format options (Ⓑ) are only used for saving Web graphics and then function like the interlaced option in GIF. The image is transferred and displayed in layers that become progressively clearer. Real transparency is not possible in JPEG files unless you use clipping paths. Therefore, you can set under the Matte option (Ⓒ) how transparent areas in your image should be handled (i.e., with which background color it should be saved).

5.21.5 File Formats for Book and Magazine Printing

When files are prepared for professional printing, it should be clear who will make the necessary *color separations*, you or the print shop (suggestion: print shop or publisher). In both cases, certain adjustments are necessary. A color separation separates the image into the colors used for printing; generally this is CMYK. Suitable file formats are TIFF (compressed) and EPS.

A rule of thumb is 300 dpi for photographs in books and magazines and about 200 dpi for newspapers.

Encapsulated PostScript (EPS) contains the image in PostScript format. Raster (pixel) image vector graphics can also be embedded into an EPS file. You can also embed preview images so that the desktop publishing program can display a rough image of the file. This is useful because many desktop publishing programs cannot interpret the PostScript content of EPS files.

Because these images are rarely used as independent images but rather are embedded into a desktop publishing file, you need to clarify which format can be imported by the desktop publishing program and how it can separate their colors in case the color separation is carried out through the desktop publishing software. The file format is not the only thing important here; the compression method used also needs to be supported. Not all desktop publishing programs support LZW compression, for example.

A good solution can be the PDF format. It is getting more support from desktop publishing programs and can display images (even whole pages).

Ideally, the image is sized to the exact size it is supposed to be in the desktop publishing program, so it does not need to be scaled anymore. The resolution should be matched to the printing method.

When delivering images separately to a publisher for printing, you should submit the highest possible quality of the image and leave the preparations for printing to the production department of the publishing house.

5.21.6 File Formats for Other Purposes

There are several other formats whose application is determined by the purpose of the image. Under Windows, for example, an image you want to display on the Desktop as the background needed to be in BMP format, but the newer versions of Windows also accept JPEG files.

To integrate images into desktop publishing layouts, EPS can have advantages. Don't forget to embed a preview image into the EPS file so it can be displayed in the desktop publishing program (you can set this option in the Save dialog box of the image editing program). The TIFF format is the best choice for the embedded preview image because it can be interpreted by most PC and Mac programs.

Other considerations need to be made when sending images with email. This subject is covered in section 7.4.4. JPEG is the standard file format, but PDF can also be a good solution. In the Adobe world, PDF can be used to transport files between Adobe programs, while almost all information such as layers (as of Acrobat 8.0), masks, paths, color profiles, and metadata is preserved.

Table A-2 on page 332 gives an overview of which information can be saved with which file format.

Previously widespread image formats such as BMP (in Windows) and PICT in the Mac environment, as well as TARGA, are outdated. Generally, I suggest you try to keep the number of different file formats to a minimum.

5.22 Undo Functions and Automated Processes

5.22.1 Undo Work History

All image editing programs allow you to undo the last command, generally by using `Ctrl`-`Z` (Mac: `⌘`-`Z`). Many programs also allow you to undo several steps. You can specify the number of steps that can be undone, and you should keep in mind that every saved step takes up storage space. Generally, it is sufficient if you can undo the last 20 to 30 commands. The smaller your storage capacity, the smaller this value should be. When the maximum number is reached, the steps before can no longer be undone. The better image editing programs also offer a *history palette*, in which individual commands that have been carried out are displayed. This palette allows you to go back several steps at once. History palettes are available in Paint Shop Pro, Photoshop, and Photoshop Elements.

Undo History palette in Photoshop Elements.

Photoshop Elements calls this function the *Undo History palette*. You can drag the slider bar on the left back to the desired command or you can select the command directly with the mouse in the scroll list. You can then see the image as it was at this stage in the editing process. As long as you have not made another edit, you can reactivate the steps that have been grayed out in the palette. Only when you choose a new command are all the steps you undid deleted permanently. In Photoshop, you can open the undo palette by choosing Window ▸ History; in Photoshop Elements, choose Window ▸ Undo History. The Undo History palette is only available until you close the image.

Photoshop and Paint Shop Pro also allow you to save certain temporary states. You can go back to one of these saved temporary states and continue editing from there.

5.22.2 Batch Processing and Macros

When you're working with multiple images that are similar, some processing steps are repeated over and over again – for example, scaling images to a uniform size or resolution, converting them to a different file format, and renaming them. Better image editing programs offer a batch processing

mode for these cases.

In Photoshop Elements, this function can be found by choosing File ▸ Process Multiple Files. The batch processing options are somewhat limited in Photoshop Elements for scaling, renaming images, and some Auto corrections. You can also apply auto corrections such as Auto Levels, Contrast, Color, and Sharpen.

There are a number of specialized programs available for converting images. For the Macintosh, there is, for example, the shareware program Graphic-Converter, a very powerful tool. For Windows, you can use Formati [65] or PhotoResizer [80]. For Unix and Linux, ImageMagick [78] is available. This one, however, works with command lines.

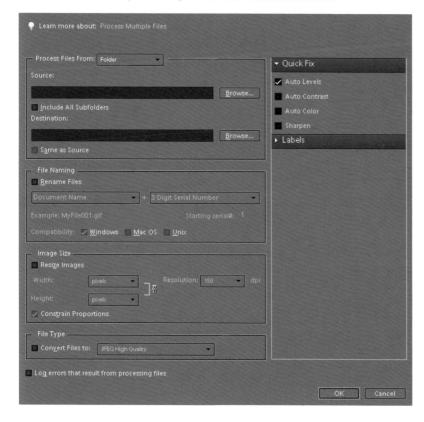

Batch processing dialog box in Photoshop Elements.

Macros and Actions

When you're working with editing processes that are repeated, it makes sense to record them and save them as working sequences or macros. Most advanced image editing programs offer such a function. In Photoshop, macros are called *actions*. They can be recorded, altered, and saved so they can be loaded for repetitive tasks. Some useful functions are now offered commercially as Photoshop actions, generally as freeware or shareware.*

The typical procedure for creating actions is to activate the record button, carry out the action, stop the record function, and save the sequence under an action name. In Photoshop, these functions are then available in the *actions palette*, which can be accessed via the Window menu. With the actions palette, you load actions from the file system, show and activate loaded functions, and record new functions.

An action is applied by opening an image, selecting the action (not action set!) in the actions palette, and clicking the play selection button ▶.

→ *Photoshop Elements does not support actions.*

* *ShutterFreaks [77], for example, offers actions that can be used to reduce noise in your images.*

Photoshop actions palette

The new action button ▣ allows you to record a new action and the start record button ● begins the recording process of the commands you enter. The stop recording/playing button ■ ends the recording of the macro. You can recall the action when you need it, but you can also still alter it. As usual, you can also delete an action by dragging it to the trash can 🗑. You can also delete individual commands from an action.

Several actions can be grouped into an action set. This increases the overview in a cluttered palette. In the example shown, the Default Actions action set is opened and the Color and Tonal Correction action is selected. A new action set can be created with the create new set button ▭. The action file has a file ending of ".*atn*" in Photoshop.

In Paint Shop Pro, the actions are called scripts and are generally found in special folders under the image editing program. In Photoshop, this is the folder called Photoshop-actions in the presets folder. Actions and action sets can also be loaded from other folders.

Some programs, such as Paint Shop Pro, do not necessarily need to record an action but allow you to group and save several steps from the history palette into an action.

Because some of the recorded steps may be image specific (e.g., a selection of an image area), they may need to be replaced with image-neutral steps. Most programs allow you to make such a change, including Photoshop. For details about this procedure, check the Photoshop help file.

5.23 Profiling Devices

→ *The subject of color management is complex, but color can be managed with a little know-how. A good introduction for photographers can be the book "Color Management in Digital Photography" by Brad Hinkel.*

As already mentioned, there is no ideal capture or presentation device for color in our physical reality. In addition, the color behavior of input and output devices changes with time due to aging effects or operating temperatures of monitors, for example. Even a change in the lighting situation can cause us to perceive colors differently. Colors on monitors will appear paler, for example, when bright light hits them. Colors on prints are affected by the ink and the paper. Output devices like monitors can be corrected to a certain extent by adjusting the brightness, contrast, and color settings. The color output of other devices can be measured and compared with reference colors, and the correction table can be used to adjust the device.

→ *Calibrating and profiling of devices is useful only when you work with programs that support color management, which most good image editing programs do by now (at least to a certain extent). Photoshop Elements does, and of course Photoshop does a fantastic job.*

Ideally, a device is calibrated and profiled for every new user sequence, and with a reliable measuring device. For the hobby photographer, this is not necessary, especially because the measuring devices used may be very expensive and the process takes time. It makes more sense to limit your color management to simpler methods with which the amateur photographer can still achieve acceptable results.

It is simpler, for example, to use a device-specific ICC profile that the manufacturer has already created for the device series. However, this does

not account for manufacturing tolerances within the device series or aging effects as well as the effects of different work environments and settings.

A simple calibration procedure for your monitor is described on page 222.

If a manufacturer's profile is not available, you can use a profile that applies to a whole category of devices, but it will therefore be less accurate. For example, there are ICC profiles for CRT and TFT monitors. If you know the type of phosphor used in a CRT monitor, which is hopefully listed in the device manual, this can also be taken into account in the ICC profile.

You can also use software and test images on the monitor to calibrate it, which is acceptable for many applications. This software is often part of the operating system or the image editing program (as is the case with Adobe). This is a minimal calibration that you should absolutely do. It should be done regularly (roughly every two months), and if your requirements are higher, even more often. The calibration should only be conducted once the monitor has reached its operating temperature, which takes about 30 minutes; TFT monitors (flat screen monitors) only need 15 minutes.

A significant improvement over this very simple calibration is the use of monitor color measuring devices, which, together with software, determine the colors of a test image and calculate the device ICC profile from this information. They can be saved and reloaded. The price for such measuring devices starts at about $100 for calibrating monitors. Some very high-end monitors that are specially made for the professional color workflow come with such a measuring device built in. Their prices, however, lie above the budget for the average amateur photographer.

Profiles for scanners are created with a reference card – for example, an IT8 card. The card consists of a color table. It is printed with true colors on a piece of cardboard and is relatively color fast. You can also find transparency versions of the IT8 card. The profiling software compares the resulting color image with the digital reference values and calculates a correction matrix, the ICC profile. Of course, while scanning you will have to deactivate the color management and color correction settings of the scanner software.

IT8 card (by Fujifilm)

Unfortunately, the necessary software and color reference charts are still so expensive that they are only included in scanners of the upper price range (see, for example, www.silverfast.com).

The same method and technique can also be used to determine an ICC profile of a digital camera. However, this software is still not included with cameras, not even the expensive ones. Additionally, you would have to create different profiles for different camera settings (such as for different ISO settings).

Measuring printers is the most complex of the methods. For this purpose, you print a reference page (a color table) and then measure the resulting colors with a spectrometer. The profile is created from the comparison of the reference colors with the measured colors. This process needs to be repeated for different papers and inks.

Print profile kits (including software and a measuring device) start at about $500. In section 7.2.3, you can find out about other ways to get print profiles.

If you print a color document at a print shop, it should already have finished ICC profiles for its printing presses, printing methods, and the papers used that can be made available to you. Otherwise you can find a generic profile at ECI [10].

Table A-1 in appendix A shows where to save and find ICC color profiles. In Mac OS, ICC profiles have the ending "*.icc*", under Windows either "*.icc*" or "*.icm*". Therefore, if you cannot find a profile data file in Windows, simply rename it accordingly. In Windows, a profile is installed by selecting it and using the right mouse button to select the Install Profile function. On the Mac operating system, you simply move it to the appropriate profile folder.

5.23.1 Monitor Calibration

For the assessment and editing of images, correct color reproduction on screen is essential. How can you correctly assess colors and tonality if you are not sure that the colors on your monitor are the ones that are in the image?

Manufacturers' monitor settings will result in crisp and pleasing image reproduction – often, however, the colors are not necessarily reproducing truthfully. Therefore, you should calibrate and profile your monitor if you intend to do serious color work. There are two basic approaches for this:

a) Calibrating and profiling your monitor visually using your eyes as a measuring instrument

b) Making use of a colorimeter to calibrate and profile your monitor

The first way is inexpensive but rather inexact, unfortunately. The second way requires investing in a calibration suite (including software and hardware) but results in a more precise profiling.

In all cases, the first step is to set up your graphics card to a color depth of 24 bits or more. Additionally, the monitor should have warmed up for approximately 30 minutes.

Actually, what is called *calibration* (or *profiling*) ideally consists of two steps:

1. **Calibration**
 The aim of calibration is to define a highly accurate, *standardized state* for the device; for example, when calibrating a monitor, you manually set the controls to achieve a certain *luminance* (brightness of your monitor's white), that is known to suit color work. Also, you set a *white point* that conforms to an industry standard, such as D50 or D65 (color temperatures of 5,000 or 6,500 Kelvin, respectively). The *white point* of your monitor is a mix of R, G, and B that will represent *white*.

2. **Characterization (profiling)**

When a monitor is characterized, colored target patches with known color values are sent to the monitor. Their color values, as reproduced by the monitor, are recorded by a colorimeter. The profiling software will then compare these color values to the ones sent out and calculate a device's *color profile* from that. The profile is essentially a translation table. It translates the color values of the image to those that have to be sent to the monitor in order to produce a color as close as possible to that of the original image.

A colorimeter is an instrument that measures the red, green, and blue light spectrum (returning an RGB value) of a light source – here that of the colored light sent out by the monitor.

To perform either step, especially when calibrating a monitor, it is advisable to use a hardware device like a colorimeter or a spectrophotometer to measure color.

Only somewhat more expensive profiling suites will offer both functions, while the less expensive packages (like Pantone's *huey*) will offer only profiling (characterization).

Adobe Photoshop Elements, of course, is "color management" aware, implying that it does color-manage your images wherever possible, also making use of monitor ICC profiles.

The current versions for Windows as well as Mac OS X offer a simple calibration/profiling of the monitor without a profiling appliance, instead using test images and a wizard

Software-Based Profiling for Monitors with Windows

With Windows, you will find this application under Start ▸ Control Panel ▸ Adobe Gamma – only, however, if you have installed any of the numerous Adobe application supporting color management (for instance, Adobe Photoshop, Elements, FrameMaker, or Acrobat).

Adobe Gamma offers two modes: "Step by Step (wizard)" or more directly using the Control Panel.

When you're using the Control Panel version of Adobe Gamma, the panel will include all essential preferences (figure ①) in a dialog box. You can also call up the Gamma Wizard from this dialog. In the dialog, you set three parameters:

▸ **Phosphors** (LCD displays use another luminous type)

▸ **Gamma** (see the description on the next page; we recommend a value of 2.2): If you deactivate *View Single Gamma Only* (figure ①), you can set up the individual gamma values for red, green and blue. Using the sliders below the colored patches, make the inner and outer rectangles blend as well as possible. For this, it helps to slightly close your eye until the fields get blurred.

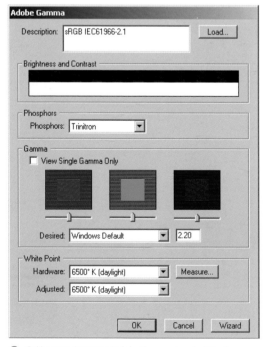

① *Calibration Assistant (Adobe Gamma) under Windows*

▸ **White Point**: Here you should set the white point to that of the color space with which you predominantly work. With sRGB and Adobe RGB (1998), this is 6500 K.

The monitor profile thus created can be saved – actually, Adobe Gamma will do this automatically – and can be recalled later either automatically using the Adobe gamma loader or by using Start ▸ Control Panel ▸ Display ▸ Settings ▸ Advanced ▸ Color Management.

Display Calibrator Assistant of Mac OS X

With Mac OS X, a *Display Calibrator Assistant* is available for calibrating (actually for calibrating and profiling) your monitor. You will find it by following these steps: Open *System Preferences* from your Dock. Select *Displays* and choose the *Color* tab. Now select your monitor (if you have more than one) and click *Calibrate*. This will bring up the *Display Calibrator Assistant* (see figure ②). Here, activate *Expert Mode*. Now follow the instructions of the Assistant. It will guide you through the whole process using simple steps, finally creating a monitor ICC profile and activating it.

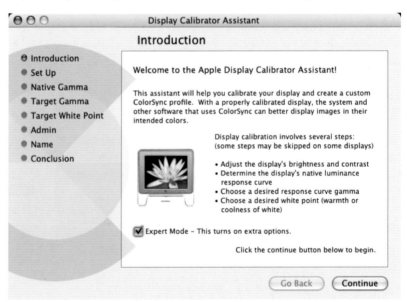

② The "Display Calibrator Assistant" of Mac OS X will guide you with simple, well-explained steps through the whole calibration process.

Sites with help for monitor calibration:
http://epaperpress.com/monitorcal/
http://www.softpedia.com/get/Tweak/
Video-Tweak/

For Windows, and to a lesser extent also for Mac OS X, there are some more ways to set up your monitor for the best results. To the left we've listed the URLs with more information.

Monitor gamma

With monitors, there is a nonlinear relation concerning input voltage and brightness. Applied to CRT monitors, for example, to achieve 100 percent luminance will require more than double the voltage of 50 percent luminance. The gamma value of displays gives, moreover, a correction factor.

This gamma curve also depends on the white point you intend to use. This curve actually describes how luminance values are distributed from black to white and what luminance level 50% will have. Traditionally, a gamma of 2.2 is used for Windows, while with Mac OS, a gamma of 1.8 was the standard for a long time. This means that the same image looks brighter and shows a bit less contrast when displayed with Mac OS (using gamma 1.8) than it does with Windows (using gamma 2.2). To achieve a similar look on both systems, you have to use the same gamma value. The standard gamma value of 2.2 fits better to sRGB and Adobe RGB color spaces, while the Mac value of 1.8 better matches ECI-RGB as well as the processing of CMYK images when preparing them for press printing. (Photoshop Elements, however, does not support CMYK.) In general, a gamma of 2.2 is preferable; we recommend it explicitly. Of course, other gamma values can be used; however, you should not go beyond a gamma of 2.2.

For a fine color differentiation with your monitor, in particular in grayscale, lower gamma values (about 1.4– 1.8) are better suited than higher ones. Unfortunately, this does not get on optimally with the Windows default settings nor the gamma values accepted there of digital photos (such as those without embedded color profiles).

The gray wedges, which one finds on the web,** allow you to check whether the current gamma setting (brightness and contrast) of your display is suitable for photo editing. If you can distinguish all grayscales to be found there cleanly on the display, you have a useful setting.

** For instance see www.hutchcolor.com/images_and_targets. html*

Hardware-Based Profiling for Monitors

Although calibrating your monitor visually is better than doing no calibration at all, if accuracy and precision are important, you should use a hardware-based color-measuring device, e.g., a spectrophotometer or colorimeter to achieve optimal results. There are several reasonably priced packages currently available starting from $90 and going up to about $250 for a complete kit.* If you can afford it, we recommend the GretagMacbeth/X-Rite Eye-One Display 2 kit. While the cheaper packages (e.g., Pantone's huey) allow only for profiling and provide no calibration, the more expensive packages also allow you to calibrate your monitor and to freely select the target values (gamma, luminance, and white point).

** Your choices include: GretagMacbeth Eye-One Display 2 [44] , ColorVision Spyder and Spyder Pro products, and the entry-level device huey, which is sold by Pantone as well as by GretagMacbeth/X-Rite [44].*

The entire calibration and profiling process will take you about ten minutes. After a good initial calibration is achieved, the next calibration will be even faster. Depending on your personal quality requirements, you should re-calibrate (and re-profile) your monitor every month. Some professionals do this even once a day.

With hardware-based calibration packages such as huey™ or Spyder2 Express available for about $90, there is hardly an excuse for not using one of these hardware-based monitor profiling packages if you care about color confidence in your work!

➜ Here are the target values we recommend you to use when calibrating and profiling your monitor (both for Windows and Mac OS X):

Gamma:	*2,2*
White Point:	*6 500 K (D65)*
Luminance:	*100 cd/m² for CRTs and*
	120–140 cd/m² for LCDs

Monitor Profiling with huey

Of all the monitor profile packages we know of, **huey** is the simplest to use. This set, sold by Pantone for less than $100, will run with Windows XP (and Windows 2000 and Vista), as well as with Mac OS X (10.3 or higher). It requires a spare USB port. It will profile CRTs as well as LCDs and LCD laptops.

The package includes profiling software and the huey colorimeter. This is a device used to measure the three primary colors (R, G, and B) of a monitor. The colorimeter is quite small and handy and it comes with a small support stand seen in figure ①. The stand helps to measure the room light.

The colorimeter is connected to your computer via USB – though the USB cable is a bit short for our taste.

The installation of the huey package is straightforward and doesn't pose a problem – but you should connect the huey to the USB port only *after* installing the software. After installing the package, you will see a huey icon on your desktop (Windows) and in your Taskbar. A click on it will start the profiling of your monitor. With Mac OS X, having two or more monitors, you will have to relocate the menu bar to the display you want to profile.

What is missing, unfortunately, is a reasonable online manual containing at least a brief introduction on monitor profiling. However, the program provides some online help.

The entire process of monitor profiling takes about five minutes and will run like this:

① *huey colorimeter, about 4 inches tall*

1. After starting huey, you must select the kind of display in use. The program, in almost all cases, will do an educated guess, so you need only to confirm the selection and continue.

2. The program next measures the ambient light in the room. So it can do so, you place the device in its stand and align it with your display – facing you (see figure ②) and away from the screen.

3. Now, remove the device from its stand and place it on your monitor using its suction cups. The position for the huey is clearly marked (see figure ③). While reasonable with CRTs, this is questionable with an LCD, whose surface can be quite easily damaged.

② *The second step is measuring the room ambient light.*

Other packages use a counterweight on the USB cable hanging on the rear of the monitor. They should have done something similar for the huey (using a longer and stronger USB cable). I prefer to hold the huey with light pressure to the LCD surface by hand for the few minutes taken for the entire process.

4. In the next step, the program outputs a sequence of colored patches onto the monitor. The colors of these patches are measured by the colorimeter (figure ④).

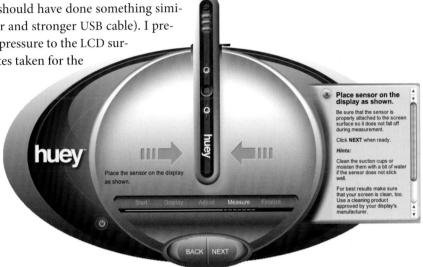

③ *Place your huey on the screen on top of the place indicated.*

④ *The huey program will display a sequence of different colored patches that are measured by the colorimeter. To the left, you see a kind of progress bar.*

This process takes about 3–4 minutes. Do not switch to another program while the huey profiling is running.

5. Having finished the displaying/measuring sequence, the program has all the values to calculate the monitor profile. The display in Figure 9-32 will appear, allowing you to see the test image before and after profiling.

6. The huey program offers profiles for a number of different purposes (see figure ⑥). The names are a bit fuzzy. This may be for novice users to color management, but it is, in our opinion, not a good choice for photographers. On the right of figure 6 (page 228) is a translation for these settings (color temperature and gamma).

⑤ *A first version of the profile is finished. You can switch between a before and after view.*

⑥ *The switch allows you to temporarily deactivate the effect of the controls.*

With this, you are finished. Huey will install the new profile in a directory appropriate for your operating system, and will activate it.

7. In a final dialog, you can select whether huey should monitor your ambient room light and adapt the profile accordingly (see figure 7). We disabled this function, but you may change this setting later on.

⑦ *You can activate a permanent measurement of the room light and a corresponding adaptation of the monitor profile.*

Profiling your monitor with huey is extremely easy – really made for the beginner. Our results with a laptop were good – better than with some more expensive packages. Those others, however, lead to somewhat better results with standard monitors, but not with laptops.

We repeated this on Macintosh monitors and also with our Windows systems. In both cases, the results using huey were good.

Since 2007 there is a Pro version of the huey tool available, which will allow you to calibrate several monitors to the same setting, and offers D-numbers and gamma values instead of the ones shown in the sidebar above. The standard huey can be upgraded to the Pro version by a firmware update.

5.24 Automatic Corrections

Photoshop Elements and almost all other image editing programs for beginners offer a host of automatic corrections. They stretch from the auto correction of red eyes – at times already done when the images are transferred to the computer from the memory card – through the automatic removal of color casts and the automatic optimization of lighting, color, and contrast. Photoshop Elements even offers a Smart Fix, which is supposed to simultaneously correct all of these aspects of an image. Automatic corrections are helpful for the beginner because they give you nice pictures even if you don't know much about image editing.* They often do a good job, but not always! They rarely give you the result you could achieve with a little bit of effort and a little bit of experience. But to gain this experience, you will have to let go of the automatic functions every now and then or simply use them as a starting point for further image optimization.

** Automatic functions use sophisticated algorithms.*

In Photoshop Elements, the automatic corrections can be found under *Quick Fix* or ![Quick]. It is divided into four parts: *General Fixes*, *Lighting*, *Color*, and *Sharpen*. In addition to the auto function, each section includes the most important adjustment sliders for the correction.

Because it is often hard to see if a correction improved the image, I recommend to switch to the display mode in which the image is shown in a Before/After view. The menu for this is found at the bottom of the editor window (see figure ①-Ⓐ).

① Photoshop Elements Editor in Quick Fix Mode showing a Before/After view of the image. ▾

You can always undo the last correction by clicking the *Reset* button (top right), and in the drop-down menu (bottom left), you can display the before and after images side by side. This is useful. The image becomes smaller in the preview window, but you can clearly see what effect the auto function or the individual correction with the slider bar has.

After your first attempts with the automatic functions, you should try to make the corrections yourself, as was described in the earlier parts of this chapter. Start by making global corrections that apply to the whole image. After that, if appropriate, make corrections to selective, individual areas. To do this you will most likely have to select the area first with one of the selection tools and then make the correction.

Use adjustment layers to make the corrections so that the correction can be modified. The opacity slider of the adjustment layer can then always be adjusted to determine how much the correction should be visible in the image.

5.25 Thoughts on Image Manipulation

Original ▲ and edited image ▼. Is this image manipulation?

The transition from *image correction* to *image manipulation* is very smooth, and it is almost impossible to give general recommendations about what is *allowed* and what is no longer appropriate. Images used in advertising are strongly corrected and manipulated. The model with the perfect skin does not exist, and politicians having no imperfections in their faces on election posters is more due to image editing and masking than to Mother Nature. Also known in politics is the retouching of whole persons from group photographs. Think about what the purpose of the image is and who will get to see it.

Be especially careful when retouching images of people when the images are meant for publication; you will also have to think about privacy and publicity rights (see section 4.17 on page 124). Some people like their wrinkles and freckles and do not want them changed, and some people are thankful for a skilled retouch.

Here are some technical suggestions for image editing and manipulating:

▶ Make sure you still have the original image. You might, for example, want to go back to the original to compare it with the new version.

▶ Be conservative with changes and corrections.

▶ Try to minimize the individual correction steps. Every correction potentially adds to loss of quality.

▶ If you are lightening parts of an image, adding lights and shadows, increasing perspective distortions, or making other similar corrections, you should make sure these corrections appear realistic in comparison

to the light and space proportions of the photograph – as long as you wish to create a realistic impression.

Does the shadow fall toward the correct direction in regard to the main light source? Are the proportions of shadows, buildings, and people correct? Are the colors of lights and shadows correct?

▶ Before spending a good amount of money to print a color image, it is best to check it by printing it on a laser printer. This can be done quickly and inexpensively. You can see flaws relatively easily, even on a black-and-white print of an ink-jet or laser printer, and it offers you another way to view the image other than on the screen. The omission of color can also be useful. It shows you where your image might need more or less contrast.

If you have to get the approval to use an image, this print might serve as an evaluation copy. You can also use it to sketch out changes you plan to make later.

→ *As of Photoshop Version CS2, the clone stamp tool and other insertions can be made in reference to a perspective point and be inserted with the correct perspective.*

5.26 Troubleshooting

With increased capabilities of image editing programs, their complexity also increases. It is easy for the user to overlook a setting and get an unexpected result. Therefore, I want to list a few typical situations and tips.

Nothing is drawn • At times, the pen, brush, or eraser tool is activated but you cannot see a visible result of the drawing. There are two typical situations in which this happens:

▶ **A different area is selected**
Often a selection is activated that is either very small or located in another area of the image and is thus not visible. All drawing tools are now limited to this selection. Simply deselect the selection (in Photoshop Elements by pressing Ctrl-D (Mac: ⌘-D)).

▶ **You're working on the wrong layer**
If you inserted something into the image – by choosing Select ▸ Copy ▸ Insert or by using the text or vector tools – a new layer is automatically created and becomes the active layer. The layers below are still visible, but they cannot be edited. This is a good reason to (almost) always have the layers palette open, so, with a glance, you can check which layer you are drawing in. In the layers palette, you can click the thumbnail of the desired layer and thus make it the currently active layer.

Eraser or pen does not react correctly • Almost all painting and drawing tools use the current foreground color; the eraser uses the current background color. Check which colors are currently set as foreground and background colors. Clicking on the ⤵ icon in the lower area of the toolbar switches the foreground and background colors. Clicking on the ◼ icon (at

the bottom of the tool bar or by pressing ⬚) resets the foreground color to black and the background color to white.

If the diameter of the drawing tool is set very small – only 1 to 2 pixels – the mouse cursor can be difficult to see at the standard zoom setting. Zoom out a little and check to see where the cursor is located, and then zoom back into the image. Here it is practical if your working space is slightly larger than the image, which is not always possible when you're zoomed into the image.

Clone stamp tool does not react correctly • If you accidentally pressed the ⬚ key while selecting the clone stamp tool in Photoshop (or Photoshop Elements), the pattern stamp tool ⬚ is automatically selected and a (previously) selected pattern is added to the image. This is not usually the effect you desire. Therefore, check to see which stamp tool is activated.

Wrong selection • You try to select something with the rectangular marquee or the lasso tools but the result of the selection is not correct. In this case, you probably either accidentally held down the ⬚ key or activated a combination mode* for the selection in the options bar. The program now continually adds and subtracts the new selection from the old one or creates an intersecting selection. Change the selection mode back to the standard mode. Instead of using the modes in the options bar, it is better and faster to use the keyboard shortcuts to choose the desired selection mode.** When you release the key, the mode automatically reverts back to the standard mode.

*In Photoshop (Elements), the combination mode is activated in the options bar with the icons.

** For Photoshop Elements keyboard shortcuts, see the table on page 149.

Because the different selection modes are often-used functions, it makes sense to write yourself a note with the keyboard shortcuts and place it next to your monitor for reference.

If you chose a soft edge (feather) for your last selection, the program rounds the selection to this edge width. If you are now working on an image with a different (lower) resolution, this might at times create an unexpected selection border (e.g., with the rectangular marquee the corners become rounded). Check the width and feather of your selection tool in the options bar.

Functions are grayed out • At times certain functions (such as filters) you want to use are inactive (grayed out) or simply do not react. This can be because the function is not supported in the currently selected color mode. Numerous filters cannot be used in 16-bit color mode (per color channel), in indexed color mode (2 to 8-bit total), and in grayscale, CMYK, HSL, and Lab modes.

Change the color mode of the image to use one of the supported functions. Be aware, though, that changing color modes can cause loss of quality in your image.

Filters, including the sharpening filters, can so far be used only on pixel layers and not on adjustment layers. If you have an adjustment layer

located on the very top of your layers, you will first have to create a composite (pixel) layer and then use the filter on this layer.[*]

Simplifying the Workflow

Sticky notes • During complex image editing tasks, the same functions are repeated over and over again. This includes the different selection functions (such as select, deselect, inverse), merging a layer down, activating the clone stamp tool, moving a portion of the image with the hand tool, and undoing the last operation. Most of these functions have predefined keyboard shortcuts (or you can define new ones for them).

Working with these keyboard shortcuts is much faster than using the mouse to choose menu options. You can prepare yourself small notes with these keyboard shortcuts and tape them to the edge of your monitor to remind you of the keystrokes until you know them by heart, which may never happen if you only use the image editing program every now and then.

Create straight lines and edges • I have mentioned it several times already, but beginners tend to forget it: almost all drawing and correction tools allow you to create a straight line between the last and the current mouse position. To do this, you have to click once with the left mouse button (with the tool selected) into the area where the line should begin, then release the mouse button, hold down the ⇧ key, and click with the left mouse button at the place the line is supposed to end.

This not only works with the pen or brush, but also with the eraser, lasso, sponge, blur, and sharpen tools and the dodge and burn tools, as well as the clone stamp tool.

Large screen, second screen • A good monitor is essential for image editing – the larger, the better! The falling prices of acceptable flat-screen monitors have been a blessing for me, and usable 19-inch TFT monitors can now be bought for less than $300 and 21-inch screens for less than $1,000. Treat yourself, if at all possible, to such a screen. Your eyes will be thankful and a good monitor can outlast a computer.

However, do not throw out your old monitor. It can very well serve as a second monitor. Almost all newer computers (except some laptops) support two monitors, as does Windows XP and Windows Vista (Mac OS has for years). The old one is well suited – even if it is smaller and the quality is worse – for displaying numerous palettes of the image editing program. This creates a lot more space in the main image window.

When buying a new monitor, you should make sure it has digital input (DVI), even if your current computer does not yet support it. With an adapter, the monitor can be hooked up to an analog port. Your next computer will most likely have a digital port and a digitally controlled monitor displays a better and sharper image.

As of Photoshop CS3 and Photoshop Elements 6: Ctrl-Alt-⇧-E (for Windows) and ⌘-⌥-⇧-E (for Mac). The previous versions used Ctrl-⇧-N followed by Ctrl-Alt-⇧-E (for Windows) and ⌘-⇧-N followed by ⌘-⌥-⇧-E (for Mac).

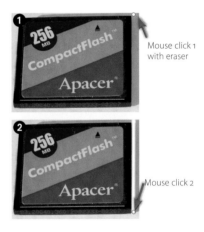

Mouse click 1 with eraser

Mouse click 2

12-inch TFTs have 1280 x 1024 pixels, 20-inch TFTs have roughly 1400 x 1050 pixels, and 21-inch TFTs have 1600 x 1200 pixels.

RAW Conversion

6

What is this mysterious RAW format? Why should we shoot RAW images when the new digital cameras can produce well-optimized, sharpened JPEG images high in contrast and often much faster than they produce RAW files?

Slightly simplified, an image in RAW format consists of data that the camera reads from the image sensor and saves to temporary storage; this is raw and unedited sensor data (therefore RAW). Every camera does this, even if the images are stored as JPEG files in the camera. If you shoot JPEG or TIFF, the camera edits the data internally. It carries out a color interpolation to convert the grayscale image into color. Then it sharpens the image, optimizes the contrast, suppresses noise slightly, calculates the color temperature (set either automatically or by the photographer) in comparison with the image data, and in JPEG files compresses these image data and then saves the data into a format (usually JPEG) that can be easily edited. And all this happens within the small built-in computer chip in the camera.

→ If your camera does not support the RAW format, just skip this chapter. The methods described here are available in Photoshop Elements as of version 3, but the specific RAW converter that I will demonstrate here is Adobe Camera Raw 4.2 that can be used with Elements 4, 5 and 6. The basic techniques shown in this chapter are quite universal and may be applied to almost all other RAW converters as well.

6.1 RAW Format

For the RAW format, the camera takes the data read from the image sensor without editing it, and packages it together with information about the exposure in a RAW file. Editing needs to take place in the computer, and with that comes a few disadvantages and many advantages.

It is unfortunate that almost every camera manufacturer uses its own proprietary format, which can vary from one camera model to the next. There are a large number of different RAW formats, and not every RAW conversion program can process them all. Thus, if you want to edit RAW images, you will have to make sure your program can handle the RAW format of your cameras. Most camera manufacturers provide a simple RAW conversion module with each camera package, but these converters are often very simple and can convert only the format of the manufacturer. From the view of the photographer, a standardization would be nice, and Adobe made a suggestion with the Digital Negative Format (DNG) format, but so far few manufacturers (e.g., Leica) have picked it up. In the short term, there is unfortunately no improvement in sight.

→ There are a tremendous number of RAW formats. Throughout this chapter I will use the term "RAW" as a generic name . You have to replace it with the format name of your specific camera's RAW format.

Most current digital cameras in the middle and upper price range – this applies to digital cameras above approximately $400 USD and all digital single lens reflex cameras – offer a RAW format besides JPEG (with compression). The RAW format of the camera has a few advantages over JPEG and TIFF files:

▸ The RAW file contains more image information, often 10, 12 or 14 bits per image pixel instead of the 8 bits typical for JPEG files. This image information can then be saved as 16-bit TIFF files. This allows for a higher dynamic range and offers a larger buffer for potential loss of image quality during image editing. This presumes an image editing program that can process 16-/48-bit images, such as Photoshop CS/CS2/Cs3, Photoshop Elements since version 3, PhotoLine 32, Paint Shop Pro, Picture Windows Pro, and GIMP 2. The RAW converter module DCRAW is a plug-in for the free GIMP program [35].

▸ The RAW format is pretty much an unedited extract of image information from the image sensor. Optimizations of the image such as white/color balance, exposure corrections, sharpening, and improving contrast can be controlled much better in the RAW converter or carried out in an image editing program. With in-camera JPEG and in-camera TIFF files the conversion and editing happens automatically (with little control) in the camera, while RAW allows you an individual control in the conversion program or during image editing on the computer. There is no loss of quality in RAW files compared to the lossy compression used in JPEG files.

▸ The image in the RAW format can be considered as undeveloped, exposed digital film (negative). It is possible to still manipulate the image during development (e.g., achieve a slightly higher light sensitivity or higher contrast), so the RAW image can also be optimized during the conversion to TIFF or JPEG, especially the exposure and the white balance.

As opposed to film, the RAW image can be developed (converted) more than once. Therefore, it is a good practice to archive the original RAW image file. In my experience, new RAW conversion programs and versions can optimize the RAW files better than older versions, especially because the algorithms for color interpolation, sharpening, and noise suppression continue to be improved.

More on the subject of color interpolation can be found in section 2.2.1 on page 10.

Because it is rare to get something good for free, you sometimes pay a price for working with the RAW format:

▸ The RAW file is larger than the corresponding compressed JPEG file, which is especially painful on memory cards and can cause the file-saving process to take longer.

▸ To convert RAW files, you need to use special RAW converters, either as stand-alone programs or as plug-ins. While most camera manufacturers such as Canon or Olympus provide such conversion programs as part of the camera package (sometimes as a Photoshop plug-in), they must be bought for other cameras.* The commercially available RAW converters, of which a number are available, are oftentimes a better alternative, although with varying conversion quality and support of different RAW formats. One advantage of most of them is that they support more than just the RAW formats of a single brand.

** For example, Nikon Capture NX for the Nikon NEF RAW format.*

As mentioned, there is no standardization in the RAW format. As a result, every camera manufacturer has its own format, sometimes even several for different camera models. The RAW files of various manufacturers therefore carry different filename extensions.** If you buy a new camera, you may have to wait some time before it is supported by the third-party RAW conversion programs because even if the RAW format has not changed, other camera-specific parameters are necessary for RAW conversion.

*** For example, ".nef" in Nikon RAW files, ".crw", ".cr2", or (a little confusing) ".tif" for Canon RAW files, and ".orf" for Olympus RAW files.*

Additionally, the RAW conversion process is another step in the photo workflow. Printing RAW data directly on a photographic printer (e.g., through PictBridge) or sending them to a service provider is so far rarely possible.

While JPEG and TIFF files will be supported for a very long period of time, this might not be true for all RAW formats currently supported by applications. Some manufacturers already dropped the support of the RAW format of outdated digital cameras. For this reason it makes sense to keep at least one non-RAW version of your images using TIFF or DNG.

6.2 RAW Converter Modules

→ *The version of Adobe Camera Raw provided with Photoshop Elements is slightly limited compared to the full version. Therefore, it should also be easier to handle for the beginner.*

A good overview of RAW converters can be found at [14] and [26] and a discussion of some RAW converters at [24].

If you want to buy a RAW conversion program, you should make sure the RAW files from your camera are supported. A universal RAW conversion program that is continually updated is *Adobe Camera Raw* (for Windows and Mac), which comes with Photoshop CS3 (Photoshop 10). Adobe Camera Raw also comes with Photoshop Elements starting with version 3. It supports a wide range of RAW formats from different manufacturers and integrates the converter into Photoshop's image browser so that you can preview the RAW files (with standard settings applied).

Good universal converter alternatives are *Capture One DSL*, made by Phase One [40], *BibblePro* by Bibble Labs [32] and SILKYPIX *Developer Studio* by Ichikawa Soft Laboratory [41]. All three applications run with Windows as well as Mac OS X. They focus only on RAW conversion and come with a good file browser with a preview function for RAW images.

Canon provides *Canon EOS Viewer Utility* and *Canon Digital Photo Professional* for free with its digital SLR cameras. Both allow for a good and flexible conversion and a preview in the image browser. However, both programs convert only Canon's RAW formats (for Windows and Mac).

* *The image editing programs PhotoLine 32 (beginning with version 11) and Paint Shop Pro (since version 9) can also process RAW files.*

Nikon offers a good converter for its own RAW formats: *Nikon Capture NX* [39] (for Windows and Mac).* Another good RAW converter is *LightZone* by LightCrafts [38]. It also features very good photo editing and runs with Mac OS as well as Windows.

The all-in-one programs Apple *Aperture* (Mac) and Adobe *Lightroom* (for Windows and Mac) both support transparent processing of RAW files. In addition, they function as image editors for JPEG and TIFF files. In these programs, you can hardly tell the difference between working with RAW files, TIFFs, PSDs, or JPEGs. Both programs also offer excellent image management. The third function both applications provide is a good image database. You can also print, and generate slide shows and web galleries with these all-in-one applications.

→ *A short description of Aperture and Lightroom can be found in section 8.8 on page 326.*

Apple also offers the much simpler *iPhoto* (Mac), which can handle a limited number of RAW file formats and comes with a simple image editing and image management module.

In Mac OS X, I now use the *RAW Developer* (Mac, [37]). I like the range of functions as well as the colors generated. For what it offers, at approximately $85, it is cheap.

A number of other programs are available, such as the *Breeze Browser* (Windows, [33]), made by Breeze Systems. It is only a matter of time that more professional RAW conversion programs hit the market due to the current boom of digital SLR cameras.

For the beginning, it is best to use the Adobe Camera Raw converter in Photoshop Elements. It is fast and delivers good image quality.

The subject of image management is covered in section 8.6 on page 311.

When you work with RAW files, you want to make sure your image management program can read them and show preview images in the picture

overview. Only a few image management programs are good at this task. Good RAW support is offered, for example, by iView Media Pro as well as Extensis Portfolio [51]. In the Organizer, the image management program that comes with Photoshop Elements, the Adobe Camera Raw module is used. But, all of these image-mangement-only programs do not show the modifications you apply to RAW images using a RAW converter in your image previews.

6.3 RAW Conversion

In the photo editing workflow diagram in section 5.2 there is an optional step – the one of RAW conversion. When you work with RAW files, converting them is usually the first step in image editing and optimizing.

Generally, you should save converted images as TIFF or PSD files using a lossless compression (but you can also save them as JPEG files). The modified workflow chart is shown in diagram ①, and detailed in diagram ②. The steps in parentheses are optional and only useful if you do not wish to scale or sharpen your image in the image editing process (for example, in Photoshop).

The most essential step in the RAW conversion process is the color interpolation; that means the transformation of image and color information from the image sensor of the camera into an RGB picture. The image sensor of most digital cameras – as described in section 2.2.1 (page 10) – do not capture three color components (R, G, B) per image pixel but only a gray value under a red, green, or blue filter element. This value is used in the color interpolation to calculate an RGB value for each individual image pixel (according to the Bayer method). This color interpolation is not necessary when a Foveon sensor is used, but some RAW processing has to be done nevertheless.

The white balance is closely related to color interpolation. While the white balance is set automatically or by choosing a particular color temperature in the camera, the RAW converter offers more options for setting the white balance and color tones, and this is available in all RAW converters.

Some all-in-one programs can directly print RAW files, therefore you may not have to do the final RAW conversion to TIFF, PSD or JPEG.

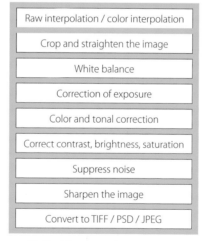

② *Workflow steps of RAW conversion*

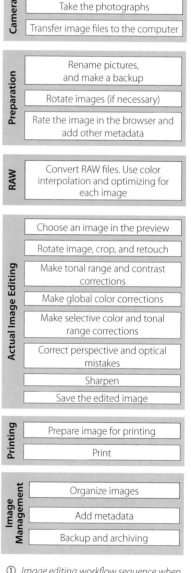

① *Image editing workflow sequence when using RAW files*

What Do I Do Where?

A number of image optimizations can be carried out in the RAW converter as well as during actual image editing. A combination is also possible. Therefore, you may want to come up with a strategy for making the following corrections:

▸ Contrast optimization
▸ Image sharpening
▸ Color saturation
▸ Conversion to black-and-white (if necessary)
▸ Noise suppression and correction of aberration errors
▸ Other functions such as rotating, cropping, and lens errors

RAW converters offer more functions for image correction in newer versions, even those options that are found in the newest image editing programs. Some converters include rotating, cropping, and corrections for lens errors and perspective, and some even come with clone stamp tools. Some newer converters offer selective correction. This includes, for example, Nikon Capture NX [39] and LightZone [38].

The typical RAW part of the photo workflow is shown in diagram ② (these are settings, not operations).

One tried-and-true strategy is to be very conservative with the corrections in the RAW converter after the exposure correction step, and make final adjustments in the image editing program. The color saturation, in particular, is often better when applied to selective areas, and this is usually only possible in an image editing program. The same is true for the contrast.

The RAW conversion process is very similar in different RAW conversion programs. Differences can be seen in the quality of the conversion, in the individual options for settings (i.e., for color correction), in the batch processing of the conversions, and of course in the user interface.

Most RAW converters come with useful settings for most formats and camera models. However, they always can be adjusted individually. Once you have found the right values for your camera and the type of images you shoot, you can usually save these values and load them again later to apply them to other conversions. Most converters also allow you to process a number of files together (batch processing).

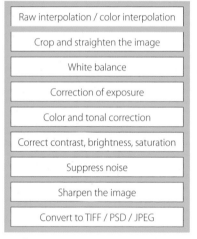

| Raw interpolation / color interpolation |
| Crop and straighten the image |
| White balance |
| Correction of exposure |
| Color and tonal correction |
| Correct contrast, brightness, saturation |
| Suppress noise |
| Sharpen the image |
| Convert to TIFF / PSD / JPEG |

② *Workflow steps of RAW conversion (repetition)*

➡ *All image corrections made in the RAW converter are not destructive; that means they do not change the original image and are simply saved as alteration instructions with the image and can be changed or carried out again.*

6.4 Using Adobe Camera Raw (ACR)

I want to show you the conversion with the Adobe Camera Raw 4.2/4.3 converter, here on Windows. The user interface on Mac OS X is almost identical. Adobe Camera Raw is part of the Photoshop CS3 package and part of Adobe Photoshop Elements as of version 4, 5, and 6.

If the Adobe Camera Raw module is installed with your version of Photoshop CS (or later) or Photoshop Elements (which happens automatically when the programs are installed), the file browser will show the contents of RAW files as a preview. The size of the image thumbnails can be adjusted in the Photoshop presets under the option File Browser. The larger preview images (as shown in figure ①) generally adjust to the size of the browser window and can be adjusted with the image size slider at the bottom right in Photoshop Elements. You should keep them as large as possible so that you can make a qualified choice about an image already in the preview.

Adobe Camera Raw 4.x – part of Photoshop CS3 and Photoshop Elements 6 (it may also be used with Elements 4 and 5) – has added many new features. These include auto corrections and the options to rotate and crop the image. The way the program is handled and the most important functions have not changed though.

① *Adobe Camera Raw or the image browser under Photoshop Elements (as of version 6) shows small preview images of the RAW files (which can be recognized by the .cr2 file name extension in the Properties window).*

If you have selected a RAW file and call up any editing function (e.g., the *Full Edit* function, either by using Ctrl-I or by selecting the function from the fly-out men with the right mouse button), Elements will automatically pass the image on to Adobe Camera Raw and the ACR window will come up (see figure ② on page 242). (We will abbreviate "Adobe Camera Raw" by "ACR" in the following text.)

When first working with RAW image files, they do not differ from working with other files in the Elements image browser. Double-clicking the preview image, which normally opens the Elements editor program, will open the Adobe Camera Raw module though (see figure ② on page 242).

When editing in ACR is finished, you actually have several options (explained later in more details):

▸ Open the file. ACR will pass a rendered TIFF, PSD or JPEG file back to the Elements editor. Additionally, ACR will save the settings done in ACR as a so called *sidecar file*. This is a text file (using an XMP structure) containing all the settings for the RAW file. The sidecar file has the same name as the original RAW file but has an ".xmp" extension. This way Adobe avoids modifying the original RAW file.

▸ Selecting Done will save the current settings alongside the RAW file and do no more. No further part is passed along to PSE, however the PSE preview will be updated to reflect the editing done in ACR.

▸ Selecting Cancel will remove all settings that were modified in ACR and leave the RAW file unmodified. Nothing is passed back to PSE.

▸ If you use Save Image, ACR will convert the image to DNG; DNG is a special kind of RAW format. The dialog box that comes up allows you to set a number of options for this conversion process. Currently, this is not a useful function for most users. It might be useful, if you intend to pass your RAW file to an outside party that is able to work with DNG or if you intend to use an image database other than the Elements Organizer, as ACR can embed a good preview of the modified RAW file into DNG.

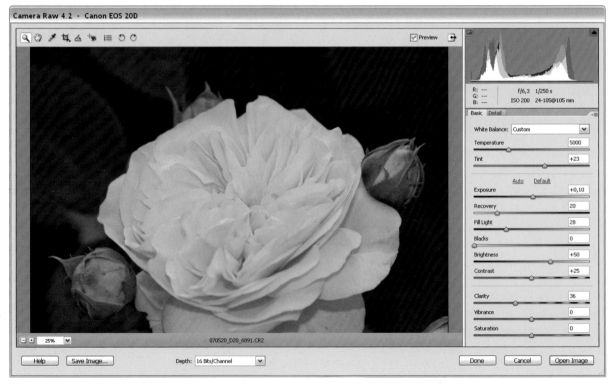

② *Photoshop Elements 6 – Adobe Camera Raw window*

The Adobe Camera Raw User Interface

The user interface of Adobe Camera Raw is well organized and offers a wide range of settings. The standard presets take into account the characteristics of the RAW format as well as those of the camera model – this is taken from the EXIF data of the RAW file.

The Adobe Camera Raw interface differs between Photoshop (full version) and Photoshop Elements, and several functions of the full ACR version are not visible in Elements. Using each function is the same in both versions. The following description is based on the Adobe Camera Raw version that comes with Photoshop Elements 6.

The toolbar at the top of the Adobe Camera Raw window offers some of the most-used functions. Clicking on the ☰ will bring up the *Preferences* dialog to customize Adobe Camera Raw.

ACR toolbar

I recommend the setting shown in figure ③. Let ACR save the image settings in a Sidecar file in the same directory where the original image file is (see setting in figure ③). This allows for an easy migration of the RAW images to another location if needed later on. All you have to do is copy the Sidecar file along with the image file.

With the zoom tool 🔍, you can zoom into the image and hold down the Alt key to zoom out. The hand ✋ moves the view of the image (or you can hold down the spacebar). With the rotate buttons ↺ ↻, the image is rotated 90 degrees to the left or right.

Use the crop tool 🔲 to do a cropping of your image, restricting the view to the relevant parts of the original picture. Simply click and drag a rectangle

③ *These are the ACR Preferences settings I recommend for PSE*

with your mouse covering the part you want to keep. You can still adjust the area by dragging on any of the left, right, upper, or lower lines of your rectangle. You can even rotate your crop by moving your mouse outside the rectangle. The cursor will become a new shape: ↱ . Now drag the mouse (slowly) and see how the area will rotate. The image outside the cropping area is darkened to allow for better judgment.

Use the fly-out menu of the right mouse button to set a ratio for your cropping area. If the option is not offered, select *Custom* to define your aspect ratio. Selecting *Normal* from this menu removes any ratio you may have set.

Activate the straighten tool ⬟ to straighten your image. Now, draw a line along an edge of your image that should run horizontally or vertically after straightening.

The tool for red-eye-removal 👁 will be explained later on. By default, the Preview button should be activated.

The Preview button allows you to toggle between the standard settings and the settings currently selected by you; the result can be seen in the

large preview window. If *Preview* is activated, ACR immediately shows the effect of alterations in the preview image. Therefore it is good practice to select this check box. The ⤧ symbol toggles between full-screen view and normal view.

Most conversion settings are located on the right side of the Adobe Camera Raw window. A very important control mechanism (besides the preview image) is the histogram. You should pay attention to it while making adjustments. You especially want to avoid clipping the highlights (avoid letting the histogram touch the right edge).

The settings are divided into two groups under the tabs *Basic* and *Detail*. All changes can be seen (almost) immediately in the preview image and the histogram, which is of great help because it makes it easy to see if particular (color) areas are being clipped. The histogram shows this by touching the left or right edge. But let's start with the corrections done in the *Basic* tab.

6.4.1 Main Conversion Settings on the Basic Tab

The most important conversion settings – those you use most often – are found on the Basic tab:

White Balance

After the first image corrections such as straightening and cropping, the very first step you should take is to achieve a good white balance. There are several fundamental ways to achieve a good white balance:

1. Automatic white balance, done by the camera. The camera analyzes the colors of the scene shot and estimates its color temperature. For JPEGs and TIFFs, the camera applies the WB to the image that is stored on the flash card. For RAW images, the color temperature value is embedded into the RAW file metadata but not applied to the pixel data. ACR will use it as an initial WB setting. For outdoor photography, in-camera WB often works quite well; for tungsten and other kinds of artificial light, it can be way off.

2. Manual color temperature setting in the camera, adapted to the scene and lighting. You either select a color temperature using camera settings (estimating the color temperature) or perform an explicit white balance with your camera using a white card. You can find out how this is done from the manual for your camera. Again, with JPEGs and TIFFs the custom WB will be rendered into the image, while with RAW files the settings are embedded as metadata. ACR reads these values from the RAW file and uses them as an initial setting for white balancing (showing *As Shot*, as illustrated in figure ④, page 245).

3. White balance adjustment using the eyedropper tool (as described on page 245).

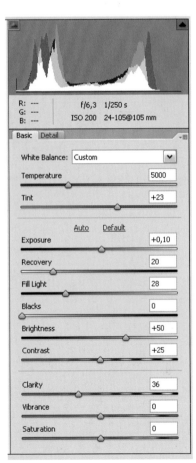

In the Basic tab of ACR (here, it's ACR 4.31) you will find most of your important settings for your RAW conversion.

5. Using the *Auto* white balance function of ACR. Like the camera, ACR can measure the current color temperature. You will find this *Auto* function in the *Basic* pane in the *WB* drop-down menu (see figure ④).

6. Alternatively, you can look at the preview of your image and use the *Temp(erature)* and *Tint* controls of Lightroom to do a visual white balance adjustment. I recommend to always start with the Temperature slider and to move your slider very slowly.

 If you still have the lighting of the scene shot in mind, you can set the WB using a corresponding preset in the *White Balance* menu (see figure ④) and then do some fine-tuning using the *Temperature* and *Tint* sliders.

④ *Color temperature presets, including "Auto".*

After setting your white balance with one of the methods mentioned above, you can perform some additional fine-tuning using the *Temperature* and *Tint* controls. We recommend starting with *Temperature*. The final adjustment can also include the *Tint* control.

Figure ⑤ illustrates the way these two controls shift your colors in the total color space. If the colors of the image look too cold and you want to give them a warmer appearance, shift your *Temperature* slider towards higher temperatures. This may seem counter-intuitive. Shifting the slider to the right tells Lightroom that the lighting condition of the scene had a higher color temperature, and thus the image will look warmer when corrected. Higher scene color temperatures produce cooler colors, lower temperatures warmer colors.

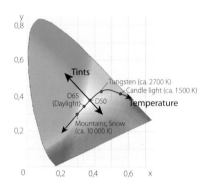

⑤ *This figure illustrates where you can shift your colors with the Temp and Tint controls.*

If you choose the eyedropper (white balance tool) 🔎 and click on a point in the preview image, its color value is considered neutral gray and the white balance is carried out with this reference. In most cases, this is the easiest way to set the white balance, but only works well if a you have a gray object in your image. White or almost white items are not good for this method, however.

If you do not like the result, you can try again or reset the original color temperature by choosing *As Shot* from the *White Balance* drop-down menu on the *Basic* tab (see figure ④).

The Histogram

For the next corrections that should be done – exposure and optimization of the tonal values – the histogram is a most import tool. With ACR 4.x it was extended quite a bit. The histogram shows the distribution of the three basic colors (Red, Green, and Blue) and their tonal values in your image. The tonal values are X-axis – starting with black to the left and going to pure white at the right side –, while the Y-axis shows the relative number of image points of a certain tonal value. The higher the mounting is at a certain point of the X-axis, the more points of that value are in the image.

If you have a mountain gathered at the left side of histogram, your image is probably underexposed having a lot of black or dark pixels. If your

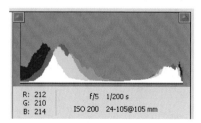

The two colored triangles indicate clipping in the shadows as well as in highlights.

histogram peak accumulates on the right side, your image is probably over-exposed – which in most cases is worse than being a bit underexposed.

The ACR histogram will show more than the curves of R (red), G (green), and B (blue). The white curve represents the combination of R+G+B, while the magenta curve combines red and blue pixels and the cyan curve combines green and blue pixels

There are two small triangles in the histogram. If they are highlighted, this indicates that there is *clipping* in the image. Clipping means that some areas are oversaturated (over- or underexposed), showing no more de-tails (structure). This clipping may be in regard to a single color only, in two colors, or in all three of the RGB colors.

The left triangle indicates clipping in the shadow parts of the image, the right one indicates clipping in the highlights. The color of the high-lighted triangle indicates what colors channels are clipped.

⑦ *The red and blue colors show where in the image clipping takes place.*

To really see where these clipped areas are, click on the triangle and underexposed areas will be marked red ■ while overexposed areas will be marked blue ■ (see figure 7). This function is especially helpful when ad-justing the settings for *Exposure*, *Recovery*, *Fill Light*, *Blacks*, and *Brightness*.

Because these colors may be distracting during image evaluation, you can also press the Alt key (Mac: ⌥) to have the clipping displayed in color while using your sliders. When you let go of the Alt key, the clipping colors disappear. When you press Alt/⌥ the rest of the image will be masked black or white (depending on the slider you currently use) and only clipped areas will be marked by the clipping color.

The color values under the mouse cursor are shown just below the his-togram with its RGB values. Additionally, ACR will show the aperture, f-stop, and ISO setting as well as the focal length used (if available in the EXIF data of the image).

Basic Tonal Corrections

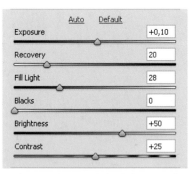

These are the controls for the basic tonal corrections.

→ *The white point defines which gray value is assigned to the lightest point in the image.*

The tonal corrections are done using the sliders of *Exposure*, *Recovery*, *Fill Light*, *Blacks*, *Brightness*, and *Contrast*. Some of these controls are new with ACR 4.3 that comes with Elements 6.

ACR offers an *Auto* button, though with *Auto*, the results are rarely good. Often, however, it can provide a useful starting point for some fine-tuning. The *Auto* feature sets the controls for *Exposure*, *Blacks*, *Brightness*, and *Contrast*. *Recovery* and *Fill Light* are initially set to zero. If the result of the Auto feature is not good, click on *Default* to go back to the initial state.

As the name implies, the *Exposure* slider allows you, within limits, to make corrections to the exposure; realistically, you can use up to approxi-mately 1.5 aperture/shutter speed stops up or down. This primarily controls the highlights (sets the white point). When you hold down the Alt key (Mac: ⌥) while adjusting this slider, Adobe Camera Raw will show in the

preview window which areas are clipped. You can look at the histogram for this as well. If we get clipping in the highlights, the histogram will touch the right side, and the clipping warning triangle in the histogram is highlighted.

In this case, we carefully push the *Exposure* control to the left, watching the image preview as well as the histogram. Ideally, we want no clipping in the highlights and not much clipping in the shadows. If the image is not too strongly overexposed, I recommend to leave the exposure slider at its default value and use *Recovery* instead to bring back some clipped highlights.

① *This image is slightly underexposed but shows good details in highlights.*　　② *Highlights control set to +24 and Blacks to +0.*

If an exposure correction of about -0.5 to -1.0 is not sufficient, we use the *Recovery* control, pushing it to the right. If your overexposure is not too bad, this should bring back details in your highlights without blocking the shadows. (However, never use this method as an excuse for sloppy exposure in the first place!)

In ACR, the histogram and a large-scale preview help to optimize exposure. For us, there is a strict rule: Avoid clipping, especially in highlights. (An exception to this rule may apply to some single specular highlights you may encounter with reflections on metal surfaces or on water).

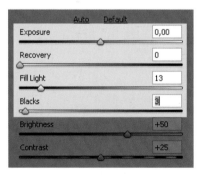

Using *Fill Light,* you can correct blocked shadows, showing no details, without brightening the entire image too much. If the clipping control of your histogram no longer indicates any strong clipping in your shadows and your image looks good on screen, all is fine. Don't overuse this control or your image might get an artificial impression. Using too much *Fill Light* will increase noise in your dark image areas. *Fill Light* can be very effective when used in moderation.

Blacks allows you to set your black point (the black point defines how dark the darkest point is in the image). The default used by Lightroom depends on your camera. If the shadows are clipped, move this control slightly

to the left or set it to zero. (With some images, of course, dark shadows might be desirable.) If your histogram indicates free space to the left, you may slightly push *Blacks* to the right. This will also increase the contrast of your image (if this is desirable). Again, watch your histogram and your preview to avoid blocking too much of your shadows. Alternatively, temporarily hold down Alt/⌥ to see the clipped shadow parts of the image.

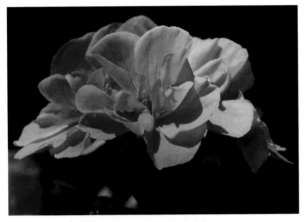

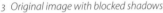

3 *Original image with blocked shadows* ④ *Fill Light improved the details with the stalk in the lower part.*

The *Brightness* control, as its name implies, controls the brightness. (It behaves a bit like the Photoshop Levels *Gamma* slider.) Be cautious when using this control because with most images, highlight clipping is more destructive than shadow clipping. According to our experience, the warning shown by the highlight clipping indicator of the histogram appears a bit late. The clipping indicator, which you see in your image preview when holding down Alt/⌥, seems to be more precise. However, it only works when setting *Exposure, Recovery,* and *Blacks,* but not with *Brightness* or *Fill Light.*

Also, move your cursor over critical image areas and watch the RGB values displayed below the histogram. If you optimize an image for printing, the brightest points should not go beyond 245 and the darkest areas should not drop below about 8. Beyond these values, neither highlights nor shadows will show any details in the print, though they might be visible on screen.

For some images, however (I saw this with some NEF RAW files from a Nikon D200), you have to start by pulling *Brightness* quite far to the right and only then do the rest of your tonal tuning with the other controls mentioned above.

For many photos, we do not touch the *Contrast* control. If we want more or less contrast, we often use the image editor instead. Usually, you achieve your contrast using an S curve with the *Curves* command (in Photoshop) or by settings a proper white point (using *Brightness*) and black point (using *Blacks*). The usage of *Contrast* often leads to clipping in some of the RGB channels.

Color Correction in the Basic Pane

In the *Basic* pane, ACR provides two controls for further color tuning (apart from *Temperature* and *Tint*): *Vibrance* and *Saturation*. Both actually influence the saturation of your photo. If you want to increase saturation a bit, with most images *Vibrance* will be the better choice as it avoids oversaturating colors that are quite saturated already. It also adapts better to skin tones and does not saturate them too much.

Original image
(could use a bit of more saturation)

Image with Vibrance = +80, Saturation = 0
(too strong already)

Vibrance = 0, Saturation = +80
(much too strong, clipping in red)

However, most of the time you don't want to shift all colors of your image, only a certain color range. To this end, you should use the function of the image editor and not the sliders here. (With ACR in full Photoshop or in Lightroom, there is a *HSL/Color/Grayscale* pane, that can be used for this.)

These three controls will all influence your colors. Clarity is new with ACR 4.x, enhancing your local contrast (also called "micro-contrast").

Clarity is a different affair. Clarity improves local contrast and midtone contrast. Most images benefit from some Clarity enhancement. To get an optimal impression of its effect use a 1:1 zoom level and then switch back to an overview. The easiest way to describe this function is to say: "Just try it, but don't overdo it", but pulling up Clarity too much may increase some noise that was not visible before.

Original image

Image with Clarity turned up to 100%

The Clarity control is quite useful to bring out details in fine structures like leaves, rocks, grass, hair, and fur. It should be avoided on human skin and faces.

① *Detail tab with ACR 4.3 and PSE 6.0*

6.4.2 Settings on the Detail Tab

The settings Sharpness as well as Noise Reduction – the latter is divided into *Luminance Smoothing* and *Color Noise Reduction* – are closely related and are combined under the *Detail* category. The Luminance Smoothing option reduces jumps in brightness in single neighboring pixels, and the Color Noise Reduction slider reduces color jumps; both are effects of *noise*. For all these function you should zoom your preview to 100% in order to get a more accurate view of your settings.

Sharpening

While JPEG files coming from the camera are already sharpened in general, RAW images will appear a bit soft due to the demosaicing process that is part of RAW conversion. Therefore, a bit of sharpening is required in order to compensate for this effect. This is the reason ACR does some sharpening by default. The amount of additional sharpening required and in what way very much depends on your image and on your personal taste.

While in the previous versions of ACR sharpening was just a single slider, with ACR 4.3 sharping has become more elaborate. Looking at your total image editing process with RAW files, you should adopt a two-step sharpening process:

1. A slight sharpening in your RAW converter. This is to compensate for the slight fuzziness which is the result of the color interpolation done in the RAW conversion. If you shot in JPEG, the camera already made this compensation.

2. Do the final sharpening in your image editor (in our example it's PSE) and adapt this to your output size and your output method.[*]

** This part of sharpening is covered in section 5.11.*

In any case, you should not sharpen too much or you will loose image details. If you intend to skip the second step mentioned above, you may do a bit more general sharpening that is be required independent of your output method.

Printing on an inkjet printer will introduce some more fuzziness (even more with offset printing) caused by dithering. If you're preparing images for printing, your sharpening can be a bit stronger. If, however, you print from Elements, this additional sharpening should be done as part of the printing process.

If, however, we optimize images in Photoshop or LightZone (or any other external application) and plan to do sharpening there, we do just a little sharpening in ACR.

So, here let us stick to *general* sharpening (or *basic* sharpening). You will find the controls for sharpening in the *Details* pane (see figure ①). If you see a warning in that Details pane, ACR reminds you that you should use a zoom level of 100% (1:1), to properly see the effect of your settings. This applies to sharpening as well as noise reduction!

There is a general rule for sharpening: Don't sharpen too much. It's very easy to ruin an image by over-sharpening. You introduce halos and other kinds of artifacts if you sharpen incorrectly or too much. Actually, good sharpening is an art, and there are many sharpening plug-ins out there on the market for Photoshop.

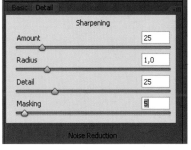

Sharpening PSE 6.0

Let's see what ACR can do for you with sharpening. Because ACR works nondestructively you can change your sharpening settings without any loss of quality! Before starting with sharpening, first switch to a zoom level of 1:1 (100%) or more. Center your preview on an area with fine details; it's there that you want your sharpening to take effect. Only this will allow for a correct assessment of the results. Sharpening (like ACR 4.2/4.3) has four controls:

- ▶ *Amount*
- ▶ *Radius*
- ▶ *Detail*
- ▶ *Masking*

First, if *Amount* is set to zero, ACR does no sharpening at all. *Amount* and *Radius* work similarly to those of USM (*Unsharp Mask*) in Photoshop. Stay at a moderate level for *Radius* (0.8–1.0 is a good starting point) and keep *Amount* at a level at which your image does not look over-sharpened (you need to use at least a 100% (1:1) magnification in Lightroom to judge sharpening results).

In some way, the *Detail* slider modifies the result. First let's mention halos. If sharpening creates halos (mainly the bright ones), this is good and bad. Good because it provides a stronger sharpening result; bad if you can see the halos on larger prints. If you set *Detail* to 100, you will potentially get quite strong halos, while a value of 0 suppresses them very well. We tend to use a very low *Detail* value (below 10–20) or even opt for 0, depending on the image.

① *Original image that for sharpening.*

See effects of the Detail control below.

The effect of the Detail slider is illustrated in figures ② to ⑤. While figure ② shows no halos, the image in figure ④ already shows strong halos (*Details* set to 50), and the image is actually busted due to halos in figure ⑤, where *Detail* is set to 100.

② *Details = 0*

③ *Details = 20*

④ *Details = 50 (visible halos)*

⑤ *Details = 100 (strong halos)*

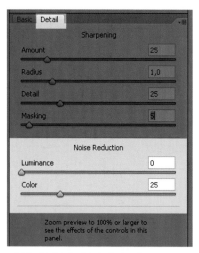

"Noise Reduction" includes luminance noise and color noise.

Noise Reduction

If you have shot with film, you know that the film grain limits the final resolution you can archive. However, the noise in digital images looks a little bit different; unfortunately, worse. There are two kinds of noise: *luminance* noise and *color* noise. The degree of noise you will encounter in your image depends on several factors:

▸ The camera (sensor) you use. The smaller the sensor, the more noise you will potentially get. Newer cameras tend to have less noise (compared to older ones at the same sensor size and the same resolution).

▸ The ISO setting used for the shot. The higher the ISO value, the more noise will appear. It is always best to use as low an ISO value as possible. On the other hand, a noisy image can look much better than a blurred one caused by camera shake.

▸ Your image. Shadows show more noise than bright areas.

▸ Your image processing. Pulling up dark areas, e.g., using *Fill Light*, will make noise more visible in these areas.

With some shots, a bit of noise is absolutely acceptable, e.g., with available light shots. We are accustomed to this from highly sensitive film. With other photos, noise can be rather annoying. It is a matter of taste. Don't get too obsessed about low noise. Some noise won't even show in most prints.

When you start reducing noise, the first step is to use a zoom level of 1:1; each pixel of the image is displayed on your screen. With noise reduction, a zoom level of 2:1 may be even better. Focus on areas with disturbing noise, but also watch the rest of your image by frequently zooming out again. Reducing noise is quite easy if fine details are of no concern. Noise reduction is always an act of balancing noise against fine details!

① *A typical "available light" shot taken by using a flash (Nikon D200 using ISO 3200) shows strong noise.*

② *Image with noise reduction applied (using Luminance +93, Color +75). Be patient, the update will take some time!*

Correct slowly because the update of the preview may take time. When adjusting these controls, be patient or you may tend to overcorrect!

As with sharpening, if we intend to do fine-tuning outside of Adobe Camera Raw, we refrain from doing noise reduction in ACR at all and do it in Photoshop, using a plug-in like *Noise Ninja* or *NoiseWare*, because we like their results better than those of the Photoshop filter and that of ACR, sometimes. If, however, you editor is Photoshop Elements, I recommend to do your noise reduction here. There are a whole lot more noise removal plug-ins for Photoshop out there on the market; these two are reasonably priced, however, and we like their results.

Nevertheless, you should only do noise removal if noise is really a problem on screen – with a standard viewing distance – or in you print. Frequently, we do not perform any *luminance* smoothing at all, while a certain level of *color* noise removal is an essential part of any RAW conversion.

6.5 Actual RAW Conversion

When you are happy with the settings of the image – when the image looks good in the preview – click the Open or Open Copy button in the lower-right corner and the actual RAW conversion process is carried out. The original file remains unaltered. The converted image is created and automatically placed into the Photoshop Elements image editor. There you can continue editing the image and save it in an appropriate file format.

These are the buttons that start or cancel the actual RAW conversion.

However, before you actually convert the image, check your color depth setting, which can be found right below the preview window.

Almost all RAW converters offer 8-bit and 16-bit, as does Adobe Camera Raw. If your image editing program supports 16-bit (per color channel), you can choose 16-bit. Photoshop Elements added 16-bit image editing in version 3. The image file will be twice as large and image editing will require more RAM and computer power, but the image retains a larger range of information and a larger reserve for possible losses of image quality due to image editing steps. When printed on a photo printer or an ink-jet printer, the finished image needs to be converted to the 8-bit mode. If you print from Photoshop Elements, PSE will do this for you on-the-fly while printing.

If you are new to RAW conversion and your image editor is Photoshop Elements, however, I recommend to stay with just 8-bit, because many of the filters and editing functions of Elements do not yet support 16-bit. If, however, you use the Photoshop full version for image editing, use 16-bit, as this will give you more leeway for corrections without losing too much image quality.

If you used 8-bit for the conversion and find out that your image quality is too low after editing in the image editor, you can go back to your RAW file and do a new conversion, this time using 16-bit.

If you choose Save Image, the image is saved directly without being placed into the editor, as a DNG file. This is a manufacturer-neutral RAW file format. You will then see the *Save Options* dialog box shown in figure ①. In this dialog box, you can choose where to save the file and a new file name as well as compression options (the latter is quite useful).

The option *Convert to Linear Image* should not be activated. *Embed Original Raw File* is also unnecessary and just increases the file size. A large JPEG preview embedded into the image has advantages though. Cancel and Help are self-explanatory.

① *Save Options dialog box for saving DNG files*

6.6 **Nondestructive Editing**

Most tools in Adobe Camera Raw work very much as those of a regular image editor – like that of Photoshop Elements explained in chapter 5. But there is an important difference between these tools in the Elements editor and in Camera Raw: In Camera Raw, no tool actually modifies your RAW file, while in Elements modifications are immediately applied to the pixel image. Camera Raw, instead, saves all your image editing parameters as an editing instruction set – in a separately readable file.

This file may either be stored in a central data file (for all images of a user) or stored along with each modified RAW file, using the same name as the image file but ".XMP" as file name extension. I recommend using the latter option. If you copy or move your RAW files, make sure you copy or move these sidecar files as well.

Click on this icon (part of the ACR tool bar), to call up the Preference dialog.

You set up your file handling instructions in the ACR preferences, that you can call up by clicking on the ☰ icon of the ACR tool bar. For the dialog see figure ③ on page 243.

There is one minor exception to the rule given above. If you edit a DNG file (which is also a RAW format), ACR will imbed the XMP information containing the modifications in the DNG file and not use a sidecar file.

In both cases the XMP information – be it in the sidecar file or in the central database – will also contain the rating you applied to an image in the Organizer of Elements as well as all keywords and other IPTC metadata you added to the file.

Again, I would like to emphasize the advantage of working with RAW files. While editing in a RAW converter you work with 16-bit and can make strong modifications without losing too much image quality. Working with RAW files allows you to recover quite a bit of lost details in clipped

* *About ± 1 f-stops should do it.*

highlights and shadows by pulling the *Exposure* control up or down˙ or by using *Recovery* and *Fill Light*. Those parts would be lost forever if you would edit a JPEG file coming directly from the camera. Also, color correc-

tions (e.g., through White Balance) can be done to a large extent without losing any quality. Yes, working with the RAW converter in addition to the image editor is yet another step in your image workflow, but I think it is well worth it.

6.6 Auto Conversion or Not?

Since Photoshop Elements Version 3, Adobe Camera Raw includes auto settings for the exposure, shadows, brightness, and contrast sliders. These auto functions ensure that an image still looks acceptable in the preview even if the exposure was not optimal. They can be activated and deactivated by selecting the appropriate check boxes with each function and are quite good, but they do not always do the best job. Therefore, you may want to deactivate them for some images or use them as a starting point and add your own adjustments. When you add your own adjustments, the corresponding auto function is deactivated and the check in the check box disappears. The values that Adobe Camera Raw uses with the auto functions are in many cases a good place to start.

In Camera Raw version 4.x the number of Auto buttons was reduced to just one (see figure ②). It controls all the sliders shown in figure ②.

Limitations on ACR in Photoshop Elements

The functions of the Camera Raw converter are limited in Photoshop Elements compared to the full Photoshop version. On the one hand, this simplifies their use for beginners; on the other hand, useful functions are not available. Other RAW conversion programs (some were described on page 238) offer significantly more functions and are more comparable to Adobe Camera Raw in the full Photoshop version. Those who want to bring out the optimal quality in their image during the RAW conversion process should, once familiar with RAW, use one of these converters or switch to one of the all-in-one programs (see section 8.8, page 326).

However, the Elements version of Adobe Camera Raw is a fast converter that supports many RAW formats and offers good conversion quality. Therefore, it is a good way to get started.

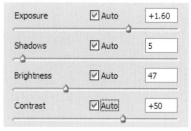

① *ACR in Elements provides a number of Auto functions as shown above. Above you see the option in ACR 3.x.*

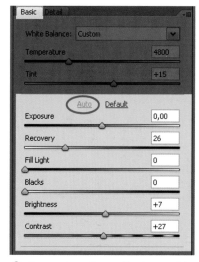

② *Since version 4, Camera Raw just provides a single Auto button.*

Printing and Presenting of Digital Photographs

7

The goal of photography and of our digital photo editing is to create images for our audience, in printed or electronic form. That is the subject of this chapter.

An overview of the many presentation methods can be seen in Figure 7-1. There is a multitude of free specialty programs for each method. Most beginner image editing programs, however, offer simplified versions for creating prints and presentations. Only when you have special needs – for example, creating high-quality digital slideshows – is the use of specialty programs justified.

The emphasis in this chapter is on current, good quality ink-jet printers, printing images on digital photo printers, and presenting them in electronic form.

This chapter includes just an overview of the subject "Printing". It is covered in great depth in my book Fine Art Printing for Photographers [9].

Presenting Photographs

The photographer has a multitude of options to present his pictures nowadays in both physical form, such as ink-jet prints and digital photo prints, and electronic form, such as on the computer screen, as a modern slideshow on a TV or projector, or as a web gallery on the Internet (to name only the most popular methods). Each presentation method has advantages and its own applications. Each also requires special preparation and perhaps special tools.

You should take some time to look at each one of these presentation methods and become familiar with them. Often, you will find that you need to present your images in one format or another with short notice, and you will be happy that you already know what is involved in a particular presentation method.

The inexpensive beginner programs are certainly good enough to start with. Only when your requirements increase is it worth spending the extra money for special programs.

Today there are four main methods for physically presenting photographs (single or in small quantities):

▸ Printing on photo paper with a digital photo printer
▸ Printing on a dye-sublimation printer
▸ Printing on an ink-jet printer
▸ Presenting an image collection in the form of a photo book

Figure 7-1: The most important and popular presentation methods for photographs

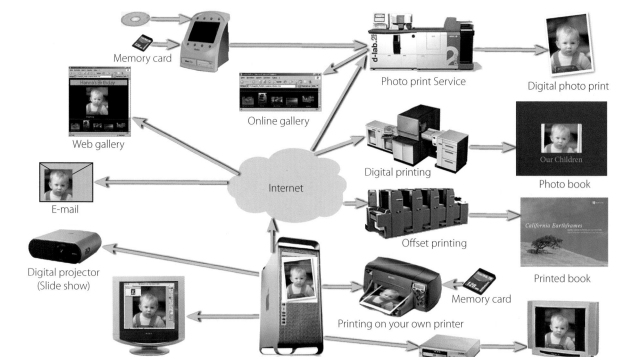

There are also a large number of further options, which I won't cover because they are not affordable for an individual photographer (amateur or professional) or because they apply to only certain niche markets.

For larger quantities – above approximately 200 images of the same photograph – the methods listed previously are too expensive. This is when you go back to conventional printing, usually offset printing. For smaller print runs, print shops also use digital printing methods. I will not cover these here.

7.1 Photo Printers

If you want several copies of the same picture, it is cheaper to get it printed at a photo developing store. The image is printed in the lab on photographic paper. The result is comparable to a traditional photograph. Especially when several copies are needed, it saves time and money. When the image resolution is high enough, they are no different than traditional photos; the method is similar and the paper is the same.

These pictures can be ordered with different finishes (matte or glossy) and in different sizes – most providers will stick to standard formats (see sidebar). When ordering, you should be aware that most print formats have a ratio of 2:3 (width:height) while most image sensors have a ratio of 3:4. An image that has not been cropped on the computer, therefore, will be cropped on the print or come with white border strips. Some photo print shops will allow you to specify which variation you would like. If you have your own paper cutter, you can remove the white border strips yourself.

In addition to the classic photo sizes, some providers offer other formats that better fit the 3:4 ratio of digital cameras. In most cases, the finished pictures are done quickly, and if you order through the Internet, sometimes in less than 24 hours. The image quality of such print shops is usually good enough for the consumer and amateur market, but most providers only offer formats up to 8×10 inches.

Some companies will offer larger formats up to 11×14 inches and yet others will be able to print up to 16×20 inches.

There are three types of photographic service providers:

1. **Photographic print services for the consumer market**
 These stores are made for mass production and therefore can work very quickly and cheaply. They usually produce smaller pictures, typically from 3×5 inches to 8×10 inches. Generally, they offer two papers: glossy and matte. Special requests cannot be processed. The quality is good for normal demands. Their advantage is that they are cheap and turn around the order quickly. Besides prints, they also often offer to print pictures on T-shirts, cups, mouse pads, and photo calendars.

Standard print sizes:

3.5 x 5 inches (7:10)

4 x 6 inches (2:3)

5 x 7 inches (5:7)

6 x 8 inches (3:4)

8 x 10 inches (4:5)

8 x 12 inches (2:3)

11 x 14 inches (11:14)

12 x 18 inches (2:3)

16 x 20 inches (4:5)

Some typical poster sizes:

18 x 24 inches

20 x 30 inches

24 x 32 inches

30 x 40 inches

The workflow is simplified and generally the printing software will carry out an automatic image optimization procedure. This is useful for most unedited snapshots and improves their appearance. The optimization is based on the EXIF data embedded in the image. The auto optimization can, however, wreck havoc on an image that you already edited. Therefore, some stores allow you to choose whether you want to deactivate the optimization for the order. At times, the optimization software may also recognize that the image was already edited and skip the optimization process.

2. **Photo book producers**

In this case, a photo book is created with special software and then sent to the service provider for printing and binding. Many photographic print services offer this as an additional option but generally they farm out the order to a specialty provider. Creating photo books is described in section 7.1.3 on page 265.

3. **Specialty providers**

Larger prints are usually printed on ink-jet printers. The typical maximum size is approximately 44–64 inches wide (for high-quality prints) because this is the maximum print width of the currently used Epson K3 printers (Epson Stylus Pro 9600). We can expect wider sizes in the future.

These are often providers who have created high-quality enlargements for photographers in the past from traditional film processing. Their prices are significantly higher than the services catering to the consumer market, typically by 3 to 5 times. Therefore, they can fill custom orders, produce most sizes and formats ordered, deliver very high-quality work, often offer a larger range of papers (for example, specialty papers for high-quality black-and-white enlargements), and also offer image optimization on individual images. They are willing to talk with you about your order.

You can usually visit a provider's website to find information on how the images should be sent in. Additionally, they provide an ICC profile for printing. This has two purposes:

A. It allows you to do a soft proof on the monitor.[*]

* The concept of soft-proofing is described in Fine Art Printing for Photographers [9]. Photoshop Elements unfortunately does not support soft proofing!*

B. You should convert your image from its current color profile into the one from the provider when you send the file for printing. Individual color profiles are still ignored, even in this process.

7.1.1 Photographic Print Services for the Consumer Market

Some typical prices per print (consumer market):

4 x 6 inches	*$0.15*
5 x 7 inches	*$0.99*
8 x 10 inches	*$3.99*
16 x 20 inches	*$17.99*
20 x 30 inches	*$22.99*

Plus shipping costs depending on the number of prints you ordered. The minimum is usually $1.50 to 2.50.

Photographic print service providers accept JPEG files and (with some limitations) also TIFF images. They do not process RAW files. The printing software so far ignores embedded profiles and assumes that an image is saved in RGB mode and comes from the sRGB color space. The printing process for the consumer market (mass market) is optimized for these settings. The images are often automatically optimized and information for this process is taken from the EXIF data if this data is still present in the image file. Automatic optimization, of course, presents the same problems you get with automatic corrections in an image editing program.

The ordering process (including preparing the images) is rather simple:

1. Organize the desired images and place them together in one folder (as copies of the original image files). This makes the ordering process much easier.

2. Reduce all layers (in the image editing program) to the background layer (if you still have layers in your images) and convert the images from 16-bit (if you worked with this color depth) to 8-bit (Image ▸ Mode ▸ 8-Bit per Channel).

3. Next, set the resolution of your images to the appropriate value (see the description on page 201). For photographic prints, the ideal resolution should be between 200 and 400 ppi. Most service providers prefer between 200 to 300 ppi. A resolution of 400 ppi is useful only if the image has very fine details and if the machine of the service provider can actually work with 400 ppi. Otherwise, it simply leads to large image files. Posters can be scaled to a resolution of 150 to 180 ppi.

If you are using the Resample Image function in Photoshop to scale an image, you should use "bicubic smoother" for increasing the size and "bicubic sharper" for reducing the size of the image.

4. Make sure that your image is saved in one of your service provider's standard sizes. A list of sizes can be found on its website. If the size of your images deviates from the standard size, you will have to specify in your order what should be done with the white space because prints are made exclusively in the standard sizes.

5. If your images are saved with a color profile other than sRGB, you should carry out a color space conversion to sRGB for each image:
 (a) Open the image (in the Photoshop Elements editor)
 (b) Choose Image ▸ Convert Color Profile ▸ Apply sRGB Profile.
 Now you do not need the embedded profile any longer (it only makes the files larger); I usually keep it embedded in the files, though.

6. If the images have not been sharpened yet, you should sharpen them slightly after scaling them. They don't need to be sharpened as much when you're printing them on a photo printer as they do when you're printing them on an ink-jet printer because the dithering that creates some blur is not present in this method of printing.

7. Save the image in a format that the photographic print service provider accepts, either TIFF (lossless compression) or JPEG with a low compression factor (a Photoshop setting of 8 to 10 is typical).

When you're sending in TIFF files, you should check the service provider's website to see if uncompressed or compressed TIFF files are accepted.

8. Open the order software of the service provider and assemble your order. Most providers offer a special software program that can be downloaded from their website.* You only need to download the software one time. Double-clicking usually starts the installation process.**

** While most service providers offer Windows software, some special Mac programs can also be found.*

*** You should check for updates to the service provider software periodically. Some programs update automatically.*

9. Do one last check of your order and then send it. It can sometimes be practical to print the finished order on your printer for control purposes, even just as a screen shot.

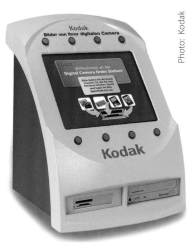

Digital order station (Kodak)

There are two methods used to deliver the image data:

1. You can take your memory card, CD, or DVD to a store with an order kiosk and transfer the data there. Alternatively, some stores allow you to drop off a CD or mail it in. Because this is more work for the store, not all providers offer this choice. It is unlikely that you will want to part with your expensive memory cards, so CDs are the best choice.

 At the order kiosk, an order is put together by choosing the desired paper size, the number of prints, and the finish (glossy, matte, cropping, white border). Some kiosks will allow you to make simple image corrections, such as cropping, contrast improvement, and removing red eyes.

 When you give data files to a photographic print shop, you usually provide ordering instructions on an envelope that holds the media, just as it used to be with film.

 The finished images can be picked up later. Some companies will mail the pictures for a small fee.

 Some photo print stores will finish the pictures in 1 to 2 hours; usually this service is a little more expensive.

2. You send the image data to the photographic print service provider over the Internet. The finished pictures can then be either picked up in the store or mailed (depending on the provider). With this method, an electronic form is filled in.

The second method has two variations for transferring the data:

1. **Use of a special client program**
 A special program (client program) is downloaded from the Internet to your computer (one time). This is used to put together the data for the order. When the order is finished, the client program sends the image data together with an electronic order form to the photo service provider.

 The advantage of using this solution is that you can put together the order without having to be online. The client program can also do certain checks on your local system, such as to see if the image resolution is sufficient for the desired size and if the file format is supported. The client program is platform specific. While many services offer programs for Mac OS, Linux client programs are not available. The program is proprietary to the service provider and needs to be installed on your computer. If possible and if available, this is the more comfortable of the two solutions.

2. **Use of a web browser for uploading image data**
 This is the more universal solution, but not always as comfortable as using a special client program. Additionally, you can run into problems with different browsers; the reference browser is Internet Explorer. If you use this process to order, you will have to be online the entire time.

The details of the services offered vary from provider to provider: price, size, turn-around time, and accepted payment methods. Image quality can also differ. Images can be printed not only on paper, but also on cups, T-shirts and mouse pads. There are also differences regarding the accepted file formats, but JPEG is accepted by all service providers.

When the images are printed, they are generally optimized for sharpness, color, and contrast. This can be deactivated in some programs during the order process.

When an online photographic service provider is used, payment is usually by credit or debit card. Some may offer additional payment methods.

Delivery of the images takes about 2 to 4 working days. Some stores can deliver the very next day. Most service providers charge $2 to $3 or more for shipping, depending on the size of the order. The list on page 260 shows approximate prices per print. At times, you can find temporary specials.

Most internet photographic print services will ask you to register, enter your client data into a profile, and choose a user name and password. This may be annoying at first, but it saves you from having to enter the data again for your next print order. The order windows differ between various providers. A general sequence of registering and ordering is described here:

1. Download the native client program of the photographic print service from its home page (one time).

2. Double-click on the downloaded data file; this generally starts the installation process. The program will add an icon to your Desktop.

3. Click on the icon to start the client program, and connect to the server of the photo print provider.

4. Register (one time). You can then make subsequent orders without completing steps 1, 2, and 4.

5. Assemble your order.

6. An image browser is used for assembling the order. Some programs have the capability to make some image corrections, but it is best to do this step in your own image editing program and to limit corrections in the client program to cropping and rotating. Before adding an image to the order list, you choose the desired paper size and the number of copies. Individual images can be deleted or their sizes changed. The client program will show a summary of the order and many will also display the total amount of money due for the order.

 Some programs offer additional options, such as indicating if the image resolution is sufficient for the desired print size.

7. Finally, you complete the order and the images are sent to the photographic print service provider.

The basic sequence of ordering prints online is the same, even if the client software programs differ from one service provider to another.

Test a new photographic print service provider by placing a small test order, and if the price and quality are suitable, stay with this service provider, even if another one may be a few cents cheaper.

Sending in the order over the Internet and then picking up the pictures at the local store is another option available with some providers. This will save you the shipping costs.

The use of digital cameras is continually increasing, and with it, so is ordering pictures over the Internet. Therefore, many beginner image editing programs have the option to contact an Internet photo print service directly from within the program. In Photoshop Elements, this option is located in the functions bar under the ▣ icon, Order Prints . The program loads a list of photo service providers that are supported by the Adobe server. The list is very short and does not represent the large range of services offered on the market.

Digital images can also be made into slides and negatives, but only a few professional labs offer this service.

Digital pictures can also be made into color slides. This service is provided by special service bureaus and is mainly used to create slides for presentations and talks. The option can be used, however, to transform a digital image to be used as a slide. The price varies from one service provider to the next and depends on the size of the order. For small numbers, you will have to budget about $8.00 per slide plus shipping costs.

7.1.2 High-Quality Photographic Print Services

The previously described services were meant for the consumer market. They are fast, they are cheap,[*] and the quality is sufficient for amateur needs. But after all the work we put into our pictures with image editing, sometimes this may not be enough. In such cases, you should look for a professional lab.

** See the price chart on page 260 .*

The prices at professional labs, however, are quite a bit higher than in the consumer segment – 5 to 8 times higher. But you receive very high-quality prints; smaller pictures are usually printed on a digital photo printer,[*] while larger pictures are printed on large ink-jet printers. With the latter, you often have the choice between several types of papers, as described in section 7.2.4, and various paper surfaces.

** Currently, digital photo prints can be made up to 60 inches wide, but at a significant cost. The digital file needs to have a very high resolution for this!*

Because the custom printing of images is not as standardized as in the consumer print services, communication with the provider is of utmost importance! If you cannot find anybody to talk to, you've chosen the wrong service provider.

➔ *Once you have found a good provider, avoid switching because of slight price differences!*

While the service provider usually considers the color profile when printing on an ink-jet printer – the provider prints either from Photoshop or from a raster image processor (RIP) – using ICC color profiles and providing profiles for soft proofing on your monitor is not well supported. A good service provider should provide you with a print profile though.

Preparing the images for a custom photo lab is the same as described earlier for the consumer service providers. The only difference is that the images should be converted not to sRGB but to the color profile provided by your service provider. Unfortunately, Photoshop Elements does not offer a function for such a conversion. For this, you need to use the full version of Photoshop or another tool.

7.1.3 Photo Books

A popular and beautiful way to show your images is with photo books, which are also well suited as presents. They come in a wide range of sizes, and you'll find some made from cardboard, some with linen covers, and even some that are leather bound. Technically, they are printed digitally with acceptable quality, even if it is not quite as good as a print from a digital photo or an ink-jet printer. The number of pages is typically from 20 to 120.

Photo books usually include a combination of images and text. Predefined design elements, such as the typefaces and the type sizes, depend on the software.

If you stick with a simple layout, it is easier to deal with the restrictions. The design possibilities – such as typeface, placement of the images, background, and cover – differ widely from one service provider to the next. In some simple layouts, you can choose only the image title, while others allow you to place larger chunks of text.

iPhoto, a part of the Apple *iLife* Suite, is a flexible and sophisticated tool. It allows you to choose the typeface and work with different layouts through predesigned templates. It then creates an errorless PDF that can be sent to the service provider.

You should not tamper with these files after they have been created. None of the providers allows you to send in a file you create yourself; the printing procedure is quite restricted so that they can offer low prices.

Photo book – created using Apple iPhoto.

Most design programs can be figured out relatively quickly after experimenting a little. First you choose a basic layout and open the folder in which the prepared images are located. Then you simply pull the desired images into the predefined elements on the page and replace the preset text with your own text.

As preparation, it is useful to collect all the images you want to use in one folder (for example, in an image management program) and to prepare them how you want them to look in the book. Make sure the image resolu-

Examples of photo book providers:
www.shutterfly.com
www.apple.com/ilife/iphoto/features/books.html
www.kodakgallery.com/PhotoBookOverview.jsp
www.fotoinsight.com/book
www.mypublisher.com
www.photobookpress.com
More can be found on the Web.

tion is high enough – approximately 200 to 300 dpi – and that the images are saved as JPEGs in the sRGB color space.

Most programs are available for the Windows environment. You can find book providers by searching the Web with the keywords "photo book". The software is often part of beginner image editing programs (for example, Photoshop Elements offers this function) or you can download a software package for free from the website of a photo book service provider. These programs will lead you through creating the book and then creating a print file, often in PDF format, which is sent to the service provider. Production and shipping usually takes about 8 to 14 days.

The price for 20 pages at the size of 8 × 8 inches is approximately $30 (and of course varies from one provider to the next). Additional pages cost about $1 per page.

Album Sheets

A simpler version of a photo book is the album sheet. Your images are printed on separate sheets – as described in section 7.2 – which can be bought from various paper merchants together with the album. The album sheets are premade with holes so that the assembly is clean and easy.

7.2 Printing with Ink-Jet Printers

My book (with coauthor Uwe Steinmueller) Fine Art Printing for Photographers [9] describes the process of printing with ink-jet printers in detail. This chapter in only an introduction to this complex subject.

➜ *If you want to take advantage of cheaper third-party manufactured inks, you should read test reviews about them in trade journals or on the Web.*

This section deals with high-quality photographic prints on ink-jet printers. Good ink-jet printers can produce surprisingly high-quality prints nowadays, even museum-quality prints. In addition to a good ink-jet printer, an essential prerequisite for top-quality prints is suitable paper. I will limit the discussion here to Epson printers because I have had good experiences with them. Similar results can be achieved with other brands, such as HP or Canon.

In addition, I won't cover cheap printers and papers. The same goes for cheap inks. Not only is the lightfastness and therefore the life of the picture questionable, but there are no appropriate color profiles available for these products.

7.2.1 Choosing a Good Ink-Jet Printer

Today you can buy a letter-sized ink-jet printer for $90 to $150 that will deliver acceptable image quality. However, if you want high-quality photographic prints with a long life span, there are a few things you will need to consider, and you'll most likely need to spend more, usually above $200.

Color Range and Inks

Normal ink-jet printers work with 4 colors (cyan, magenta, yellow, and black); photo-quality ink-jet printers work with a minimum of 6 colors. The latter usually add light cyan and light magenta ink colors. The extra colors

allow the printer to reproduce a larger range of colors and to render skin colors better and with more gradations, for example. More ink colors can further improve the print quality, and therefore you can even find fine-art printers with up to 12 ink cartridges.*

More inks do not only improve the color range, they also increase the cost for inks.

If you also want to create highest-quality black-and-white prints, the printer should have two or three different black or gray inks. This helps in rendering fine gradations in black-and-white pictures. If the printer has only one black ink, you can use a special RIP optimized for black-and-white prints to improve print quality significantly.**

Because glossy and matte papers require different black inks for optimal results, the printer should support both types of ink, even if you mostly print in color. Typically, *Photo Black* is used for glossy and pearl papers and *Matte Black* for matte papers.

Because the present ink-jet printers show weakness in reproducing saturated blue and red tones, the new generation of fine-art printers adds separate inks for red and blue, thus expanding the printer color range even more.

Types of Inks

In the discussion of printers, I differentiate between two different types of inks:

Dye-based inks • These are the most commonly used type of inks in the consumer segment and can be found in almost all desktop ink-jet printers manufactured by Hewlett-Packard and Canon, as well as many cheaper Epson printers. They reproduce saturated colors and a large color space, but they lack the lightfastness of pigment-based inks.

HP was able to create a high level of lightfastness by using special swellable paper, but you are therefore limited to a smaller range of papers. Dye-based inks should always be used with microporous and swellable papers.

Pigment-based inks • The color consists of colored pigments, which are relatively large compared to the color molecules of dye-based inks. The advantage is that they are more resistant to light as well as gases (such as ozone) present in the air, which bleach color. Therefore, these pigment-based inks have a very high lightfastness, even without using special ink-encapsulating coating on the surface of the paper. However, pigment-based inks display slightly less color saturation, and according to my experience, they tend to clog the printheads. On the other hand, you can choose from a wide range of papers. Because these inks do not penetrate as deep into the paper or the coating of the paper and sit more on the surface, they are more prone to abrasion. However, they are less likely to smudge than the water soluble dye-based inks.

For example, the Canon imagePROGRAF 5000 or the HP 3100.

Two or even three black/gray inks are offered in the HP 8450, the Canon 9500, and the Epson R2400.

** *This, however, requires a bit of know-how and exceeds the scope of this book. It is covered in [9].*

→ *When using dye-based inks, you should use coated paper, –with either a microporous or swellable coating. Both absorb the ink quickly into the surface of the paper without bleeding the ink.*

The potential disadvantage of a lower color saturation in pigment-based inks has been mostly remedied by the manufacturers in the last few years by concocting new ink recipes – for example, the third-generation pigment inks from Epson (UltraChrome K3).

If you want high lightfastness and at the same time flexibility, I recommend pigment-based inks. Printers using pigment-based inks are offered by Epson, Canon, and HP.

Manufacturer and Third-Party Inks

Inks are the biggest cost factor in printing (in addition to the paper), and the business models of printer manufacturers assume that they will earn much more on ink than on the printers. Therefore, it seems to make sense to choose cheaper third-party inks. While this is suitable for office documents in which color accuracy and long print life are not important, it is not recommended for high-quality photographic prints, at least not until you have gained some experience.

When third-party inks are used, the ICC profiles provided by the manufacturer and the print drivers are no longer accurate. Some printer manufacturers also threaten to withdraw the warranty for the printer if you use third-party inks.

Lyson [59] and Pantone [45] are known for good ink quality. Both offer color profiles for their inks and for a certain number of supported printers for free on their websites.

This does not mean there are no high-quality third-party inks, but using the manufacturer inks will keep you on the safe side. Once you have gained some experience and the warranty is expired, you can look around for high-quality third-party inks. The ink tests published in some magazines can be helpful, as well as user stories found on the Internet.

Printer Resolution

Actually, you can ignore this criterion for choosing a printer because all printers that fulfill the other criteria will have a sufficient printer resolution. Do not be confused by values that are hyped up for marketing purposes. Resolutions of $2\,880 \times 1\,440$ (or similar values) are not really worse than, for example, values of 5,680 (or even more). We rarely use these maximal resolution values in our print workflow because they usually cause the print job to take longer and use more ink without significantly improving the results. Small ink droplets bring more advantages (they are indirectly related to the printer resolution) because they can reproduce finer tonal gradations, especially in lighter image areas. The typical droplet size of 1–5 picoliter is almost always sufficient.

The higher printer resolution value relates to the horizontal direction, where the printhead glides back and forth, and the lower value relates to the vertical direction, where it is realized through the paper feed mechanism.

Supported Paper Sizes

The range of ink-jet printers for photographic printing starts at letter size. Many images only reach their optimal impact at a certain size. Therefore, printers that can print tabloid size (11 × 17 inches) can be purchased, but for significantly more money. They usually range between $500 and $900. If you want to print a lot, these larger printers can be worth the price, though, because they come with larger ink cartridges and therefore cheaper ink (this can make a difference by three times!).

Equivalencies of paper measurements in the United States and Europe:

U.S. measurement	Metric size	DIN
8.5 inches	*21.6 cm*	*A4*
13 inches	*33.0 cm*	*A3/A3+*
18 inches	*45.7 cm*	*A2*
24 inches	*61.0 cm*	*A1*
44 inches	*111.7 cm*	*> A0*

For very high-quality photographic prints – so-called fine art prints – you may want to use heavier and therefore thicker paper. Again, it is worthwhile to check the printer specifications. The maximum paper thickness allowed should be ≥ 0.4 mm (or 230 gsm). When you're using thick papers, it is advantageous if the printer has a fairly straight paper path (often more than one paper path are available) because it can be difficult or impossible to bend the paper to 180 degrees.

Printer Port

Finally, the parallel port has been replaced by the USB port. USB 2.0 is in theory faster than the older USB 1.1 port, but it rarely matters in practice. USB is the correct choice for desktop printers and comes with cables up to approximately 15 feet long. Some printers also offer a FireWire port (IEEE 1394). FireWire is roughly as fast as USB 2.0, and with it, you can connect the printer to two computers at the same time without having to change the plugs.

➔ *Some printers create problems when they are connected via a USB hub or with a USB cable that is too long.*

Printer Speed

Of course, the printer speed also plays a role when you're choosing your printer, but it's much more significant for commercial service providers than for the ambitious amateur or the single professional photographer. In addition, higher integrated and larger-print heads make the new generations of ink-jet printers faster. Today, print times (at a very high quality) of 2 to 3 minutes for a letter-size photograph and approximately 4 to 10 minutes for a tabloid-sized image (covering the full page) are realistic. When pure text is printed, the printers are much faster. The printer speed is influenced by the print resolution or quality setting and whether you print one-directional (which usually results in better image quality) or bidirectionally (which is faster).

7.2.2 Print Strategy

Printing an image from a program using the Ctrl-P (Mac: ⌘-P) command is not the best method. I consider the following methods adequate for printing high-quality images:

A. From the image editing program via the print driver. Additionally, the image editing program handles the color conversion. Therefore it needs a color profile that was created for the specific combination of printer + driver settings + inks used + paper type.

B. From the image editing program (e.g., Photoshop Elements) via the print driver, leaving the color conversion to the print driver. This method is recommended for black-and-white prints if the print driver supports a special black-and-white mode. This is done without a color profile.

For options A and B, Photoshop can be replaced with other equivalent programs that support color management and color space conversions like Photoshop. This includes, for example, Apple Aperture and Adobe Lightroom. Other image editing programs can also do this (e.g., Photoshop Elements and Paint Shop Pro), but they rarely offer the range of settings Photoshop does.

Of course color management is possible in the print driver, more so under Mac OS X in combination with ColorSync than under Windows XP. The Windows operating system uses either an internal printer color profile or the settings made in the print setup dialog box; which one is not always clear.

It assumes though that the image is saved in the sRGB color space, which may be incorrect. Thus, especially under Windows, it is advantageous if the image exists in the sRGB color space because the print drivers assume so.

The disadvantage of this method is that you could end up playing with many different driver settings and attempting many print jobs before you reach the optimal result, and the whole game starts over with the next image.

One such special print program is Qimage, which we describe on page 280.

C. Printing through a special print program. Instead of Photoshop, it can take care of the color conversion as well as handle further tasks – such as scaling the image to an optimal resolution for the printer and additional sharpening – adapted to the printing process.

D. Printing through a RIP. This is similar to option b, but the RIP takes care of the color conversion for both color and black-and-white prints. This is only recommended for the advanced user. In addition, good RIP software is not exactly cheap.

** HP and Canon both offer plug-ins for their new fine-art printers, which practically replace the print driver, offer more color management, and support 16-bit data.*

In the future, printer drivers will become available that can support full color management with external profiles.* In addition, we can expect that the operating systems will offer more options, as the current version of Mac OS X does with its ColorSync function. Windows Vista also has made some improvements in this area.

7.2.3 Printer Profile

I want to stress the importance of the color profile for the printer for a high-quality photographic print. But where do you get the profile? There are several options:

A. Get one from the manufacturer. They are usually supplied with the printer or can be found on the manufacturer's website.

B. Look on the websites of paper or ink manufacturers if you are using third-party products.**

*** The profile must be compatible with printer + ink + paper + print settings. Generally these companies will provide explicit instructions for the print settings. Pay attention to them!*

C. Get an individual profile from a service provider.

D. Create your own individual profile.

The differences between individual printers of a particular type have decreased significantly for high-quality printers. The profiles supplied by the manufacturer (solution A) are therefore sufficient in many cases. If you are a beginner, you should forget about solution D, because it requires a lot of

experience and is of more interest to professionals or semiprofessionals, who generally use the full version of Photoshop.

Some providers who create profiles can be found in section C.5. The cost can range from $30 to $80 per profile (for one printer and one paper). If you order several profiles at once, you will get a discount.

➜ *I want to stress that the list on page 347 is in no way complete!*

The process of creating a printer profile via a service provider is as follows:

1. The starting basis is a standardized digital image with different color fields. It is often part of the profile creation software, which you download from the service provider's website. You print the image on the printer for which you want to create the profile. It is important to make sure the printer driver does not make any color corrections and color management is turned off. You should use the paper and ink for which the profile is supposed to be created. When you're creating a color profile for printers, you always need to consider printer + ink + paper + print settings (print resolution or print quality). You should make yourself a note about the print settings you used and also save them with a descriptive name as a print setting in the printer driver.

Standardized digital "target" image for the creation of print profiles (by Bill Atkinson, size reduced)

2. The printed standardized digital "checkerboard" image is now measured and the printer profile is created using special software. When you are using a profiling service, you send in your print and the provider will create the profile for you.

➜ *When you are printing the standardized image on your computer, it is absolutely necessary that all color management functions are deactivated and that the printer driver does not carry out any color adjustments!*

3. As a result, you get the ICC profile as a profile file. You place this file into the appropriate folder on your computer. (See section A.1, page 331.)

7.2.4 Papers

High-quality prints on ink-jet printers require specially prepared papers. The *right* paper contributes enormously to an optimal print. The choice of ink-jet papers nowadays is huge. Therefore, the *right* paper means that, above all, the paper needs to be suitable for ink-jets – basically, it needs to have an appropriate coating. Additionally, the paper and coating need to be suited to the ink used (dye based or pigment based). And then, the paper should be compatible with the image subject and mood as well as the use of the print. You need to consider the paper color, the representation characteristics, and the surface structure. And last but not least, your own taste is important.

➜ *Further information about papers can be found in Fine Art Printing for Photographers [9]. There are some comments and recommendations on www.outbackphoto.com/printinginsights/pi_papers/essay.html and on the very informative website of Clayton Jones [19].*

Paper Coating

Paper coating comes in three different variations:

▸ Microporous coating
▸ Swellable coating
▸ Resin coated (RC)

Microporous Coating • The coating consists of a thin layer of chemically neutral, ground ceramic powder. The ink is absorbed quickly into the porous material and bleeds only minimally into surrounding areas. The paper provides good water resistance, but the coating lets gases enter freely. They attack the color dyes and pigments and thus accelerate the fading of the colors. Therefore, microporous paper is not the best choice for dye-based inks if lightfastness is important.

Even though microporous coatings are primarily designed for dye-based inks, they can also be used with pigment-based inks.

Swellable Papers • The coating is made from a polymer material that swells when exposed to moisture – that means when ink is applied to the paper. The coating absorbs the ink through the top layer and deposits the pigments into the layer below. This lower layer literally encapsulates the pigments while drying and only a small portion of the ink remains on the surface. The second layer protects the ink molecules from deterioration due to gases such as ozone and hydrogen sulfite, and thus prevents the colors from fading.

These papers, meant primarily for dye-based inks, can reproduce images beautifully and concisely, but they are sensitive to moisture. Most of these papers come with a gloss or luster/satin finish.

Such swellable papers are offered by Epson, Fujifilm (i.e., Premium Plus), Hewlett-Packard (i.e., HP Premium Plus Photo), Ilford, and Kodak, among others.

RC Papers • This is a paper used in the traditional world of photography. RC papers are used almost exclusively to make traditional color darkroom prints for the consumer market. This type of paper is now also used for printing with ink-jet printers. RC paper consists of a layer of base paper sandwiched in between two plastic layers, or the base paper has been omitted completely and it consists only of plastic. This paper needs an additional microporous or swellable coating in order to be usable for ink-jet printing.

RC paper's look and feel comes closest to that of traditional photo paper.

Paper Surface

There are many different paper surfaces available for ink-jet printing, more than we know from traditional photography:

▸ Glossy
▸ Semi-gloss, luster, satin
▸ Matte, watercolor

Additionally, printable canvas papers have yet another surface structure. You can also find exotic ink-jet papers such as Japanese and coated copper papers.

High gloss and semi-gloss papers generally yield more brilliant pictures with more details and look more similar to traditional photographs.

They can be used with the highest print resolution. When presented behind glass, however, they lose their strength; the glass acts as a type of equalizer.

Satin, matte, and watercolor papers can emphasize certain subjects as more noble or artistic (or more painterly); they certainly have their place in ink-jet printing, even if the colors appear a little more muted. Especially for black-and-white prints, they often give another dimension to the image. I feel that semi-gloss combines the advantages of both extremes (high gloss and matte).

7.2.5 Print Preparation

High-quality prints require a little bit of preparation of the image as well as of the paper and printer.

In Fine Art Printing for Photographers [9], we describe in detail how to prepare the tonal values of an image, how to determine the black and white points of a printer and paper combination, and how to set the black and white points for printing.

Image preparation • Generally, the image needs to be prepared a little bit before printing. This includes scaling it to the desired print size and final sharpening. These modifications should be done only to a copy of the original image. It may also be necessary to slightly increase the contrast and the color saturation and to set the white and black points. The best resolution depends on the printer used. When scaling up, you should use the Photoshop Elements *bicubic smoother* interpolation method, and for scaling down you should use *bicubic sharper*.

The best resolution is 360 ppi for Epson and Canon printers and 300 ppi for most HP printers.

Paper preparation • First take the paper out of its protective covering (paper should always be stored within its protective covering) and carefully wipe off any paper dust still attached to the surface with a soft brush. The dust can clog the printheads and the paper feed rollers.

When handling sensitive paper, you should wear clean cotton gloves to prevent fingerprints on the surface of the paper. Some papers are very sensitive. Avoid touching the printable or printed surface of the paper.

➡ You should protect your printer from dust when not in use.

Printer preparation • Turn on the printer and give it some time to finish its initialization cycle. It makes sense to first run a nozzle check on cheap paper before doing a larger print run because the printheads of ink-jet printers tend to get clogged with dried-up ink. Recognizing such a problem ahead of time can save you much wasted ink, time, and expensive paper during the actual print run. All good printers offer this testing function. You may have to run the cleaning utility of the printer several times if the problems are pronounced.

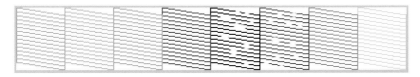

A nozzle check helps to recognize clogged printheads and correct the problem before printing.

Check the ink level monitor of the printer to make sure you have enough ink for printing. It is quite annoying when the printer stops in the middle of

a picture because a single ink cartridge is empty. This can also show in color shifts or breaks in the print.

The function to check ink levels can be found in Windows (for most Epson printers) in the print driver under the heading [Maintenance] and there under the ink check 📋 icon.

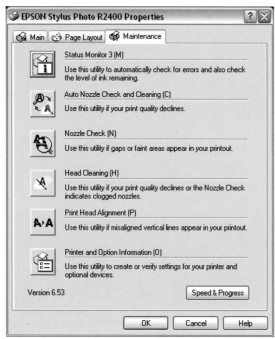

Using the "Maintenance" tab in the printer driver, you will find several useful printer maintenance functions.

Before printing larger images, you should check the ink levels of the printer.

In the Mac OS X environment, you will have to search in a different place, not in the print driver dialog box. The function can be found in the printer service program 🖨, which can be reached through the Dock. There you click on the function configuration 🛠.

Next, place the prepared paper into the printer and make sure it sits snugly but not too tightly in the paper feed tray.

When you're using thick or stiff papers, it can be helpful to support the paper feed of the printer by gently putting light pressure on the upper edge of the paper with your finger.

→ I recommend that you turn on your ink-jet printer once a week, or at least once every 14 days. This causes most printers to briefly flush the printheads. This procedure uses some ink but prevents larger problems from clogged printheads.

Immediately after printing, the print is very sensitive to damage. Therefore, do not touch the paper on the printed area and let it lie flat in a (as much as possible) dust-free environment to dry for a minimum of 1 hour. Before you do anything else to the print, such as framing or spraying it with a protective coating, you should wait at least 24 hours.

7.2.6 Actual Printing

The instructions in this section are applicable to Epson printers and print drivers. Of course, there are differences in the individual settings available within the different drivers and models. Most of the descriptions can also be applied to other Epson printer models and printers from other manufacturers. Here, I show the dialog boxes in the Windows environment, using the Epson R2400 printer as an example, which I consider to be a good printer.

Printing Color Pictures,

I print most color pictures right out of Photoshop Elements and let the program take care of the color space conversion. (For a color space conversion, the color values of the current color space are translated into the color space of the printer.) Therefore, I explicitly deactivate color management in the print driver.

In Photoshop Elements (since version 5), use the File > Print command (or click the print icon in the image editor or in the Organizer) because this brings up a dialog box that allows you to adjust more settings. Within the Print Preview dialog box (figure ①), click the *Page Setup* button to open the Page Setup dialog box (②). To see the correct options for paper sizes, you will first have to click the Printer button (②), choose the correct printer, and then click OK.

In the Page Setup dialog box, you can then choose the correct page size and orientation so that the Photoshop Elements preview can recognize the right page size. Click OK again to return to the Print Preview dialog box, where you can set other parameters.

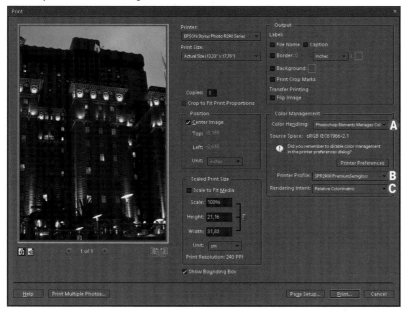

① *Print dialog box of the Photoshop Elements image editing program*

② *From the Page Setup dialog box, you can also set the target printer.*

First, set the print scaling percentage, the position of the image on the page, and the orientation. Most images look better with a white border than without one. The preview in the dialog box helps you make that decision.

The next important settings are the Color Management settings. First set the *Color Handling* (see figure ①-Ⓐ). If you have a suitable profile and you intend to print color, use *Photoshop Elements Managed Color*. From the Printer Profile drop-down menu Ⓑ, choose the (hopefully correctly installed) color profile for your printer. In this example, it is the Epson

Premium Luster paper for the Epson R2400 printer. Ideally, besides the printer and the paper, it should also take into consideration the print quality setting. The appropriate print quality or print resolution is set later in the print driver dialog box (see figure ④,-Ⓕ).

From the Rendering Intent menu (figure ①-Ⓒ), you should choose either *Perceptive* or *Relative Colorimetric*. I usually choose Relative Colorimetric. This setting determines how colors in the image that the printer cannot reproduce 1:1 are printed. If the color range of the digital image is much larger than what the printer can reproduce, you should choose *Perceptive* (we do not want to address this issue here any further).

Clicking *Print* opens the dialog box (figure ③) of the print driver, in this example, the print driver of the Epson R2400. The essential settings can be accessed by clicking the *Properties* or *Preferences* button (Ⓓ). This opens the dialog box shown in figure ④.

③ *Basic print driver window (here Epson R2400 for Windows)*

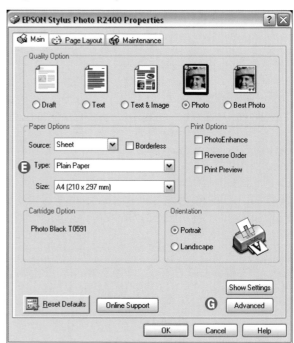

④ *Expanded print driver window (here Epson R2400 for Windows)*

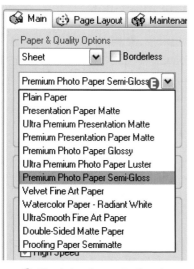

⑤ *The choice of paper significantly influences the print settings.*

First take a look at the different settings. One of the most important settings is the Type setting (Ⓔ) under Paper Options (figures ④/⑤). In addition to normal paper, this menu will list only Epson papers with Epson printers. If you are using a different paper type, you will have to guess which Epson paper comes closest to your chosen paper (some paper manufacturers give advice on their websites about this). In this example, I chose Epson Premium Photo Paper Semi-Gloss, which is compatible with the previously selected color profile and, even more importantly, with the actual paper inserted in the printer. Here you also select the paper source and again the paper size.

Another important setting is the *print quality*, which you set under Quality Type (Ⓕ). The quality settings offered here depend on your printer and the type of paper your selected. (This is the reason why you have to select your paper type first.) For a high-quality print on appropriate paper, you should choose Best Photo (when using the Epson R2400).

Further settings for the color management can be made through the Advanced button (Ⓖ), which will open the dialog box shown in figure ⑥. (Once you activated this screen, you can immediately go to this window by checking the *Show This Screen First* box.)

If you print *without* using an appropriate print profile, you can adjust a number of color settings. Often you will need several attempts, though, until the print on the paper (mostly) matches the image on the screen, and you have to start from scratch with the next image.

In this example, I left the color space conversion to Photoshop or Elements by use of an ICC profile. Now we want to get to the color management settings in the print driver dialog box. Select the ICM radio button (Ⓗ) to display settings shown in figure ⑦. Finally, deactivate ICM (Ⓘ) under the ICC Profile heading, which turns off the color space conversion through the print driver. ICM stands for Image Color Management and refers to the color management of the print driver. If the image editing program *and* the print driver carry out color space conversions, it happens once too many times and creates problems. It should only be activated in one place, either in the program or in the print driver!

In this example, I used the color space conversion of Photoshop Elements and deactivated it in the print driver, which is the recommended procedure for printing color pictures as long as you have an appropriate color profile.

Clicking OK starts the actual print job.

It's sometimes a bit difficult and time consuming to get everything right, so save your settings in the print driver by clicking on the *Save Setting* button (figure ⑦-Ⓙ) on page 278. Use a descriptive name (⑧), but not too long.

Recall these settings the next time you print on the same paper with the same settings. The saved settings can then be reloaded in the menu shown in figure ⑧.

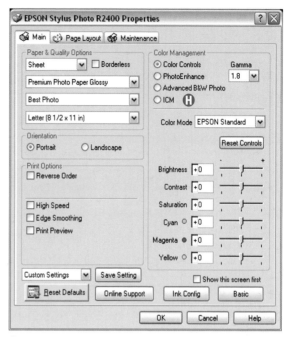

⑥ *Advanced color settings in the print driver*

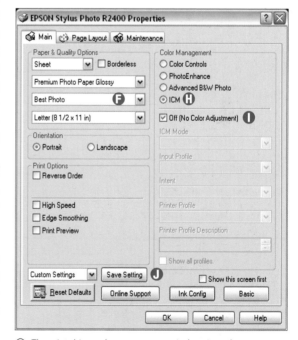

⑦ *The print driver color management is deactivated.*

→ *Initially, it might help you to make notes about your settings on your test prints. Otherwise, you quickly loose the overview and waste paper and ink.*

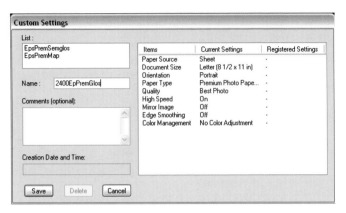

⑧ *Save your settings for your paper type.*

→ *When printing, the type of paper chosen influences a number of settings not visible in the print driver dialog box, such as the ink droplet size and how much ink is applied to the paper, and this is very important!*

In summary, here are the essential settings when printing color images:

1. Choose the target printer. If your printer is not set as the default printer, it is a bit more complicated. You need to open the Photoshop Elements Print dialog box (①) and click *Page Setup*. In the Page Setup dialog box (②), click *Print* to open the Print dialog box (③). Choose the target printer and click OK to go back to the Page Setup dialog box. Set the paper size and click OK to go back to the Print Preview screen.

2. In the Print Preview dialog box (①), choose the color profile and the rendering intent.

3. Open the print driver dialog box to adjust the settings. This includes, with certain overlap, the following:
 a) The correct paper type (figure ⑤-Ⓔ)
 b) The paper source and another check of the paper size
 c) Print quality or print resolution (figure ④-Ⓕ or ⑦-Ⓕ)
 d) The type of color management. This should be deactivated in the print driver if it's activated through the image editing program to prevent converting the color space twice.

The whole process is quite complicated and requires planning because settings need to be made in several nonintuitive dialog boxes and some settings have to be set more than once, such as the paper size and the print quality. Make sure the settings in the different dialog boxes match, and save your settings with descriptive names.

Printing Black-and-White Images

When printing black-and-white images, you should leave the color space conversion to the print driver – if it offers such a mode and the printer comes with more than one black ink, as does the Epson R2400. Besides black ink, the R2400 also comes with two gray inks (called *Light Black* and *Light Light Black*) and can therefore produce prints with very fine gradations of grays.

When you print a grayscale image from Photoshop Elements, you begin as described earlier for color prints. First you open the Print Preview dialog box and choose the target printer, the paper size, the image print size, and the position of the image on the paper. Color management is different though. When you're printing black-and-white images, the Photoshop Elements print dialog box (as shown in figure ⑨) shows slightly different settings for color management. Under Printer Profile (Ⓐ), I choose *Printer Color Management.*

* *This means that the print driver, instead of the image editing program, takes care of the color management.*

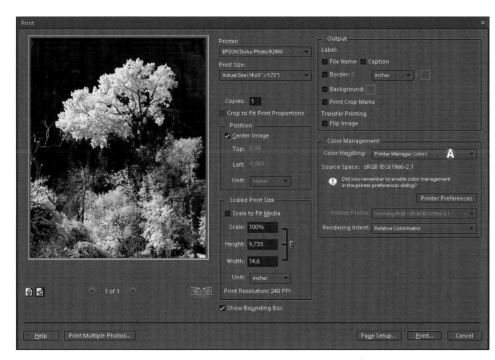

⑨ *Color settings in Photoshop Elements when printing black-and-white images*

In this example, I chose *Advanced Black and White Photo* in the print driver. (This mode is not available with all printers!) When using the R2400, there are four standard options available in the drop-down menu: neutral, cool, warm, and sepia (see figure ⑩). I started with neutral and liked the result. To adjust the tint in more detail, you can choose Settings. Then you will see the dialog box shown in figure ⑪.

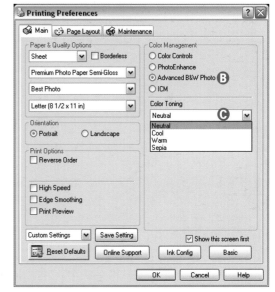

⑩ *Here I activate the Advanced Black and White Photo mode.*

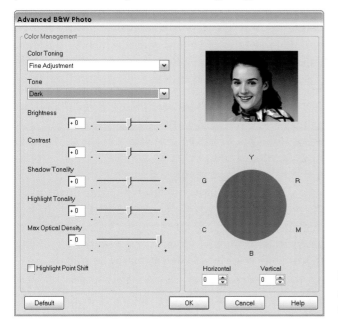

⑪ *Advanced Black and White Photo dialog box for the Epson R2400*

Besides the tint of the print, you should set the color tone – *black intensity* would be a more descriptive term here. The standard setting, Darker, under Color Tone, is very dark. Therefore, I usually use Dark or Normal. You should be careful in making changes to these settings.

7.3 Print Applications

Printing directly from Photoshop, Photoshop Elements, or Lightroom using the standard print driver is not always the best solution for a number of reasons:

▸ Photoshop and Photoshop Elements can work directly with only the print driver of the printer's manufacturer.

▸ At times, you may want to place more than one image on a page. Photoshop does not offer a good solution for this.

▸ The (color) print of black-and-white photographs requires special settings that are not available in Photoshop or Photoshop Elements.

▸ You need a real print server.

A RIP is already included in printers with a postscript processor

In these cases, you can use a program that is called a software raster image processor (RIP). These RIPs are mostly used by professional print shops to achieve better color management, to print several images on one page, and to get better print performance. For most needs, a special print program such as Qimage is sufficient.

7.3.1 Qimage

Qimage is only available for Windows

The Qimage software, made by Digital Domain Inc. [57], comes in a pro version and a lite version. At $50, the pro version is a relatively cheap, but at the same time a multifaceted and functional, print solution for Windows computers. Here is a list of useful Qimage features:

Qimage supports various printers such as those from HP, Epson, and Canon

▸ Support for a broad range of ink-jet printers.
▸ Color management; works with ICC profiles.
▸ Batch processing of images. In the batch mode, you can print, scale, and carry out format conversions.
▸ Placement of several images on one output page.
▸ Automatic image scaling for optimal print quality. Offers several different scaling algorithms.
▸ Sharpening (optional).
▸ Selective color corrections and fine-tuning.
▸ Image-oriented browser helps in selecting files for printing.

The user interface requires some learning, partly due to the large number of settings involved. This, however, provides a lot of flexibility. There are many

Qimage features I do not use – for example, image editing and RAW conversion or importing from flash cards or through TWAIN (scanner).

You can download a fully functional version of Qimage from the Web and test it for 30 days. If you purchase a license on the Web, a license key is emailed to you. Installation is simple: Click on the installation file. No other setup is required, but you should check to see if the correct monitor profile is selected.[*]

Qimage is not a true RIP. Instead of processing its own dithering and color translations, it uses the manufacturer's print driver for actual output to the printer. This process has limitations, but it also has the advantage that a large number of printers are supported.

Qimage performs several important printing tasks:

▸ Scaling calculations to adapt the image size optimally to the printer's resolution; offers several very good algorithms[**]

▸ Sharpening (can be deactivated)

▸ Helpful administrative functions (for example, saving and loading print driver settings)

▸ Placing several images on one output page; helps in creating contact sheets

After starting Qimage, browse to the image folder, where Qimage displays preview thumbnails (figure ①). Accessing a folder with many images may take a few minutes. Once in the proper folder, you can hide the folder browser (using F4).

* *Qimage accesses the Windows system default profile.*

** *Qimage knows the optimal image resolutions for the supported printers, and will up- or down- scale the image accordingly before passing it on to the actual print driver.*

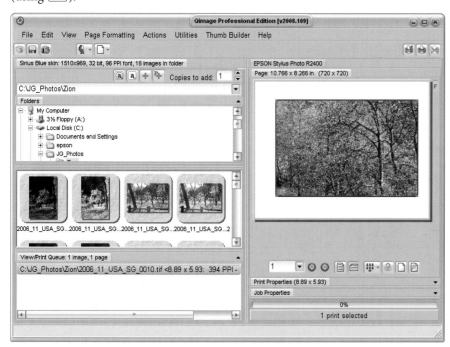

①

Qimage Pro window with the file browser open

Before starting the print, you should make three settings:

1. Printer setup (File ▸ Printer/Page Setup, or click 🖶).
 This brings up the standard print dialog box of your printer, in which you can make all settings. Qimage stores these settings and they can be saved under a special name.

2. Page setup (page size, orientation, borders, and so on) using the various options under Page Formatting)

3. Settings for interpolation and sharpening. For this, click the *Job Properties* button – or even more detailed – use Edit ▸ Preferences ▸ Printing Options (see figure ②).

② *Here you can adjust the interpolation and sharpen settings in Qimage Pro.*

Select the interpolation method for up- and downsizing your image (figure ②). Qimage offers various methods and indicates their respective quality and speed (Qimage Lite shows a simplified dialog box).

Additionally, check the color management settings by choosing Edit ▸ Preferences ▸ Color Management (figure ③) By default, Qimage uses the monitor profile set by the operating system. You can also define the working color space for the print. As mentioned before, it is important to select the right printer profile. You also set the rendering intent here. For most profiles, *Black point compensation* should be activated. The settings you define here are just default settings. You may change them for a specific job, e.g., when printing on different paper, you have to select another printer profile.

This can be done in *Job Properties*. If the job properties are not visible, click the *Job Properties* button (see figure ④). You can also change your Print resolution, Interpolation, and Sharpening settings. There are also options to add information about the file name or EXIF

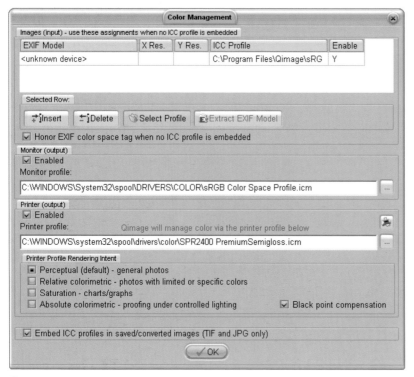

③ *The Qimage CMS dialogs allows to set your printer profile and rendering intent*

data of the print, add crop marks, guide lines, or even borders.

To print an image, merely drag your image icon onto the empty page icon (figure ⑤). Alternatively, you may select the image thumbnail and click ➕ (⧉ calls up an image preview).

When you select several images and click ➕, the images are automatically placed on the page at the image size currently selected in the page window. As many images as possible are placed on a page, and additional pages/print jobs are created automatically as needed. You may delete individual images from a page or modify their placement.

You can still scale the image in this preview using your mouse, change the placement, and delete images from the page or a page from the job. You can also change the page orientation using the ▭ and ▤ icons.

If you want to fine-tune the layout of an image on the page, click on the ▣ icon. Qimage will bring up its Full Page editor (see figure ⑥). In this editor you can crop and rotate the image and tune the layout and placement of the image.

④ *The Job Properties are shown and can be modified here.*

⑤ *Drag your images onto the page preview icon.*

◀ ⑥ *The Full Page Editor of Qimage allows to fine-tune the image on your page, including cropping, rotating, and changing the placement on the page.*

Images printed with Qimage look more concise, which means they appear sharper than prints made from Photoshop. This may be attributed to the optimized scaling done by Qimage before the page is passed on to the print driver, as well as to the sharpening applied to the image (deactivate the sharpening feature if the image appears too sharp). The up-scaling algorithm that Qimage uses is good even for significant enlargements and can save you the cost of special scaling software.

7.4 Electronic Presentation

* *PowerPoint represents a popular presentation program, but Impress (part of OpenOffice/StarOffice), Keynote (by Apple), and Lotus Freelance also belong to this category.*

Projector for presentations (here NEC LT260)

** *Cheap projectors can be bought for approximately $1,000. Be aware, though, that replacement projector lamps are very expensive. The life span of a lamp ranges from 1,000 to 5,000 hours.*

Besides the traditional paper print or the picture in a desktop publishing layout, images are used more and more in purely electronic presentations. This can be single pictures in a PowerPoint presentation,* a screen presentation using an automatic or mouse-click-controlled slideshow, or a video presentation that can be played on a monitor or on a TV (controlled through a DVD player) as an MPEG film. You can easily add multimedia components such as audio into these types of presentations. There is a huge range of electronic formats, replay programs, and tools for creating electronic presentations. In this section, the discussion will be limited to the presentation of photographs.

There are three essential questions you should ask yourself when considering how to present your pictures:

▸ **Who will your audience be and how many people will you be addressing?**
 Electronic albums presented on a monitor are suited for single persons and small groups. When presenting with a video projector, be aware that your images will loose color saturation and sharpness. Projectors are also being used as home television these days.**
 For small group, you can also present your images on a television using a DVD player.

▸ **Who will display the presentation, a speaker or the viewer?**
 In the latter case, you either have to save the presentation in a format that can be played practically anywhere by anybody (in a standardized and popular format), or you have to include the presentation program, i.e., a self-extracting and self-playing program.

▸ **How will the data be transported, and how much data can be sent?**
 Sending film or movie presentations (such as MPEG, QuickTime, or AVI) via email or posting them on the Web is still limited by the amount of data you are working with. However, presentations can be transported on CDs or DVDs. To send an electronic album through the Internet or email, the images need to have an appropriate low resolution (see the specifications in the next paragraph).

For all electronic presentation methods, a relatively low image resolution of 75 to 100 ppi or image sizes (in pixels) of about 600 × 400 up to 1280 × 1024 are needed at 24-bit color depth, and the images should be saved as JPEGs (usually). At times, 8-bit will do (i.e., with GIF or PNG-8 images).

The following basic procedure is the same for almost all presentation types:

▸ Choose the images for the presentation. Preferably place them into their own, separate file folder. It is even easier to mark them with a

special tag – in Photoshop Elements, for example, you can create a new tag for them. Then you can use this tag as a search criterion and the image browser will display only the images you want.

▸ If you have not done this yet, give titles to your images. They can then be displayed in the presentation as image titles (if you so desire).

▸ Today it is no longer necessary to scale the pictures to an appropriate presentation size (≤ 1200 × 1024 pixels) or to convert them into a format suitable for the presentation. Almost all programs take care of this automatically.

▸ Decide on the sequence, page background, image titles, and other design elements. Usually you can choose from a number of predefined designs for the layout and you can adapt the type face and color, among other characteristics.

▸ Often you can also choose transition effects and how long each image is displayed. Some programs allow you to add an audio track to your presentation. Web galleries do not have this option.

You should definitely test the result – perhaps even on a second system.

Beginner image editing programs, as well as many of the simple programs that come with digital cameras, offer a wide range of presentation methods.

If you click into the box to the left of the tag in Photoshop Elements (i.e., slideshow), the organizer shows only the images you assigned this tag to.

7.4.1 Slideshows on the Computer Screen

Monitors have a high luminance, do not need to be set up like projectors, and provided the screen is sufficiently large, are ideal for presenting to a small group of viewers. Such a presentation can also be sent by e-mail, and music or other audio data can be added.

There are a large number of freeware and shareware programs available for creating screen presentations. Many image management programs also can create such presentations, such as Apple's iPhoto, ThumbsPlus by Cerious, and Photoshop Elements. Other programs are Jalbum and StudioLine Photo.

The result can be files in various formats. Some programs use their own formats, but then a specific presentation program must be present on the computer when the slideshow is played. Some programs can be embedded into the presentation file, but it also makes the file size larger.

A more elegant variation is to use a standard multimedia format such as QuickTime or Acrobat/PDF. You can assume that most computers have compatible software installed already. Photoshop Elements uses the PDF format for slideshows. The output can be optimized via the assistant (for screen presentations, video shows, etc.). For the presentation, you can choose the sequence in which the images are shown and the style for image

➔ *Many cameras allow you to show images directly on a TV via a video cable, without a computer and CD.*

titles, background, frames, and duration, as well as the image transitions, playing speed, and audio track. The procedure is described on page 284.

If the presentation program does not automatically resize the images for the output media, you should use a conversion program to reduce the resolution* – on a copy of the original image of course! This can dramatically reduce the size of the presentation file and speed up the production process, and it often helps in a smooth presentation flow.

* Formati [65], PhotoRiser [80], XnView [86], and (on Mac OS) GraphicConverter can scale and convert file formats in batch mode.

7.4.2 Slideshows in Video CD Formats

A variation of the slideshow on the computer is to burn a CD or DVD in VCD, S(VCD) or video DVD format. This way, the slides can be presented on a television with a DVD player. Shows created in video formats can also be watched on the computer if you have a compatible player.

VCD = Video CD with a resolution of 352×288 pixels (PAL). This roughly equals VHS quality.
(PAL stands for Phase Alternating Line.)
SVCD = Super Video CD with a resolution of 480×576 pixels (PAL).
MPEG-1 format with 25 frames per second is used. For still images, you can also use a resolution of 704×576 pixels (PAL).

The option for creating such video formats can be found in a number of commercial CD/DVD burning programs, such as Nero Burning ROM (5.5 or later) by Ahead and WinOnCD by Roxio. Also, some image management programs for beginners offer these options (for example, Photoshop Album and StudioLine Photo). These programs are usually very easy to use, and simple presentations can be created quite quickly.

Video DVD uses MPEG-2. For PAL, the MPEG-2 standard supports the following resolutions (in pixels):
720×576
704×576
576×352

The production procedure is once again the same as described on page 284: select the images, decide on the sequence, scale, convert the format, and choose transitions and audio tracks. The image resolution must be adapted to the chosen video format (see measurements in the sidebar). Most programs will do this automatically.

The simple programs for producing such presentations offer an image sequence with only simple transitional effects and linking of embedded audio data. With real video production programs, you can perfect the presentation or rework the results created with one of the simple programs. This allow you to create complex image transitions, fade sound in and out, add movie and image titles in many variations, and include additional movie clips. Low-cost programs like this are available for the amateur and are included for free in many video camera packages. When you create your presentation in one of these programs, it allows you to import still images and sizes them according to output automatically. You may have to convert special image file formats to one of the standard formats such as TIFF or JPEG, though.

Windows comes with a simple program called MS MovieMaker. The Mac OS X operating system comes with iMovie.

The final rendering of the movie can take some time, especially on older, slower systems. The movies also take a lot of storage space on your hard drive, depending on the chosen format and the resolution. It is best to first save a movie to the hard drive and check it (watch it) before burning it to CD of DVD. You can burn the CD or DVD with the production program

or a stand-alone CD-burning program (in Mac OS X, for example, with iDVD).

Check that the DVD player can actually handle the CD or video format you used, which can vary from manufacturer and model. Of course, you can also play these movies on a computer with the appropriate player software. You can find commercial as well as free players on the Web.[*]

PC video formats are another alternative to the CD/DVD video formats. This includes, for example, Apple QuickTime, the AVI format, various Microsoft video codecs, and (new on the market) the MPEG-4 and DivX formats. You can find players for each of these formats on the Web, often for free.[**] These formats are *not* suited for replaying the presentation on a TV with a DVD player.

Many newer cameras offer the option to display the images directly from the camera on a television with use of a video cable.

→ *All listed formats can be burned on DVD as well as CD, as long as there is enough space. They can also be burned to CD-RWs and DVD-RWs, which is cheaper for the first attempts because they can be overwritten.*

* *A proven video player is, for example, PowerDVD by CyberLink.*

** *A universal player that is available for several computer platforms is the QuickTime player made by Apple. It comes as a free version as well as a commercial version; the latter allows you to create and edit video files.*

7.4.3 Internet Presentations – Photo Galleries

At times you may want to present your pictures on an Internet site as a web gallery or photo gallery so that they can be viewed by friends or colleagues and are freely accessible to others. Such a web gallery is nothing other than a website on which the images are presented as thumbnails (miniatures) with one image enlarged. When you click on one of the thumbnails, it appears enlarged in the browser window.

Of course, with some time and effort, you can create a web page with common software such as Adobe Dreamweaver or GoLive, Netobjects Fusion and even with a text editor. The task is easier and faster, though, with one of the special web gallery tools. Many image management programs and some image browsers offer this option as an integrated function. For example, Paint Shop Photo Album, iPhoto, and Adobe Photo Elements all support this function. The all-in-one programs Apple Aperture and Adobe Lightroom (described in sections 8.8.1 and 8.8.2) offer nice options for this as well. Additionally, you can find programs

A simple web gallery, created with Adobe Lightroom 1.3

specializing in creating web galleries, such as *Jalbum* [66], which is free for private use and available for several computer platforms.

Again, the procedure for creating web galleries is the same as outlined on page 284: choose the images, determine the sequence, resize the images (to ≤ 800 × 640 pixels), and convert them to an appropriate format (JPEG). Most programs automatically take care of the last two steps.*

Finally, you choose the page background, the webpage layout, and the text for the individual images. Usually, you can choose from predesigned templates. Typefaces and colors and background colors (and similar components) can still be adjusted in the dialog boxes.

Most programs come with an easy-to-use wizard to guide you through the steps. For example, in Photoshop Elements 6, choose Create ▸ Online Gallery or use Share ▸ Online Gallery to create a Flash or HTML web gallery (depending on the Category and Template you select). The look is very much the same in both versions:

1. A new empty panel is created by Photoshop Elements (see figure ①).

2. Now you drag the image you want to include in the gallery into this panel. You can also select several images from your preview and drag them to the gallery panel. Selecting an image in the panel and clicking the minus button allows you to remove the image.

3. Arrange the images in the way you want them to appear. Just drag them in your preferred sorting order (see figure ①).

4. Click on the Next button to go to the next step. Here you first select a type of gallery – there are several available. Next you select a gallery template. When you click on Next, Elements will generate a first preview of the gallery – this may take some time – and show a preview in its preview panel. In this preview you can already test navigate your gallery.

Formati [65], PhotoRiser [80], XnView [86], and (on Mac OS) GraphicConverter can scale and convert file formats in batch mode.

① *Drag your images to the gallery panel and sort them the way you want them to appear.*

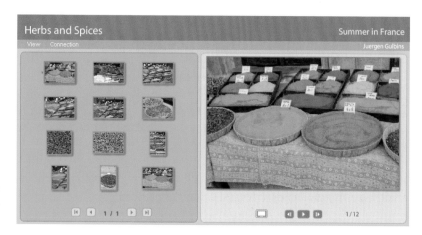

② *This is a first preview of a gallery. You can already navigate in it and you can edit the various titles and captions.*

5. In the dialog box that comes up, enter the gallery title, the caption and some more descriptions. Here you can also set the color of the background, the various borders, and additional settings – depending on the template you choose (see figure ③).

6. In the final step you give the gallery a file name and decide where it should be saved. With that, Elements will generate the actual gallery and save it to the folder specified. Now you can upload your gallery either to a public Adobe gallery site, your own web site (using FTP), or create a CD or DVD from the gallery.

The result is first saved into a separate file folder that contains the HTML or Flash files with a subfolder for the images. Both can simply be integrated into your own home page or added to a more complex website with one of the previously mentioned web design tools.

Like Photoshop Elements most of the web gallery programs can transfer the pages directly to an Internet server, typically using FTP. (File Transfer Protocol (FTP) is a common method for transferring data on the Internet.) You may have to enter some information, such as the target server, the target file folder, and perhaps a password. For continued use, this information is usually saved in a transfer profile.

Some photographic print service providers offer web gallery features for their customers so that family members and friends can view the developed images in an electronic photo album, download them to their computer (with some providers), and order prints. A website address and a password is usually required for access. This can save you from making print copies for friends and acquaintances after social gatherings or vacations. The function at a service provider to choose and order prints thus becomes very useful. You no longer have to deal with reordering prints for others and everybody can choose the images and sizes (and with it the prices) they want.

→ The scheme described here will work with most of the functions Photoshop Elements 6 offers under the Create and Share tabs.

7.4.4 Emailing Images

When sending images via email, you have to think about two aspects:

1. The total volume of all images should not be too large because it takes a long time to transfer the data and it can clog the inbox of the recipient.[*]

2. The recipient should be able to view the images without any problems.

Therefore, the images need to be resized to an appropriate screen resolution (that means ≤ 800 × 640 pixels) and converted to an appropriate format.

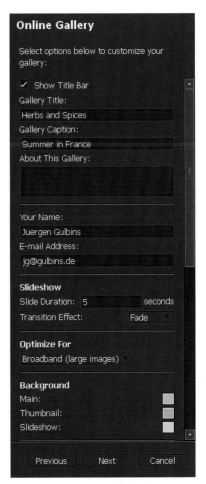

③ *Here you enter the Title and Caption for the gallery. The options offered here depend on the gallery template you selected.*

[*] *Many email providers limit their email box sizes to 10 MB and the maximum size of a mail attachment to 1 to 2 MB.*

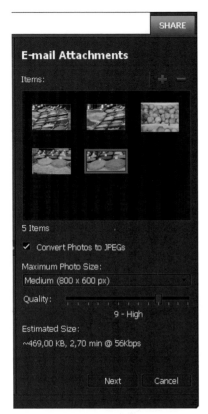

Photoshop Elements 6 provides an easy way to send a photo via e-mail using E-Mail Attachments.

For the format, you should use JPEG with a medium to high compression rate. The compression factor is a compromise between quality and size. Only if the recipient is to make a high-quality print of the image should you choose the TIFF format with a LZW or ZIP compression. Also make sure that the recipient is able to work with LZW or ZIP compressed TIFF files.

A small number of images/files can be attached to an email message. Almost all image management programs offer this option, but you may have to select the email program to be used.

If you are sending several images, you should pack them into an archive format. ZIP is a universal format because it is the standard for Windows and can also be unzipped in Mac OS and Linux/Unix. (Packaging compressed images into an archive file such as ZIP does not reduce the volume of data any further but makes the files easier to handle (in one archive file.)

A good alternative – especially when the images do not need to be processed by the receiver – is to pack the images into an electronic photo album in PDF format. The Acrobat PDF viewer (Acrobat Reader) allows comfortable viewing of pages and the ability to turn pages, zoom in and out, rotate, and print. For this, you need the relatively expensive full version of Acrobat or an image editing program that offers the option to save your files as PDFs (which is often the case now).

Most up-to-date photographic applications like Apple Aperture, Adobe Lightroom, and Photoshop Elements provide an easy mechanism to send a photo via email and do everything that has to be done, including converting, scaling, compressing, and embedding the images into an email. You just have to select the images to send and specify the recipient (usually selecting it from the address book of your default email client).

In Photoshop Elements 6 just select Share ▸ E-Mail Attachments, drag your images to the e-mail panel that comes up, select the image size (Elements will automatically scale the images to that size), and the JPEG quality factor. In the next step, enter your message and select a recipient. The Photoshop Elements wizard will guide you through the whole process.

A slideshow can also be sent via email in the previously described manner. It can be sent as an attachment, but you will have to attach it manually. The document should also not be too large, which rules out video formats.

Image websites that can be created with the all-in-one programs Adobe Lightroom and Apple Aperture are much more comfortable and flexible. You can easily design and configure many styles and variations.

7.5 Other Forms of Presentation

Contact Sheets

When looking at the print options, you should not overlook contact sheets made in Photoshop Elements and other programs. With contact sheets, you can print several image miniatures on one page. It is practical to also include and print the names of the files.

In Photoshop Elements, you select the images in the browser and call up the Print function (Ctrl-P; ⌘-P on the Mac). In the dialog box shown in figure ①, you select *Contact Sheet* under the *Type of Print* option, and under *Select a Layout*, you choose the number of columns you want to have on the page. This, at the same time, defines the size of the individual images.

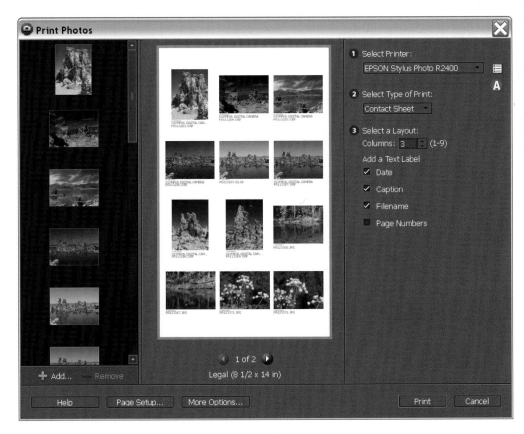

① *Contact Sheet dialog Box in the Photoshop Elements image browser*

You can also choose which additional information (Date, Caption, Filename) you would like to print. Photoshop Elements then automatically creates the print pages for the chosen images.

Use *Page Setup* to set up your page size and orientation and to set further printing parameters by clicking on the ▤ icon (see figure ①-Ⓐ).

Greeting Cards

Attractive images make nice greeting cards. There are enough occasions to use them, such as birthdays, weddings, and family celebrations as well as holidays such as Christmas and Independence Day. They are also useful as thank you cards. Photographers used to enlarge their own photographs in the darkroom, and you could buy special photographic paper in the shape of a postcard. Nowadays we use the computer and have much more room for creativity.

You can create greeting cards with your normal image editing programs. However, it is quicker and simpler with special greeting card functions in the amateur image management programs such as iPhoto and Photoshop Elements. Here you can choose style, size, background, and frames for the photograph on the greeting card, and you can add text to the image page or the back page. The result can be printed on your own printer, or if you need several cards, you can send it to a photographic print service (see section 7.1, page 259).

Greeting card created using Print Shop Pro

If you want to utilize the greeting card function of your image management software, you should edit and crop your image (you can also put several on one card) before adding it to the template. Images with clear contours and enough contrast or – as in the example – with a clear silhouette are well suited, and of course they should fit the occasion.

In Photoshop Elements, the function can be found – as usual – in the browser or editor by choosing Create ▸ Greeting Card (since version 6 you have to use Create ▸ MoreOptions ▸ Greeting Card). Here you have the choice between several predesigned templates.

Photo Calendar

Calendars are very popular presents for Christmas or New Year's. A photo calendar with your own pictures therefore has special appeal, especially if the pictures relate to the recipient of the gift. For calendars, there are several possibilities:

1. You buy an empty photo calendar and glue your own pictures into it. Even several small, color-coordinated pictures on one calendar page can be attractive. If the photograph is smaller than the empty space in the calendar, you can enhance the appearance by adding a mat of colored paper. The color of the frame should be coordinated with the most dominant color in the image or be in contrast to it. The advantage of this solution is that the calendar is already spiral bound. And you do not need any special tools for this.

2. You create the calendar pages with an appropriate program completely electronically – image plus date portion – and print them on your own printer or send them to a photographic print service. It is relatively cheap to get them bound in a local copy shop. If you do a Google search

using the term "+calendar +photo +program" you will get a number of hits.

3. You send your images to a photo service that offers a special calender function. It will print a calender containing your images.

4. You can use a DTP program like MS Words, Adobe FrameMaker, Adobe InDesign, or QuarkXpress in which you design your calendar and paste your images on the calender pages. This is definitely the hardest way, but will give you the most flexibility for the design, layout and size.

A function to create calendars can be found, for example, in Photoshop Elements, but only after you have registered with the photographic print service partner. This provider prints the finished calendar pages and binds them.

Calendar page created in InDesign

Calender page created in Photoshop Elements 5 (after registration).

Image Capture and
Management

8

Normally, the topic of image capture and management would appear much earlier in a book about digital photography. However, since the first chapters already address many basic concepts, this topic did not get covered until now. Nevertheless, it is an important one – even more for digital photography than for analog photography. You usually produce more images with digital photography than with film, and the organization, filing, and backup require distinctly different procedures. There are a number of significant benefits, in particular with regard to duplication and backup and to searching your image portfolio, but organizing and managing digital images does require discipline.

8.1 From the Camera to the Visible Image

The possibilities to capture an image, to edit it, and to output and present it respectively, are so diverse that it is hard to keep track of them all. The diagram in figure 8-1 illustrates the options, but the most important paths from the image into the computer are as follows:

In addition, many digital cameras permit the display of the images directly on a TV via a video cable.

1. Directly from the digital camera via a USB or FireWire connection
2. From the memory card of the digital camera via a card reader

Images from an analog camera are mostly developed by processing services. The following results are possible:

3. A negative that can be captured by a film scanner
4. Slides that are retrieved by a slide scanner
5. A photo or picture CD that can be imported
6. Photos that can be scanned by a scanner

Figure 8-1: Potential paths for image capture, editing and output

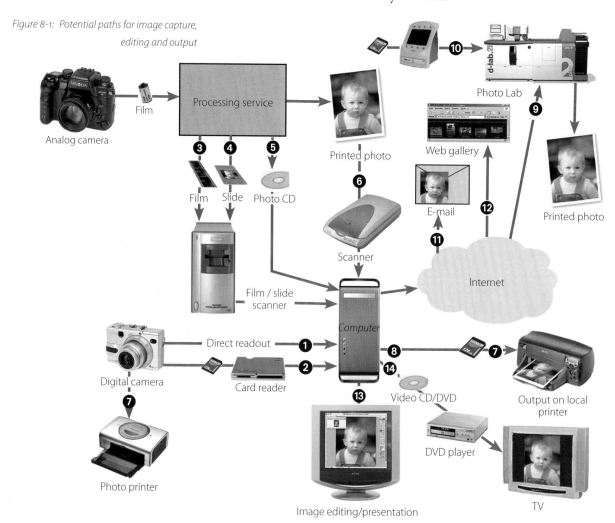

You can get a paper print from your digital image through one of the following options:

7. Directly from the memory card of the camera to a printer with card slots (employing the PictBridge protocol)
8. From the PC to a (dye-sublimation or ink-jet) printer
9. From a digital photo print service after you send them via the Internet and either receive them by mail or pick them up in the local photo shop
10. From a processing service after you load the digital images from the memory card of the camera into an order kiosk and then either receive them by mail or pick them up at the store

Besides integrating the images in a desktop publication, there are other means for the electronic circulation and presentation of images:

11. Sending via e-mail
12. Publication on a website (web gallery)
13. Presentation as slideshow on the PC screen or using a digital projector
14. Production of video CD or video DVD rendered on a TV via a DVD player

Newer cameras can directly display images on a TV (via a cable).

In particular for electronic presentation, numerous file formats are available for almost all purposes.

8.2 The Toolkit

A fundamental advantage of digital images is that you can edit and manage them on the computer. For this, you need a number of software tools, some of which are already supplied with the camera. However, it is worthwhile to determine how far they meet your own demands and which additional components need to be acquired – be it in the form of freeware programs, inexpensive shareware tools, or commercial programs. Solutions are available for all relevant desktop platforms: Windows, Apple Mac OS, and Linux/Unix. As usual, the largest selection is offered for Windows.

Just as one type of car cannot satisfy the needs of all drivers, the demands of all photographers are not met by one single tool or program. The requirements of the individual user are determined by the equipment they use (digital camera, computer, printer), by the number of images to be processed and archived, and by the type of images and the respective quality standards. Finally, budget plays a role as well as which tasks you want to perform yourself and which you prefer to delegate.

The typical workflow of a photographer will offer clues as to the necessary tools.

Image management is a must for photographers.

The workflow steps are as follows:

▸ Downloading images from the camera or memory card to the computer

▸ Examining and evaluating the images

▸ Transferring the images to the image bank of an image management application (if downloading and inspection was not done using an image management system)

▸ Rating your images and applying more metadata (if not yet done on image inspection)

▸ Editing the images, possibly requiring specific tools for particular tasks

▸ Printing and presenting of the images on diverse media:
 – monitor or digital projector
 – TV (e.g., through a DVD player)
 – Internet
 – paper, on a local printer
 – paper, in the form of a magazine or book
 – photographic paper, through a processing service

This list is already rather long. If you also consider different add-on tasks, for which specific tools are available, you can easily lose track. Just think about the systematic renaming of image files, the display and output of the image metadata, the production of index and overview prints, image editing with numerous specific filters (for example, when you are creating greeting cards from photos). In addition, features of the different tools overlap to some extent.

Thus, it is worthwhile to limit oneself to a few good programs and plug-ins. Although their acquisition may be more expensive, you quickly learn to use them efficiently. This is indeed better than procuring a huge collection of programs that you hardly ever use. Do experiment with different programs before deciding on a work environment with a few tools. And keep in mind that the number of available features will increase with each program release and an update of your current software might enable you do without another specialty tool.

The features of operating systems also evolve. For example, Windows XP can read data directly from the camera or a card reader (via a USB or FireWire port) without the need for an additional driver. Windows Vista features even more improvements. The same applies to Mac OS and the current Linux releases. The file browser from Windows XP and the preview from Mac OS X* can also directly display the readout images as individual icons (JPEG images) without the help of an extra image browser. Even the metadata in the EXIF format can be displayed.**

"Spotlight" from Mac OS X even permits you to search by metadata.

**Right-click on the filename, choose Properties, select the Summary tab, and click the Advanced button.*

Nevertheless, where a large number of images and specific formats are concerned it is better to resort to specialized tools.

Data Transfer to the Computer

The technology for the data transfer – such as USB, FireWire, card adapters, and card reader – was described in section 2.5.1. To some extent, wireless transmission is also possible (Bluetooth and WLAN).

The newer operating systems allow data transfer without specific drivers. Windows 98, Windows Me, and Mac OS 9.x require additional drivers, which are either supplied with the card reader or downloaded from the Internet. Newer Linux systems also do not need an additional driver. The image files can then be downloaded directly from the card or the camera to a folder on the PC by dragging and dropping or copying and pasting.

Universal card reader for SmartMedia, Memory Stick, and CompactFlash cards

When purchasing a new card reader with a USB port, select one with a USB 2.0 port.

USB 2.0 is backward compatible with older USB 1.1 ports but will work slower on a USB 1.1 port.

The basic versions of image management programs, which are described later in the book and are supplied with almost all new digital cameras, also offer direct data transfer from the camera or the card reader. Many photography programs (e.g., Photoshop Elements) feature a downloader, which starts the image download as soon as the card is inserted into the card reader.

8.3 From the Camera to the Computer

Organization Is Half the Battle

Because of the high volume of data, obtaining good results with digital photography requires effort and discipline. Therefore, the following workflow is recommended:

1. Transfer the images promptly from the camera to the computer.

2. Check the transferred images by taking a random sample.
 If the images have been transferred completely and flawlessly and have been backed up, they can be deleted from the memory card, preferably while in the camera.

 → *Again: The memory card should be deleted only by using the Format option on the camera. Formatting, as opposed to simple deletion, also erases the file structure. This enables quicker accesses afterward.*

3. Examine the images on the computer as thumbnails in an image browser or image management software.

4. Delete blurred or other unusable images from the disk as well as from the archive.

5. Rename each remaining image with a meaningful name. You can accomplish this simultaneously for multiple images with the help of respective batch processing tools.

 A proven naming formula is presented on page 312.

6. Examine the images individually at full screen size.

7. Crop them to a reasonable size or view.

8. If the images will be processed further and they are not yet saved in a format with lossless compression (e.g., TIFF), they should be saved in such a format now.*

9. Where required, provide images with additional comments or descriptions (e.g., copyright note).

10. Generate second backup copy of each image on an external data medium (CD, DVD).

11. If the images have not been transferred to an image management program (step 3), this should be done now. Preferably, assign metadata right away and categorize them (see section 8.6, page 311). At this point, also check the metadata supplied by the camera – nowadays typically in EXIF format. Complement the image's metadata with comments such as an image title, notes regarding the exposure, names of people in the images and possibly their addresses, and a copyright notice. This information is usually stored in the IPTC format or placed in the IPTC fields. This can be carried out with the help of the image management program,** the image editing program, or if necessary, with specialized programs such as *Exifer* [75]. If required, a watermark can be applied as well (for example, with the Digimarc procedure in Photoshop).

Only now are you ready to start with the actual image editing.

When evaluating your images, be critical and keep only the good ones. You should delete technically inferior and severely under- or overexposed images. This way, you can maintain a clear overview of your image collection. It thus becomes more manageable and takes up less memory on the hard disk and the backup media.

You should keep in mind, though, that neither the hard disks of computers nor the external backup media are infallible. Therefore, a promptly generated backup copy should be the norm for important images.

For yourself as well as to exchange with others, it can be useful to create a contact sheet like the one you get when you have film or slides developed by photo services. Reviewing a contact sheet is often more convenient than reviewing images displayed on the monitor. Some image management programs offer this feature, or you can utilize one of the numerous free image browsers, almost all of which offer contact sheet printing. For Windows, these are, for example, the rather powerful IrfanView [79], Jalbum [66], and XnView [86]; for Mac OS, Jalbum and XnView. With Mac OS X, you can also use iPhoto. Jalbum and XnView are also available for Linux and Unix.

See table A-2 on page 332 and the description in section 5.21, page 214.

**Photoshop Elements, Photoshop, PhotoLine 32, and Paint Shop Pro support this feature, as do the all-in-one programs Apple Aperture and Adobe Lightroom.*

All current image management programs support the creation of contact sheets. In the process, you can configure which data is printed with an image.

8.4 Scanners and Scanning

Even those who shoot digital images usually have a collection of old prints, film, and slides, which they would like to convert and add to their digital collection. Whereas scanners used to be outrageously expensive – and they still are in the professional market – today you can acquire a usable color scanner for paper originals for $50 to $180. The scanning software is so straightforward that even a layperson can obtain acceptable results with a little dedication and effort. Once an image has been scanned, the process of editing it is similar to the process for editing images taken with a digital camera.

Photo scanner
(Epson Perfection V500 Photo). Source: Epson.

8.4.1 Selection of a Scanner

The range of scanners in the consumer segment is comparable to that of digital cameras, but with lower entry-level prices. And as with digital cameras, scanners in the lower price range are subject to similar fast changes in models. The following list includes the essential criteria for the selection of a flatbed scanner:

In the professional market, high-quality and expensive drum scanners are still frequently used.

▶ **Resolution**
Resolution typically ranges from 600 spi* (samples per inch) to 1200 spi in the lower price range and from 2400 to 4800 spi in the intermediate and upper price segment. However, only the optical resolution is really relevant, not the interpolated resolutions. Interpolations can be performed better on the computer than with a scanner and do not provide any image improvement but rather large volumes of data. The truly needed image resolution is typically moderate and reaches approximately 300 dpi for high-quality photos with a 1:1 image scale – unless you want to enlarge the original, as you would, for example, with slides. Today, even the most inexpensive scanners already have an optical resolution of 600 dpi.

** This means ›samples per inch‹. However, the terms ›dpi‹ (dots per inch) and ›ppi‹ (pixels per inch) are almost exclusively used instead. Therefore, I will subsequently refer to the scan resolution in ›dpi‹.*

The effective resolution – i.e., the fine details that a scanner is able to differentiate – is usually 30 to 50% below the optical resolution specified by the manufacturer. These deviations are caused by flaws in the utilized glasses and optics.

Especially flat and compact scanner (here, Canon, LIDE 70 with 2400 × 8 800 spi). Source: Canon.

▶ **Color depth**
This is the number of bits the scanner captures per pixel (red, green, and blue). The standard is 8 bits (or rather 3 × 8 bits). More complex scanners are also able to capture 3 × 10, 3 × 12, and even 3 × 16 bits. Although the final processing at the computer is often carried out with 3 × 8 bits, the extended color depth of the scanner offers a better differentiation of hues and gray tones, in particular in bright and dark image areas.

Usable(flatbed) scanners for amateurs are around $50 to $180, including scan software and optical character recognition (OCR) and basic image editing capabilities.

Although today 48 bits (3 × 16 bits) are frequently specified, even for less-expensive scanners, the supplied scanning software does not always have the capability to pass this color depth on to image editing. Yet the

If you truly want to use a color depth of more than 8 bits (per color channel) for image editing, the image editing software needs to support the 16-bit mode (see table 5-1 on page 128).

optimization would only be advantageous there. If the data sheet specifies ›48-bit internal‹, this indicates that the scanner driver only passes on 24 bits to the application.

▶ **Scanning speed**

Scanning speed can differ substantially from scanner to scanner, but it's only relevant if you are scanning a large number of images. Scanning speed is usually indicated for letter size with a bitonal resolution of 300 dpi. Unless you are a professional, moderate speeds are sufficient (around 90 to 160 seconds per letter page at 300 dpi and 24 bits).

With higher resolutions, the scanning speed is limited not only by the scanner itself, but potentially by the slow transfer via the USB 1.1 port. FireWire, and USB 2.0 have a clear advantage here.

In the amateur segment, scanning speeds of 30 to 60 seconds, in black and white, per letter page at 300 spi are sufficient and common. In color (3×8 bits), this equals roughly 3 minutes per page. A higher scanning speed is particularly useful for high-resolution scanning. Specifications regarding the scanning speed are sometimes hard to find in the product data sheets.

▶ **Maximum scan area**

For home use, maximum scan area is typically 8.5×11 inches. Larger formats are notably more expensive; 8.5×14-inch scanners start at $370 and 11×17-inch scanners start at $1,000.

▶ **Interface**

Whereas the standard interface used to be SCSI in the intermediate and upper price range and a parallel port in the lower price range, today USB can be found in the lower price range and FireWire in the upper. If you are planning a new acquisition, opt for USB 2.0 or FireWire because it offers a higher transfer rate.

▶ **Transparency unit**

For some scanners, a transparency unit is offered, either built in or as an optional component. With it you can also capture monochrome and color negative film as well as slide film. However, if the scanner does not have a high enough resolution (starting at 2400×2400 dpi),[*] this is not a sensible enhancement. Also, for these purposes the scanner should be able to capture a higher optical density. However, you should be aware of the fact that scanners within the price range of $50 to $180 will not reach the image quality of true slide scanners.[**]

** Even a resolution of 2400 × 2400 ppi would allow a photo size of only approximately 3.8 × 5.7 inches at 300 dpi.*

*** Good slide scanners start at approximately $500; less-expensive entry level models start at $300.*

You can't really trust the resolution specifications of most flat-bed scanners. The effective scan resolution is usually about ¼ of the resolution given by the manufacturer. Sadly, the numbers given are used for marketing hype.

▶ **Density range**

The density range is relevant for the transparency units and indicates the (logarithmic) ratio of the tonal values of the brightest (not quite white) and darkest (not quite black) spot on the image. Good scanners reach values above 3.0, excellent ones above 3.5 (with 3 × 16 bits). A superior dedicated film scanner should reach a density value of 4.0 or more.

▶ **Software bundle**

Scanners are usually bundled with a complete software package, which, if purchased separately, could almost cost as much as the scanner. Part of the basic equipment is a scan plug-in, which permits accessing the scanner from different applications. In addition to the actual scan module, a basic image editing program as well as copy and OCR software are part of the scanner package for the amateur market. OCR software allows you to convert text pages to Word or other text formats after scanning. Often a basic document/image management program is also part of the package.

The scan support for Mac OS X is rather poor. If you want to work with a Mac, you should pay particular attention to the supported software. The scanning software VueScan [74] may be of help. VueScan supports numerous scanners under Linux. SilverFast can also be considered (with higher-quality scanners).

In most cases, these software packages are so-called "light" versions, i.e., slim versions of full software packages. However, these versions – a case in point is Adobe Photoshop Elements – are sufficient for most needs. If you register this software, you often receive an inexpensive update offer for the full version later.

One of the best scan modules is SilverFast from LaserSoft Imaging. It offers very good scan and correction features and mostly taps the full potential of the scanner. It supports scanning at higher color depths than 3 × 8 bits, as long as the scanner is capable of it. However, the SilverFast package only comes with scanners that cost $200 or above. It can be bought separately, but at the cost of a medium-priced scanner.

VueScan, from Hamrick Software [74], works with many different scanners and supports more scanner features than the scan drivers of the manufacturers. VueScan is available for Mac OS X, Windows, and Linux. At $40 for the standard version and about $80 for the professional version, it is rather inexpensive.

Frequently, scanners come with copy and print software, which permits you to use the scanner as a copier through interaction with the printer. The usefulness of this software is questionable though, since it's hardly used in practice, unless you are using a multipurpose device* that carries out copying independently. If you are using separate devices, the computer and the printer need to be switched on for copying.

** These multipurpose devices are also called all-in-one devices.*

▶ **Automatic document feeder (ADF)**

Automatic single-sheet feeders are useful if you want to scan many pages or if you are working in the classical archive environment. With respect to image editing and for the amateur, they make the scanner more clumsy and expensive and are hardly used in practice.

If you need an automatic document feeder, you can also opt for all-in-one devices that combine a scanner and a printer to create a kind of copier; they are controlled by the computer and are relatively inexpensive. The emphasis, however, is not on the highest scan quality but on the combination of office functions (printer, copier, scanner, fax).

All-in-one device (here: Epson Stylus CX5200). Photo: Epson.

8.4.2 Correct Scan Resolution

Although a high resolution is quite desirable for a digital camera, for scanning you should not necessarily select the highest resolution possible but rather the one most suited for the image you're scanning. Since the amount of data increases with the resolution squared, and with it the scanning times, it is worthwhile to determine an appropriate resolution (see table 8-1). There are a couple of important factors to consider:

▸ **Image type or rendition**
Line drawings (purely monochrome images) need the highest resolution, especially if they are used for printing. For use in printing, resolutions up to 1200 dpi are reasonable. Monochromatic halftone images get by with lower resolutions, and color images even lower. Even for printing, resolutions from 300 to 400 dpi are sufficient for an image scale of 1:1. If the image is only displayed on the screen, 75 to 100 dpi is sufficient.

▸ **Image scale/magnification factor**
The resolutions mentioned previously and in table 8-1 apply if an image is rendered at a scale of 1:1. However, if the image is enlarged, the resolution needs to be increased by the respective image scale. If the image size is reduced, the resolution can be decreased correspondingly.

It might make sense to scan photos with a color depth of 16 bits per color channel if the scanner, the scan software, and the image editing program are capable of this. Thus, you can correct the tonal range during image editing and convert the image to 8 bits per color channel afterward. In particular with slides and color negative film, this can lead to better results. In this way, the amount of data (and the scan time) is only doubled initially.

A letter page with 24-bit color depth and scanned at 1200 dpi requires approximately 400 MB (virtual) memory.

To scan with a resolution above the optical resolution of the scanner is not very useful because it increases the scan times and the amount of data, but it doesn't necessarily provide better image quality. A higher resolution – e.g., to enlarge the image – is achieved faster, with more flexibility and better control, in an image editing program. Keep in mind that the amount of data increases with the square of the resolution!

Table 8-1: Appropriate Scan Resolution (in PPI/SPI for the Image Scale 1:1)

Type of Image	Monitor/ Web	Laser Printer	News print	Color Printer	Book Print	Inkjet Printer
Line drawing (1 bit)	75–100	600–1200	300–400	400–1200	600–1200	600–1200
B&W photo (8 bit)	75	100–150	150–200	150–300	300–400	300–400
OCR	300–400 dpi in B&W (1 bit), gray scale (8 bit); color (24 bit) only, if text is colored					
Color graphics (8–24 bit)	75–100	150–200	100–200	100–150	300–400	300–400
Color photo (3 × 8 bit)	75–100	100–150	150–200	180–360	300–400	300–400
Slide (24/48 bit)	Dependent on the required magnification scale: 1200–4800 spi (not interpolated)					

8.4.3 Preparation for Scanning

As with digital photography, if you spend some time preparing, you can prevent potentially time-consuming editing steps afterwards:

▸ **Clean the glass pane to remove dust and dirt.**
Glass panes have a tendency to accumulate dirt. They should be cleaned with a soft microfiber cloth before each scan session. For persistent dirt, a mild cleaner can be used as well, but be careful that no cleansing solution enters the scanner.

▸ **Clean the image of dirt and lint and remove creases**
If the originals are creased, some slight ironing under paper might help. Slides should be taken out of their glass frames.

Wipe off glossy originals with an extra-soft cloth to remove fingerprints and similar spots. Negative film and slides should be handled very carefully. They should be touched only on the edge (outside of the image area) and an air blower should be used to dust them off before scanning.

▸ **Place the image on the glass in the correct orientation.**
Each time you rotate the scanned image, it not only results in quality losses but also takes time and effort.

▸ **Lay scanning materials flat on the scanner and close the scanner lid**
If you are scanning uneven originals (thick books, jewelry, 3D objects), you can also employ a black cloth as a cover.

If you are scanning duplex print originals (e.g., from newspapers or books), a black cardboard placed on the original will prevent the backside from showing through. You might have to brighten the image or increase its contrast afterward.

▸ **Prescan**
This allows a first check. You can determine how you want to crop the image, thus saving time and data. For a quick prescan, 75 to 100 dpis are usually sufficient. In the prescan, you can set the contrast and the white, black, and gray points as well as the scaling.

Scanners that permit a color depth above 8 (or 3×8) allow you to capture the brightness range ideally. If you are using a scanner ICC profile, the manual correction on the scanner can be omitted.

You can find scanning tips on the Web at [28].

It is almost unbelievable how persistently lint, fingerprints, and dirt accumulate unnoticed on the glass pane of the scanner. You can clean the glass pane with either a cleaning cloth for glasses or a microfiber cloth with glass cleaner applied to it (and not directly to the glass pane).

Can with compressed air to blow off dust

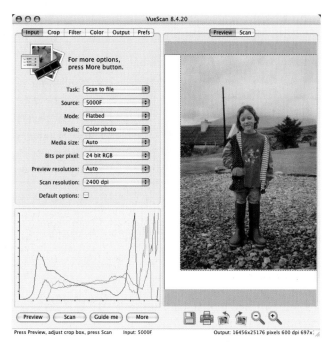

Typical prescan window (using VueScan)

* See section 5.23.1, page 222,. SilverFast, as
well as VueScan [74], support the scanner
calibration.*

Just as with image editing, the calibration of the monitor is part of the preparation.* The scanner should also be calibrated if you have high demands on halftone and color scans. However, you need specific software and special scan templates for this purpose.

The self-calibration of the scanner – a kind of automatic white balancing – should not be prevented or aborted. An abort can cause the scanner to deadlock, requiring you to restart the scanner as well as the operating system.

If the result of a scan is not satisfactory, it is usually more efficient to rescan the original with different settings than to correct the result through image editing

8.4.4 Scanning

After a good preparation, the actual scanning is rather straightforward and only requires a little patience. Although the scan software does offer a cancel button, an active scan should not be canceled. Too often the software gets stuck in the process and the system must be restarted. Therefore, it is preferable to let the scan finish and to delete the result.

There are at least two scanning procedures:

▸ **Scanning with the scan software supplied with the scanner**
Scanners in the lower price range offer a rather plain but easy-to-use program with a wide range of features. This, for example, is what the Canon software offers:
– Scanning and saving as a file
– Scanning and printing (a kind of copier function)
– Scanning and faxing (requires a fax modem)
– Scanning and saving to an archive/catalog
– Editing the scanned image
The image editing features are very basic; you're better off using a full-fledged image editing program.

Typical scan multi-palette (here from Canon)

However, high-end scanners offer very sophisticated scan software, such as the previously mentioned SilverFast software.

*For SilverFast, check the home page of
Lasersoft at www.silverfast.com.*

▸ **Scanning using a TWAIN plug-in**
This allows scanning from the image management software or the full image editing software via the import or TWAIN interface. Almost all current image editing programs as well as image management programs and image browsers support the TWAIN interface. When connecting to the scanner (in most cases) a scanning dialog box with a preview window appears.

*TWAIN is a widespread standardized interface
for scanner access from other programs.*

In the dialog box, you can set the scan options such as image crop, resolution, and image type. The scan result is then transferred to the program accessing the scan and is available as an image there. For the most part, you will have to close the preview window explicitly!

For scanning photos, the second procedure is more convenient since image editing programs offer better features for correction than the simple scan software. This does not apply, though, to specific scanning programs such as SilverFast.

If you have little experience with scanning, you can accept the automatic scanner settings and in most cases you will receive usable results. For making high-quality scans, you need to learn more about the subject.

In both variations, however, you should use the capabilities of the scanner and the scan module to capture the full tonal range when scanning photos, slides, or negative film. Because, even less-expensive scanners record a wider tonal range (usually more than 8 bits per channel) in this preliminary stage than is inherent in their final scan result – normally 8 bits or 3 × 8 bits. You might have to activate an Extended option for this.

Similar to working with levels (see page 168) and curves (page 176), you can frequently apply subtle corrections and capture the ideal tonal range during the scan. For the most part, this can be applied not only to the blended channel but also separately to the individual RGB channels.

If the scan dialog box offers it (as shown in the adjoining screenshot from Canon Scan-Gear) you should set the white and black points with the respective eyedroppers during the prescan (i.e., you should define what should appear white and what should appear black). All tonal values in the image that are brighter than the selected white point will be set to white, and in the same way all tonal values that are darker than the selected black point are set as black. Selecting an appropriate gray point is more difficult, but it also allows a potential color correction.* A poorly selected gray point, however, might result in a more intense color cast. A large enough preview window is important, though, to evaluate the effects. Therefore, the ability to expand the preview window is essential.

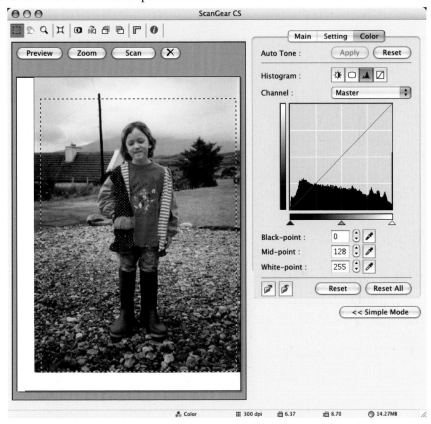

Certain corrections – for example, the tonal range – should already be applied in the scan panel (here ScanGear under Mac OS X).

If you are scanning several similar images, the Canon scan module ScanGear (just like many other scan modules) allows you to save your settings in a file as a profile, which you can reuse for later scans. The same applies to VueScan and SilverFast.

* *If you are using a scanner ICC profile, the profile (hopefully) should take care of the color correction. In this case, you should either select an appropriate setting or refrain from applying any corrections in the scanning software!*

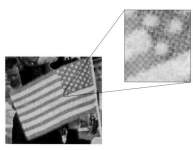

Cropped scan from a newspaper with distinct print pattern/moiré

Moiré patterns can occur when printed material (such as magazines and books) is scanned. They occur when the scan pattern and the print pattern are superimposed. Sometimes the print pattern is just too distinctly visible. Therefore, some scanning programs offer a special descreening feature.

If a descreening feature is not available, you might be able to find it in the image editing software. If this is the case, it is recommended that you scan with a lower resolution. If the descreening feature is missing in the image editing software as well, the moiré pattern can be clearly reduced through blurring. However, instead of applying the blur to a specific area only, as described in section 5.13.5 on page 191, in case of moiré it is applied to the whole image. In this case, you should avoid prior automatic sharpening in the scan module. Nor does it make sense to scan patterned images in high resolution, because that only reinforces the pattern (if you take a picture of the photo instead of scanning it, the moiré pattern largely disappears).

For OCR, colored text or text against a colored backdrop needs to be scanned as color (8 or 24 bits) and the contrast might have to be increased in the image editing phase. An increase in contrast, which clearly improves the OCR error rate, is also recommended for black text on slightly toned or dirty pages.

For optical character recognition (OCR), a resolution of 300 to 400 dpi is recommended. In particular for magazines and books, it might be useful to scan in the grayscale mode instead of the black-and-white mode. You can then define the ideal limit for black and white later during image editing, using the contrast settings. You can achieve better and more controlled results this way than by using the automatic conversion mode of the scanner.

This is also true for other originals that should be black-and-white images in their final stage. In this way you can quickly and easily remove dirt and gray edges caused by the fold – particularly in older books – through image editing.

Image Post-Editing

Post-editing scanned images is similar to editing the images taken with a digital camera. The essential steps, as outlined in section 5.2 on page 130, are as follows:

- Performing a quality check of the scanned image
- Aligning the image as required (see section 5.6.1 on page 167)
- Cropping the image (the less-relevant parts) to reduce the image size and expedite subsequent editing
- Performing level correction (see section 5.7 on page 168)
- Adjusting contrast and correcting color (see section 5.8 on page 169)
- Retouching flaws and dirt (see section 5.13 on page 186)
- Scaling the image to the final format (see section 5.14 on page 201)
- Sharpening the image* (see section 5.11 on page 181)
- Saving the image in an appropriate format (see section 5.21 on page 214)

** Sharpening can be omitted for line drawings.*

8.5 Scanning Slides and Negatives

There are different methods to capture a slide or negative film on the computer. Basic conditions and quality demands as well as costs determine the appropriate procedure.

There is a good book "Scanning Negatives and Slides" on scanning by Sascha Steinhoff [8].

8.5.1 From Film to CD

For the development of slide or negative film, the best alternative is to use a processing service. The processing service will use technology developed by Kodak. If you order a Picture CD or Photo CD along with the slide/film, the price per scanned image is very affordable. There are three quality levels:

▸ **Picture CD**
You can get a Picture CD when you have film developed, and the additional cost of about $5 per film is very inexpensive. The resolution is low, with 1 024 × 1 536 pixels in JPEG format. A Picture CD will hold as many as 20 to 30 films.

The resolution of the Picture CD allows enlargements up to 3.4 × 5.1 inches at 300 ppi or 5 × 7.7 inches at 200 ppi.

▸ **Photo CD**
A Photo CD is an option when you have slides or film developed. Approximately 100 images will fit on one CD. The images are stored in a special format (Image-Pac). The Image-Pac format offers five different resolutions at the same time (from 128 × 192 to 2 048 × 3 072 pixels). The quality is good; some basic processing is done during the scan. In order to open the image file (the filename extension is *.pcd*), you need specific plug-ins that are available in many image editing programs. The cost is about $1 per image plus a service charge of approximately $4 per CD.

The Photo CD permits images with enlargements up to 6.9 × 10.3 inches at 300 ppi with the highest resolution and 10.3 × 15.4 inches at 200 ppi.

▸ **Pro PHOTO CD**
The Pro PHOTO CD is similar to the Photo CD but offers the image files in the Image-Pac format at six levels of resolution (the highest resolution is 4 096 × 6 144 pixels). Compared to the regular Photo CD, an extended image enhancement is applied during the scan. The cost is around $6 to $8 per slide. Service providers are offering this service not only for the 35mm format but also for scans in the medium format.

The Pro PHOTO CD allows images up to 13.7 × 20.1 inches at the highest-quality level (300 dpi) and 20.5 × 30.7 inches.

The images of the Photo CD are not sharpened and are therefore designed for online presentation on the TV or computer screen. If they are used for offset or ink-jet printing, they should be re-sharpened in an image editing program.

For more on sharpening, see section 5.11, page 181.

The most expensive scanning option, and the one delivering the highest quality, is to obtain scans from a custom photographic lab. However, with prices ranging between $40 and $50 per image, this is only worthwhile for very high-quality originals.

All four procedures can be used for slides as well as color negative film.

Slide/film scanner (Canon, CanoScan FS4000
US). Photo: Canon.

8.5.2 Capturing Slides Yourself

Of course, you can also capture slides yourself. There are different methods for this as well. The best quality is achieved with dedicated film scanners, but you would need to invest $500 or more for a good film scanner of amateur quality. Professional scanners even range up to $20,000 and more, but provide very high quality.

A more affordable solution is to use a flatbed scanner with a transparency unit. For an acceptable quality, however, the scanner should have a minimum resolution of 2400 dpi or, even better, 4800 dpi or more, because the image will be enlarged quite a bit. You will not reach the quality level of dedicated film scanners with these flatbed scanners or only those that have their own transparency attachment, for example, Microtek's ScanMaker 8700

Depending on the number of slides that need to be scanned and the quality you demand, there are other procedures for capturing slides:

Take a photo of a projected slide • The easiest way to capture slides is to take a digital picture of a photo that is projected onto a screen by a slide projector. You need a tripod for this, which places the camera as close as possible to the projection axis (directly behind the projector). You can find the correct exposure time through trial and error. Preferably, the shutter should be released via a remote control or alternatively by a self-timer.

Photograph the slide • A better solution is to simply photograph the slide. This requires a camera with an adequate resolution, which should be around 4.0 megapixels or above. You place the slide on a light box or on another evenly illuminating background light. You use a tripod for this procedure too. First, align the camera in such a way that it has as little distortion as possible with regard to the slide. As before, you need to experiment a bit regarding the exposure time. Preferably the photographed slide should fill the whole frame; i.e., it should be shot in close-up mode and at a high zoom level. You might need a close-up lens attachment for this. Utilizing a screen of black cardboard, block the background light surrounding the slide. With a simple tube of black cardboard, you can also mask incident stray light.

Exposure toward the slide projector • If you want to photograph an entire series of slides, it is a good idea to use the slide tray mechanism of the slide projector. In this process you photograph directly into the luminescent projector, forwarding the projector with the remote control after each exposure (as well as the camera with its remote control). However, some minor (reversible) alterations are necessary on the projector. The normal projector bulb is too strong for the CCD sensors of the camera. It could damage the image sensor. Therefore, the bulb needs to be replaced with a weaker one; 20 watts is sufficient. Alternatively, a light-muffling diffuser could be placed between the bulb and the slide, or the incident light could be reduced through a gray filter on the camera. In addition, remove the lens of the

projector because no projection is required. Just as in photographing the slide, you take the picture of the slide with the zoom/close-up setting and attach an additional close-up lens, as required.

Use a slide duplicator • A number of companies offer special slide duplicators for their cameras; Olympus and Nikon even include them as original equipment with some of their camera models. Companies such as Hama (www.hama.com) and Soligor (www.soligor.com) also offer slide duplicators.

These devices consist of a tube (which is attached to the camera), a slide holder, and a diffuser (frosted glass) behind the slide. An additional macro lens attachment may also be required.

You hold the device against a neutral light source with an even illumination (a light box or bright window) and take the picture. These duplicators cost between $50 and $150.

The quality of the resulting slides depends upon the resolution as well as the optics of the camera, but this method is sufficient for enlargements up to 5.1 × 7.1 inch at 200 ppi with a 4.5 megapixel camera if the quality you desire is not too high. However, you have to provide an even and color-neutral light source, and you should keep in mind that the slide format (24 × 36 mm, ratio 2:3) does not exactly correspond with that of the digital camera (3:4).

You can find a number of manuals on the Web on how to build slide duplicators yourself.

Slide duplicators, scanners with transparency units, and film scanners are devices that are used only occasionally, sitting idly in the closet most of the time. You may want to consider borrowing such a device and capturing the slides on a rainy weekend (or two). If you treat these borrowed items carefully and thank the lender with a small sum, this may be your best solution in many cases. But do not forget to borrow the respective software as well and to update it with the latest releases from the Internet.

Slide duplicator
(company Soligor). Photo: Soligor.

It may be confusing that in analog photography the width-to-height ratio is indicated as ›height:width‹, whereas it is indicated as ›width:height‹ with digital cameras. I used the ›height:width‹ format here.

8.6 Image Management

With digital photography, image management is an issue because of the amount of images produced. Moreover, the contact sheet, which was typically generated with film development, is missing. And even more images or image variations are produced through image editing.

At the same time, image management is greatly improved through the use of the computer. Numerous programs are available for management and archiving, and they cover the needs of a broad range of users – from the amateur to the stock photography agency.

It is important that you actually use these programs consistently. As convenient and versatile as they are, they are rarely compatible with each

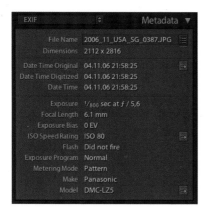

Display of EXIF metadata in Adobe Lightroom.

other. It is quite complex to migrate an existing image database to another program without losing essential components of the original organization process (categorization, comments, keywords for images). Thus, I recommend that you define your own requirements early on, experiment with different software, decide on a program, and employ it consistently. Almost all programs offer free trial versions.

8.6.1 Formula for Filenames

Image management starts with a sustainable concept for filenames and folder structures. The camera simply numbers the images consecutively and sometimes adds a date element. However, with a noteworthy image portfolio, this is not enough, and the significance of a reasonable naming scheme is widely underrated. Even with a good image management system, you cannot avoid using a naming scheme. I learned the formula below from Uwe Steinmueller and modified it slightly.

The filename should contain the following information:

** Proper format of date ensures that when the files are sorted alphabetically, they are in chronological order as well, which is very helpful in practice.*

▸ **Date** (creation of the original) in database format * (YYYYMMDD)
 For example, September 14, 2007 would be written as 20070914.

▸ **Subject or occasion** (e.g. "Wedding_Florian")
 You can also use a film number or something similar, but then a numbering scheme should exist. Make sure this part does not get too long – the complete name should not be longer than 31 characters – and that you use abbreviations consistently.

▸ **Camera name** (optional)
 For example, you could use D70 for images from a Nikon D70.

→ Do ensure that each name exists only once in your entire collection (even for multiple image catalogs and several years)!

▸ **Image number**
 To differentiate the images of a photo shoot or a larger image sequence. This number is usually provided by the camera (e.g., as part of the DPOF format).

▸ **Version or processing description**
 This is necessary as soon as you start to edit images and thus create multiple versions. The original image from the camera does not require this information.

The filename extension is particularly important in Mac OS, where it is not always correctly assigned by the editing program (as is the case in Windows).

▸ **The proper filename extension** for the file format used.
 For example, if the file format is TIFF, the extension would be *.tif;* for JPEG files, it would be *.jpg.*

It might be useful to add something to the filename to identify the backup set. However, this would require that the backups are created on the hard disk when the image files are downloaded and that the image files are grouped in such a way that backup sets are generated logically.

On the one hand you want to put as much information into a filename as possible and still have a readable structure – i.e., by adding a period or an underscore – but on the other hand, the filename, for practical reasons, should not be too long. Keep in mind, though, that further information can be placed in the image's metadata (i.e., in the IPTC data).

A complete name of an image file could look like this:

$$\underbrace{2007}_{\text{Year}}\underbrace{12}_{\text{Month}}\underbrace{24}_{\text{Day}}_\underbrace{D80}_{\text{Camera}}_\underbrace{\text{Christmas-04}}_{\text{Shoot}}_\underbrace{0027}_{\text{Image number}}_\underbrace{\text{Org}}_{\text{Processing}}.\underbrace{\text{jpeg}}_{\text{Extension}}$$

➜ Experience shows, that empty spaces, certain characters (e.g., apostrophes), and special characters such as :, /, \ *, ", and ! should not be employed, even if the operating system permits it. In addition, the complete name should not have more than 31 characters.

It is helpful to use the *Month-Day* date format, both values with two digits to ensure chronological order. The abbreviation ›Org‹ for the processing status signifies *original* in the example. A processed version could then have the name 20071224_D80_Christmas-04_0027_P1.tif

Of course, files are not renamed individually but with the help of a program, as batch processing for all files of a shoot. All image management programs offer batch renaming, even entry-level versions such as Photoshop Elements.

If you structure the file folder in which you place the photos, according to figure ①, you create additional clarity independent of any image management system, yet this sets up a good foundation for one.

① *Suggestion for a filing structure of images*

8.6.2 Data Backup

In this section, I'm referring to backing up image data. From experience, I've learned that you can never be too careful, thus my recommendation: back up, back up, back up! You should end up with at least three copies of each image:

1. One on the regular hard disk for processing and quick access
2. One on an removable CD/DVD, or even faster an external hard drive
3. A second (external) backup copy in a different off-site location
4. A third copy on a DVD, using a different brand from the second one.

Good images are valuable, in particular those taken professionally. These days, digital storage is so inexpensive and manageable that it is worth investing in them, even for amateurs!

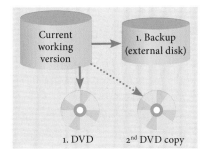

② *Backup diagram – two copies are not too many!*

Which Data Should Be Backed Up?

All original data coming directly out of the camera needs to be backed up. However, before you save the images, you should examine them quickly in a browser, delete the unusable ones, rename the files in a consistent manner, and adjust the orientation where required. That's it. Once you've done all that, you should back up the files before performing any further image editing. You can then delete the data on the camera's memory card, convert the RAW data, and begin with image editing.

The following kinds of files need to be backed up:

▸ The original files (RAWs, JPEGs, TIFFs).

▸ All completed images – (TIFFs, PSDs, JPEGs). If an image exists in multiple formats – for example as a master file and in a reduced and compressed JPEG web version – you should back up these versions as well since the conversion took some effort and time.

▸ Files representing all intermediary steps, which could be starting points for further editing.

→ *I recommend putting your operating system including all installed applications on one disk or disk partition and your data files on a separate one. This makes it easier to back up the data separately.*

▸ Your disk containing your operating system and your applications.

Theoretically, you can re-create the edited image from the original. Yet you might have invested a lot of time and effort into the final image. Since storage media are fairly inexpensive and backups run quickly, it is better to save one time too many than too little. The real work starts with the organization process.

Today, the preferred backup medium is a CD, or even better, due to its large capacity, a DVD. After the backup, a data check in which the content of the CD/DVD is compared to the data on the hard disk should be a matter of course and is indeed offered by most of the backup programs. Store your backup media safely, shielded from dust, humidity, sun, and high temperatures.

However, do not forget to back up your image database, especially if you are using a proper image management system. You do not want to lose that either!

8.6.3 Backup Software

→ *The current version of Photoshop Elements for Windows as well as entry-level image management programs already offer basic backup features for images.*

Apart from simply copying from one hard disk to another, you should invest in special backup software. This applies particularly to backing up on CD or DVD.

The features supplied with Mac OS X and Windows XP or Vista do support a basic backup, but backup software from third parties usually provides better options. It is often supplied with the purchase of a CD/DVD disk.

I have tried Nero Burning ROM from Ahead and WinOnCD from Roxio and they worked well. For Mac OS X, Toast from Roxio is the tool of choice.

Retrospect from Dantz is available for Mac OS and Windows as well as in a client-server version, which permits the backup of several different systems.

Backup on tapes is supported by the versatile product Retrospect from the company Dantz. It supports backups on CDs and DVDs as well as backups on external disks. The advantages of Retrospect are that it offers good data media management and also supports web backups.

If your backup program does not offer data media management, you should define a naming scheme for the data media and adhere to it consistently. If you don't label the media (for example a DVD) or create a proper

filing system, you might encounter serious problems when searching for the right media.

When performing a backup, you should always activate the verification feature, which compares the data on the backup media with the original data.

For Windows, I am using FileBack PC from Maximum Output Software for the automatic backup/synchronization of my internal hard disks with external hard disks, and on Mac OS X I use CronoSync from Econ Technologies; both have served me well. However, there is a broad range available in this area.

FileBack PC: www.maxoutput.com

CronoSync: www.econtechnologies.com

8.7 Browsers, Archives, Image Databases

With the use of digital cameras, the image portfolio increases much faster than with film, not only because you are taking more pictures (it costs almost nothing) but also because you are producing more files due to the different formats (RAW and TIFF) and multiple processing versions. A conventional folder hierarchy won't be sufficient for managing as well as searching these files, especially since you have to remove data from your hard disk in the foreseeable future.

The naming scheme presented earlier is a good starting point, but it's not sufficient. You will soon need a suitable image management system, also referred to as a media asset management system.* There are two types:

▸ **Ad hoc image browser**
This type allows you to quickly browse in image folders and view the images in a preview or enlarged. The features have already been addressed. The data can be stored on hard disks as well as on CDs, DVDs, and similar data media with a file system structure. **

 These browsers are available in great numbers, many of them as freeware. However, not all of them support the display of RAW files. RAW files are displayed, for example, by *ACDSee* (only in Windows). In addition, a RAW viewer is offered by the file browser in Photoshop as well as *Bridge* (as part of Photoshop CS2/CS3) and *Photo Mechanic*. These programs are useful for a quick image check, but as stand-alone applications, they are not adequate for professional image management. For this you need a genuine image database.

▸ **Genuine image database**
Image databases allow you to capture additional image metadata and store it in a database. You can provide your images with keywords, classifications, copyright notices, comments, and additional data.

 The metadata is not only stored in the image file but also in a database. This permits a quick search using different search criteria. Opening individual files while searching is no longer feasible in a large data stock.

** They are also called archives, image databases, and album programs.*

*** However, not on tape!*

There is a smooth transition from the browser to the media database.

It is the second type that we need for professional archiving/management.

A broad range of programs is available, from freeware and shareware to commercial software and single-user solutions as well as client-server systems. What should a good solution offer?

8.7.1 Requirements of Image Management

There are some essential features you should look for in an image management program. It should provide you with the ability to do the following:

▸ Capture/import images from different sources such as camera or memory card, scanner, and data media.

▸ Rename, move, copy, and delete images.

▸ Display images and browse/navigate in the image portfolio.
 You should be able to view the images in a small thumbnail as well as in a large preview. Image should be transferred automatically from the image management system to the image editing program (e.g., if you double-click on it).

→ Make sure the selected program can handle or capture your specific formats (for example, the RAW format of your camera or those of Photo CDs).

 For efficient image management, it is important that the preview images are not reloaded each time but are stored together with the metadata in the image database and are retrieved from there. The data from offline media should also be stored in the image database (with the exception of the image file itself)!

 Assign the basic metadata via a metadata template to several images (often all images of a shoot) or transfer it by copying and pasting.

▸ Display image metadata such as filename, image title, EXIF and IPTC data, keywords, categories, and the like.

▸ Change and amend image metadata (keywords, categories, copyright notices, notes). It is advantageous if the IPTC data in the image files can also be changed, and to some extent this is also useful for the EXIF metadata.

▸ Perform basic image editing such as rotating (in 90° steps) and cropping. Many image management programs also offer basic automated image enhancement (correction of tonal values, color, and contrast, etc.). These automatic enhancements, however, do not fulfill professional demands!

▸ Search with different criteria such as date, keywords, category, image type, resolution, and other characteristics

▸ Archive on other hard drive modules and external data media such as CD or DVD. The metadata and contact sheet data should be preserved even if the external image data media are removed. It should also be possible to archive the metadata.

There are a number of additional things you might want to do with an image management system:

▸ Print contact sheets (several reduced images with names printed together on a page).

▸ Create presentations in different formats,* such as screen presentations, photo or video CDs/DVDs, photo albums, calendars, posters, and greeting cards.

See sections 7.4 and 7.5.

▸ Output contact sheets and metadata for export. These can then be processed with other tools. This is also helpful if you need to migrate to another database.

Not all features are covered by just one program. However, it is practical if you can complete the tasks with a small number of tools. I have compiled a brief overview of image management programs in table 8-2 on page 325.

→ Hardly any image management program accepts the data of another. You should therefore be careful when selecting a program because changing is very cumbersome. You will almost always need to recapture a lot of data and recategorize it, which is an unthankful task for a large image archive.

 Cameras and scanners are often supplied with small image management programs. In most cases, these are not good enough to handle large image data banks.

Since most programs offer trial version on the Internet, you should test them before making a decision.

8.7.2 Metadata as Key for Image Management

If the content of the images is the focus of the photographer, it is exceedingly difficult to locate the right images in a large image portfolio without corresponding metadata. Metadata is data about the images; it describes and complements the actual image data (image pixels). There are different types of metadata with some information overlap:

▸ Data regarding the file (file attributes such as size and date)
▸ Technical data regarding the image (camera, aperture, shutter speed)
▸ Data regarding the author and rights of use
▸ Classification, rating, processing status, etc.

Without this type of metadata, image management is inefficient; with a large image data bank, it is just not enough to search images visually.

 Part of the data is captured automatically and is imbedded in the image or in the attributes of the file. This includes the file attributes as well as the technical data of the exposure (usually in the form of EXIF data).

 Other metadata must be supplied individually by the user or must be assigned from a selection. Since many of the details should be conferred to several similar images, the image management system should support this.

Depending upon the file format of the image, the metadata can be either embedded in the image file itself or kept separately. EXIF data is almost exclusively embedded in the image file.

Externally kept metadata can be stored as a second file, just as Bridge does with RAW images (the RAW conversion settings are stored in a proper XMP file). Or it can be stored in a respective database, which is more common for image management programs.

EXIF data • EXIF stands for *Exchangeable Image File Format*. EXIF data is produced by the camera and embedded in the JPEG, TIFF, or RAW image files when they are saved. The EXIF data contains information regarding the camera manufacturer, model, status of the firmware, aperture value, exposure time, lens, focal length, whether a flash was used and, if so, in which mode. In addition, exposure date and time as well as the camera program used, the resolution, and details about the white balance are included. EXIF can incorporate numerous other data – for example, the exposure location acquired by GPS. It also permits additional manufacturer-specific (proprietary) fields.

EXIF not only serves as an information source for the photographer, it's also used by the RAW converter, by the image optimizing applications such PTLens [71] or DxO [36], and by the firmware of paper developing units, which tries to optimize the image automatically to it. (You might have to deactivate this external optimization explicitly when ordering the prints!)

Usually, there is no real reason for the user to change the EXIF data himself. Therefore, neither ACR, Capture One, or DPP offer this feature.

However, if the date and time were set incorrectly in the camera, a modification is desirable. This can be achieved with specific applications such as Exifer [75], ACDSee [47], Photo Mechanic [48], and iView Media Pro [52] (now called Microsoft *Expression Media*).

IPTC • IPTC has been used by press photographers for quite some time. The IPTC definition originates from the International Press Telecommunications Council and allows details with regard to copyright, originator and author, image title, a brief description, and indexing.

Thus, IPTC has a strong Digital Rights Management (DRM) orientation but does not yet include a watermark.

Although images coming directly from the camera have an IPTC entry, the fields are usually empty and must be completed explicitly by the user. Photoshop as well as Bridge offer a feature for this. Regarding IPTC you need to know that there is an older norm and a newer one (IPTC core), containing more fields.

Keywords • Although keywords are actually part of the IPTC specification and of the IPTC data block, many applications deal with keywords as a separate kind of metadata. However, apart from EXIF data, keywords should be considered one of the most important type of metadata. They help tremen-

Date: 25.11.04
Time: 07:36:29
Model: Canon EOS-1Ds Mark II
Serial #: 303949
Firmware: Version 1.0.2
Frame #:
Lens (mm): 64
ISO: 200
Aperture: 10
Shutter: 1/500
Exp. Comp.: 0.0
Flash Comp.:
Program: Manual
Focus Mode: AI Servo AF
White Bal.: Auto
ICC Profile: Adobe RGB (1998)
Contrast: 0
Sharpening: 0
Quality: Raw

① *Display of EXIF data (here from Photo Mechanic)*

IPTC Core	
Creator	Rainer GULBINS
Creator: Job Title	Freelancer
Creator: Address	Zettlerstraße 7
Creator: City	
Creator: State/Province	
Creator: Postal Code	80992
Creator: Country	Germany
Creator: Phone(s)	Tel. +49–89–14334128 Tel. 089–14334128
Creator: Email(s)	rainer@gulbins.de rainer@astraingulbins.de
Creator: Website(s)	
Description Writer	Rainer GULBINS
Date Created	
Location	
City	Ottawa
State/Province	Ontario
Country	Kanada
ISO Country Code	CA
Title	031115_026_OttCity.jpg
Provider	Rainer GULBINS, rainer@gulbins.de
Source	Rainer GULBINS, rainer@gulbins.de
Copyright Notice	Copyright: Rainer GULBINS, all rights reserved © Rainer GULBINS, Zettlerstraße 7 D–80992 München Germany www.rainer@gulbins.de
Copyright Status	Copyrighted

Some of the IPTC metadata displayed in Bridge CS3

dously when searching for images, as well as to sort and group images. Keywords are usually also used for categorizing photos.

There are a number of books on keywording. If you want to plunge into this, again the website of David Rieck [26] will give you a good starting point. Be careful, however, that you don't get lost in the numerous information and discussions there. Therefore, we include a very brief representation of this subject.

David Rieck's website:
www.controlledvocabulary.com

Your keywording should provide answers to six "W" questions (the list was taken from David Rieck's website, where you will find a more information):*

Who is seen in the image?
What do you see in the picture?
Where is the subject located?
When was the photo shot (as long as it is not explained by the EXIF data)?
Why was the photograph taken and why is the content important?
How many persons or objects are seen in the picture?

** For more on this, see:*
www.controlledvocabulary.com/
metalogging/ck_guidelines.html

The IPTC specification applies some rules to the keyword entries:

▸ The single keyword entry – it may also be a phrase – must not be more than 64 characters. You may, however, use several keywords in every keyword field (there is only one keyword field per image).

▸ The total keyword entry should not be more than 2,000 characters (the current IPTC standard allows for more, but 2,000 characters provide for backward compatibility with the previous version of the standard).

▸ Keywords are separated by a comma or semicolon followed by a space.

The questions mentioned above also help when entering a caption into the Caption IPTC field.

A restricted vocabulary is recommended for keywords – preferably a predefined list of keywords. This guarantees a uniform way of spelling and reduces the variety of words used for the same circumstance. This of course only applies to general concepts, not to names and special locations (e.g., Bryce Canyon or Hearst Castle). When keywording an image, think about the way you will be searching for it. For categories, use the plural – e.g., use *Mountains* instead of *Mountain* or *Cattle* instead of *Cow*.

Don't to be too worried about the keywords. Often, more is better here than less. When searching for images, it helps if a concept is represented by several spellings (which somewhat contradicts what we said before). This, in particular, applies to geographic terms for which there are often several ways of spelling.

You may want to use some of the basic IPTC data (caption, title, keywords, file name) in certain forms of image presentation – e.g., the caption in a slide show or Web gallery. Keywords, additionally, are invaluable when searching for and sorting images.

You may also use the metadata for grouping images into collections (kinds of virtual folders; these, however, are not provided by all asset management systems).

Digital asset management systems like Lightroom, Expression Media, or Portfolio store metadata in their database. This allows for quick search and retrieval. Often, however, you may want to make the metadata accessible to external applications as well. Therefore, it is advantageous if there is a possibility to embed the metadata in your images too (provided the format allows for this). Lightroom does offer this. It is either done with every change or done on demand, or, optionally when exporting your images.*

* With TIFF, JPEG, and DNG files the metadata is embedded into the image file. With RAW files, an XMP (Extensible Metadata Platform) a sidecar file is created that contains this metadata.

Other metadata • Whereas EXIF and IPTC are well documented and adopted standards, there are a number of other metadata types that are not standardized. Thus, the terms for the metadata as well as its storage location can vary accordingly from supplier to supplier. This area includes the prioritization of images and their classification or categorization. They can be stored in specific IPTC data fields, but in image databases they are often only recorded in their internal databases.

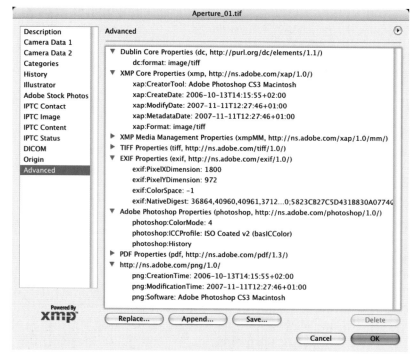

Adobe organizes its metadata in the XMP format (display in Photoshop CS3).

XMP • Adobe created the *Extensible Metadata Platform* (XMP) in order to exchange information between its applications in a well-defined manner. Today XMP is supported and used by (almost) all Adobe applications – for example, by Acrobat, Photoshop, Illustrator, GoLive, InDesign, and FrameMaker.

XMP is based on XML and is largely open; i.e., the specification has been published and XMP is supported by the Internet Engineering Task Force (IETF). XMP data can be embedded within an object file but can also be stored separately. XMP proves to be very flexible and offers predefined (standardized) as well as user-specific fields. Adobe Camera Raw, for example, stores the user-defined conversion settings in the XMP format. Photoshop can even record the processing and version history of an image in the XMP part of the image. Until now, other suppliers of RAW converters were mainly using different formats.

Categorization, assigning attributes

An essential capability of image management is the *categorization* (here used synonymously with *classification*) of images, because purely navigating (browsing) by folders, time, or filename is not sufficient. There is a broad range of possibilities that starts with simple keywords that you can assign to the images.

Many programs also allow the assignment of predefined or self-defined categories such as *sports, leisure,* and *hobby*. Preferably, you would have the option to further divide these categories and to create hierarchies this way. In this process, an element of a subcategory should automatically belong to the parent category, but unfortunately not all image management programs provide this feature. It is also advantageous if you can assign an image to several categories – e.g., to *vacation* as well as *architecture*. In most applications, categories are stored as keyword data.

The categories are complemented by the metadata that is already present in the image file (such as filename, image title, and image resolution) as well as by the numerous EXIF data provided by current digital cameras (such as exposure data, focal length, etc.). In addition, the IPTC data, including copyright notice, image title, and image notes, should be supported. Unlike EXIF data, which by now is adopted automatically from the camera images, the IPTC data has to be entered manually. Unfortunately, not all metadata is standardized, so the image title, for example, is stored in diverse metadata fields in different programs.

→ *Image management without categorization, assignment of keywords, and so on is quite useless because you are missing adequate search capabilities. Thus, you should not avoid this effort during image capture!*

Some programs also allow a search by resemblance, in which you can search for a particular image by using attributes from ›similar looking‹ images. Photoshop Album, for example, offers a search for images with similar colors.

Searching

All the metadata mentioned before actually may serve three purposes:

▸ Provide information to you (the photographer) and to people making use of the image

▸ Provide information to applications, which are processing images

▸ Allow for efficient searching of specific images

Ideally, you can search by metadata and combine several search criteria; for instance, you can search for all *architecture* images from the year *2008*, shot with the camera *xyz*.

Although most of the recent image management systems can display the EXIF data, only a few allow you to use this data for a search. However, in practice you can usually manage with a simple search – for example, searching for all images of a certain category or images of a specific time period. The results

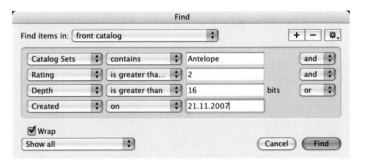

The search should permit combining search criteria (here from iView Media Pro, now Expression Media).

of a search are shown either as a list of filenames or as a list of images, in which you can search further visually.

The categorization of new images is often tedious, but it's absolutely necessary! The effort pays off quickly if the number of images is too large and a search by browsing the archive takes too long.

8.7.3 Downloader

While in the past separate, dedicated programs were used to download files from the card in the card reader (also supporting direct downloading from the camera), today a good downloader should be part of the image browser or image database application. It should not only allow for downloading, but also for renaming files using different naming schemes. A good downloader will also allow you to embed additional metadata into your imported images. Additionally, a useful feature of a good downloader is the possibility not only to copy the files to a destination folder, but also to produce a second back-up copy of the (already renamed) files.

8.7.4 Extended Features

Some browsers and image management programs offer additional features for image optimization, such as RAW conversion, image rotation, cropping features, and contrast and color corrections as well as further image editing functions. Apart from image rotation, I usually ignore these features. Hardly any actually reaches the performance, quality, and speed of similar functions in Photoshop.

I only use specific RAW converters for the RAW conversion as well. Their quality – and usually the conversion speed – is also distinctly better than those of browsers and image management programs. Therefore, I use the RAW conversion functions of these browsers and image management programs only for generating preview images for the database and browsing. In most cases, you can drag an image from these programs into an open RAW converter, which can then perform the actual RAW conversion. Alternatively, you can usually define within the browser which program should open the image. This rule does not apply to the latest generation of photo workflow tools such as Apple Aperture and Adobe Lightroom. In these programs, you can indeed use this feature.

Management Authority

Some systems want to copy the data to an otherwise inaccessible, proprietary area.

If you are employing an image management system, it is advantageous to also assign management authority to it.* This means that you retrieve the image for editing from the image management program even if the actual editing is carried out with a different program. This is the only way the image management program can reliably keep track of modifications. Thus it can consistently update its database and preview images or add new image versions automatically to its database. In this process, the image management

program acts like a minor document management system.* This may be unfamiliar for users who have never worked with such a system, but it ensures that you can use the image management system to its full capacity.

For comprehensive processing, images can be exported explicitly and the modified versions can be re-imported later.

Where Are the Image Files Stored?

When image files are imported, almost all programs offer to copy them to a proprietary data area. Instead of using this feature, I store image files in a proper folder structure and set the image management program in such a way that it leaves the image files there during importing – or copies the files from the memory card into my folder structure. This allows for simple backups of the data with dedicated backup programs as well as a clear and concise self-defined folder structure. However, you need to be careful not to rename or move the files at will, since this will lead to inconsistencies in image management.

→ *In Photoshop Elements, you can define in the default settings that the images should remain in the original storage location while they're being imported to the PSE management program and that they will not be copied.*

Creating Several Archives

Even well-organized archives can quickly become disorganized if they are too large. Moreover, the speed of the simple databases of the entry-level programs declines as the database grows. Therefore, the recommendation is to subdivide large databases into separate archives. As long as there are not too many archives, the successive search in several archives is still reasonable – for example, if you do not recall if a particular image is stored in the archive ›1998-2002‹ or in ›2003-2005‹.

Some image management systems refer to the archive (the database) as an "album" or "catalog"

If you are archiving images on external data media – and for safety reasons this should be done regularly – you should generate two copies of valuable data because the backup media could become unreadable, be damaged, or get lost.

8.7.5 Image Management Programs

As mentioned, there are two types of programs for image management: image browsers and true image databases. The transition from one type to the other is rather smooth.

The real difference is how comprehensive the database features of a tool are. Thus, almost all browsers of RAW converters – Bridge for Adobe Camera Raw and Photoshop CS2/CS3 – need to be counted among the browser type.

They also have a kind of database in which information about the images is stored, but this is more an extended cache or simple data pool than a database. With programs such as ACDSee, the differentiation is not as clear cut. However, we would still count them among the extended browsers, without considering this demeaning.

If the data pool increases, you need a true image database with powerful database functionality at its core. Here you can also differentiate

➜ *The image management feature of Photoshop Elements also uses a database in Windows, but it only works reasonably with up to 10,000 images. With more images, it runs so slowly that it becomes practically useless! Version 5 and 6 improved this a bit, still Elements is not designed for a very large number of images.*

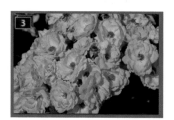

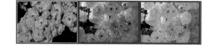

(Above) A stack in Apple Aperture. The small number 3 at the top indicates that the stack contains three images.
Below, the stack is expanded, showing all three images of the stack

further. There are programs that use a true database but are basically single-user programs. One example is Microsoft Expression Media (previously iView Media Pro). This version should be sufficient for most photographers. In windows, Photoshop Elements also has an image management system with an image database, although a basic one.

However, if several users need to access the image data pool simultaneously or Web access or network access is needed, classic database servers are required. The user retrieves a client program through which he accesses the image database. This type includes, for example, Portfolio from Extensis as well as Cumulus from Canto.

Stacks: A Nice Invention

Recently, image management programs started to provide so-called stack features. A stack combines a series of interrelated images into an image stack. The image management program then displays the top image surrounded by a frame, indicating that this is a stack. This reduces the visual image list and makes it more manageable. Photoshop Elements 5 and 6 as well as Apple Aperture and Lightroom feature these batches. You can still define the sequence of the images as well as the top image.

Of course, the images of the stack can also be displayed next to each other to provide better access to individual images. In addition, the image sequence of the stack can be modified, images can be removed from the stack, and others can be added. Moreover, the stack can be canceled.

To some extent, the software recognizes – by using the imaging time – which images should be combined in a stack; for example, images shot at short intervals are probably showing the same scene. The original image and the processed versions derived from it can also be combined in a stack in a meaningful manner.

Collections

Collections are named group of images, that are grouped either manually or by a search criteria. They allow grouping of photos across several folders or other structuring units. You may, for example, group all the images showing birds in a collection (wherever they actually reside on your disk) or all the images of a client or you may build up a collection of your best shots or all showing members of your family. Thus, collections may help tremendously when organizing images for a certain purpose. Memory-wise collections are cheap, as they do not contain the images, but only a link-list to the images. Thus you can afford to have many of them. Different names are used for collections; Apple Aperture and Photoshop Elements call them *Albums*, Lightroom calls them *Collections* and iView Media Pro (Expression Media) calls them *Virtual Sets*.

Table 8-2: Sample Image Management Programs with RAW Support

Supplier/Program	Platform	Approx. Price	Comments
Extended Browser			
ACD Systems ACDSee www.acdsystems.com	⊞	$40	Widespread in Windows; also available as professional version.
Photo Mechanic www.camerabits.com	⊞ ⬜	$150	Strong IPTC support, comparison of several images possible, automatic backup on second disk, multi-processor support; supports XMP; quite fast.
BreezeBrowser Pro www.breezesys.com	⊞	$70	Permits the creation of images for some of the supported camera models if the camera is connected to the computer via a USB port.
Entry-Level Programs for Image Management			
Apple iPhoto www.apple.com	⬜	$80	Nice, but rather limited, continues to be developed and is part of the iLife bundle.
Adobe Photoshop Elements www.adobe.com	⊞	$100	Part of the Adobe Photoshop Elements package (only for Windows).
Picasa http://picasa.google.com	⊞	Free	Free of charge, but without support of RAW files and not suited for larger image banks.
Semiprofessional + Professional			
ThumbsPlus Pro www.cerious.com	⊞	$90	Widespread in Windows; supports numerous image formats. Also supports 16-bit color depth per color channel.
Extensis Portfolio www.extensis.com	⊞ ⬜	$200	Single-user version of the professional media database for client-server operation.
iView Media Pro (now **Microsoft Expression Media**) www.microsoft.com	⊞ ⬜	$299	Raw support; also available in a light version, but then without RAW support.
Canto Cumulus Photo Suite www.canto.com	⊞ ⬜	$130	Single-user version of the professional media database for Adobe Creative Suite operation (but can do without CS); good search features, capable of scripting.
iMatch www.phototools.com	⊞	$60	XMP support, good IPTC support, good management of offline data.
All-in-One Programs			
Apple Aperture www.apple.com	⬜	$299	Covers the entire photo workflow. Very resource intensive. Very nice interface.
Adobe Lightroom www.adobe.com	⊞ ⬜	$299	Covers the entire photo workflow. Raw converter based on ACR engine.

8.8 All-in-One Programs

In a sense, all-in-one programs do not really fit anywhere in this book, or they should be part of almost every chapter. I am referring to a new generation of image programs, which I will call all-in-programs. They merge a downloader, an image browser, and image management and image editing tools into one program. Although programs such as Photoshop Elements also achieve this, this is a new type, specifically focusing on the needs of photographers in the semiprofessional and professional area. They are more powerful in image editing and image management than the usual entry-level programs. Unfortunately, they are also more expensive.* This includes Apple Aperture as well as Adobe Lightroom. Both are lacking graphical functionality such as the ability to make image collages include fonts on an image. For this you still need to resort to other programs (for example, Photoshop).

Both Aperture and Lightroom cost around $300. Street prices may be lower.

Both programs work nondestructively. Modifications of an image are not included in the image or image copy – just as with the RAW converters – but are stored as modification comments along with the image. The original image together with the modification comments is much more compact than two individual versions of the image. A modification record has an approximate size of 50 to 120 KB. With this, you can afford to have several versions of an image. However, the biggest benefit is that the individual modifications can still be subsequently changed!

Aperture as well as Lightroom can pass on an image to other programs for processing.** The returned image is considered a new image and stored accordingly. Images can also be exported explicitly to be used elsewhere. In this case, the all-in-one programs include modifications in a copy of the original image – this is also called rendering – and export this copy.

For example, to Photoshop or a specific RAW converter.

Another characteristic of these programs is that they treat RAW files, TIFFs, and JPEGs pretty much the same. During the image correction, you can hardly tell if you are processing a RAW or a JPEG image. Thus, TIFFs and JPEGs are processed in a nondestructive manner as well! The nondestructive processing requires substantial computing power because with each update of the image preview, all corrections need to be rendered in the preview. Therefore, a fast computer is a prerequisite!

A detailed description of these two programs would go beyond the scope of this book.** All mentioned image editing features are also possible with them, with the exception of layers. Aperture is currently available in version 1.5 and Lightroom in version 1.3. Lightroom can be used with Mac OS X as well as with Windows. Aperture can be used with only Mac OS X. Both programs use a true database for image management and are thus able to manage large image banks at high performance.

For a good book on Lightroom see Managing Your Photographic Workflow with Photoshop Lightroom *by Rocky Nook.*

This can be a good reason to utilize such a program. Therefore, I will provide a brief glimpse at these two programs.

8.8.1 Apple Aperture

Apple Aperture was one of the first all-in-one programs targeted to the professional and semi-professional photographer. Figure ① shows the main window of Aperture, with the management structure on the left, a large preview and a magnifying glass in the center, a part of the correction sliders on the right, and the image browser in the film strip mode at the top. The window is very flexible and can be adapted to your own needs and the current processing phase – truly ideal.

If you are working with two monitors, which is worthwhile for intensive correction work, Aperture supports this as well and can display, for example, the preview image in full size on the second monitor. This is a feature still missing in Lightroom 1.3.

In addition, individual areas can be resized or can be hidden to provide more space. The correction repertoire is quite comprehensive and distinctly larger than in Photoshop Elements. Instead, the automatic image corrections of the entry-level programs are missing; Aperture is geared more toward the semiprofessional and professional photographer.

The image management features of Aperture are very comprehensive and versatile. Thus, apart from libraries (this is the term for the entire image archive) you can create projects and subfolders as well as albums. An album is the (virtual) compilation of images, i.e., out of a search result list.

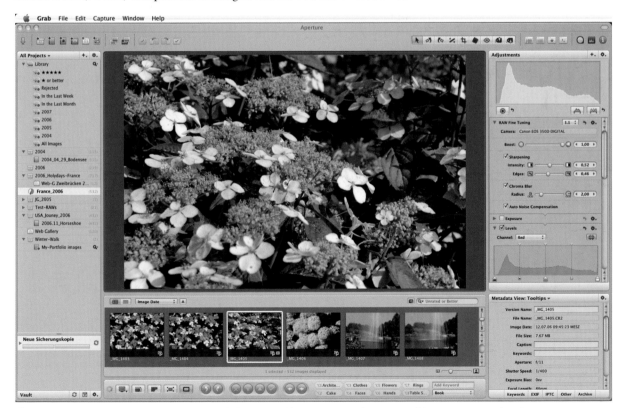

① *Apple Aperture window with project browser left, film strip and large preview in the center, and the corrections on the right*

In addition, Aperture supports image batches (stacks, just like PSE 5 and 6), as described on page 324.

The quality of the RAW conversion is good – but could still be improved (just like the speed of RAW conversion).

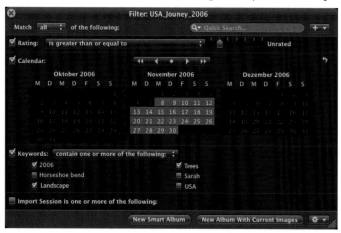

② *Apple Aperture also allows complex searches.*

The sophisticated search feature allows searching by numerous search criteria, also in more complex combinations, as shown in figure ②. The search results can be stored as a virtual collection, which gets updated automatically as soon as further images are added that match the search criteria, which is indeed a very useful feature. This allows you, for example, to create a virtual collection of all your images with five-star ratings, regardless of the real folder in which the images are stored. In addition, you can find features for the creation of web galleries and slideshows and rather sophisticated print functions. However, even more than Adobe Lightroom, Aperture requires substantial computing power. Aperture runs on PowerPCs as well as on the new Intel-based Macs. Support for new digital cameras occurs via an update of the operating system, because much of the RAW conversion is done using OS-internal functions.

8.8.2 Adobe Lightroom

Adobe Lightroom's concept is similar to that of Apple Aperture. It is also an all-in-one program focusing on the needs of photographers. Thus Lightroom offers a downloader, image management, and nondestructive image corrections. It can process RAW files, JPEGs, TIFFs, and PSDs seamlessly, and just like Aperture, it has well-developed features for the creation of prints and slideshows as well as web galleries. For image correction, Lightroom may be slightly faster and better than Aperture. Because its core image engine is based on the same engine used in Adobe Camera Raw, it supports a broad range of cameras and their RAW formats. On the other hand, Lightroom offers image management and image search features that are not as sophisticated as Aperture's.

Instead, Lightroom requires less computing power than Aperture. It is available for Mac OS X (PowerPC and Intel) as well as for Windows operating systems (XP and Vista).

In Lightroom, many items can also be configured, displayed, or hidden. The top (navigation) bar represents the typical work phases:

▸ *Library* – for downloading and renaming, image import, image export, and administration.

▸ *Develop* – for all image editing.

▸ *Slideshow* – for creating slideshows with a multitude of settings.

▸ *Print* – for printing. This is a really fine module, though softproofing is still missing in Lightroom version 1.3.

▸ *Web* – for creating Web galleries (either as HTML structures or as Flash galleries).

If you click on one of these elements, the total view will be modified accordingly. Thus Print, for example, will open a print dialog window with an almost overwhelming number of options and settings, a real quantum leap from Photoshop Elements but perhaps slightly confusing for the beginner.

Just as in Aperture, metadata can be displayed and entered and corrections can be transferred entirely or selectively from one image to others.

Functions for image correction are largely seamless for the processing of RAW, JPEG, TIFF, and PSD images, as is the case in Aperture. However, selective corrections in which the correction can be limited to certain image areas are barely available. This seems to be hardly feasible with the computing power of today's PCs.*

Adobe seems to put much effort into the continuing development of Lightroom, thus the capabilities of Lightroom might increase faster than those of Apple Aperture.

* *Photo applications such as LightZone [38] and Capture NX [39] show, however, that it can be done regardless.*

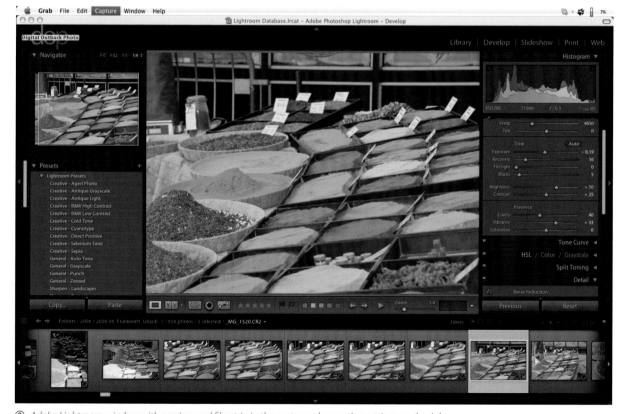

③ *Adobe Lightroom window with preview and filmstrip in the center and correction settings on the right.*

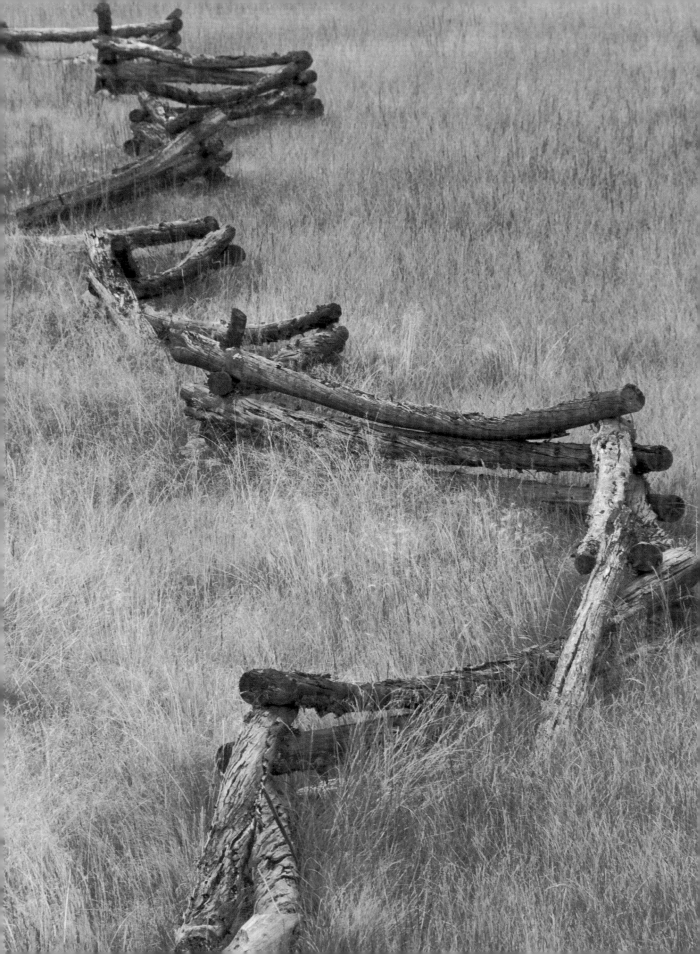

Tables

A

A.1 Where Are ICC Profiles Located?

	Table A-1: Folder Locations for ICC Profiles	
Operating System	**Folder Location**	**Notes**
Mac OS X	System/Library/ColorSync/Profiles/[1] ~/user/Library/ColorSync/Profiles/[2] Library/ColorSync/Profiles/[3]	[1] These profiles are available to all users. [2] Profiles are only available to the user. [3] Profiles administered by the operating system.
Mac OS 9	System Folder/ColorSync Profile/	
Windows Vista	C:\windows\system32\spool\drivers\color\	Here I assume that drive "C:" is the drive containing the operating system.
Windows XP	C:\windows\system32\spool\drivers\color\	
Windows 2K	C:\windows\system32\spool\drivers\color\	
Windows 95/Me	C:\windows\system\color\	
Windows NT	C:\winnt\system32\color\	

In Windows use the Finder to install or uninstall the profile. Right-click at the profile file. A popup menu will appear. Select Install Profile and Windows will install the profile or select Uninstall Profile to remove an installed profile.

In Mac OS X (or Mac OS 9) simply drag the profile to the location specified in table A-1 or delete or drag it to another folder in order to uninstall it.

A.2 Image Formats, Resolutions, and Sizes

Format/File Extension	Compression	Color Depth (per Channel)	Meta-data	Trans-parency	Layers	Color Profile	Vector Layers	Alpha Channels	Notes
RAW Various	No/slight	8–16 bits	+	–	–	+	–	–	Each is proprietary to the manufacturer.
TIFF .tif .tiff	Various: No / LZW/ZIP/ RLE/JPEG	Various, 1–32 bit	+	+	+	+	+	+	Multifaceted. Not all programs support all TIFF variations.
JPEG .jpg, .jif, .jpeg	Lossy	8/16 bits	+	+	–	+	–	–	Storage optimized. High lossy compression is possible.
JPEG 2000 .jp2, .j2c	Lossless and lossy	8/16/32 bits per color channel	+	+	–	+	–	+	Still relatively new, so far little support in desktop publishing programs, very compact.
PNG .png	Lossless	8/24/48 bits total	(+)[a]	+	–	(+)	–	–	Compact, limited browser support, no CMYK.
GIF .gif	LZW, loss through 8 bit limit	2–8 bits total	–	+	–	+	–	–	Internet graphics with 8-bit indexed colors.
EPS .eps	No (ASCII, binary)/ JPEG	1–16 bits per color channel	–	+	–	+	–	–	Used in desktop publishing programs.
PDF .pdf	Various methods LZW, JPEG …	1–16 bits per color channel	–	(+)[b]	+[b]	+	+	+	There is a special Photoshop PDF variation.
BMP .bmp	No/RLE	1–32 bits total	–	–	-	–	–	+	Still being used in MS Windows.
PSD .psd, .pdd	LZW for layers	1–16 bits per color channel	+	+	+	+	+	+	Native Photoshop format. Recognized by other image editing programs.
PSP .psp, .pspimage		1–16 bits per color channel	+	+	+	+	+	+	Native Paint Shop Pro format.
PCD .pcd	Own method	8 bits	–	–	–	+	–	–	Kodak Photo CD format. Includes image in several resolutions.

Table A-2: Image Formats and Their Options for Saving Information

a. With limitations, i.e., no EXIF data
b. Since PDF 1.5 (Acrobat Version 6) with limitations

Table A-3: Standard Image Formats and Their Image and File Sizes (at 24-bit Color)					
Size in Inch	Pixels at 150 ppi (only for inkjets)[a]	Pixels at 200 ppi (acceptable photo print quality)[a]	Pixels at 300 ppi (very good photo print quality)	Approx. file size at 200 ppi Uncompressed/JPEG compressed	Approx. file size at 300 ppi Uncompressed/JPEG compressed
3.5 × 5	525 × 750	700 × 1 000	1 050 × 1 500	2.1 / 0.4 MB	4.7 / 0.8 MB
4 × 6	600 × 900	800 × 1 200	1 200 × 1 800	2.9 / 0.5 MB	6.5 / 1.1 MB
5 × 7	750 × 1 050	1 000 × 1 400	1 500 × 2 100	4.2 / 0.7 MB	9.5 / 1.6 MB
8 × 12	1 200 × 1 800	1 600 × 2 400	2 400 × 3 600	11.5 / 1.9 MB	25.9 / 4.3 MB
12 × 18	1 800 × 2 700	2 400 × 3 600	3 600 × 5 400	25.9 / 4.2 MB	58.3 / 9.7 MB
16 × 24	2 400 × 3 600	3 200 × 4 800	4 800 × 7 200	46.1 / 7.7 MB	103.7 / 17.3 MB
20 × 30	3 000 × 4 500	4 000 × 6 000	6 000 × 9 000	72.0 / 12.0 MB	162.0 / 27.0 MB
24 × 36	3 600 × 5 400	4 800 × 7 200	7 200 × 10 800	103.7 / 17.3 MB	233.3 / 38.9 MB
32 × 48	4 800 × 7 200	6 400 × 9 600	9 600 × 14 400	184.3 / 30.7 MB	414,7 / 69.1 MB

a. At these sizes (poster sizes) you can use lower resolutions (150–200 dpi), because the viewing distance is larger.

Table A-4: Memory Cards and Their Image Capacities															
	Megapixel Camera, Values are: RAW[a], JPEG slight compression (1:4), JPEG stronger compression (1:8)														
Card size	6 Megapixel			8 Megapixel			10 Megapixel			12,8 Megapixel			16,7 Megapixel		
256 MB	86	172	344	66	132	265	51	102	204	40	81	161	31	62	123
512 MB	172	344	689	132	265	530	102	204	408	81	161	322	62	123	247
1 GB	344	689	1 377	265	530	1 059	204	408	816	161	322	644	123	247	493
2 GB	689	1 377	2 755	530	1 059	2 119	408	816	1 632	322	644	1 288	247	493	986
4 GB	1 377	2 755	5 510	1 059	2 119	4 238	816	1 632	3 265	644	1 288	2 576	493	986	1 972
8 GB	2 755	5 510	11 019	2 119	4 238	8 476	1 632	3 265	6 530	1 288	2 576	5 152	986	1 972	3 945
16 GB	5 510	11 019	22 039	4 238	8 476	16 951	3 265	6 530	13 060	2 576	5 152	10 305	1 972	3 945	7 890
32 GB	11 019	22 039	44 077	8 476	16 951	33 903	6 530	13 060	26 120	5 152	10 305	20 609	3 945	7 890	15 779
Average Image size	3,0 / 1,5 / 0,7 MB			3,9 / 1,9 / 1,0 MB			5,0 / 2,5 / 1,3 MB			6,4 / 3,2 / 1,6 MB			8,3 / 4,2 / 2,1 MB		

a. In most cameras, the RAW format is about half the size of the uncompressed format.

Megapixel	Resolution in Pixels (approx.)	75 ppi (Monitor)	150 ppi Ink-jet Printer (Acceptable)	200 ppi Ink-jet Printer (Good), Photo Print (Acceptable)	300 ppi Photo print (Good) Book Print (Good)
	Table A-5: Output Sizes of Various Camera Resolutions (Maximum Size in Inches)				
0.8	1024 × 768	Full screen	6.8 × 5.1 inches	5.1 × 3.8 inches	3.4 × 2.6 inches
1.3	1248 × 1024	Full screen	8.3 × 6.8 inches	6.2 × 5.1 inches	4.2 × 3.4 inches
2.0	1600 × 1200	Full screen	10.7 × 8.0 inches	8.0 × 6.0 inches	5.3 × 4.0 inches
3.2	2048 × 1536	Only reduced	13.7 × 10.2 inches	10.2 × 7.7 inches	6.8 × 5.1 inches
4.0	2272 × 1704	Only reduced	15.1 × 11.4 inches	11.4 × 8.5 inches	7.6 × 5.7 inches
5.0	2560 × 1920	Only reduced	17.1 × 12.8 inches	12.8 × 9.6 inches	8.5 × 6.4 inches
6.0	2816 × 2112	Only reduced	18.8 × 14.1 inches	14.1 × 10.6 inches	9.4 × 7.0 inches
8.0	3256 × 2304	Only reduced	21.7 × 15.4 inches	16.3 × 11.5 inches	10.9 × 7.7 inches
10.2	3872 × 2592	Only reduced	25.8 × 17.3 inches	19.4 × 13.0 inches	12.9 × 8.6 inches
12.8	4368 × 2912	Only reduced	29.1 × 19.4 inches	21.8 × 14.6 inches	14.6 × 9.7 inches
21.0	5616 × 3744	Only reduced	37.4 × 25.0 inches	28.1 × 18.7 inches	18.7 × 12.5 inches

Format/Name	U.S. size	Metric Equivalent
	Table A-6: Standard Paper Sizes	
U.S. names		
Executive	7.1 × 10.5 inches	18.4 × 118.9 cm
A (US Letter)	8.5 × 11.0 inches	21.6 × 27.9 cm
Legal	8.5 × 14.0 inches	21.6 × 35.6 cm
B (Leger, Tabloid)	11.0 × 17.0 inches	43.2 × 27.9 cm
Super B/Super A3	13.0 × 19.0 inches	33.0 × 48.3 cm
C (Broadsheet)	17.0 × 22.0 inches	43.2 × 55.9 cm
D	22.0 × 34.0 inches	55.9 × 86.4 cm
E	34.0 × 44.0 inches	86.4 × 111.8 cm
Metric names		
A5	15.82 × 18.27 inches	14.8 × 21.0 cm
A4	18.27 × 11.69 inches	21.0 × 29.7 cm
A4 Plus	8.27 × 13.00 inches	21.0 × 33.0 cm
A3	11.69 × 16.53 inches	29.7 × 42.0 cm
A3+	13.00 × 19.00 inches	32.9 × 48.3 cm
A2	16.53 × 23.38 inches	42.0 × 59.4 cm
A2+	19.90 × 27.72 inches	48.0 × 62.8 cm
A1	23.38 × 33.11 inches	59.4 × 84.1 cm
A1+	24.60 × 39.98 inches	62.5 × 91.4 cm
A0	33.11 × 46.81 inches	84.1 × 118.9 cm
A0++	35.98 × 49.21 inches	91.4 × 125.0 cm

A.3 Color Temperature and Color Spaces

Table A-7: Color Temperatures of Various Lighting Conditions

Typical Situation	Color Temperature
Candlelight, fire	1000–1800 K
Tungsten lamp, 60 W	2600 K
Tungsten lamp, 100 W	2700 K
Halogen lamp	3400 K
Moonlight	4100 K
Daylight, standard (D50)*	5000 K
Daylight	5300 K
Direct sunlight	5400 K
Sunny, blue sky	5800 K
Daylight, average (D65)*, north-facing window	6500 K
Flash	6500 K
Overcast sky	7000–8000 K
Neon light	8000–9000 K
Snow-covered mountains in bright sun	Up to 16000 K

* D50 = U.S. standard, D65 = European standard

Table A-8: Characteristics of Various Color Spaces

Color Space	White Point	Gamma	Notes
sRGB	6500 K	2.2	Standard for Windows
Adobe RGB (1998)	6500 K	2.2	Appropriate for most photos
Pro Photo RGB	6500 K	1.8	Very large; use only with 16-bit color depth.
ECI RGB	5000 K	1.8	Standard for European prepress
L-Star RGB	5000 K	Variable	Used in Europe for prepress photography
Apple RGB	5000 K	1.8	Outdated
Wide Gamut RGB	6500 K	2.2	Very large; use only with 16-bit color depth.
CMYK spaces	5000 K	1,8	Various variations, depending on paper and inks (whether used in the US, in Europe or in Asia)

Glossary **B**

aberration • Imaging error of lenses. There are two kinds of aberrations: color (chromatic) and spherical aberrations.

aliasing • Stair-step effect that occurs in diagonal lines in a pixelated image. It can be reduced by anti-aliasing. The neighboring pixels of the shape are supplemented by halftones. This is often used for text in pixel images.

alpha channel • An 8-bit channel that acts as a mask or selection in image editing. With its 256 possible values, it can also define transparency.

aperture • Size of the aperture opening in the lens of the camera. Large aperture values (i.e., 11) equal small openings; small aperture values (i.e., 2) equal large openings.

aperture stop (f-stop) • If the aperture is reduced by one stop, half as much light strikes the sensor. The classical aperture stops are 1, 1.4, 2, 2.8, 4, 5.6, 8, 11, 16, 22, and so on. In modern SLR cameras, the aperture can be set (almost) continuously.

artifacts • An undesirable effect visible when an image is printed or displayed, such as moiré patterns, banding, and compression artifacts. Compression artifacts (from JPEG) may result from too-severe JPEG compression. Oversharpening may also produce artifacts.

ASA • American Standards Association. See ISO.

bitmap • An image that is not described with lines and areas but consists of individual image points (pixels). An image from a digital camera is a *bitmap* image.

blooming • When a CCD sensor element is exposed to a light intensity that is too high, the electric charge can migrate to nearby elements. This undesirable spreading is called *blooming*.

BMP • Bitmap. A common file format for pixel images in Windows.

CCD • charge-coupled device. An electronic element that holds different charges depending on the intensity of the light striking it. This is used to capture light in image sensors of digital cameras and scanners.

CF • Compact Flash, a type of memory card.

CIE • Commission Internationale del' Eclairage, which means *International Commission of Illumination*. It created the CIE-L*a*b standard.

clipping path • A curve or path that defines the clipping (the outer edge) of a pictured object like a mask. In professional programs, it can be saved separately and reloaded and can be losslessly scaled and changed as opposed to bitmap objects.

CMM • color management module. See CMS.

CMS • color management system. Its goal is to display colors (images) as equally as possible on different devices. For this, it captures the color display capabilities of the individual devices—such as scanner, monitor, camera, and printer—and creates color profiles (ICC profile). The CMS uses these profiles when capturing and displaying or outputting images.

CMYK • A color model based on the four primary printing colors: cyan, magenta, yellow, and black (also called *key* color, thus K). They create a subtractive color model used in print production. Though many ink-jet printers use CMYK inks (and often additional colors), they in fact present an RGB interface to the user.

color channel • If you place each individual color component of an image into separate layers and each layer contains the color component as a grayscale image, it is

called a color channel. In the RGB mode, you obtain a red, green, and blue channel (R, G, B channels). In other color modes, there could be more or different channels.

color depth • The number of bits a color is described with. Typical are 1 bit (black and white), 8 bit, 12 bit, and 16 bit. In RGB mode, the color is described with $3 \times n$ bit (e.g., $3 \times 8 = 24$ bit). In CMYK mode, the color is described with $4 \times n$ bit (e.g., 4×8 bit = 32 bit).

color model • The way colors are described using numbers. RGB, for example, uses a triple, denoting the amount of red, green, and blue. CMYK uses a quadruple for the percentage of cyan, magenta, yellow, and black (*key*). There are other device-independent color models, such as (CIE) Lab and HSL. In the HSL color model, the colors are described with a hue, a saturation, and a luminosity value.

color space • A range of colors available for a particular profile or color model. When an image resides in a particular color space, the color space limits the range of colors available to that image. It also defines *how* the color values of an image are to be interpreted. For example, RGB, CMYK, and (CIE) Lab are color spaces. Within these color spaces there exist different variations in RGB, there is ColorSync RGB, and in Adobe RGB, there is Color Match RGB).

CRT • cathode ray tube. A component in monitors incorporating glass tubes for display.

D50, D65 • These are standardized lighting conditions for evaluating images and colors. D50 equals an illumination with a color temperature of 5000 K and D65 of 6500 K.

DCF • Design Rule for Camera File Systems. A convention for the structure of data systems and the folder and filenames for the data carriers in digital cameras. This allows files to be interchanged between different cameras.

DCS • Digital Color Separated is a special image format for separated color images (separated into the four basic colors). The image consists of five components: the four separated parts (CMYK) as well as a screen preview in full color. DCS images can be created with Adobe Photoshop, for example.

dithering • A technique in which only a few primary colors are used to simulate many different colors and/or halftones by placing dots in a certain pattern.

dpi • dots per inch.

DPOF • Digital Print Order Format. A file that can be created in a camera and contains a print order (i.e., print size, number of prints per image, and so on). This allows an automatic transfer of data or automatic replay.

ECI • European Color Initiative. This organization defines standardized means to exchange colors (color images) on the basis of ICC profiles. You may find some specific color profiles on its website (www.eci.org).

EMV • electronic magnifying viewer. Also called EVF (electronic view finder), it is an electronic view finder in digital cameras that shows the incoming light on a high-resolution monitor. When the light levels are low, the image on the monitor can be brightened.

EPS • Encapsulated PostScript. A standard file format, usually including vector graphics or a mix of vector graphics and bitmap images. Often, EPS files contain both the actual graphic information and a preview image.

EV • exposure value.

EVF • electronic view finder. See EMV.

EXIF • A standardized format for camera metadata. There are different versions (e.g., 2.1, 2.2). Newer cameras embed these metadata into the TIFF or JPEG image files. They save camera information such as the date the image was taken, exposure time and aperture, and focal length.

FireWire • IEEE 1394, for Sony i.LINK, is a fast, serial interface for card readers, digital cameras, scanners, and other peripheral devices.

flash guide number • Indicates the reach of a flash unit. With the guide number and distance, the aperture can be calculated as follows: aperture = guide number / distance (in meters). This applies to a sensitivity of ISO 100 with a normal lens (50 mm).

gamma • A monitor value that corrects the nonlinear relationship between the input voltage and the bright-

ness of the monitor. The value commonly used with Windows is 2.2 and with Mac OS 1.8. During image editing. a *gamma curve* (gradation curve) allows for a tonal correction of the image. It determines which input (gray) value is mapped to which output value. This allows you to brighten or darken particular tonal areas.

gamut • The total range of colors (and densities) a device can reproduce (a monitor or printer) or capture (a scanner or digital camera).

GIF • Graphics Interchange Format. A data format for saving bitmapped images. GIF can only save a total color depth of 8 bit (no 3 x 8 bit) and therefore its use is limited for color images. Metadata cannot be embedded.

grayscale mode • An image in which only one color component (usually black) is present in different tonal gradations.

histogram • A visual representation of tonal levels in an image.

HSL, HSV, HSB • Color models. HSL stands for hue, saturation, and luminance. HSV stands for hue, saturation, and value (or brightness value), and HSB stands for hue, saturation, and brightness.

ICC • International Color Consortium. A consortium of companies that develops industry-wide standards for color management, i.e., ICC profiles. For more information, see www.color.org.

ICM • Image Color Management or Integrated Color Management. The Microsoft implementation of the color management module in Windows.

IEEE 1394 • See FireWire.

IPTC • International Press Telecommunications Council. A consortium that developed a metadata format that describes media data for the image.

ISO • International Standards Organization. An ISO value describes the light sensitivity of film or image sensors. High values correspond to a high sensitivity.

JEIDA • Japan Electronic Industry Development Association. An association of companies with the goal of defining common standards. In the meantime, it has become JEIDA, an even larger Japanese association.

JPEG • Joint Photographic Experts Group. A lossy compression method and file format. The term is also used to describe bitmapped images that have been saved with JPEG compression. Different levels of compression are available.

Lab color mode • Also L*a*b. Describes a theoretically ideal color space that encompasses colors visible to humans and is larger than the RGB or CMYK color spaces. Colors in this model are defined by L (luminance) and two color components, *a* and *b*. The *a* represents the axis ranging from red to green, while *b* ranges from blue to yellow.

LCD • liquid crystal display. A display technique used for flat-panel monitors as well as small displays in cell phones and digital cameras.

line screen • The number of lines per measurement unit in printing. The line screen is noted in lines per inch (lpi). Laser printers usually use a line screen of 65 lpi, newspapers 75 lpi, and magazines and books 150 lpi. The necessary ppi value of bitmapped (pixel) images needs to be about 1.4 to 2.0 times as high (depending on the quality factor).

lpi • lines per inch. The measure used to define printing resolution (or screen frequency) with typical halftone printing methods, such as offset printing. One image pixel is simulated with a pattern of several small print dots.

luminance • Brightness value.

mask • Covers an image area to protect it from editing.

metadata • Data that describes an object (e.g., an image), for example, with the date of exposure, copyright notices, rights usage terms, and imaging information.

metamerism • The effect of color (typically gray or almost black) appearing different under different lighting conditions (e.g., daylight or artificial light). The strength of the effect depends on the color/ink and the dithering method.

moiré • A distracting pattern that appears when two similar patterns are superimposed. It can occur when you're scanning printed images, scaling, or superimposing fine, regular patterns.

noise • Several image pixels that do not display the correct color. This occurs when high ISO settings are used (e.g., for night photography) and is especially visible in darker image areas. High temperatures of the image sensor increase noise. It is roughly equivalent to grain in film.

path • Form or vector curve. It can serve as a selection, a clipping path, or a vector graphic. A clipping path surrounds parts of an image that should be visible.

PictBridge • An industry standard that allows you to print directly from the camera to any printer (both need to support PictBridge), generally by using a USB cable or Bluetooth.

plug-in • A module that expands the functions of program. Often the plug-in needs to be placed in a special folder of the program so that it can be recognized as such and used. In image editing programs, almost all filter functions are plug-ins.

ppi • pixel per inch.

PSD • Photoshop data. The native file format of Photoshop and Photoshop Elements, in which practically all image information as well as layers, color profiles, paths, and so on are saved. PSD can be imported by almost all image editing programs and therefore can be utilized for transferring data.

PSP • Paint Shop Pro data. The native file format of Paint Shop Pro.

raster • Pattern of micro print dots. In offset printing, each raster point represents one pixel of the original and is composed of yet another pattern of individual micro print dots.

RGB • A method to describe color by the combination of the three base colors red, green, and blue. The color is composed by the different brightness levels of these three colors. CRT and LCD monitors use the RGB method to display color.

separation • The process of separating a color image into four (or more) components or channels. Every channel contains only the grayscale values for its color. For CMYK images, these are cyan, magenta, yellow, and black channels.

SLR • single-lens reflex.

spi • samples per inch. This is the correct term for describing the resolution of scanners.

spline • A type of line/curve that is composed of several line segments that can include soft arches and sharp corners. It allows you to create complex curve shapes relatively easy.

sRGB • A standard color space for monitors. It is intended for images presented on monitors or on the Web.

TFT-LCD • Flat panel monitors based on *thin film transistor* technology.

TIFF • Tagged Image File Format. A file format for images. TIFF acts as an envelope format for many different image formats and allows several different compression modes, most of them lossless. It can also save additional metadata (for example, in the EXIF format).

TrueColor • A monitor setting that uses either 24- or 32-bit color depth.

TTL • Through the Lens. Measuring exposure values through the lens or a viewfinder the shows the light entering through the lens.

TWAIN • A common, standardized software interface for scanners. With a TWAIN plug-in, you can access a scanner from many programs that support TWAIN.

USB 2.0 • A faster port than USB 1.1. It is advantageous when connecting storage devices, scanners, and digital cameras to the computer.

USM • Unsharp Mask. A method of sharpening an image by increasing the contrast of its edge pixels.

UV • ultraviolet. The light spectrum above the visible range for humans. The light creates a slight gray cast on film or image sensor (without using a UV filter).

vector graphic • A graphic that can consist of lines, arrows, text, and areas. Because the elements are not pixels but described by a mathematical formula, the graphic can be scaled without loss and can be edited after its creation.

web gallery • An HTML page (internet page) with images that can be enlarged (or displayed on their own page) by clicking on them.

Literature and Internet Sources C

Please keep in mind that Web links may change, specific information may be removed or a web address may vanish completely. We welcome information about such discrepancies so that we can correct them in the next edition of this book.

C.1 Books

1. Katrin Eisman. *Photoshop: Restoration & Retouching*. New Riders, Berkeley, 2006.

2. Martin Evening. *Adobe Photoshop for Photographers*. Focal Press, Oxford, 2006.

3. Bruce Fraser, Chris Murphy, Fred Bunting. *Real World Color Management*. Peachpit Press, Berkeley, 2004.

4. Tim Grey. *Color Confidence: The Digital Photographer's Guide to Color Management*. Sybex, 2006.

5. Cyrill Harnischmacher. *Closeup Shooting: A Guide to Closeup, Tabletop, and Macro Photography*. Rocky Nook, Santa Barbara, 2007.

6. Martha Hill. *The Art of Photographing Nature*. Three River Press, New York, 1993.

7. Peter Krogh. *The DAM Book: Digital Asset Management for Photographers*. O'Reilly, Sebastopol, 2006.

8. Sascha Steinhoff: *Scanning Negatives and Slides*. Rocky Nook, Santa Barbara, 2007.

9. Uwe Steinmueller, Juergen Gulbins. *Fine Art Printing for Photographers: Exhibition Quality Prints with Inkjet Printers*. Rocky Nook, Santa Barbara, 2007.

C.2 Organizations and Institutes

10. European Color Initiative (ECI). You can find ICC profiles for ECI-RGB as well as for offset printing here: www.eci.org

11. International Color Consortium (ICC). The home of ICC with much information on ICC profiles: www.color.org

12. Wilhelm Imaging Research (WIR). The reference site for information on the life span of papers, photographs, prints, and inks: www.wilhelm-research.com

C.3 Information on the Internet

13. Apple: *ColorSync—The Standard for Communicating Color*. A comprehensive introduction in to the ColorSync color management system. www.apple.com/colorsync/

14. Betternet: *Raw-Converter.com*. News about digital photography and especially about RAW converters. www.raw-converter.com

15. Mauro Boscarol: *Introduction to Digital Color Management*. An informative website about color management: www.boscarol.com/pages/cms_eng/

16. *Digital Photography Review (DP-Review)*. An website with current information on new digital cameras and their accessories. You can sign up for a weekly newsletter. www.dpreview.com

17. Jack Flesher: *UPrezzing Digital Images* (Mac, Win). The article talks about enlarging images. You can download a free plug-in for scaling. www.outbackphoto.com/workflow/wf_60/essay.html

18. *Hahnemuehle*. A well-known German manufacturer of traditional and digital fine-art papers. For many of these papers, you can find ICC profiles for various printers (and their standard inks). www.hahnemuehle.com

19. Clayton Jones: *Fine Art Black and White Digital Printing. An Overview of the Current State of the Art*. A very informative site about black-and-white printing. www.cjcom.net/articles/digiprnarts.htm

20. *Epson USA*. Here you can find improved ICC profiles for the Epson R2400. www.epson.com/cgi-bin/store/editorialannouncement.jsp?cookies=no&oid=59082651

21. Hutcheson Consulting: *Color management notes*. Informative site about CMS, scanning, and proofs. Includes a number of free test color files. www.hutchcolor.com/CMS_notes.html

22. Microsoft: *Color Management and Windows: An Introduction*. www.microsoft.com/whdc/hwdev/tech/color/icmwp.mspx

23. Microsoft: *Color Interchange Using sRGB*. www.microsoft.com/whdc/hwdev/tech/color/sRGB_Print.mspx

24. *OutbackPhoto.com*. Exceptionally informative website about digital photography with good images, product reviews, and much more. Created and maintained by Uwe Steinmueller. www.outbackphoto.com

25. *panoguide.com*. Website about panorama photography. www.panoguide.com/technique/

26. Picture Flow LCC: *Rawworkflow.com*. Focuses on Raw conversion. www.rawworkflow.com

27. Michael Reichman: *The Luminous Landscape*. An interesting website about photography (emphasis is on landscape photography) with test reports, tutorials about special subjects, and many image examples. http://luminous-landscape.com

28. Wayne Fulton: *A few scanning tips*. www.scantips.com

C.4 Tools on the Internet

RAW Conversion

29. Adobe: *DNG-Konverter* (Mac, Win, free). www.adobe.com/products/dng/

30. Adobe: *Lightroom* (Mac, Win). All-in-one program with RAW conversion, image editing, and image management. http://labs.adobe.com/technologies/lightroom/

31. Apple: *Aperture* (Mac, Win). An all-in-one program for photographers. Good image management information. www.apple.com/aperture/download/

32. Bibble Labs: *Bibble* (Mac, Win). Bibble is a universal, good, and for its quality, cheap RAW converter. www.bibblelabs.com

33. Breeze Systems: *Breeze Browser* (Win). The Breeze browser is an image management program, file browser, and RAW converter for various RAW formats. www.breezebrowser.com

34. Canon: *Digital Photo Professional* (Mac, Win). A RAW converter for Canon RAW files. www.canon.com

35. Dave Coffin: *Dcraw – Raw Digital Photo Decoding in Linux* (Linux, Win). Dcraw is a free RAW converter plug-in for GIMP. http://cybercom.net/~dcoffin/dcraw/

36. *DxO Optics Pro* (Mac, Win). Corrects lens errors (distortions, vignetting, and chromatic aberration). www.dxo.com

37. Iridient Digital: *RAW Developer* (Mac). Good and low-cost RAW converter for Mac. www.iridientdigital.com

38. Light Crafts: *LightZone* (Mac, Win). This stand-alone program allows you to make very fine tonal value optimizations on images. www.lightcrafts.com

A report about this software can be found at www.outbackphoto.com/artofraw/raw_26/essay.html

39. Nikon: *Nikon Capture NX* (Mac, Win). A new-generation RAW converter (works with RAW, JPEG, and TIFF images). Supports only the RAW formats of Nikon DSLR models. www.nikon.com

40. Phase One: *Capture One DSLR* (Mac, Win). C1 is a RAW converter that supports many RAW formats. http://www2.phaseone.com

41. Ichikawa Soft Laboratory: *SILKYPIX* (Mac, Win). Universal RAW converter. www.isl.co.jp/SILKYPIX/english/

Color Management

42. Color Solutions Software. A company specializing in color management with a whole range of solutions from calibrating monitors to profiling printers. www.basiccolor.de/english/index_E.htm

43. Color Vision. Offers various packages for profiling monitors and printers (Mac, Win). www.colorvision.ch

44. Gretag Macbeth. Offers various tools for color management—for example, Eye-One Display (Mac, Win). www.gretagmacbeth.com (now a part of X-Rite: www.xrite.com)

45. Pantone. Known for the Pantone color system, it is also the manufacturer of third-party inks for Espon printers. Here you can also find fine-art papers and the huey colorimeter (Mac, Win). www.pantone.com

46. X-Rite offers monitor profiling kits as well as tools for profiling scanners and printers (Mac, Win). www.xrite.com

Image Management

47. ACD Systems: *ACDSee* (Win). Image management. www.acdsystems.com

48. Camera Bits: *Photo Mechanic* (Mac, Win). A powerful download program and browser with some functions for image management. One of its strength is handling IPTC data. www.camerabits.com

49. Canto Software Inc: *Cumulus* (Mac, Win). An image/media management system with client-server architecture. The server with the media databank can also run on Unix systems. www.canto.com

50. Atlantic Software Exchange: *ThumbsPlus Pro* (Win). A flexible image browser with good functions for image management. With plug-ins, it can also display and process various RAW formats. www.cerious.com

51. Extensis: *Extensis Portfolio* (Mac, Win). *Portfolio* is a professional image and media management program with client-server architecture. Extensis also offers a tool called *Intellihance Pro* for optimizing images, as well as the masking tool *Mask Pro*. www.extensis.com

52. iView Multimedia: *iView Media Pro* (Mac, Win). Good image management for photographers. www.iview-multimedia.com

Editors, Filters, and Other Tools

53. *Curvemeister* (Win). A Photoshop plug-in for color correction. www.curvemeister.com

54. *EXIF-O-Matic* (Mac, Win). A small program for displaying and exporting EXIF data of photographs. www.instituteofthefuture.org/exifomatic/

55. Digital Light & Color: *Color Mechanic Pro* (Mac, Win). A powerful and comfortable tool for removing color casts and making other color corrections. www.colormechanic.com

56. Digital Light & Color: *Picture Window Pro* (Win). For the price, it is a powerful image editing program. www.dl-c.com

57. Digital Domain Inc: *Qimage* (Win). A low-cost, functional, and multifaceted printing module for printing images on ink-jet printers. www.ddisoftware.com

58. *The Gimp* (Mac, Win, Linux). The home page of the GIMP project. GIMP is a fast, professional, and free image editor for Unix/Linux, Windows, and Mac OS. www.gimp.org

59. Lyson (now Nazdar). Manufacturer of high-quality inks and other accessories for ink-jet printing, including third-party inks for Epson printers. You can also find fine-art papers and continuous ink systems. www.nazdar.com/

60. Multi Media Photo: *Photomatix*. A tool for creating HDR (high dynamic range) images (Mac, Win). www.hdrsoft.com

61. Nik Multimedia Inc: *Nik Color Efex Pro* (Mac, Win). *Nik Color Efex* is a set of filters offered as a Photoshop plug-in. www.nikmultimedia.com

62. Nik Multimedia Inc: *Dfine* (Mac, Win). *Dfine* specializes on reducing image noise. www.nikmultimedia.com

63. NeatImage: *Neat Image* (Mac, Win). Photoshop plug-in for reduction of noise in photographs. The program comes in a standard and a pro version. www.neatimage.com

64. *Noise Ninja* (Mac, Win). A powerful tool for working with image noise. A little complex in use. www.picturecode.com

65. *Formati* (Win). A freeware batch converter that can convert and scale various formats. http://jansfreeware.com

66. *JAlbum* (Mac, Win). Web photo album generator. www.jalbum.net

67. *JPEG Cleaner* (Win). A program to work with and delete metadata in JPEG and GIF files (e.g., before passing them on). www.rainbow-software.org

68. *The Plugin Site*. A website specializing on plug-ins for image editing. Includes many free filters, including the freeware filters Harrys Filter. http://thepluginsite.com

69. PowerRetouche: *Lens Correction* (Mac, Win). This company offers a number of Photoshop plug-ins for working with photographs: Black and White Studio, Lens Distortion Correction, and Dynamic Range Compression Plugin: www.powerretouche.com

70. PictoColor Corp.: *iCorrect EditLab* (Mac, Win). A Photoshop plug-in for color corrections. www.picto.com

71. Thomas Niemann: *PTLens* (Win). A free, good tool and Photoshop plug-in for panoramas. It can be used to correct lens errors, for which it uses profiles for different lenses. The profiles of many cameras and lenses are already included. http://epaperpress.com/ptlens/

72. Roy Harrington: *QuadToneRIP* (Mac, Win). RIP for printing on ink-jet printers. http://harrinton.com/QuadToneRIP.html

73. Richard Rosenman: *Photoshop Plugins* (Win). A number of plug-ins (some free) for Photoshop, including the filter Lens Distortion Corrector. www.richardrosenman.com/photoshop.htm

74. Hamrick Software: *VueScan* (Mac, Win). Scanning software for many scanners. Also supports ICC profiling of scanners. www.hamrick.com

75. Friedemann Schmidt: *Exifer for Windows.* A useful, small file and image browser that shows the image metadata in EXIF, IPTC, and JPEG commentary format. www.friedemann-schmidt.com/software/exifer/

76. *The Word of Nikonians.* A small collection of free filters (Photoshop plug-ins), including Chrome, a good filter for the controlled conversion of color images to grayscale. www.nikonians.com/html/resources/software/ PhotoImage/documentation/photo_image-mk.html

77. *ShutterFreaks.* Offering a low-cost Photoshop action that reduces noise in an image in different steps. www.shutterfreaks.com/actions/

78. *ImageMagick* (Win, Linux). A powerful conversion and scaling tool that works with a command-line interface. www.imagemagick.org

79. Irfan Skiljan: *Irfan View* (Win). A free, powerful image browser that can process many RAW formats. www.irfanview.com

80. *Photo Resizer* (Win). This freeware program allows you to resize images individually or in batch mode. www.showyourphotos.com/ photoresizer_free.html

81. Broderbund.com: *Print Shop Pro* (Win). A powerful program for printing greeting cards, calendars, and posters. www.broderbund.com

82. *Fred Miranda.* Offering a number of good, low-cost filters and Photoshop actions. www.fredmiranda.com

83. *nik multimedia Inc.* (Mac, Win). Here you can find a number of photographic tools (plug-ins) including Dfine, which is used to reduce image flaws and noise. www.nikmultimedia.com

84. *Oriens Enhancer* (Win). A small but good shareware program for image editing. www.oriens-solution.com

85. Lizardtech Software: *Genuine fractals.* A commercial software program for scaling bitmapped (pixel) images without (much) loss. www.lizardtech.com/solutions/photo/

86. Pierre-Emmanuel Gougelet: *XnView* (Mac, Win, Linux). A free image browser for private users that can import, display, and export many image formats. It can also be used for batch processing. www.Xnview.com

87. *PTgui.* A user-friendly graphical interface for the tools used to create panorama images from a sequence of individual pictures (Mac, Win). www.ptgui.com

88. *Panorama Factory* (Win). A powerful and comfortable stitching program to assemble several individual images into one panorama picture. www.panoramafactory.com

89. *Photo Plugins* (Win). Here you find a whole number of Photoshop plug-ins, such as for a high-quality conversion to black and white or for correcting lens errors. This program is donation-ware, which means you make a donation if you are happy with the program. www.photo-plugins.com

C.5 Examples of Internet Photo Print Services

90. *Shutterfly*: www.shutterfly.com

91. *Apple*: www.apple.com/ilife/iphoto/features/ books.html

92. *Kodak*: www.kodakgallery.com/ PhotoBookOverview.jsp

93. *Foto Insight*: www.fotoinsight.com/book/

94. *My Publisher*: www.mypublisher.com

95. *Photo Book Express*: www.photobookpress.com

Index

U
undo 218
 work history 218
Universal Serial Bus (USB) 26
unsharp mask (USM) 181, 182
USB (Universal Serial Bus) 26, 38
useful tools 34
USM (unsharp mask) 182, 340
 Threshold 182
UV (ultraviolet) 340
UV Filter 30
UV filter 92

V
vector graphic 340
vector graphics 203
vibrance 249
vibration reduction (VR) 17

viewfinders 19
 DSLR 19
 optical viewfinders 19
vignetting 16
VR (vibration reduction) 17
VueScan 303

W
WB 52
WBM (wireless bitmap) 44
web gallery 341
white balance (WB) 51, 244
 manual 52
white point 169, 224, 246
wide angle 14
WIR 343
WMF (Windows meta format) 44

X
xD-Picture Cards 24
XMP 242, 254, 320
XMP (Extensible Metadata Platform) 45

Z
ZIP compression 41, 214
zoom 140, 141
 digital zoom 14
 lenses 14
 optical zoom 14

Brad Hinkel · Steve Laskevitch
Photoshop CS3 Photographer's Handbook
An Easy Workflow

Photographers often feel intimidated when starting out with Photoshop; the sheer number of tools and options can be overwhelming for the beginner. In *Photoshop CS3 Photographer's Handbook*, you will find a straightforward guide that provides a simple, yet effective workflow for editing photographs in the newest generation of Photoshop. Designed to get you quickly working in Photoshop, the essential information needed for image editing is included. More advanced Photoshop techniques are covered in step-by-step projects that will guide you to new levels of image manipulation and creativity.

Use the *Photoshop CS3 Photographer's Handbook* to:

- Get a solid foundation towards understanding Photoshop CS3
- Learn a practical workflow for editing images
- Learn techniques for image editing with simple step-by-step instructions

June 2007, 208 pages
ISBN 978-1-933952-11-6, $35.95

Rocky Nook, Inc.
26 West Mission St Ste 3
Santa Barbara, CA 93101-2432

Phone 1-805-687-8727
Toll-free 1-866-687-1118
Fax 1-805-687-2204

E-mail contact@rockynook.com
www.rockynook.com

rockynook

Alain Briot

Mastering
Landscape Photography

The Luminous-Landscape Essays

rockynoo

"You don't take
a photograph,
you make it."

ANSEL ADAMS

Alain Briot
Mastering Landscape Photography
'The Luminous Landscape Essays'

Mastering Landscape Photography consists of thirteen essays on landscape photography by master photographer Alain Briot. Topics include practical, technical, and aesthetic aspects of photography to help photographers build and refine their skills. This book starts with the technical aspects of photography; how to see, compose, find the right light, and select the best lens for a specific shot. It continues by focusing on the artistic aspects of photography with chapters on how to select your best work, how to create a portfolio, and finally concludes with two chapters on how to be an artist in business. Alain Briot is one of today's leading contemporary landscape photographers. He received his education in France and currently works mostly in the southwestern part of the United States. Alain Briot is a columnist on the highly respected Luminous Landscape website.

November 2006, 256 pages
ISBN 1-933952-06-7, Price: $39.95

Rocky Nook, Inc.
26 West Mission St Ste 3
Santa Barbara, CA 93101-2432

Phone 1-805-687-8727
Toll-free 1-866-687-1118
Fax 1-805-687-2204

E-mail contact@rockynook.com
www.rockynook.com